OBJECT LESSONS:
ZOFIA RYDET'S *SOCIOLOGICAL RECORD*

BOOKS
N° 13
The MUSEUM UNDER CONSTRUCTION book series
We are building a Museum of Modern Art in Warsaw
We are writing a new history of art

OBJECT LESSONS:
ZOFIA RYDET'S
SOCIOLOGICAL RECORD

EDITED BY
KRZYSZTOF PIJARSKI

MUSEUM OF MODERN ART
IN WARSAW 2017

BOOKS
N° 13

ZOFIA RYDET
SOCIOLOGICAL RECORD
PHOTOGRAPHS SELECTED BY
SEBASTIAN CICHOCKI

9 ZOFIA RYDET, *PEOPLE IN INTERIORS*, FROM THE *SOCIOLOGICAL RECORD*, OLSZÓWKA, PODHALE REGION, 1978

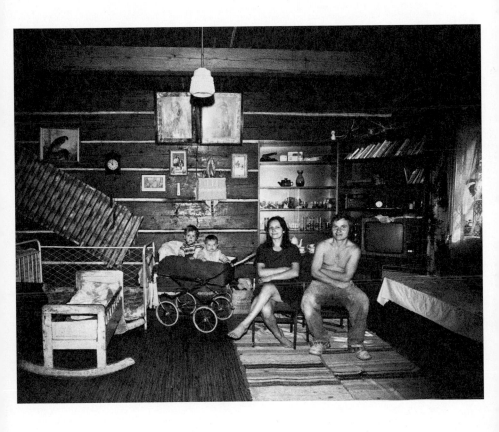

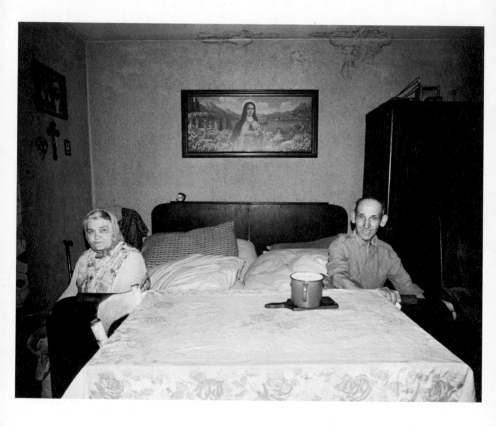

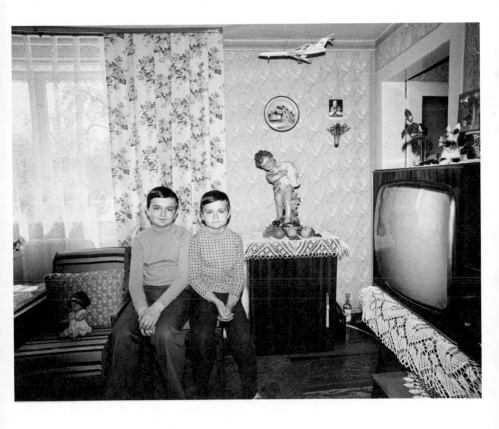

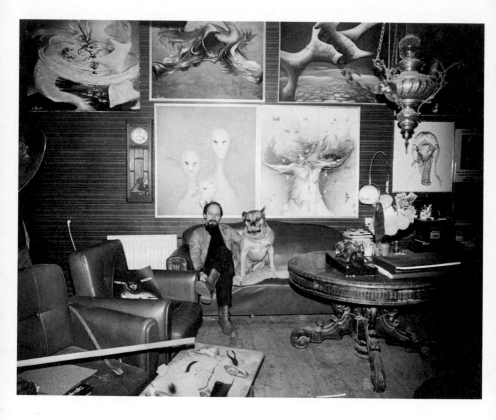

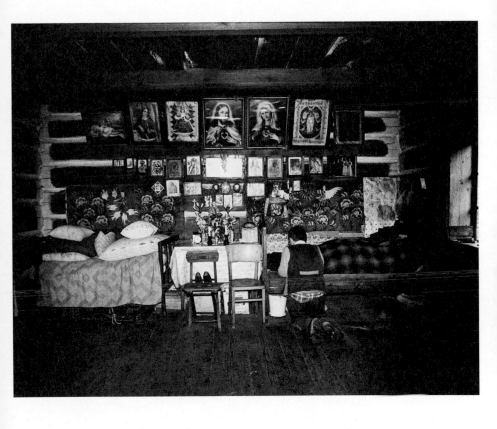

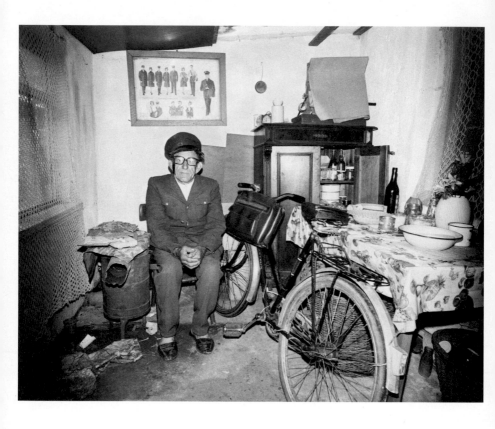

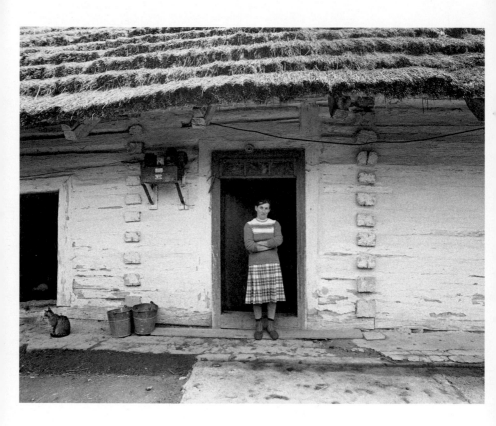

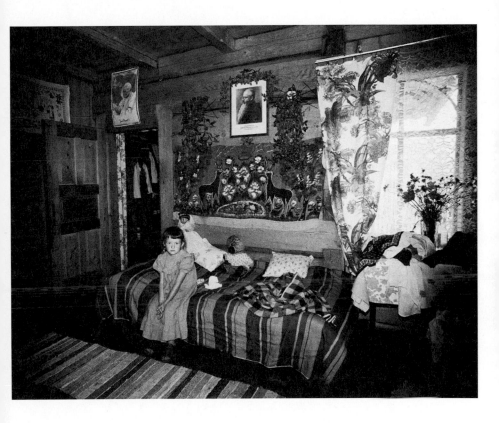

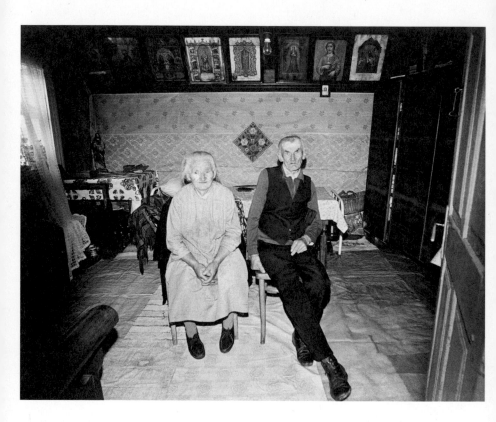

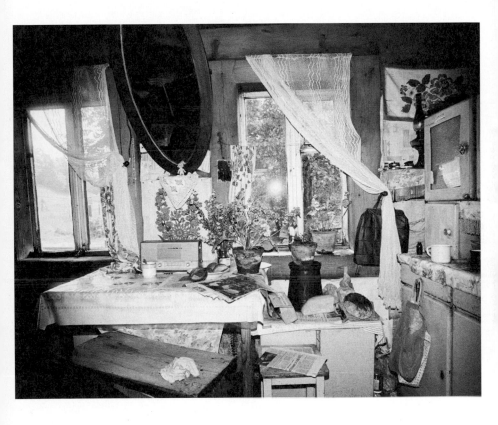

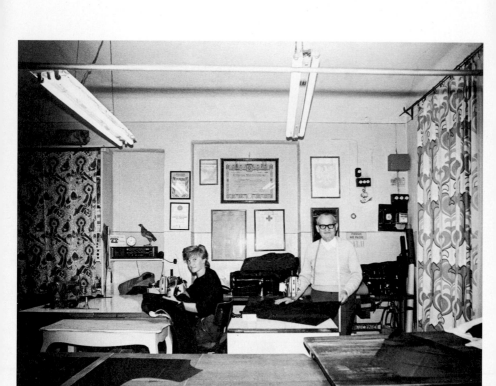

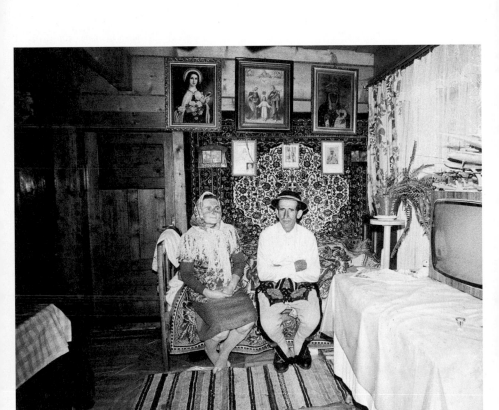

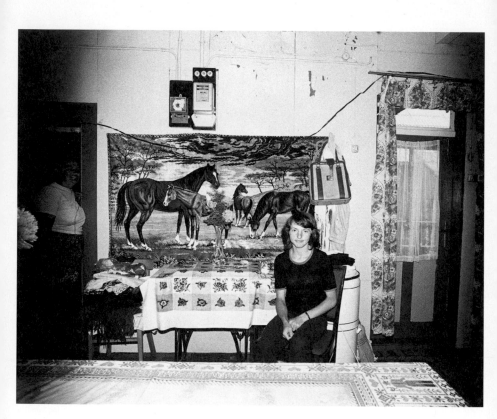

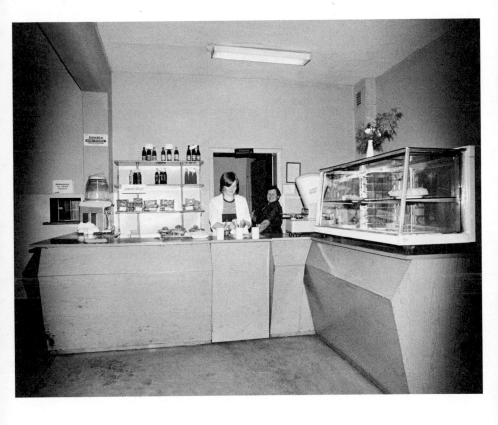

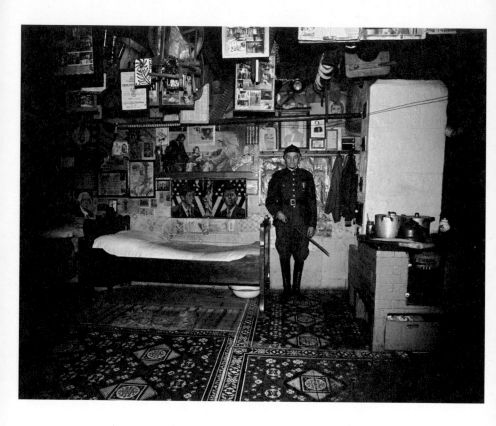

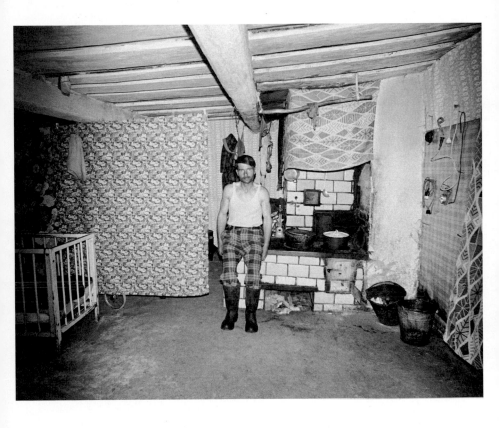

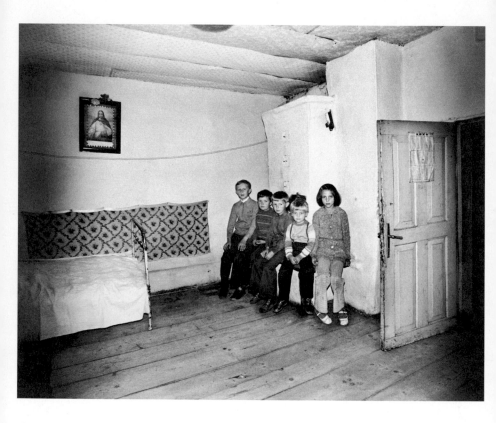

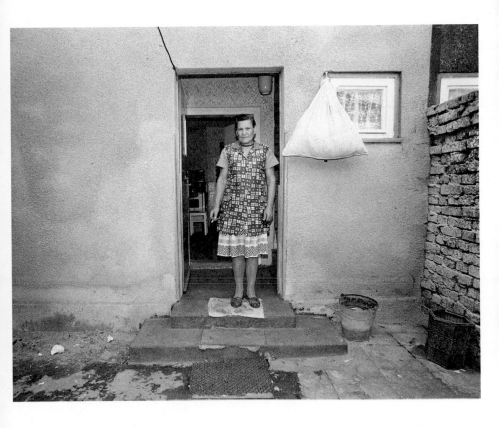

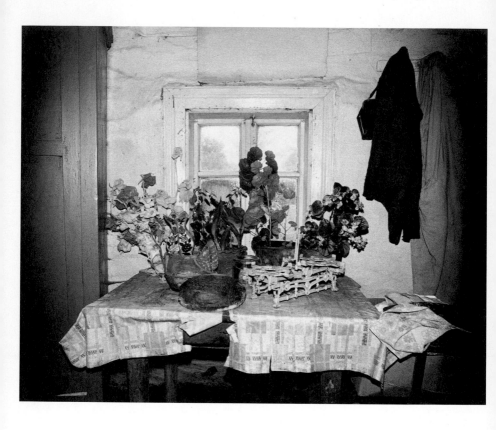

Sebastian Cichocki is the chief curator at the Museum of Modern Art in Warsaw and curator of the long-term public art project Bródno Sculpture Park, also in Warsaw. Selected curated and co-curated exhibitions include the Polish pavilions at the 52nd and 54th editions of the Venice Biennale, with, respectively, Monika Sosnowska ("1:1," 2007) and Yael Bartana ("… and Europe will Be Stunned," 2011); "The Resistance of the Form" (Powszechny Theatre, 2017); "Rainbow in the Dark: On the Joy and Torment of Faith," (SALT Istanbul, 2014); and "Making Use: Life in Postartistic Times" (2016), "Zofia Rydet: *Record*, 1978–1990" (2015), and "New National Art: National Realism in Poland in the 21st Century" (2012), all at the Museum of Modern Art in Warsaw. He is author and editor of, among other titles, *A Cookbook for Political Imagination* (Zachęta National Gallery of Art; Sternberg Press, 2011, co-edited with Galit Eilat), *The Future of Art Criticism as Pure Fiction* (Bęc Zmiana, 2011), *Spoken Exhibitions: An Institutional Opera in Three Acts* (Bęc Zmiana, 2011), *S.Z.T.U.K.A.* (Dwie Siostry, 2011), *Earth Works! An Exhibition about Soil, Dust, Mausoleums and Slime* (Bęc Zmiana, 2013), and *Mirage* (Bunkier Sztuki, 2013). Cichocki's curatorial work is focused on "postartistic," Arte Útil, and land use–related practices, as well as literature as a form of exhibition-making.

ART BEYOND ART

Sociological Record by Zofia Rydet is a monumental photographic project, which, in recent years, has finally come to be regarded within the context of contemporary art.[1] Although fragments of the series were shown in numerous exhibitions in Rydet's lifetime, and given ample coverage in both the specialist and popular press, Sociological Record continues to pose many unknowns that are a challenge to art historians, curators, and academics from other fields conducting research into the theme of visual culture in Eastern Europe in the 1970s and 1980s.

In 2015, the Museum of Modern Art in Warsaw prepared the exhibition "Zofia Rydet: Record, 1978–1990," part of a larger program on Rydet's archive, co-authored by four institutions: the Foundation for Visual Arts, the Museum of Modern Art in Warsaw,

1 Part of the Sociological Record was presented during the 12th Baltic Triennial at the Contemporary Art Centre in Vilnius (2015) and in the exhibition "The Keeper," at the New Museum, New York (2016).

the Zofia Rydet Foundation, and the Museum in Gliwice.[2] This collaboration has resulted in the digitization of *Sociological Record*, making it available almost in its entirety as an online archive.[3] For the Museum of Modern Art in Warsaw, this was another stage in our research-cum-exhibition program, dedicated to the key figures of Polish art of the twentieth century such as Andrzej Wróblewski, Alina Szapocznikow, Włodzimierz Borowski, and Oskar and Zofia Hansen. Unusually, the program was focused on a single work that is not easy to ascribe a defined character—the *Sociological Record*.

Rydet began work on the *Record* at the relatively advanced age of sixty-seven. By that point, she was an artist with wide-ranging contacts in neo-avant-garde circles, and one with a defined and unique position among Polish photographers in a field otherwise dominated by men.[4] The series comprises some 27,000 photographs, taken in over one hundred Polish villages and small towns. The concept for the series—which evolved into a photographic program that lasted more than a decade—was simple: the documentation of house interiors, complete with their inhabitants. Rydet used a wide-angle lens, usually with strong flash that highlighted the details: the hosts posed against the wall, looking straight into the camera. The artist was interested in how individual aesthetic preferences, political opinions, and religious beliefs manifest themselves through the arrangement of one's private space.

Zofia Rydet first defined her idea of documenting the interiors of Polish homes in a letter sent to Krystyna Łyczywek, in

2 "Zofia Rydet: *Record*, 1978–1990," September 25, 2015–January 10, 2016, curated by Sebastian Cichocki, Karol Hordziej; with architectural design by Marcin Kwietowicz, Grażyna Stawicka; graphic design by Pilar Rojo; production by Katarzyna Karwańska, Tomasz Gutkowski; and academic collaboration, research by Maria Sokół-Augustyńska, Zofia Augustyńska-Martyniak (Zofia Rydet Foundation). The exhibition was shown again, in France, the following year: "Zofia Rydet. *Répertoire*, 1978–1990," Jeu de Paume – Château de Tours, November 19, 2016–May 28, 2017.

3 The archive can be accessed at http://www.zofiarydet.com.

4 During her lifetime, Rydet was known primarily as the author of two photographic series, both subsequently published in book form: *Mały człowiek* [Little Man], published in 1965, a series devoted to children and growing up; and *Świat uczuć i wyobraźni* [The World of Feelings and Imagination], published in 1979 as *Świat wyobraźni Zofii Rydet* [Zofia Rydet's World of Imagination], a set of surrealist photomontages with motifs such as mannequins, gloves, dolls, etc.

1967. The photographer only began its implementation eleven years later, although most of the motifs from *Sociological Record* do appear much earlier in her archive. These include motifs that are "classical" for the *Record* as well as those which form part of other, shorter series: women in front of their houses, photographs of photographs, or craftspeople at work. Rydet was to continue the series for the rest of her life. This is how Rydet phrased her goals for the *Record*:

> It is intended to present a faithful portrait of man in his everyday environment, this cocoon of sorts that he has himself created, which, on the one hand, becomes the decor of his immediate surroundings, the interior, but which also exposes his psyche.[5]

There has been a tendency in Polish academic literature to interpret Rydet's project in the spirit of humanist photography or as the sentimental preservation of images of the "premodern" countryside, succumbing inevitably to processes of modernization. The series coincided with a particular moment of theoretical reflection in Polish photography; at the time, the medium was discussed as a possible sociological tool—this approach culminated in the 1st National Review of Sociological Photography in Bielsko-Biała, in 1980. Toward the end of the 1970s, the publishing house Ludowa Spółdzielnia Wydawnicza intended to publish *Sociological Record* as an album. This idea was given up, probably due to qualms about the perception that Poland could come across as a poverty-stricken and unmodernized country. On taking a closer look at the artist's ambition and the context of her activities, *Sociological Record* finds a place alongside other social photographic programs such as Chauncey Hare's *Protest Photographs*, [SEE: P. 176] created in the 1960s and 1970s, where the political content of the photograph relies on the discipline and antispectacular quality of the image, and on the use of a conceptual "method statement."

Sociological Record was never finished. Aware as she was that she would be unable to finalize her oeuvre and to document the interiors of all Polish homes (and let us note that in the 1980s, *Sociological Record* expanded to incorporate the photographs she had

5 Zofia Rydet, *O swojej twórczości* (Gliwice: Muzeum w Gliwicach, 1993).

taken in Lithuania, France, Germany, and the US, where the artist was mainly interested in Polish immigrants' residential interiors), Rydet continued to shoot her photographs with increasing determination and impatience, rarely returning to the negatives taken earlier. On a few occasions, she revisited households that she had photographed previously in order to document the changes that were taking place in the Polish countryside. Incessantly on the road, busy traveling and taking photographs, yet growing weaker with increasing age, the artist did not make prints from the majority of the negatives that she had assembled. As a result, only a small fraction of the work came to be known, whereas certain stills were endlessly repeated in exhibitions, in various formats.

In the last years of her life, Rydet began to modify the gathered material using scissors: she added pieces of textiles, dried flowers, buttons, and so on. Her collages from the 1990s represent a return to the surreal portraits of her early creative phase, replacing the obsessive, quasi-documentary, and never-to-be-finished program of the *Sociological Record*. Its open-endedness poses a problem both for researchers and for curators presenting fragments of the series today. It is difficult to delineate the boundaries of the *Record*, which comprise haphazard shots or takes that provide the leaven for departures into new thematic subseries. It is logistically impossible to exhibit the entire series or as much of it as Rydet had managed to assemble during her lifetime. To produce contemporary copies from the negatives, the majority of which have never been presented to the public, yet are nevertheless designated to the *Record*, requires decisions on cropping, brightness, and contrast that involve getting into the artist's mind and "thinking Zofia Rydet"—imitating her methods on the basis of those of the author's prints that do exist. Even the very allocation to a particular thematic group can be a conundrum, as the same shot may be part of the "core" *Sociological Record*, or else be slotted, for example, into the group *Presence*, so long as it contains some papal motif. This fluidity and the shifts within the collection set a trap yet also invest it with vitality, making it possible to use individual elements to construct an almost infinite number of opinions and statements.

The exhibition at the Museum of Modern Art in War-
saw, in 2015—accompanied by a research symposium[6] that resulted
in the present book—was based on the idea of a "reconstruction" of
an exhibition that never was, relying—to the extent to which this was
possible within the format of a temporary museum exhibition—on
the instructions in Zofia Rydet's notes and her private correspond-
ence, which had left blueprints of the possible ways to present *Socio-
logical Record*. The artist postulated a differentiation of photographic
formats, a presentation of the many subseries of the project, exper-
iments with the frames, copies, and slide projections. In a rough out-
line of an exhibition (from around 1983), she wrote,

> The main element will be photographs of interiors of
> homes with their owners. There are great numbers of
> them; to keep it from becoming tedious they had to be
> shown in various formats: [...] couples, women, chil-
> dren, the ill, or homes that are similarly decorated, e.g.
> old interiors with wood-burning stoves, or character-
> istic pictures and tapestries.[7]

Not all the series identified by Rydet found their way
into the exhibition at the Museum of Modern Art in Warsaw; rather,
there are symbolic fragments of the artist's life oeuvre—those that
concern people (such as *Women on Doorsteps* or *Artists' Homes*) or objects
in the public space (for instance *Windows* or *Myth of Photography*). We
placed an emphasis on the essential, canonical shots of people pos-
ing inside homes; this has been the largest such presentation to date,
with this one grouping alone comprising 240 photographs. Following
the artist's own suggestions, we abandoned the grouping of the pho-
tographs by region, instead introducing the formula of a formal
"atlas," unconstrained by geography or time, divided according to
Rydet's own classification into thematic groups such as windows, fam-
ilies with children, the infirm, artists' homes, professions, and so on.

6 "Between 'Old Objectivity' and 'Naive Conceptualism,'" a research
 symposium on Zofia Rydet's *Sociological Record*, January 8–9, 2016, curated
 by Krzysztof Pijarski.
7 Zofia Rydet, "Rough Outline of the *Sociological Record 1978–1983* Exhibition,"
 unpublished manuscript, undated, c. 1983, accessed November 13, 2017,
 http://zofiarydet.com/zapis/en/pages/sociological-record/notes/
 maszynopis-nie-datowany.

One of the most prominent features of *Sociological Record* has become, for us, the constant evolution of the rules of engagement for the project. In due course, it began to be fragmented into a number of subseries, some of which came to be presented as stand-alone series, for instance *Myth of Photography*, *Women on Doorsteps*, *Objects & Decorations*, *Presence*, *Windows*, or *(Disappearing) Professions*. Her journeys and work on *Sociological Record* inspired Rydet to discover ever-new potential developments for the project; for example, the artist would photograph the interiors of buses, always seated directly behind the driver, so that the interior would be reflected in his mirror. Many of the photographs in the *Sociological Record* archive resulted from the artist's obsessive cataloging of various objects or events (for example TV sets, wall hangings, horse carts, *monidło*,[8] or tombstones) or else they completely evade the logic of the series (various curiosities, sketches for series that were never made or were visually attractive, photographic "errors," for example those related to taking shots in mirrors). The artist frequently emphasized that these subseries were, for her, commensurate parts of the project and that they should be presented side by side with the "canonical" shots of inhabitants posing against the backdrop of the wall. In one of these subseries, one can notice the influence of Jerzy Lewczyński[9]—Rydet's close friend and himself a photographer, with whom the artist often engaged in discussions on the role of photography in everyday life, and the need to eradicate the divisions between professional and amateur photography, between the original and a copy.

Today, of those subseries that Rydet so consistently assembled when working on her *Record*, the most significant seems to be *Women on Doorsteps* (which Rydet also titled *Matriarchs* or *Standing Women*). The photographer requested that women step outside the house and pose in front of or next to the front door, noticing that

8 "A very particular kind of portrait produced by provincial photographers [...] [which] usually took the form of a large black-and-white print, later colored by the photographer." See Ewa Klekot's essay in this volume, "Between the Ethnographic and Material Culture," 131.

9 Jerzy Lewczyński (1924–2014). Renowned Polish photographer. From the 1960s onward, he worked on his theory of the "archeology of photography." In his art, he employed found negatives and photocopies.

there were only a limited number of poses that the photographed women adopted, from arms folded over their chests to a provocative hands-on-hips attitude. This typology of gesture brings to mind projects in conceptual art, such as the Marianne Wex collection *"Let's Take Back Our Space": "Female" and "Male" Body Language as a Result of Patriarchal Structures* (1972–77). Rydet's decision to portray the women outside their homes is significant—the artist emphasizes their power, charisma, and the responsibility they hold over the rest of their family. The whole *Sociological Record* is pervaded by the spirit of emancipation—created by a woman who had devoted her entire life to photography, using her camera as a tool for the creation of "art beyond art." Interpretation of Zofia Rydet's art from a feminist perspective; research into the thematic subseries that the *Record* comprises; and analysis of the political context in which the project came into being are just some of the issues that require in-depth study and reflection from the perspectives of art history, the sociology of imagery, and ethnography.

 The present compilation of texts is a corollary to the initial, five-year stage of collaborative archival and curatorial work on Zofia Rydet's *Sociological Record*. My thanks go to Krzysztof Pijarski, the editor of this volume and curator of the Rydet symposium at our museum; to Karol Hordziej, co-curator of the exhibition "Zofia Rydet: *Record*, 1978–1990"; and to the incomparable Zofia Augustyńska-Martyniak and Maria Sokół-Augustyńska of the Zofia Rydet Foundation—without their commitment, knowledge, and passion we would not have been able to rediscover Rydet's work and to appreciate fully its tremendous significance for contemporary art museums.

Krzysztof Pijarski is an artist working mainly with photography, assistant professor at the Łódź Film School, art historian, and translator. Author of *Archeologia Modernizmu. Michael Fried, fotografia i nowoczesne doświadczenie sztuki* [An Archeology of Modernism: Michael Fried, Photography, and the Modern Experience of Art] (Wydawnictwo Biblioteki PWSFTviT, 2017), *(Po)Nowoczesne losy obrazów. Allan Sekula/Thomas Struth* [The (Post)Modern Fate of Images: Allan Sekula/Thomas Struth] (Wydawnictwo Biblioteki PWSFTviT, 2013). A collection of his translations of essays by Allan Sekula was published by the University of Warsaw Press in 2010. Editor of *The Archive as Project* (Archeology of Photography Foundation, 2011) and at the online academic journal *View. Theories and Practices of Visual Culture*.

"PERPETUAL INVENTORY": AN INTRODUCTION

My intention was to detachedly capture reality in the most simple, objective, and authentic manner. During this process I realized that my work is beginning to take on a different hue. I began to see that these simple photographs exposed a great truth about the human condition.[1] —Zofia Rydet

Photography, you see, is an expression of the distance of the observer, who records and never forgets that he is recording [...]; but at the same time photography also assumes the complete proximity of the familiar, attentive, and sensitive with regard to even the least perceptible of details such a familiarity allows and enjoins the observer to seize and interpret right away (do we not say that someone who behaves well is "attentive"?), with regard to the infinitely small detail of a practice even the most attentive of ethnologists often fails to notice. But photography is equally interwoven with the relationship that I have never ceased to build with my subject, and not for a moment did I forget that my subject is people, human beings whom I have encountered from a perspective that—at the risk of sounding ridiculous—I would refer to as caring, and often as moved.[2] —Pierre Bourdieu

1 Krystyna Namysłowska, "Portrait En Face: Zofia Rydet," 1990, Polskie Radio—Regionalna Rozgłośnia w Łodzi Radio–Łódź S.A., accessed November 13, 2017, http://zofiarydet.com/zapis/en/pages/sociological-record/media/radio-lodz. [Translation modified.]
2 Franz Schultheis, "Pictures from Algeria: An Interview with Pierre Bourdieu" (Collège de France, June 26, 2001), in *Picturing Algeria: Pierre Bourdieu*, eds. Franz Schultheis and Christine Frisinghelli (New York: Columbia University Press, 2012), 32. [Translation modified.]

W hen, in 1978, Zofia Rydet began working on the series that would later be called *Sociological Record*, little did she know the extent to which the project would consume her. Photographing people in Poland in their homes, or on their doorsteps, as well as in their surroundings, she produced a massive archive of more than 27,000 negatives replete with faces, interiors, objects, and pictures. Rydet never managed to give the *Record* final shape—either in the form of a book or an exhibition. There was always another place she wanted to visit, always more people she wanted to photograph.

Because Rydet's project has never been shown in a sufficiently broad selection, nor, in the time after her death, made accessible for research until fairly recently, the work's reception was limited to repeating what has already been said about it. This volume, coming out of a research symposium organized at the Museum of Modern Art in Warsaw, as a rejoinder to the exhibition "Zofia Rydet: *Record, 1978–1990*," was conceived to make the *Record* available for further reflection by bringing it back to use, both as an object of interpretation, and of photography theory, by recontextualizing it from different points of departure.

A natural classification for Rydet's work is that of the documentary tradition, from August Sander's physiognomy of the German nation and Walker Evans's explorations of the American vernacular, to projects contemporary to Rydet's endeavor, like Wilmar Koenig's *Portraits* (1976–77) of people in their homes, [SEE: PP. 196–97] Michael Schmidt's portrait of a city district, *Berlin-Wedding* (1978), [SEE: PP. 200–202] or Herlinde Koelbl's inventory of German living rooms with their inhabitants, *The German Living Room* (1980). The photographic survey movement of the late nineteenth century, as described by Elizabeth Edwards,[3] with figures like Sir Benjamin Stone and his attempt at recording the architectural heritage and waning pageants of the British Isles, is also an important point of reference; not only because these practices produced immense photographic archives, but because these practices partook in a

3 See Elizabeth Edwards, *The Camera as Historian: Amateur Photographers and Historical Imagination, 1885–1918* (Durham: Duke University Press, 2012).

"salvage ethnography"[4] aimed at alleviating the "anxieties of cultural disappearance" of the time,[5] by providing a form of "informational stability in a rapidly changing world that threatened cultural, and indeed racial, obliteration, hybridity, and homogenization, as well as the disappearance of the authentic object."[6] It is not difficult to argue that all these characteristics, especially the desire for the authentic, relate directly to the *Record*. At the same time, when returned to and made use of by Zofia Rydet's sitters themselves, as happened during the project *Something That Will Remain* (2014–15), a community art initiative based on revisiting the *Record*'s most prominent locations, Rydet's pictures become, retroactively, family photographs, tokens of familial bonds, or—seen from outside of the structure of kinship—vernacular images.

 "Perpetual inventory," a job description that drew the attention of Robert Rauschenberg, seems to perfectly describe the character—encompassing, interminable—of Rydet's life project. Rosalind Krauss used this description as the title for her account of Rauschenberg's involvement—in his practice of collecting and reusing silkscreens of popular imagery, and his project to produce a photographic record of America, "foot by foot, 'in actual size'"[7]—with the idea of an archive that she defined as a "photographic corpus through which reality is somehow ingested, organized, cataloged, and retrieved."[8] As Benjamin Buchloh argued in the context of Gerhard Richter's *Atlas*, the 1960s witnessed the appearance of a series of "structurally similar yet rather different projects," based on the idea of the archive constituting "photography's innate structural order,"[9]

4 Elizabeth Edwards, "Salvaging Our Past: Photography and Survival," in *Photography, Anthropology and History: Expanding the Frame*, eds. Christopher Morton and Elizabeth Edwards (Farnham: Ashgate Publishing, Ltd., 2009), 67.
5 Ibid., 70.
6 Ibid., 68. The authentic was a major topic of interest for Rydet, as is evident from her published correspondence.
7 Rosalind Krauss, "Perpetual Inventory," *October* 88 (Spring 1999): 107.
8 Ibid., 108.
9 Benjamin H. D. Buchloh, "Gerhard Richter's 'Atlas': The Anomic Archive," *October* 88 (Spring 1999): 118. This recognition can be traced back to Allan Sekula's "The Body and the Archive" *October* 39 (Winter 1986): 16. "The camera is integrated into a larger ensemble: a bureaucratic-clerical-statistical system of 'intelligence.' This system can be described as a sophisticated form of the archive. The central artifact of this system is not the camera but the filing cabinet."

and drawing on photography's "seemingly infinite multiplicity, capacity for serialization, and aspiration toward comprehensive totality."[10] These projects, among which Buchloh also counts the typologies of industrial structures by Bernd and Hilla Becher [SEE: P. 190] and the work of Christian Boltanski, "systematically organize knowledge as didactic models of display or as mnemonic devices," and are "notable either for their astonishing homogeneity and continuity (as is the case with the work of the Bechers) or for the equally remarkable heterogeneity and discontinuity that defines Richter's *Atlas*."[11] One could also add the work of Hanne Darboven, or, again, the silkscreened canvases of Rauschenberg, based on "a loose grid of enframed photographic spaces that seem to present one with nothing so much as a visual archive: the storage and retrieval matrix of the organized miscellany of images, which presents the memory as a kind of filing cabinet of the mind."[12]

However, the reason for bringing up this context is not merely the haphazard if fitting idea of a "perpetual inventory," but exactly this insistence of questioning the "mnemonic competence" of the photographic image[13] in a time when the idea of a continuous and coherent model of the subject, one based on memory, seemed to be in peril. As Buchloh claims:

> Mnemonic desire, it appears then, is activated especially in those moments of extreme duress in which the traditional material bonds among subjects, between subjects and objects, and between objects and their representation appear to be on the verge of displacement, if not outright disappearance.[14]

In relation to this he brings up the contemporary "conditions of repression of historical memory," a central topic for postwar Europe and also one of import when looking at the *Record*, broached and reflected on in several contributions to this volume.

10 Buchloh, "Gerhard Richter's 'Atlas,'" 118.
11 Ibid., 117.
12 Krauss, "Perpetual Inventory," 107.
13 Buchloh, "Gerhard Richter's 'Atlas,'" 119.
14 Ibid.,136.

Another reason for advancing this context is the formal stringency of Zofia Rydet's *Record*, a trait nowhere to be found in the documentary tradition (nor in the survey movement), wherein the repetition of motifs is never married to a strict set of formal constraints. The decision of Sebastian Cichocki and Karol Hordziej to show the *Record*'s central series, *People in Interiors*, in the form of an imposing grid, brought out exactly this archival underpinning of Rydet's work, and at the same time kept the curators' interpretive intervention in the work to a minimum (in other words, they were not dissimulating the use of archival material), allowing the *Record* to come forth in the full force of its expanse without too strong of an inclination toward oriented readings.

Rydet's own idea of presenting the *Record* was much closer to Jorge Ribalta's concept of a "public photographic space" saturated with pictures, going back to what he called a "plebeian public photographic sphere or [...], in other words, to a popular, minor and in a way anti-artistic use of photography."[15] With the photographs of people in interiors constituting the backbone of the project, Rydet desired to show an inexhaustible number of them; presented in different formats to keep the work from becoming tedious, but at the same time arranged thematically to allow for comparisons across regions.[16]

All of this supplemented by the various thematic subseries, and, in addition to that, "to break up the subject and to situate it," Rydet planned to use "meter-long landscape photographs, panoramas of villages and small towns," as well as "photographs showing roads into villages, with original road signs," to the extent of showing villages "in their entirety," a characteristically maximalist claim on her part. One can see that realizing this program, as curator, would require assuming Zofia Rydet's position, and this, at a time in which we have yet to come to grips with her work, would have been highly problematic. There are only so many prints and juxtapositions

15 Yolanda Romero Gómez and Jorge Ribalta, "Becoming Mr. Hyde: A Conversation," in *Monumento máquina. Jorge Ribalta*, eds. Romero Gómez and Ribalta, exhibition catalog (Granada: Centro José Guerrero; Cáceres: Fundación Helga de Alvear, 2015), 288.
16 For Rydet's position on this subject, see Sebastian Cichocki's introduction to this volume, "Art beyond Art," 35, footnote 7.

of pictures she has made herself, not to mention exhibition presentations, with the bulk of the *Record* bequeathed to posterity in the form of an archive. And although Olivier Lugon insists on an inherent instability at the heart of the documentary tradition, where "'documentary' is often taken as the antonym to 'artistic,' yet it stems primarily from the artistic field,"[17] the *Record* is arguably more than that, spanning whole worlds, between high art and vernacular practice, between formal stricture and sentimental mindedness.

This is why this volume is intent on keeping the reading of the *Record* as open as possible, and refrains from attempts at legitimizing it as art. Zofia Rydet entered the field of visual art, or that of art photography, from vernacular practice—by way of the Gliwice Photographic Society (Gliwickie Towarzystwo Fotograficzne, or GTF), an amateur association that yielded other important figures, such as Jerzy Lewczyński. We take this genealogy as a reminder that photography simply cannot be defined in purely aesthetic terms without performing a violent cut from the larger context in which it is embedded. And although the *Record* has been shown exclusively in an artistic context, Rydet herself was unresolved about how to define her work. Is it a piece of art, visual sociology, or perhaps, above all, a testimony of its time? "Maybe I'm unique, because really every one of us, every artist, really wants to be an artist," she insisted. "And I really don't much care. What I care about is the power behind what I do."[18]

Object Lessons, in attempting to stay true to the *Record*'s indeterminacy, proceeds in four thematic chapters and three interludes. The book sets out by offering a double portrait of the artist herself: a firsthand account, in the form of a photoessay, by Anna Beata Bohdziewicz, of her wanderings with Zofia Rydet during one of the photographic trips undertaken while working on the *Record*, and an attempt, by Adam Mazur, to recapitulate the existing scholarship

17 Olivier Lugon, "'Documentary': Authority and Ambiguities," in *The Greenroom: Reconsidering the Documentary and Contemporary Art #1*, eds. Maria Lind and Hito Steyerl (Berlin: Sternberg Press; Annandale-on-Hudson: Bard College, 2008), 35.
18 Józef Robakowski, "Interview with Zofia Rydet (Solo exhibition at FF gallery in Łódź, 1990)," video, 4'50", accessed November 15, 2017, http://zofiarydet.com/zapis/en/pages/sociological-record/media/wywiad.

and criticism on Rydet, and to chart how much we already know about her, and how much we have still to learn.

The aim of the second chapter is to provide a varied and at the same time precise critical framing for the *Record*, one that will allow for responsible further inquiry. Here, Ewa Klekot argues for the ethnographic rather than sociological character of the *Record*, insisting that in its archival form it can be read as ethnographic field notes, focused to a great extent on the "experiential and existential" dimension of rural life. As raw material for further development, the *Record*, in Klekot's account, ought to be treated with great care to avoid appropriating the work in too simple a fashion.

Abigail Solomon-Godeau questions the *Record*'s status—between oeuvre, corpus, and archive—and drawing on the available archival scholarship, explores the relationship between the production of oeuvres out of photographic archives and constructions of identity, forwarding the notion of photography not only as a mnemonic, but also repressive, device.

In approaching Zofia Rydet's *Record* from the perspective of German photographic art of the 1970s, Maren Lübbke-Tidow shows that Rydet—in light of a whole field of highly accomplished practices to portray, or record, various aspects of the surrounding social reality—did not stand alone in her sensibility; further, Lübbke-Tidow develops a precise and attentive account of the *Record*'s specific character as a piece of photographic art in its own right.

My own contribution is focused on reconstructing the local debates on "sociological photography" and the possibility of a critical photographic practice in a time of social unrest, on the eve of martial law in Poland, and, based on her letters and other statements, on the drawing of a different picture of Zofia Rydet, positing the *Record* as "Protest Photographs."

The third chapter ventures into different territory, treating the *Record* as a theoretical reflection on photography itself. Hence Régis Durand dwells on the question of narration in photography and the *Record*, with John Berger's concept of the "reflecting subject" as point of departure. Further, Helen Petrovsky reads the *Record* and Rydet's subsequent work, *The Infinity of Distant Roads*,

against Charles Sanders Peirce's theory of the photographic sign; and Łukasz Zaremba takes up the pictures appearing abundantly within the *Record* as object of study, recognizing in Rydet an iconophile in the Latourean sense.

The last chapter consists of an extended consideration, by Agnieszka Pajączkowska, of the aforementioned *Something That Will Remain*, a project Pajączkowska initiated together with Zofia Augustyńska-Martyniak, Zofia Rydet's grandniece and president of the Zofia Rydet Foundation. Here, the volume comes full circle. The revisits to the places Zofia Rydet photographed not only teach us a great deal about how Rydet really proceeded, but they also profanate the pictures, in the Agambenian sense, bringing them back into circulation, not allowing them to become rarefied art objects, but agents in the iconophiliac's dream of eternal mediation.

The visual interludes between the chapters serve a similar purpose: edited by, in order of appearance, Sebastian Cichocki, the American artist Sharon Lockhart—who has described her important reading of the *Record* as "an effort to look at the lives of women; how they would like to be represented and how they represent themselves"[19]—and myself. Each selection allows for different patterns and connections to emerge, developing into autonomous, but related, narratives, arguments, points, and capers. The *Record* is considered here not only in terms of art and the history of photography, but also as a theoretical object through which more can be said about photography as a social practice and tool of knowledge production, as imaging technology and a visual way of thinking, as well as about its role in reconstructing and representing the other, and the meaning of (archiving) the world.

I would not be able to finish without having first extended my deepest gratitude to all involved in the realization of this book: To Sebastian Cichocki, who invited me to organize a series of discussions, and then later the symposium "Between 'Old Objectivity' and 'Naive Conceptualism'" in January 2016, to accompany the show that he co-curated in 2015–16 with Karol Hordziej, which lay

19 "Sharon Lockhart's Selection," accessed November 15, 2017, http://
 zofiarydet.com/zapis/en/collections/sharon-lockhart.

the groundwork for the ideas produced in this volume; to all the authors, of course, who have contributed compelling, insightful, and fresh work on Zofia Rydet; to Zofia Augustyńska-Martyniak and Maria Sokół-Augustyńska of the Zofia Rydet Foundation, for all their help and advice—without their work none of this would have been possible; and last, but not least, to the publisher, Kasia Szotkowska-Beylin, for her unwavering support, crucial input, and patience, and our English editor, Meagan Down, for her titanic work and editorial acumen.

At some point, with martial law still in force in Poland, Zofia Rydet wondered whether the *Record* would be "the best thing I leave behind."[20] She may have been right.

20 Zofia Rydet , Letter sent to Jerzy Busza from February 3, 1982, accessed November 13, 2017, http://zofiarydet.com/zapis/en/pages/sociological-record/letters/jerzy-busza-03-02-1982.

Anna Beata Bohdziewicz is a photographer, journalist, and curator. She studied Polish archeology and ethnography at the University of Warsaw. She has worked in film as set assistant and second unit director, among other positions. Her *Fotodziennik czyli piosenka o końcu świata* [Photodiary, or, A Song On the End of the World], started in 1982 and continuing until this day, remains her most well-known work, and one which some critics compare to Zofia Rydet's *Sociological Record*.

WANDERINGS
WITH ZOFIA RYDET

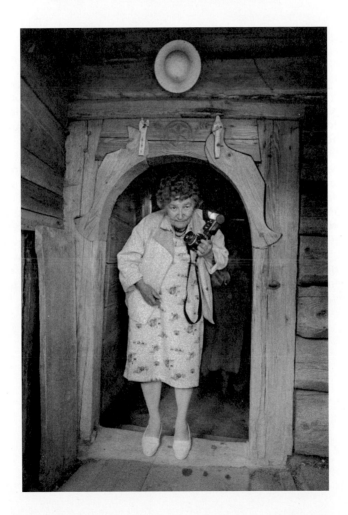

First Encounters

I first met Zofia Rydet in June 1983, while working on the exhibition "Znak krzyża" [Sign of the Cross].This was a multimedia—as we would call it today—exhibition of contemporary art, and art inspired by the Catholic faith, whose leitmotif was the cross. The exhibition, the brainchild of Janusz Bogucki, was intended to celebrate the second visit to Poland of Pope John Paul II. The prevailing mood in the ruined vaults of the Church of Divine Mercy in the Wola district of Warsaw, where we were working on the exhibition, was one of revolutionary enthusiasm—free from the interference of the state and the censor, with people working together, sharing meals... As a novice photographer, I was delighted that Professor Bogucki had invited me to take part in the exhibition. Meeting the famous Zofia Rydet was an additional bonus. Of course, I immediately took a few snaps of her in order to make a record of this event in my *Photodiary*, which I had been keeping for seven months.

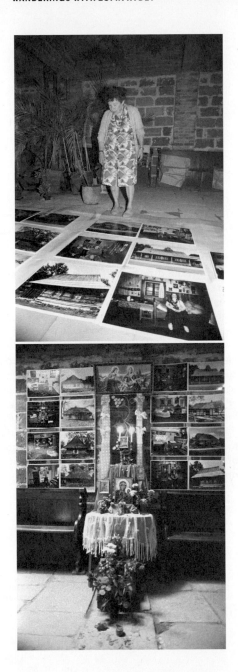

Take My Picture

The year after, I was accepted as a member of ZPAF, the Association of Polish Art Photographers, and I began to run into Pani Zofia[1] quite often, at various openings, get-togethers, symposia, or conferences. At the time, the Association swarmed with activity. Despite the considerable difference in age between us—her eighty-three years to my thirty-four—we became friends. This was a friend-ship of opposites: youth vs. old age, women vs. men (two female pho-tographers surrounded by a crushing majority of cocky guys with cameras, focused on their status), but also a friendship based on a shared sense of humor and an ironic take on the world, as well as—and certainly not of least importance—a delight shared in the spon-taneous and quite childlike joy of taking photographs, and of having them taken—often just for fun! A snap with a French policeman? A must! Another one, on a suburban train, next to the cheerful little boy? Sure thing! In the never-ending passages of the Paris airport? Yes! Yes! Trying on a new dress in a shop in Nowy Targ? (Do you think I look OK in this, shall I buy it?) But of course! What about assuming the disguise of a Victorian granny in a bonnet? Why ever not! Each of these occasions was a pretext for taking a photo.

[1] "Pani"/"Pan" (Madam/Sir) is the polite mode of address in Polish, and indeed the standard of interpersonal relationships. Until fairly recently, one needed to be rather close to address each other by name, like in France, for example. —Ed.

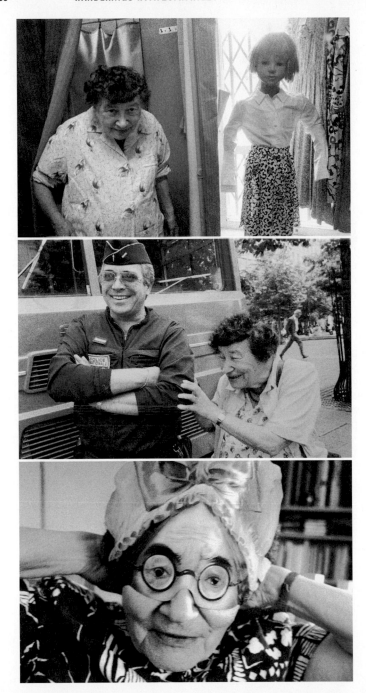

Munich

In 1988, both Zofia Rydet and I were invited to take part in the exhibition of photographers from Eastern Europe "Zwischen Elbe und Wolga" [Between the Elbe and the Volga] in the Lenbachhaus in Munich, and two years later, also in Munich, we had a joint show. This was accompanied by the enjoyable experience of trips abroad as artists from behind the Iron Curtain, giving interviews for various media and even getting paid in hard currency. Pani Zofia would spend most of hers straight away buying presents for her family.

As soon as she arrived anywhere, Pani Zofia had to check if her works had been hung correctly. If they hadn't been, she was quite capable of making the organizers rehang her photographs even if the opening already happened to be in progress. Her direct approach, pleasant voice, and her timid, or so it appeared, way of talking, made everyone succumb to her without a word of protest—as did the Polish country dwellers whom she photographed.

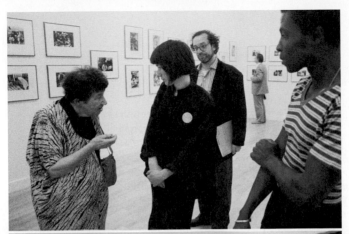

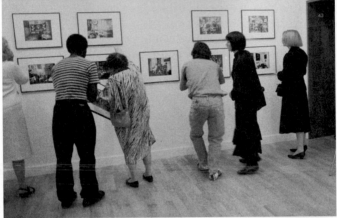

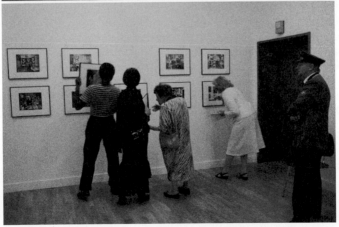

**August 1988. Traveling through the Villages
of Podhale: Cronków, Jordanów, Klikuszowa,
Krempachy, Lipnica, Łętownia, Naprawa,
Obidowa, Podwilk, Skomielna, Tokarnia**

In August 1988, soon after our Munich adventure, my husband Janusz Lipiński and I accompanied Pani Zofia for a couple of weeks during her travels in the countryside near Rabka, where she had a little house. Accompanying her on her trips to the nearby villages and observing firsthand the way that she took her photographs, I could see how the *Sociological Record* was being made—this gigantic, now famous, project on which she had worked for many years.

Every morning we would scramble into our small Fiat and drive through the Rabka region from one little village to another, following a predetermined route. When we arrived at a village we would first drive around it to see how many old houses were still standing. Then we would park somewhere central before continuing on foot to select houses.

Pani Zofia was mainly looking for old houses, in which she was hoping to find traditional interiors. She also wanted to visit places and people that she had photographed ten years earlier. By now, most of the old houses had been demolished, and those that still remained stood next to "modern," brick buildings. If we were spotted by any locals, Pani Zofia would start working her charm on the homeowners so they would let us inside.

"Good morning, good morning! We have just come to take your pictures!" "But what pictures, why, what for?!" were the usual, diffident responses. "Pictures that don't cost a penny! Pictures that the pope will see! May we come in?" and without waiting for an answer, Pani Zofia would march into the house. During all our travels there was only a single occasion that we heard a determined, "No."

"Oh, your house is so beautiful, it's lovely! We will take a beautiful photo here!" And Pani Zofia would point to the place

where the person had to sit. "But, please, I look scruffy, and my shoes are so worn out!" "No matter, this is fine, you look just great. Here, please, sit here." "But shall I at least put a clean apron on, or a nicer headscarf?" "All right, why don't you?" (But such acquiescence was rare.) And there she was, straight in, taking her photographs. These tended to be the few usual poses typical for the *Sociological Record*, but she also used the opportunity to take shots for other, newer series that she was always coming up with. It took her some time to set up the aperture and flash, as her eyesight was getting poor. "Remember, Ania," she would say, "that I do it all blind."

Even so, it was all over in the blink of an eye—fifteen or twenty minutes after coming into the house. Straight away, Zofia Rydet knew if an interior interested her; she would give it a once-over, without dwelling on the details. She only analyzed the interiors when they were revealed after developing the negatives and making prints. What I found somewhat shocking was that Pani Zofia did not allow her models to change their clothes so they could look their best, even though she stressed that she was taking their pictures for posterity and that they would be shown to the pope and so on. She wanted to eternalize her sitters in their everyday clothes, dirty and worn out from hard work. It seemed that she felt such an image showed best the truth about them.

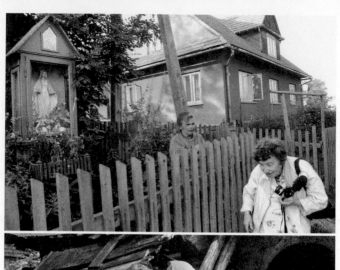

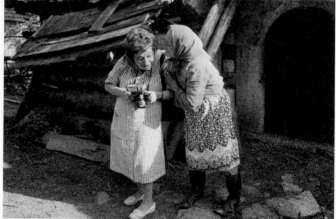

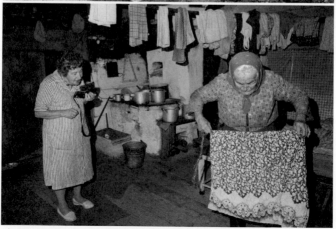

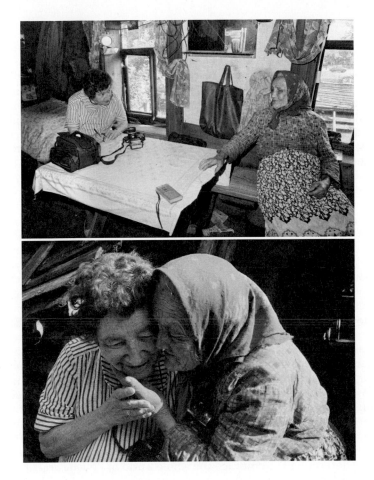

Working Conditions

Zofia Rydet entered the world of her sitters suddenly, without prior notice. She caught them by surprise in the middle of the day, as they went about their daily business. A little old lady with a crooked back, who suddenly appeared on their doorstep (my husband and I hung back, as if we weren't really there...) was not a threatening prospect, there was no reason to be afraid of her, and people did not perceive her as an intruder. This gave her an advantage, of catching them unprepared, just their ordinary selves—but at the same time, this obliged her to work in the conditions that she found. These were often very difficult and not at all photogenic, as the protagonists got on with tidying up, cooking, chatting, commenting on her, and generally carrying on with their everyday activities.

She also had to put up with the existing lighting conditions, which often made it practically impossible to take a good shot. Despite this, she succeeded, and using nothing more than a single camera with a flash and a single wide-angle lens. Was that because she carried out her ideas without treating them as "academic praxis," and so she thought impromptu solutions were permissible, as were certain technical imperfections? All her decisions, starting with the choice of the houses, were—and I have no hesitation in using the word—emotional. And her project that, much later, was called the *Sociological Record*, and that grew in the making, most certainly went beyond any "sociological" boundaries. At all times, Pani Zofia kept noticing new themes and threads, such as close-ups of windows, facades of houses, the surrounding landscape, old people's faces, portraits of women on their doorsteps, and so on and so forth. Many of these ideas were supposed to be finally turned into installations, "photographic sculptures," little shrines and such. The *Sociological Record* kept expanding to cosmic dimensions. Zofia Rydet was determined to embrace the whole world of Polish rural life in her photography.

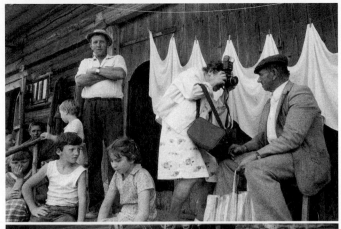

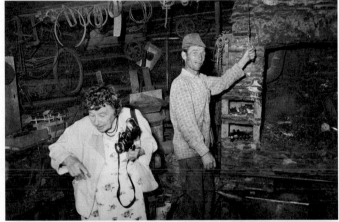

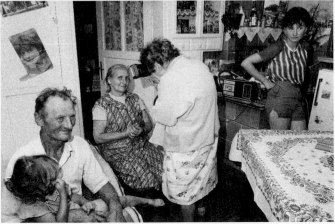

Models: Men and Women

During our travels, it was mainly women, most often Pani Zofia's age, that awaited us in their homes. She had to keep explaining to them why, instead of taking it easy at home, she was spending money traveling around photographing old houses and old people. They did not always understand her explanations, but they were full of admiration and moved by someone taking an interest in them. The men that she photographed were even more surprised. They totally failed to understand how it could be that such an old woman was traveling alone, taking photographs.

Pani Zofia acted more decisively with men; she would place them exactly as she wanted them for the shot, and they succumbed without a murmur. Perhaps they were a little frightened of her. Sometimes they knelt in front of her. I think it wasn't only because she was smaller than them. On the other hand, if taking the photograph required it, Pani Zofia was prepared to kneel in front of a man.

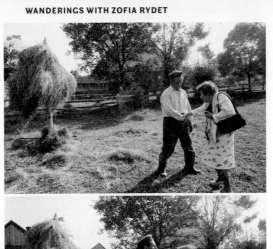

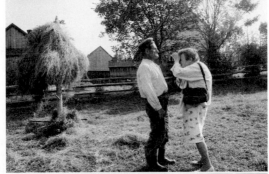

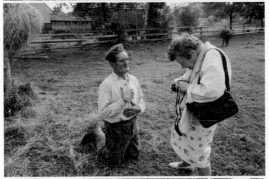

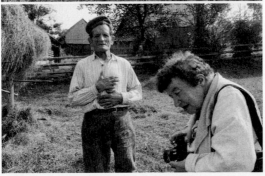

Quick Shooting—Chatting at Leisure

After the photographs had been taken, time seemed to slow down, and the atmosphere became more relaxed. Pani Zofia sat at the table and accepted tea and cake, or whatever was at hand. She took notes, chatted with the children, showed her photos, talked about her work, and answered questions, devoting all her time to her hosts.

Sometimes this lasted over an hour, as for example the conversation with the ninety-year-old Anna Worwa from Naprawa, who first recited for us all the ballads she knew, then the titles of all the books that she had read, and then went on to sing old shepherds' songs, and so on. There was no end to her stories. And Pani Zofia sat there engrossed. I was surprised as she was always repeating how little time she had left and how she had to hurry with her work.

The farewells after such encounters were very moving. Pani Zofia was accompanied all the way to the gate, with hugs and kisses; all were aware that they would never meet again—unless in heaven, in which they all believed.

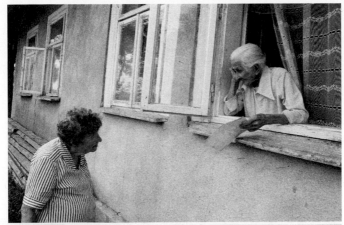

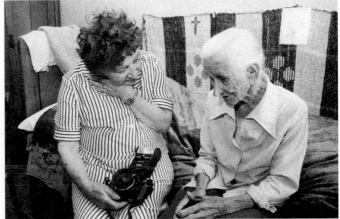

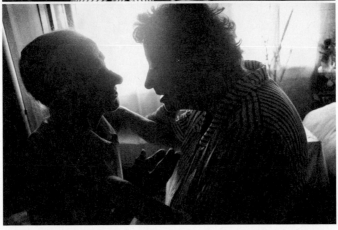

Decisive Moment

What factors contribute to the kind of photograph being made? Competent technique, good equipment, lighting, the quality of the film being used (we are talking about the analogue period of the 1970s and '80s, where film was scarce and of poor quality in Poland), the circumstances? To ask whether it may be the personality of the photographer that is decisive for the quality of the photograph appears, at first glance, to be a fatuous question. In the case of Zofia Rydet and her *Sociological Record* this is, however, the key question to ask. How is it possible that an elderly woman photographer, working alone without any assistants (apart from, and only occasionally, her young niece), without any financial or academic background, managed single-handedly to create such a monumental oeuvre? It was indeed her personality, her perseverance, her faith in the power of photography—so undermined today—and above all the way in which she engaged with other people, her gentleness combined with a sui generis despotism, and her hypnotic glance. These are the factors that ensured her photographs would have such a powerful impact on those who encounter them.

The people that she photographed look at us just as, years back, they looked at Zofia Rydet. The intensity of their gaze we owe to the photographer, her personality, and the way that she looked at them. And that's the magic of photography.

The archive of Zofia Rydet, fortunately preserved by the Foundation named after her, is bound to be subjected to a plethora of analysis and in-depth academic research. The artist, no longer with us, can do little about this. It is possible that her goals and concepts will be taken into account; equally, it is possible that they will not be recognized or interpreted correctly. It would be just as well if those who investigate her archive were to bear in mind her oft-repeated words:

I WON'T BE HERE, YOU WON'T BE HERE,
BUT THE PHOTOGRAPHS WILL REMAIN![2]

2 In the Polish: "Mnie nie będzie, Ciebie nie będzie, ale zdjęcia zostaną!"

Adam Mazur is an art historian, curator, and assistant professor at the University of the Arts in Poznań. Editor-in-chief of *BLOK* magazine of contemporary art. Author of *Historie fotografii w Polsce 1839–2009* [Histories of Photography in Poland] (Fundacja Sztuk Wizualnych, 2010) and *Decydujący moment. Nowe zjawiska w fotografii polskiej po 2000 roku* [Decisive Moment: New Phenomena in Polish Photography after 2000] (Karakter, 2012). Curator of, among others, the exhibitions "New Documentalists" (2006) and "A Non-Represented World: Documents of the Polish Transformation After '89" (2012), both at the Center for Contemporary Art Ujazdowski Castle in Warsaw.

PERHAPS THE GREATEST POLISH WOMAN PHOTOGRAPHER: PROBLEMATICS OF RESEARCH INTO THE LIFE AND ART OF ZOFIA RYDET

Zofia Rydet was born, on May 5, 1911, in Stanisławów and died, on August 24, 1997, in Gliwice. Even when reduced to biographical sketch, this detail is not so plain as to require no explanation. The city of Ivano-Frankivsk, always referred to by its historic, Polish name of "Stanisławów" in catalogs featuring the artist's work, had, until 1918, remained under Austro-Hungarian rule, in the territory of the Kingdom of Galicia. Born into this multiethnic, Polish Eastern Borderlands city that was then part of the Habsburg Empire, Rydet survived not only the Second Polish Republic, as interwar Poland was called, but also the Third Reich and the Soviet Union, as well as the entire duration of the Polish People's Republic under communism, and died in the so-called Third Polish Republic in Gliwice—a city that has been part of Poland since 1945, and had before that functioned as a German city known as Gleiwitz. Let us note that before settling down in Gliwice, in 1962, she also lived in Rabka—where her family

moved in 1944 as the Eastern Front approached Stanisławów—and, from 1945 to 1962, in Bytom.[1]

Although the history of the twentieth century left its mark on the fate of both Zofia Rydet and her family, it is difficult to trace any direct connection to historical events in her photography. Looking at her oeuvre, it is indeed possible to put forward the hypothesis that it was based on repression: the withholding of any direct references to her own lived experience. This can be seen clearly when comparing Rydet's work with that of Jerzy Lewczyński, her long-standing friend from the Gliwice Photographic Society.[2] Apart from being mentioned occasionally, this topic has not so far been researched in any of the numerous texts devoted to the artist.[3] Interestingly, it is only the *Sociological Record*, the bulk of which she made during the turbulent 1980s, that has the potential to be linked in any way to the lived, or political, context of its genesis; it is not sheer coincidence that Rydet showed parts of the series in church-related exhibitions organized by the anti-communist opposition.[4] This political dimension of Rydet's photographic practice still needs to be researched. Certainly, the *Record* is not a quest for the artist's

1 Jerzy Lewczyński, "Zofia Rydet – szkic biograficzny," *Fototapeta*, accessed September 27, 2017, http://fototapeta.art.pl/fti-2rydet.html; Lewczyński, "Zosia," in *Zofia Rydet (1911–1997). Fotografie*, ed. Elżbieta Fuchs, exhibition catalog (Łódź: Muzeum Sztuki w Łodzi, 1999), 95–100. Contrary to Lewczyński's claim, in the archive of the Zofia Rydet Foundation there are no records confirming that the artist ever stayed for an extended period in Kłodzko. Rydet's relocation to Rabka is recounted in this volume. See Abigail Solomon-Godeau's essay, "Artist, Oeuvre, Corpus, and Archive: Thinking through Zofia Rydet's *Sociological Record*," 241, footnote 34.
2 See Wojciech Nowicki, ed., *Jerzy Lewczyński: Memory of the Image* (Gliwice: Czytelnia Sztuki, 2012); Krzysztof Jurecki and Ireneusz Zjeżdżałka, eds., *Jerzy Lewczyński. Archeologia fotografii. Prace z lat 1941–2005* (Września: Kropka, 2005).
3 Adam Sobota, "Fotografia niezależna," in *Katowicki underground artystyczny po 1953 roku*, eds. Janusz Zagrodzki and Stanisław Ruksza (Katowice: Galeria Sztuki Współczesnej BWA, 2004), 250–53. Contrary to my claim, Sobota points out that Rydet and Lewczyński were alike in that their photographs "usually showed people worn out by hard work and poor living conditions, people who were deeply religious and not overly sympathetic to the prevailing political system. What emerged was an image of Poland quite unlike that presented by standard state propaganda." (Ibid., 252).
4 Adam Sobota, "Fotograficzny obraz społeczeństwa PRL-u," in *Polska fotografia dokumentalna na skrzyżowaniu dyskursów. Materiały z sesji zorganizowanej w dniu 2.IV.2005 z okazji wystawy Leonarda Sempolińskiego*, ed. Małgorzata Jurkiewicz (Warsaw: Zachęta Narodowa Galeria Sztuki, 2006), 75–81.

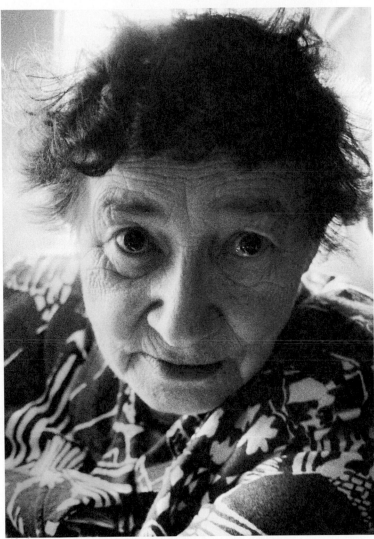

FIG. 1
ANNA BEATA BOHDZIEWICZ, *PORTRAIT*, 1988

own roots, nor a nostalgic journey into the past (so popular in Eastern Borderlands circles). From this perspective, her *Little Man*, which appeared in the mid-1960s—a period of relative stability in Poland—is a manifesto of socialist humanism, and *Zofia Rydet's World of Imagination*, published toward the end of the 1970s, the so-called Edward Gierek decade, is an example of escapist subjectivism at a time of increasing social crisis.[5] In turn, the *Sociological Record* may be interpreted as a reaction to a period of political lethargy and, more broadly, as a response to the intensity of modernizing processes, a response that took the form of a utopian attempt to make a lasting record of the sources and forms of social organization that predated modern times.[6]

Daughter and Sister

From early biographical essays, almost exclusively travesties of Zofia Rydet's own account, and later, from the narrative provided by Jerzy Lewczyński (who appears in the role of a custodian of the artist's memory), we learn only that Zofia Rydet was born into a wealthy, bourgeois family in the Eastern Borderlands, a region known as the "Kresy."[7] Her father, Ferdynand Rydet, was a politically active lawyer and supporter of the Polish People's Party of Wincenty Witos, who, in the 1920s, was three-time prime minister of Poland.

5 This decade opened to seemingly intense economic development and the first symptoms of consumerism (if one can apply such a term to communist Poland), followed by a deepening economic, social, and political crisis that led to the unraveling of the Polish People's Republic. The photographic books referenced here are Zofia Rydet, *Mały człowiek* (Warsaw: Arkady, 1965) and Rydet, *Świat wyobraźni Zofii Rydet* (Warsaw: Krakowska Agencja Wydawnicza, 1979).

6 See the only published form of the *Sociological Record*, *Obecność* [Presence], with an essay by Józefa Hennelowa (Kraków: Wydawnictwo Calvarianum, 1988).

7 Jerzy Lewczyński's posthumous reminiscences about Zofia Rydet are especially important here, because they have in the past been frequently cited verbatim and in edited forms, but, it seems, never checked for accuracy (see footnote 2). All in all, until fairly recently, no serious historical research into these matters has been conducted. See Barbara Panek-Sarnowska, *Socjologiczność fotografii Zofii Rydet* (Zielona Góra: Lubuskie Towarzystwo Fotograficzne, 2005), 13–18; and Krzysztof Jurecki, "Zofia Rydet," *Culture.pl*, accessed September 27, 2017, http://culture.pl/pl/tworca/zofia-rydet.

From Zofia Rydet's biographical notes, we learn little about the artist's mother, other than her maiden name: Nowotna.[8]

In the most informative biographical note, by Małgorzata Mach, to be found in the catalog accompanying "Zofia Rydet (1911–1997). Fotografie" [Zofia Rydet (1911–1997): Photographs], the 1999 exhibition at Muzeum Sztuki in Łódź, we read that Zofia Rydet harbored a desire to be an artist from childhood. As a young girl from a respectable family with genteel roots, she was sent off to be educated at the Central School of Home Economics for Women in Snopków, near Lviv.[9] Did she rebel? How did it come about that, finally, she got what she wanted and, defying the will of her parents, and despite a lack of any formal artistic education, succeeded in achieving her goal? The life and art of Zofia Rydet have been scrutinized from various angles by the leading critics of photography and art, and yet there has been no attempt to highlight the artist's life story with a focus on her non-conformism.

Another interesting approach, only recently entertained, is to read Rydet's biography from a feminist perspective. Karolina Lewandowska, who curated the exhibition "She-Documentalists: Polish Women Photographers of the 20th Century" in 2008,[10] placed the artist within this interpretative framework. In her essay "'Archeologiczne' prace badaczek sztuki kobiet" [The "Archeological" Work of Researchers into the Art of Women], Agata Jakubowska raises the key question of the feminist discourse, originally posed by Linda Nochlin, "Why Have There Been No Great Women Artists?" Simply, why do female figures need to be rediscovered, or recre-

8 See Lewczyński, "Zofia Rydet," *Fototapeta*. In the archive of the Zofia Rydet Foundation there are documents and a genealogical tree that points to the Czech origin of the Nowotny family. Zofia Rydet's grandmother, née Budny, married her grandfather, originally from the Sudety region, who went on to become the mayor of Stanisławów.

9 Adam Sobota, "O fotografiach Zofii Rydet," in *Zofia Rydet. Fotografie. Śląskie wspomnienia*, ed. Barbara Murawska, exhibition catalog (Gliwice: Muzeum w Gliwicach, 1995), n.p. Rydet's school certificates can be found in the archive of the Zofia Rydet Foundation.

10 Karolina Lewandowska, ed., *Dokumentalistki. Polskie fotografki XX wieku*, exhibition catalog (Olszanica: Wydawnictwo BOSZ/Warsaw: Zachęta Narodowa Galeria Sztuki, 2008).

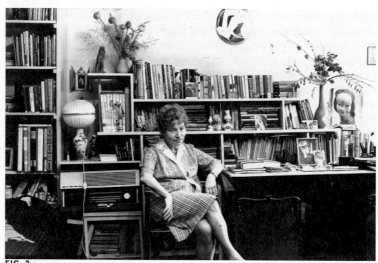

FIG. 2
ZOFIA RYDET IN HER APARTMENT IN GLIWICE,
EARLY 1970s

ated in retrospective gestures, in "archeological" terms?[11] In this context, it is worth reflecting on the extent to which the path followed by Zofia Rydet is an exception that confirms the rule of women being excluded from an artistic and—to an even greater degree—photographic life.

Thus, when attempting to read Rydet between the lines, one ought to ask not only about her artistic life, but also about her life choices, which provide a revealing context for her crucial photographic series. Unlike her female photographer friends, who usually took up the occupation as a hobby to keep their husbands company (such as Kazimiera Dyakowska, Irena Wildner-Kulik, or Maria Janik), Rydet never married or had children.[12] Although, as we are told by Jerzy Lewczyński, she was considered an attractive and pleasant woman, she did not succumb to social pressures.[13]

Although contemporary methods in the humanities resist drawing connections between an artist's work and life, in the case of Rydet, this is an indispensable task, and one in need of a multifaceted approach. It could prove vital for the interpretation of Rydet's oeuvre to publish such source materials as her correspondence, notes, and diaries, considering how even the briefest of Rydet's pronouncements have had a great impact on the interpretation of her work.

For Rydet, her family was a point of reference. This included her relationship with her brother Tadeusz, to whom she was greatly attached and who, as a "quality non-professional pho-

11 Agata Jakubowska, "'Archeologiczne' prace badaczek sztuki kobiet," in Lewandowska, *Dokumentalistki*, 50–53. In this catalog there is also a text by Adam Sobota, "Fotografujące kobiety w realiach PRL-u (1945–1989)," 40–48, which only touches on the issue of womens' presence, itself a slightly edited version of an essay that appeared in another volume; Sobota, "Pomiędzy abstrakcją a intymnością – fotografujące artystki w Polsce 1957–1968 (Fortunata Obrąpalska, Bożena Michalik, Zofia Rydet, Irena Jarosińska, Natalia Lach-Lachowicz)," in *Jestem artystką we wszystkim, co niepotrzebne. Kobiety i sztuka około 1960 roku*, ed. Ewa Toniak (Warsaw: Neriton, 2010), 137–48.

12 Danuta Kowalik-Dura, "Wstęp," in *Dopełnienie konieczne. Śląskie fotografki*, exhibition catalog (Katowice: Muzeum Śląskie w Katowicach, 2012), 12–14.

13 Jerzy Lewczyński, "Fotografia w Gliwicach 1951–2000," in *Fenomeny i fantomy. Gliwickie środowisko fotograficzne w latach 1951–2000*, eds. Marcin Gołaszewski and Anna Kwiecień, exhibition catalog (Gliwice: Muzeum w Gliwicach, 2006), 8–48.

tographer," taught her to use the camera, and introduced her to the secrets of working in the darkroom.[14] Apparently, even before the war, they went on photographic-cum-touristic exploration trips together, and at certain times during the war, it was thanks to a side business in photographic portraits that the siblings were able to provide financial support for—and indeed ensure the survival of—the family.[15]

This first, early phase of Zofia Rydet's creativity still remains almost entirely unknown, and there are grounds to believe that the two decades between 1935 and 1955 may be key to understanding her future artistic development.

Amateur Photographer

Zofia Rydet had neither a photographic nor artistic education. The beginnings of her creative work are murky and full of contradictions. She was an amateur photographer. Before the war she was employed by the Orbis travel agency in Stanisławów and probably took photos after work, with the support of her brother.[16] After the war, living in Bytom, Rydet ran a stationery and toy shop "Blok" (and later, a second, "Kameleon"), and among others, "took photographs of people that she saw through the shop window."[17] It was not until 1956 that she became a member of the Gliwice Photographic Society, founded three years earlier.[18] In addition to artistic

14 Sobota, "O fotografiach Zofii Rydet," n.p.; Małgorzata Kanikuła, "Dziecko, czyli mały człowiek," Biuletyn Fotograficzny Świat Obrazu, no. 6 (2008): 33–40. See Zofia Rydet, "Tadeusz Rydet. 1909–1987. Wspomnienie o bracie," in Fotografia artystyczna na terenach pogranicza w latach 1945–1987, ed. Krystyna Łyczywek (Szczecin: Związek Polskich Artystów Fotografików, Delegatura Szczecińska, 1988), 125–27.

15 See Lewczyński, "Zosia," 98.

16 Ibid., 13–14. In the curatorial notes accompanying "Zofia Rydet: Record, 1978–1990," we read that the Stanisławów branch of the Orbis travel agency belonged to the artist's brother, Tadeusz, and that it operated until 1941. According to the archive of the Zofia Rydet Foundation, the agency was on lease to Rydet's brother and he was her employer.

17 Sobota, "O fotografiach," n.p. Regrettably, Sobota does not reference any dates nor refer to any specific photographs; moreover he calls these Rydet's first photographs ever. This does not tally with information provided by Lewczyński in "Zosia," 95–100. In Little Man, we can find photographs taken from behind the counter in Bytom, but from the early 1960s.

18 Anonymous source in Zagrodzki and Ruksza, Katowicki underground artystyczny, 408–9.

reasons and the ability to liaise with like-minded company, another significant consideration for Rydet was probably the access to photographic materials afforded to members, at the time increasingly rationed by the authorities, as well as entry to the studio and the lab. Many of the photographs assembled in Rydet's first important album, *Little Man*, came from her travels, particularly to other Eastern Bloc countries (Albania, Bulgaria, Czechoslovakia), Non-Aligned countries (Yugoslavia, Egypt, Lebanon), and even the capitalist West (Italy).[19] We do not know much about the trips themselves—and they took place during the bleakest period of the Polish People's Republic—or about the relationship between Rydet's professional work and her photography.[20]

How did it come about that a clerk from a provincial tourist office, later the owner of shops selling toys and stationery in the city of Bytom, in the remote Recovered Territories, had, within a few years, exhibited at the art salons of the capital, such as Krzywe Koło and Zachęta National Gallery of Art, and succeeded in having *Little Man*, her first album, published by a leading publisher, with graphic design by Wojciech Zamecznik, already an acclaimed graphic artist? [FIG. 3–4] From the very beginning of her artistic path, Zofia Rydet engaged in the animation of photographic life at a local level (she was responsible for the exhibition program at the Gliwice Photographic Society), a national level (her involvement in ZPAF, the Association of Polish Art Photographers), and at international levels (her support extended to FIAP, the Fédération Internationale de l'Art Photographique). Thus, Zofia Rydet stands out not only as a photographer, but as an organizer who dynamically climbed the rungs of organizational hierarchies and photographic associations. She evolved from an amateur photographer, becoming perhaps the most important female Polish photographer,[21] respected by critics,

19 Adam Sobota, "Zapisy Zofii Rydet," in Fuchs, *Zofia Rydet (1911–1997).*
Fotografie, 8; Karolina Lewandowska, "Nota od wydawcy reedycji," in Rydet,
Mały człowiek, rev. ed. (1965; repr. Warsaw: Fundacja Archeologia Foto-
grafii, 2012), vii–xix.

20 From the archive of the Zofia Rydet Foundation we gather that these were
trips organized by Orbis, which was nationalized after the war. Rydet
traveled together with her brother Tadeusz and her nieces.

21 Sobota, "Zapisy Zofii Rydet," in Fuchs, *Zofia Rydet (1911–1997). Fotografie*, 14.

FIG. 3
ZOFIA RYDET, *DRAMAS*, FROM THE SERIES *LITTLE MAN*, 1961

sought after by museums, and awarded by the state authorities.[22] This was unusual, especially if one takes into account the history of the family, resettled from the eastern lands of the Kresy, whose social class was not "politically correct." What was the nature of Rydet's institutional career? What were her relations with the authorities like, and how did they evolve?

Not only the acclaim and honors in the artistic world, but also our awareness of the magnitude of the tasks that the artist accomplished, ought to help to dispel any lingering doubts (such as those mentioned even in the biography produced for Rydet's afore-mentioned posthumous exhibition of 1999) about the quality of the photographs produced, the supposed amateurish carelessness and visual chaos of her output. It might be true that the ailing artist, in her advanced years, was no longer able to deliver prints that were up to the standards of ZPAF; but for many decades her photographs did, it seems, represent a very high quality. How did Rydet's attitude toward prints evolve? How did she decide which to select, repro-duce, and sign? What made her exhibition photographs different from her working prints? Were her photomontages important as stand-alone works, or did their role end with their reproduction for the purposes of a publication or exhibition? Answers to such funda-mental questions are still absent from the existing scholarship on Rydet. This dearth of data not only makes market speculation and abuses in exhibition practice possible, but also allows for a glib rehashing of opinions describing as "amateurish" the works of one of the most efficient and professionally dedicated of photogra-

22 See Wojciech Makowiecki, ed., *Polska fotografia intermedialna lat 80-tych. Fotografia rozproszona*, exhibition catalog (Poznań: Galeria BWA/Galeria Wielka 19/Salon Poznańskiego Towarzystwa Fotograficznego/Galeria ON, 1988), n.p. Regarding state recognition, in addition to the numerous honors and medals awarded at exhibitions and competitions in Poland and abroad, Rydet was the recipient of, among others, the Meritorious Cultural Activist Badge of Katowice (1968), the Honorary Badge of Merit of the Board of the People's Council in Gliwice (1970), the Gliwice City Award for Lifetime Artistic Work (1972), the Award of the Minister of Culture and Art for Lifetime Artistic Work (1975), the Gold Cross of Merit (one of the highest marks of distinction in Polish culture, 1976), and the Main Award of the Association of Polish Art Photographers for Outstand-ing Achievement (Jan Bułhak Medal, 1985).

phers.[23] Much as this is a shameful admission to make, we have, in fact, no idea what sort of photographer Rydet was.

Colleague

We have little idea, either, of when Zofia Rydet made her debut. In the compilations of her most important exhibitions (generated by Rydet herself for exhibition catalogs), she refers to various shows, while the critics and historians who wrote about her work provide contradictory information.[24] Rydet's exhibition history is complicated by the fact that she, on principle, never declined to participate in shows, even in exhibitions organized by students or non-professional associations. In that sense, until the end of her life, she obstinately, or maybe even playfully, described herself as an amateur artist, contesting the institutional rules of engagement in the art world.[25] So far, there has been no comprehensive and critically edited bibliography or timeline for Zofia Rydet's exhibitions, or a timeline of the shows that she organized on behalf of the Gliwice Photographic Society (or GTF, by its Polish acronym) and ZPAF.[26] And we do not know where she sent and to whom she gave her photographs as presents, although we do know that she was generous with them.[27] What is certain, however, is that a significant turning point in Rydet's life arose from her connection with the Gliwice Photo-

23 See Anna Zawadzka, "Ja jedna przedłużam im życie," *Wysokie Obcasy*, no. 18, May 10, 2008, 38–46; Jacek Tomczuk, "Nie uśmiechać mi się. Patrzeć prosto w obiektyw," *Przekrój*, May 2, 2011, 36–39; Krzysztof Jurecki, "Prawda losu ludzkiego według Zofii Rydet?," *O.pl*, accessed September 28, 2017, http://magazyn.o.pl/2015/krzysztof-jurecki-prawda-losu-ludzkiego-wedlug-zofii-rydet/#/; and Sebastian Cichocki, "Zapis przejrzany," *Art & Business*, no. 9, 2015, 44–49.
24 Jerzy Busza, "Zofia Rydet i mitologie dalekich podróży," in *Wobec fotografów* (Warsaw: Centralny Ośrodek Metodyki i Upowszechniania Kultury, 1990), 96–110. See, by way of comparison, Juliusz Garztecki, "Zofia Rydet, czyli serce," *Fotografia*, no. 9, 1967, 203–04. An unpublished timeline, prepared by the Zofia Rydet Foundation, starts with the artist taking part in a post-competition group exhibition, organized in 1951 by the magazine *Moda i Życie*. Rydet qualified for the exhibition with her work entitled *Dolina Strążyska* [Strążyska Valley].
25 Sobota, "O fotografiach," n.p.
26 The Zofia Rydet Foundation is working on Rydet's comprehensive exhibition history and bibliography; as of yet, however, it has not been published.
27 Lewczyński, "Zosia," 95.

graphic Society, and, more broadly, with the Silesian photographic community.[28]

Although at first glance this topic seems covered, when reading the reminiscences of Alfred Ligocki or Jerzy Lewczyński that have dominated official catalogs, one may form the impression that "Zosia," wrapped up in listening to the tales of these neo-avant-garde experimenters, spent her time mainly throwing name-day parties and making "delicious salads."[29] Much as some may enjoy the drift of this narrative, it is unlikely that such activities were the sum total of Rydet's role in the photographic community.[30] It is remarkable that the most factual account that we have of one of the most interesting artistic circles in postwar Poland comes by way of its members, including the invaluable Jerzy Lewczyński. The reconstruction of Rydet's network, together with her approach to work and the influence that she had on other artists, both male and female, should prove revealing. The research to date paints a picture of the Gliwice Photographic Society as somewhat insular. We do know, however, that this was one of the most influential hubs nationally, with strong links to the centralized ZPAF.[31] The members of the Society traveled extensively, prepared numerous exhibitions, and maintained well-developed links abroad—thus an in-depth probing of institutional archives is of merit. Such research would contribute to a reconstruction of the anthropology and sociology of the artistic and daily life of the intelligentsia elite in the Polish People's Republic, for whom photography was a lifestyle of choice and an escape from politicized mundanity.

28	"Ninety percent of what I have achieved, I owe to the Photographic Society," Zofia Rydet declared in conversation with Garztecki, "Zofia Rydet, czyli serce," 203.
29	Lewczyński, "Fotografia w Gliwicach," 31; Alfred Ligocki, "Trzydzieści pięć lat fotografiki śląskiej," in *Formy i ludzie. Almanach fotografiki śląskiej* (Katowice: ZPAF, 1988), 13–24.
30	Lewczyński, "Fotografia w Gliwicach," 21–49.
31	See Anna Kwiecień, "Fenomen gliwickiego środowiska fotograficznego (1951–2000)," in *Fenomeny i fantomy*, 9–14. (English summary, "A Phenomenon of the Gliwice Photographic Society [GTF] in 1951–2000," 146–47).

Humanist

In the war of clichés that rages among critics of Rydet's art, a staple is the pointing out of how her series *Little Man*, and more broadly, her work since joining the GTF, in 1956, right up to the publication of that album, in 1965, was influenced by Edward Steichen's exhibition "The Family of Man,"[32] which was shown in communist Poland in 1959. That iconic exhibition had been as influential as it was inspired by the characteristic perception of the world by postwar photographers. Apart from mere statements of influence, we have yet to see any detailed study addressing the specificity of Rydet's practice, as well as a critical consideration of its relationship to Edward Steichen's project, or to the photographs of Henri Cartier-Bresson, Édouard Boubat, Robert Doisneau, William Klein, Robert Frank, Chim Seymour, and other artists, with whom the photographer from Gliwice has been compared.[33] It does not seem to be the case that the author of *Little Man* was a naive imitator of Steichen's concept. *Little Man* is an unusual album; we know little about how it relates to the author's exhibitions and her earlier projects. In any event, this first album is a model instance of a photobook, and those she published in the following decades—*Zofia Rydet's World of Imagination* (1979) and *Presence* (1989)—form a coherent series that is yet to be analyzed as an entity.[34] This connection between projects that at first glance appear completely different, indicates that Rydet acted

32 Anonymous source, in Zagrodzki and Ruksza, *Katowicki underground artystyczny*, 408–409; Sobota, "Pomiędzy abstrakcją a intymnością," 144. In turn, Katarzyna Kalina finds similarities with Henri Cartier-Bresson and Édouard Boubat, "Szersze spojrzenie. Fotografia związana z Gliwickim Towarzystwem Fotograficznym na tle fotografii światowej," in Gołaszewski and Kwiecień, *Fenomeny i fantomy*, 15 (English summary, "Photography Related to the Gliwice Photographic Society Versus World Photography: Broader View," 147); Sobota, "Zapisy," 5; Kamila Leśniak, "'The Family of Man' po latach. Wokół krytyki i recepcji wystawy," *Roczniki Humanistyczne* 61, no. 4 (2013): 205–40.

33 See Ligocki, "Trzydzieści pięć lat fotografiki śląskiej," 15. "Her art is characterized by a wealth of imagination and depth of reflection, and it is steeped in profound emotion. The artist's attention is focused on man, his psyche, his attitude to the world and his position therein. In short, all that Malraux refers to as human fate."

34 In the archive of the Zofia Rydet Foundation, there exists a dummy of a book, prepared by Zofia Rydet herself, of the unpublished photobook *Wieś* [Countryside], dated 1957–61, a sort of forerunner to the *Sociological Record*. The design for this photobook has been arranged as a selection of spreads and included as an insert to this volume. —Ed.

FIG. 4
ZOFIA RYDET, *DRAMAS*, FROM THE SERIES *LITTLE MAN*, 1961

deliberately and consistently in producing books and carrying out her consecutive projects, which combine, overlap, and result from, or complement, one another. Unlikely as this may appear, in the work of the author of the *Sociological Record* there is much of the dialectics of document and creativity that pertains to photography, spread out between a sociological record and a world of imagination. Instead of any sustained analysis of the web of relations between the individual projects (unique in the history of Polish photography), what we have had so far is critics squabbling over which project they deem the best, which one will leave its mark on the history of photography, and which one makes Zofia Rydet "perhaps" the greatest Polish photographer. Meanwhile, the moment Rydet set her heart on something, she would carry on determinedly according to plan, regardless of her advanced age. It mattered not to her that she was, supposedly, belated in her humanism when compared to Steichen, or that sentimental photomontages would have been more appropriate to the late 1960s rather than to the caustic and conceptual turn of the 1970s, or that a photobook about images of the pope would have been a significant event during martial law, but not when communism was falling, and so on.[35]

Such failures to take into account the autonomy of Zofia Rydet's modus operandi, the fact that she herself shaped her artistic practice, is perhaps the greatest oversight to afflict recent research on the artist. Thus, we don't see the forest for the trees; we see no consistent artistic path, noticing instead a series of haphazard projects, from among which we arbitrarily choose the one that we favor at any given moment. Until now, critics and curators of the most important exhibitions have tended to either link everything with everything else (Alfred Ligocki, Krzysztof Jurecki, Adam Sobota, Andrzej Różycki) or have taken great care to select a specific part, while forgetting about the bigger picture.[36] The fact remains that, when one examines closely Rydet's artistic output, it is hard to be

35 Urszula Czartoryska defends Rydet's collages from the label of "sentimentality," proving that they had been "deliberately thought out with perspicacity, intersubjective truth." See Czartoryska, "Untitled," in *Świat wyobraźni Zofii Rydet*, n.p.
36 Sobota, "Zapisy," n.p.; Adam Mazur, "Zofia Rydet, *Zapis*, 1978–1990," *SZUM*, no. 11, 2015, 159–61.

unaware of her relentless consistency, nor of her deviations and intuitive experimentation.

Without a doubt, it is people who are the focus of Rydet's art. Already when working with her brother, who was much enamored of landscape, she was well aware that this was where her own interests lay.[37] When assembling her photographs for *Little Man*, Rydet was aware that her colleagues from the GTF were busy discussing the abstract concepts of "anti-photography"; similarly, when working on *The World of Feelings and Imagination* or the *Sociological Record*, she could see the outcomes of conceptual and photomedia activities taking place around her.[38] On each occasion, her own works could appear "naive" (why not "consistent" or "authentic"?) or old-fashioned. Even the *Sociological Record* is, to a large extent, detached from the era that it was made in.[39] This detachment is very noticeable in the catalog of "Polish Intermedia Photography of the 1980s,"[40] the leading exhibition of photography during that decade. Can Rydet's humanism be taken seriously today? Or does this "dated" humanism provide an opportunity for "affective" interpretations? Her professional practice, choice of photographic topics, and her interesting biography apart, Rydet—as every good artist does—confronts us with her own idiosyncratic stance and viewpoint. What we are able to do with this mixture of devotion, authenticity, solemnity, and spirituality is a different matter completely. It may be hard to stomach, or easier to write off as eccentricity, but this does not change the fact that Rydet is one of the outstanding propositions in postwar Polish art.

37 Zofia Rydet, "O Zapisie Socjologicznym," *Konteksty. Polska Sztuka Ludowa* 51, no. 3/4 (1997): 192–97.
38 Ibid.
39 Jerzy Busza, "Krótka refleksja na temat fotografii socjologicznej," in *Z perspektywy czterdziestolecia. FOTOGRAFIA POLSKA. 1945–1985. Materiały sympozjum XV Konfrontacji Fotograficznych w Gorzowie Wlkp. w dniach 10–12 maja 1985*, vol. I (Gorzów Wielkopolski: Wydawnictwo Gorzowskich Konfrontacji Fotograficznych, 1985), 128–139. Mariusz Hermanowicz, "Dokument czasu," in *I Ogólnopolski Przegląd Fotografii Socjologicznej Bielsko-Biała 1980* (n.p., n.d.), n.p.
40 Makowiecki, *Polska fotografia intermedialna*, n.p.

Photomontage Expert

For some critics and curators, Zofia Rydet's photomontages, objects, and naive ways of displaying and combining media are examples of work of an "inferior" sort,[41] in which folk naiveté goes hand in hand with an epigone's take on surrealism. [FIG. 5] Urszula Czartoryska placed these works somewhere between those of the primitivist painter Teofil Ociepka, the communist photomontage artist Mieczysław Berman, and the Czech surrealists Karel Teige and Jindřich Štyrský, whereas Jerzy Busza compared Rydet to Zdzisław Beksiński,[42] the avant-garde photographer connected to the Gliwice circle, who later abandoned this heritage, embracing an idiosyncratic notion of painting characterized by the "coexistence of extremely radical innovation with a deeply rooted traditionalism."[43] It would be useful, however, to be provided with some analysis rather than a mere list of names as reference points. In the final analysis, one could forgive Rydet such "sentimental" works, and yet she consistently kept combining them with works that were noble and sparse, such as the *Sociological Record*.[44] Well, this is what Rydet was like, and attempts by critics, historians, and curators to sweep her supposed kitschiness under the carpet will not amount to much but will, rather, obfuscate the real impact of her oeuvre. Rydet did care about form—but she did not care about purity of form. Her photomontages and objects—of value to a handful of critics and important for the artist herself—not only show her sensitivity, but also demonstrate her manner of working: the use of photography to make man-

41 Krzysztof Jurecki, "O etosie fotografii. Na przykładzie twórczości kilku fotografów ze Śląska," in Zagrodzki and Ruksza, *Katowicki underground artystyczny*, 283–84.

42 Czartoryska, "Untitled," n.p.; Jerzy Busza, "Świat uczuć i wyobraźni," in *Wobec fotografii* (Warsaw: Centralny Ośrodek Metodyki Upowszechniania Kultury, 1983), 174–81; Busza, "Zofia Rydet i mitologie dalekich podróży," 103.

43 Formulation by critic and curator Janusz Bogucki, quoted after Krzysztof Jurecki, "Zdzisław Beksiński," *Culture.pl*, accessed September 28, 2016, http://culture.pl/pl/tworca/zdzislaw-beksinski.

44 Adam Mazur, "Zofia Rydet *Zapis socjologiczny*," *Dwutygodnik*, accessed September 28, 2017, http://www.dwutygodnik.com/artykul/3828-zofia-rydet-zapis-socjologiczny.html.

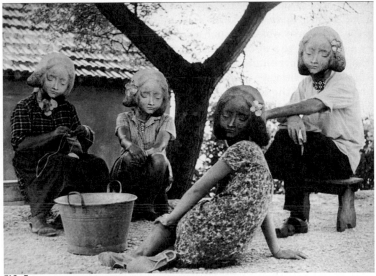

FIG. 5
ZOFIA RYDET, *EXPECTATIONS*, FROM THE SERIES
THE WORLD OF FEELINGS AND IMAGINATION,
1975–79

ifest her view of the world, her emotional perception, and her rela-
tionships with other human beings.[45]

Documentalist

In her critical study, Karolina Lewandowska refers to
Rydet as the "author of the most prominent documentary project in
Polish photography post-1950."[46] Let us add: the most prominent
after that of the grand pictorialist Jan Bułhak, creator of the concept
of *fotografia ojczysta*, the Polish equivalent of the German *Heimatfoto-
grafie*.[47] Yet the problem of such a pronouncement lies in the fact that
as a medium, the documentary was never Rydet's goal in and of
itself.[48] The short enunciations recorded by Andrzej Różycki or Józef
Robakowski aside, we have no idea how Zofia Rydet defined the doc-
umentary, and the texts that critics have written to accompany her
works on the whole obscure rather than illuminate her message, sur-
rounding the reader with a smokescreen of metaphysical musings
by the authors.[49] The analysis by Alfred Ligocki, which barely touched
upon Rydet's photography, was written more than thirty years ago,
under martial law, while more contemporary authors such as Adam
Sobota and Krzysztof Jurecki, who brandish comparisons to August
Sander, do not dwell on the point in detail.[50] In turn, Barbara Panek-

45 Ligocki, "Trzydzieści pięć lat fotografiki śląskiej," 13–24.
46 Lewandowska, *Dokumentalistki*, 217.
47 Sobota, "O fotografiach," n.p. See, by way of comparison, Andrzej Różycki,
 Zofia Rydet. Zapis socjologiczny 1978–1990, exhibition brochure (Gliwice: Art
 Reading Room in Gliwice, 2012).
48 Adam Sobota put this aptly: "Without a doubt, Zofia Rydet is one of the
 most important photographic artists in Poland in the latter part of the
 twentieth century. The wealth of her legacy is deceptively difficult to
 categorize, since the artist only observes formal requirements insofar
 that they match her psychological needs. As an outstanding documental-
 ist, she at times employs the documentary as the basis for further
 creation." Sobota, "O fotografiach Zofii Rydet," n.p.
49 Andrzej Różycki, "Nieskończoność dalekich dróg. Podpatrzona
 i podsłuchana Zofia Rydet A.D. 1989," *Konteksty. Polska Sztuka Ludowa* 51,
 no. 3/4 (1997): 183–87; Anna Beata Bohdziewicz, "Zostały zdjęcia,"
 Konteksty. Polska Sztuka Ludowa 51, no. 3/4 (1997): 189–91; Andrzej Różycki,
 Zofia Rydet. Fotoandrzejozofia, exhibition brochure (Łódź: Galeria 87,
 December 2015–January 2016); Karol Jóźwiak, "Inwentaryzacja wiz-
 erunków," in *Zofia Rydet. Inwentaryzacja wizerunków*, exhibition catalog
 (Kraków: Fundacja im. Zofii Rydet/Katowice: Muzeum Śląskie w Katow-
 icach, 2013), 8–48.
50 Ligocki, *Czy istnieje fotografia socjologiczna?*, 108–11; Sobota, "O fotografiach,"
 n.p.; Sobota, "Zapisy Zofii Rydet," 12.

Sarnowska, author of the most profound analysis of the *Sociological Record* yet, defines this crucial series as the "most characteristic of Rydet's oeuvre."[51] Apart from the emotional testimony by photographers close to Rydet, until the exhibition at the Museum of Modern Art in Warsaw, curated by Sebastian Cichocki and Karol Hordziej on the basis of research conducted by the Zofia Rydet Foundation, nobody had made any sustained attempt to capture the dynamics of the *Sociological Record*, or to indicate its genesis, significance, or the overall intent of the artist. The reappraisal came alongside a comprehensive, years-long project to edit and digitalize Zofia Rydet's archive, which, besides the exhibition at the Museum of Modern Art in Warsaw (which later traveled to the Jeu de Paume in Tours, France[52]) also resulted in the creation of a website with a digital catalog.

To put this differently, until now, even when in the actual presence of Rydet's magnum opus, we were obliged to employ our imagination—not so much in order to come to grips with the general picture of her project as to be able to reconstruct for our own purposes why and to what end it was created. With its exhibition, the Museum of Modern Art in Warsaw set a number of milestones: its curatorial interpretation of Zofia Rydet's oeuvre, renewed research, and the digitization of the archive of the Zofia Rydet Foundation, now publicly accessible. This will need to be followed by laborious analysis, resulting in an even more onerous synthetic assessment of the project.

The exhibition inspires reflection on the "sociology" and "academic approach" of the *Sociological Record*, marking a return to the debate, which faded out in the 1980s, on socially-engaged photography.[53] The exhibition teases with the power imbalance and megalomania of the works, which perhaps to some extent reflect the overall character of Zofia Rydet's activities. Moreover, the *Sociological Record* exposes issues that today's researchers cannot evade: the

51 Panek-Sarnowska, *Socjologiczność*, 7.
52 "Zofia Rydet. *Répertoire*, 1978–1990," Jeu de Paume – Château de Tours, November 19, 2016–May 28, 2017.
53 See Ligocki, *Czy istnieje fotografia socjologiczna?*; Zbigniew Dłubak, "Fotografia socjologiczna," *Obscura*, no. 8, 1984, 33–40.

combination of the progressive entropy of the project with its sym-
bolic violence as well as class domination, and last but not least, the
author's moralizing.[54] The assembled archive is crying out to be ana-
lyzed by anthropologists and ethnographers, as well as—and this is a
must—by art historians and photographers.[55] The sheer wealth of the
collection demands a group effort over many years to come, although
it does not preclude ardent acts of maximum commitment by ambi-
tious researchers. Without a doubt, it is also necessary to reexamine
the relationship between the *Sociological Record* and the series pro-
duced earlier or simultaneously, such as *The Infinity of Distant Roads*
(1980) or *Silesian Suite* (1980–90), as well as to recognize its relation-
ship to its historical context—considerations that were beyond the
scope of the exhibition at the Museum of Modern Art.[56]

Photography after Zofia Rydet

Zofia Rydet passed away two decades ago. Today, the
label "Zofia Rydet" brings to mind various posthumous exhibitions
and the activities of the foundation bearing her name, as well as the
part of the artist's narrative that has impacted her enduring pres-
ence in the artistic and photographic landscape. This is by no means
a trivial legacy, and it is only beginning to develop against the backup
of rival concepts and working strategies dealing with Rydet's output.
Let us emphasize that this research ought to take into account the
influence that the author of the *Sociological Record* has exerted on gen-
erations of artists. In a sense, the history of Polish photography can

54 In the end, the recurring imagery of Pope John Paul II became the
 leitmotif of *Obecność*, a book that Rydet published in collaboration with
 Józefa Hennelowa in 1988, the year that precipitated the fall of the Polish
 United Workers' Party. Even at such a time, Rydet remains detached; she
 does not photograph momentous events such as John Paul II's papal
 mass for the nation or mass demonstrations in the streets, choosing
 instead to illustrate Hennelowa's spiritual meditations. In her Introduc-
 tion, Hennelowa writes: "The reflections gathered here, which accom-
 pany Zofia Rydet's album, are devoted to the home and hearth, in both
 the literal and metaphorical sense." Hennelowa and Rydet, *Obecność*, 6.
55 As regards the potential for ethnographic, including comparative,
 research, see Izabela Kowalczyk's curatorial introduction, *Etnografowie
 w terenie*, eds. Anna Brzezińska and Agata Stanisz, exhibition catalog
 (Poznań: Stary Browar Słodownia +1, 2014).
56 See Sobota, "Zapisy," 6–7; Ligocki, "Trzydzieści pięć lat fotografiki
 śląskiej," 23.

be viewed as two distinct periods, Before Rydet and After Rydet, or rather before and after the *Sociological Record* (including the version exhibited at the Museum of Modern Art). Significantly, it is not only those who had the opportunity to meet Rydet in person that are much indebted to her. Among the artists that in numerous ways continue her endeavor one can count Andrzej Różycki, Piotr Wołyński, Julia Staniszewska, Weronika Łodzińska, Łukasz Skąpski, Paweł Bownik, Renata Dąbrowska, Przemysław Pokrycki, Anna Bedyńska, Michał Jelski, Maga Sokalska, Marek Wasilewski, Jan Brykczyński, Rafał Milach, Karolina Jonderko, the team of visual sociologists led by Marek Krajewski, the now defunct duo Zorka Project, and two young photographers, who passed away all too early—Ireneusz Zjeżdżałka and Konrad Pustoła.[57]

Let us not deceive ourselves: research into Zofia Rydet fell into stasis after the fecund period between 1997, the year of the artist's death, and when the issue of *Konteksty* magazine themed on Rydet was published, and 1999, when her posthumous monographic exhibition at the Muzeum Sztuki in Łódź took place. The exhibition "Zofia Rydet: *Record*, 1978–1990" at the Museum of Modern Art in Warsaw set out to change this status quo. To date, research into the oeuvre of Zofia Rydet has taken one of two paths; either the "museum" approach—compiling archives, maintaining and editing the collection, and attempting to nail down the historical facts—or else the "creative" slant, with curatorial interpretations, artistic transformations, poetic projections, reproduction and speculation with works

57 See Różycki and Rydet, *Fotoandrzejozofia*; the revised edition from 2012 of Rydet's *Mały człowiek*; Elżbieta Petruk and Bogna Świątkowska, eds., *Natalia Fiedorczuk. Wynajęcie* (Warsaw: Bęc Zmiana/Narodowe Centrum Kultury, 2012); Andrzej Kramarz and Weronika Łodzińska, *Dom/Home* (Kraków: Muzeum Etnograficzne im. Seweryna Udzieli w Krakowie, 2009); Lewandowska, *Dokumentalistki*; Marianna Michałowska, "Portret we wnętrzu – między socjologią a antropologią fotografii," in *Społeczne dyskursy sztuki fotografii*, eds. Marianna Michałowska and Piotr Wołyński (Poznań: Akademia Sztuk Pięknych w Poznaniu, 2010), 87–104; Piotr Wołyński, ed., *Formy zamieszkiwania. Publiczne i prywatne przestrzenie miasta* (Poznań: Uniwersytet Artystyczny w Poznaniu, 2010); Joanna Rzepka-Dziedzic and Łukasz Dziedzic, eds., *Fotografia dokumentalna w projektach fotograficznych* (Cieszyn: Galeria Szara, 2005). Another specific issue is the matter of Rydet's reception abroad, in the Eastern Bloc and in the West. See Vladimír Birgus, "Konfrontace Polské Fotografie," *Československá Fotografie*, no. 12 (1979): 536–40.

taken out of context. The exhibition at the Museum of Modern Art demonstrated that the two approaches can to some extent be combined. The "Record" is a radical departure for museum standards—a bid to rewrite the narrative of Rydet's art. I take the curators' word for it when they declare that they aim to fulfill the wishes of the artist herself. This approach seems in keeping with Rydet's own modus operandi. She was an artist who never ceased to rewrite her story, who was forever transforming herself, continually evading all attempts at pigeonholing her.

ZOFIA RYDET
SOCIOLOGICAL RECORD
PHOTOGRAPHS SELECTED BY
SHARON LOCKHART

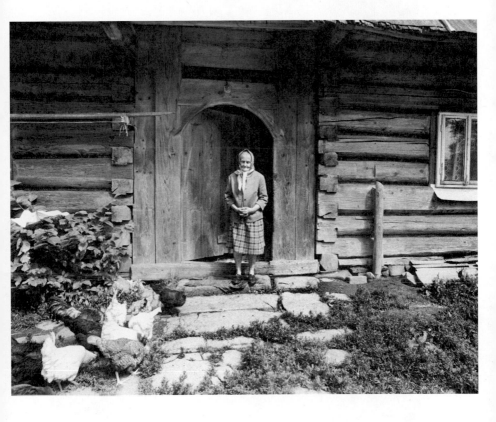

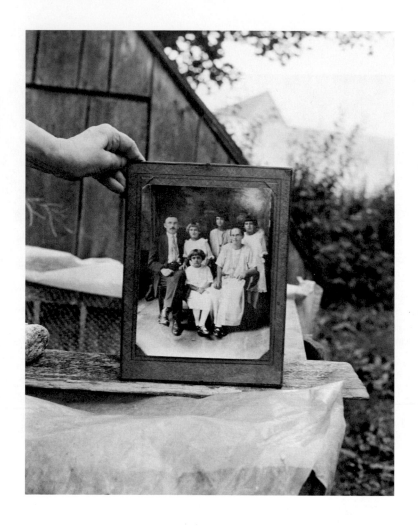

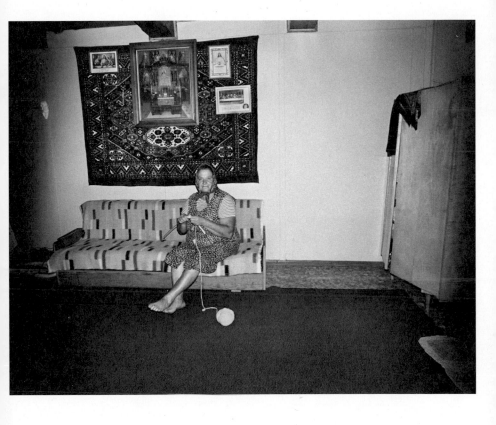

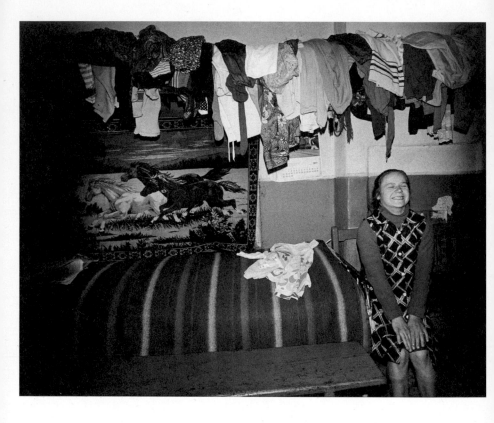

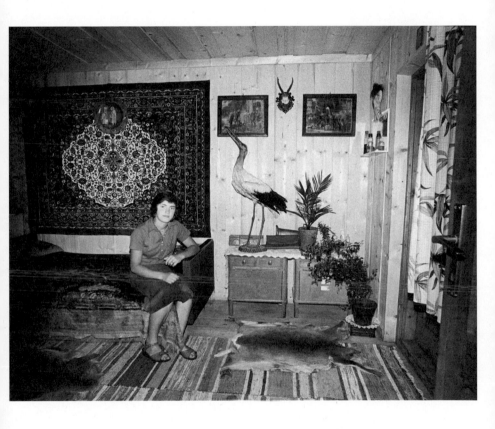

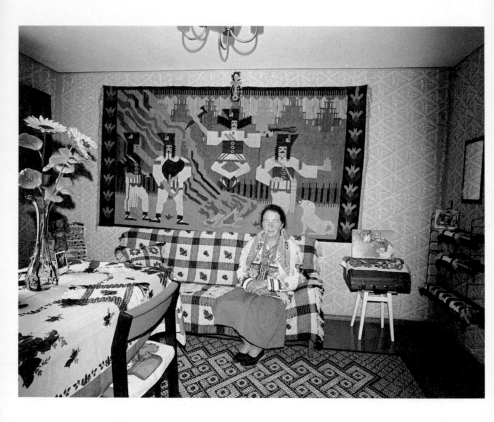

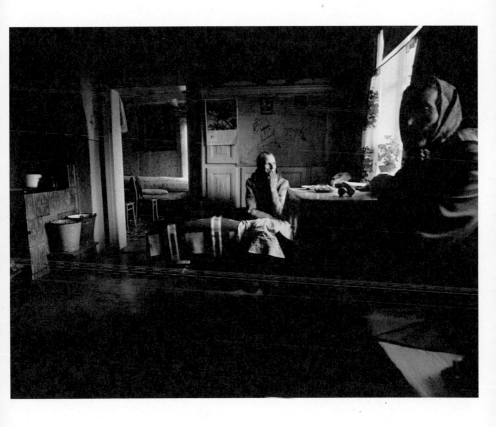

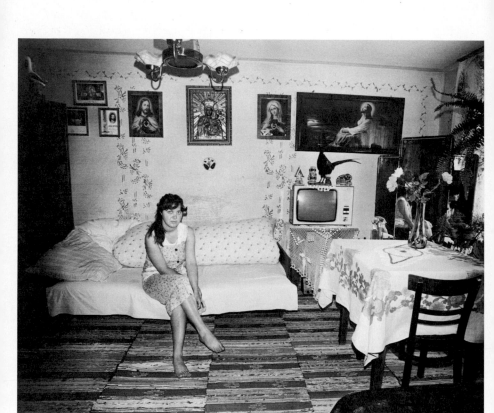

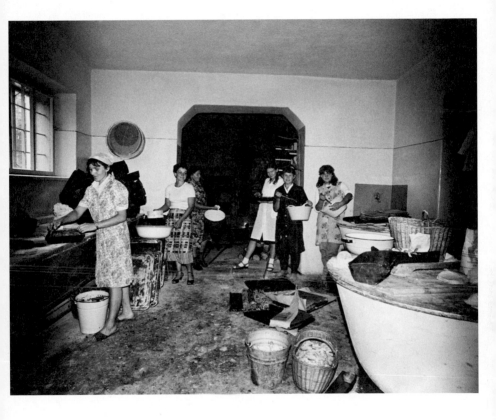

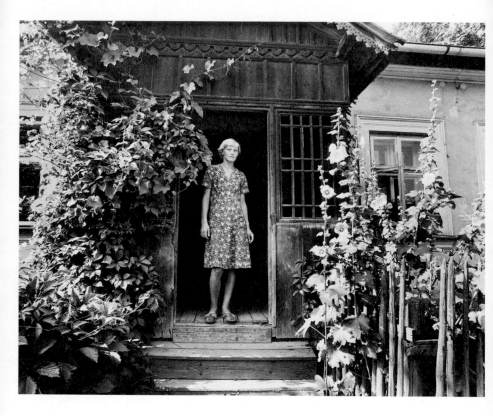

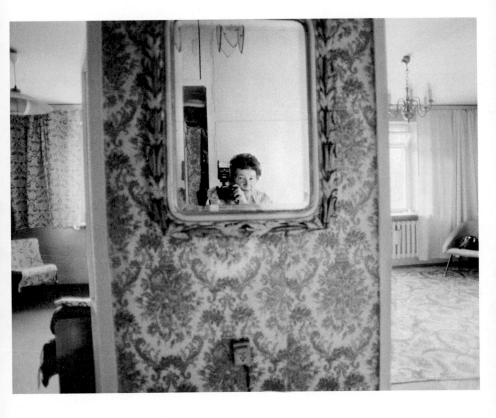

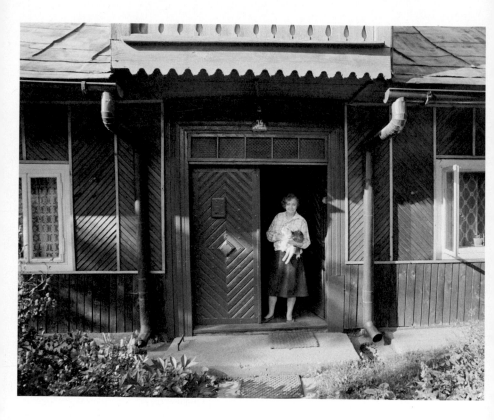

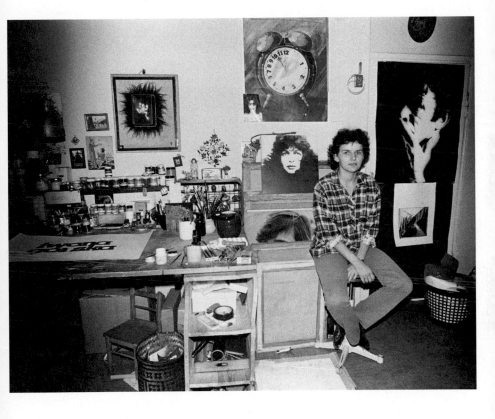

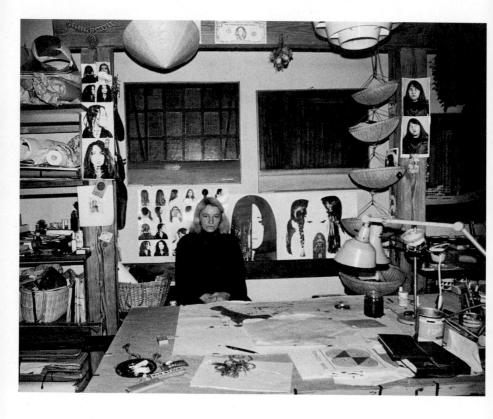

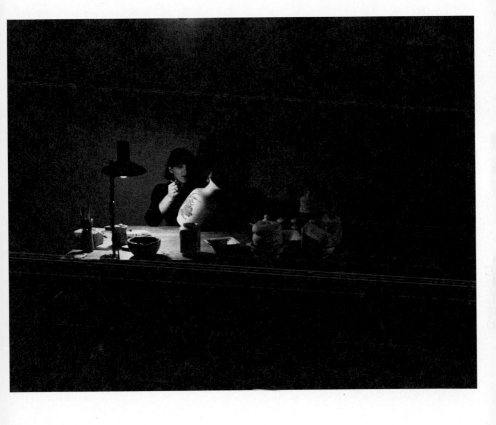

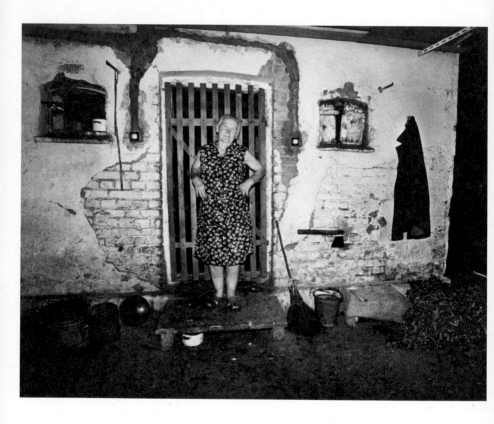

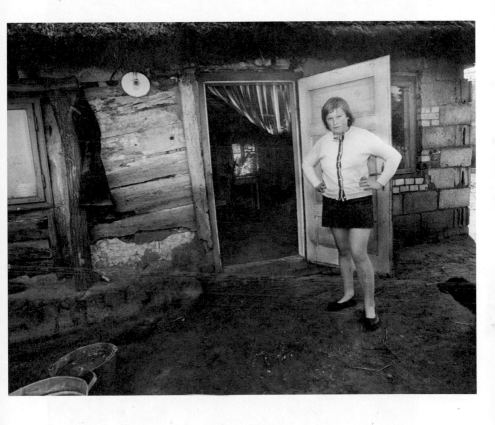

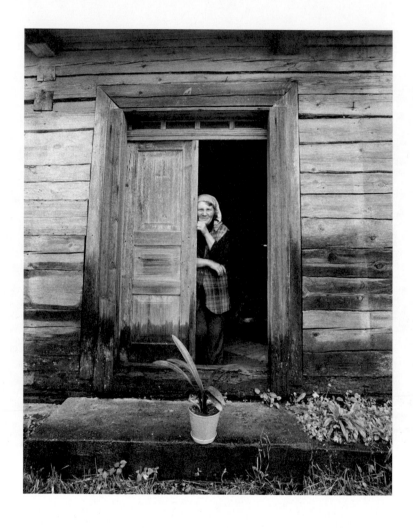

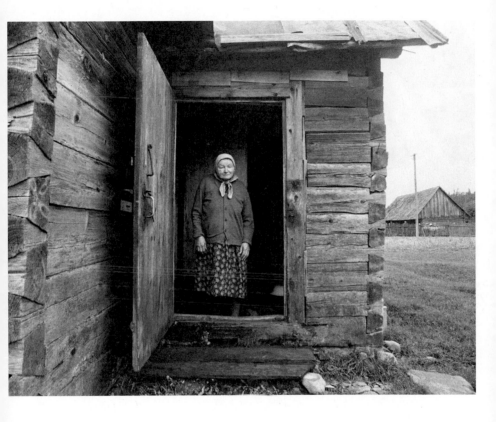

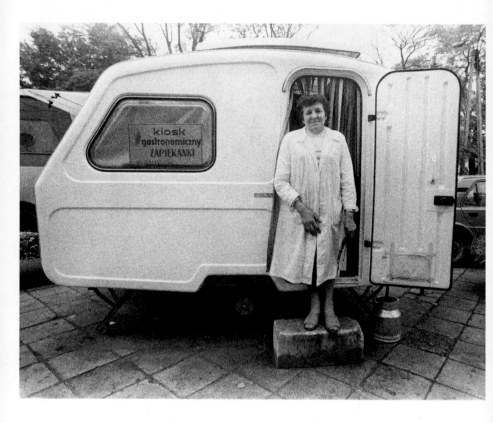

Ewa Klekot is an anthropologist and translator. She teaches at the Institute of Ethnology and Cultural Anthropology at the University of Warsaw and at the School of Form in Poznań. Her research interests include the anthropology of heritage and the museum; the anthropology of design and art; the social construction, in particular, of folk art and primitive art; the materiality of things considered to be design, art, monument, or museum object; and the socially differentiated potential of art ("kitsch"). She is member of the editorial board of *Ethnologia Europaea* and *Zbiór Wiadomości do Antropologii Muzealnej* [Collection of Anthropological Museal Information].

BETWEEN THE ETHNOGRAPHIC AND MATERIAL CULTURE

In the year of Zofia Rydet's death, 1997, the quarterly journal *Konteksty*, published by the Institute of Art of the Polish Academy of Sciences, dedicated an extended section to the photographer.[1] Published since 1947 as *Polska Sztuka Ludowa* [Polish Folk Art], from 1990 onward the journal bore the slightly enlarged title of *Polska Sztuka Ludowa. Konteksty* [Polish Folk Art: Contexts], together with the further English subheading *Cultural Anthropology, Ethnography, Art*. The changes in the publication's name reflect a rather complicated history of the discipline of anthropology, both in academia and in the intellectual tradition of the Polish humanities. Zofia Rydet was awarded a place in the periodical because of her focus on the countryside and its rural inhabitants, which fell both within the category of *ludowy* [folk] and *etnografia* [ethnography]. However, when speaking about her work she rarely, if ever, drew a connection between her actions and the term "ethnographic." On the contrary, she adopted the title *Sociological Record*, exhibiting in the broader framework of

1 Anna Beata Bohdziewicz, "Zostały zdjęcia," *Konteksty. Polska Sztuka Ludowa* 51, no. 3/4 (1997): 189–91; Andrzej Różycki, "'Nieskończoność dalekich dróg.' Podpatrzona i podsłuchana Zofia Rydet A.D. 1989," *Konteksty. Polska Sztuka Ludowa* 51, no. 3/4 (1997): 183–87; Zofia Rydet, "O Zapisie Socjologicznym," *Konteksty. Polska Sztuka Ludowa* 51, no. 3/4 (1997): 192–98.

so-called "sociological photography," a theoretical notion that gained momentum toward the late 1970s, precisely when her idea of a series dedicated to people in their home environments took shape. At the same time, on more than one occasion the photographer herself claimed that the name "Sociological Record" was not her own idea, but rather a proposition courtesy of eminent photography critic and art historian Urszula Czartoryska.[2]

My aim in this essay is to illuminate Rydet's work by way of the contextual paradigm in which the *Konteksty* publication had placed it, namely the discourse of ethnography in Poland. To accomplish this, I will outline the most important developments and tensions within Polish ethnography, where the construction of the Polish countryside and its inhabitants as "folk" occurred. I will argue that Rydet's work, and the methods she used, resulted from her understanding of the categories "sociological," "ethnographic," and "folk," all of which were grounded in the worldview of the Polish intelligentsia, of which she was also a member. And while the representations of the rural within this worldview were for the most part consistent with those formulated within the discourse dominating Polish ethnography, Rydet's mode of interaction with the village world, which she photographed, led her to transmit in her work some understandings corresponding with the representations provided by this discourse's outsiders such as Jacek Olędzki or Piotr Szacki, who instead of describing the "folk ways" of the villagers, focused on the experiential and existential dimension of living the village life.

I will therefore begin with a brief overview of "ethnography" as it has been conceived by the vast majority of Polish-language users, namely as the academic discipline researching "the folk," very much within the continental, Romantic, and Herderian tra-

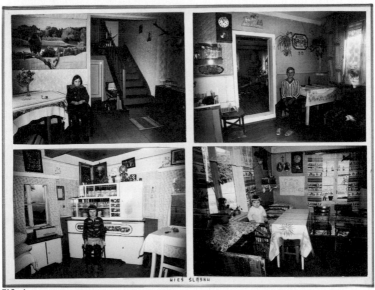

FIG. 1
ZOFIA RYDET, *THE SILESIAN VILLAGE*, FROM THE
SOCIOLOGICAL RECORD, c. 1980s

dition of *Volkskunde*.[3] I will show how far Rydet's approach was embedded in the vision of the countryside constructed within the *Volkskunde* tradition, and to what extent her photographs can be interpreted as sharing the understandings of the Polish ethnographers of her time who tried to shun the folkloristic straightjacket of the *Volkskunde* tradition. It is my position that on a conceptual level Rydet, being a member of the intelligentsia, was shaped by the *Volkskunde*-vision of the village world, but at the same time her photographs can be interpreted as a disruption of that tradition.

To develop this argument further, I will focus on another meaning of the Polish word *etnografia*, which entered common usage only in the 1990s under the influence of the American social sciences, where it is used as a technical term meaning the fieldwork method. However, in the discipline of cultural anthropology the stress has been placed on the fact that "ethnography" comprises both the "being there," or "staying in the field" (fieldwork and the collection of field materials), as well as the subsequent writing of an account for the public "at home." I'd like to look at Rydet's techniques of work, comparing them to such an understanding of "ethnography." Finally, this will take me to Rydet's way of showing her village subjects in relation to their material culture, with several different aspects of this relationship placed in focus: possessions,

3 Originally appearing in the eighteenth century and initially used interchangeably, the terms *Völkerkunde* and *Volkskunde* began to refer to different subjects of studies by the nineteenth century: *Völkerkunde* came to mean the studies of geographically exotic cultures and peoples, while *Volkskunde* stood for socially exotic rural folk of modernizing Europe. The writings of German philosopher Johann Gottfried Herder (1744–1803) were crucial for defining the subject of the discipline and its object of study. "On the eve of an industrializing modernity, Herder's work solidified the modern invention of the 'folk' category." Regina Bendix, *In Search of Authenticity* (Madison: University of Wisconsin Press, 1997), 35. In Germany, the involvement of *Volkskunde* in modern nation-building, nationalism, and later with the Nazi *völkisch* ideology, resulted in a thorough critique within the discipline and the subsequent deconstruction of the term *Volk*. In Poland, a similar critique of the terms *lud* and *ludowy* has been occurring within the discipline of ethnology since the 1980s, but unfortunately it has yet to reach a wider audience.

inhabited space, and various kinds of imagery including TV sets as "imagery dispensers" of sorts.

Ethnography, understood as either a method or a discipline, is based on contact with the Other. As a method, the Other is multifarious; as a discipline, the Other can only be the Folk. In English, the Polish noun *lud* translates to both "the folk" (understood as peasantry, rural dwellers), and to "the people." Behind the concept of ethnography as a discipline there is then the Romantic concept of the folk as "the roots of nation"; itself a continuation of the Herderian meaning of the term *das Volk*.[4] This way of conceptualizing peasants resulted in the development of an academic discipline focused on studying the "folk" and documenting this group in order to spare their valuable essence from modern cultural change, as well as to provide the modern nation with necessary legitimization in the form of folk roots and traditions. The discourse of the Germanic *Volkskunde* (and its corresponding Slavic and Scandinavian terms, including the Polish *ludoznawstwo*) constructed and promoted the image of its "object of study" as temporarily and socially exotic folk, consisting of savage and rough but also noble and picturesque peasants.[5] Exoticizing strategies, however, seem to have been applied rather unconsciously, both as a result of establishing "folk" as an object of scientific observation, and as a consequence of class prejudices deeply ingrained in the feudal relations that characterized the

4 Herder's *Volk*, being the roots of nation, also carried strong social connotations, as he stated in his *Stimmer der Völker in Liedern* (1807), "*Volk* does not mean the rabble in the alleys; that group never sings or rhymes, it only screams and truncates," quoted in Bendix, *In Search of Authenticity*, 40. According to Bendix, "He postulated a whole people in history, where everyone was suffused with myths and folk poetry. In the course of history would occur a division of the people into a level of the learned and a level of a folk, and the mythology would remain, in the form of tales and folk songs and legends, among the folk where such goods were taken care of and passed on." (Ibid., 41). "Herder implied a differentiation between an idealized and rural 'folk' and those new urban lower classes who were rapidly losing the 'natural nobility' of their peasant forebears." (Ibid., 47).

5 Arturo Alvarez Roldán and Hans F. Vermeulen, "Introduction: The History of Anthropology and Europe," in *Fieldwork and Footnotes: Studies in the History of European Anthropology*, eds. Roldán and Vermeulen (Routledge: London, 1995), 1–17; Vermeulen, "Origins and Institutionalization of Ethnography and Ethnology in Europe and the USA, 1771–1845," in Vermeulen and Roldán, *Fieldwork and Footnotes*, 39–59.

Central and Eastern European countryside long into the nineteenth century. In nineteenth and early-twentieth-century Poland, as in the rest of Europe, the agency of the discipline was vital for the formation of the most important of national myths: that of the undivided and coherent nation, indispensable to the creation of the modern nation-state. The *Volkskunde* folk was used politically to bridge the gap between the Polish nobility and peasantry, silencing the most acute and most enduring social conflict.

With the Polish People's Republic, as was the case with many other totalitarian regimes, folklore became the single valid representation of the rural and the peasant, providing a useful tool for policing class and social differences via aesthetic code. On the one hand the rural world, once submitted to modernization, was stigmatized as backward and lacking in culture, while on the other hand it offered an aesthetically gratifying representation of the archaic: folklore as proof of culture to present to modern urban culture-bearers. In Poland, such a position coincided with a very conservative, nineteenth-century conception of art and culture shared by the new (communist) government elites as well as the *longue durée* of the prejudices held against "low-cultured" peasants engrained in the "high culture" historically propagated by the gentry. Making folklore a question of aesthetics dragged the rural world into the modern game of social distinction through judgment of taste: when the difference could not be phrased as folklore it was usually marked as kitsch. In the later years of the People's Republic, urban Poles, exhausted by the folklorization of mass culture, began to equate one with the other.

The first location where Rydet began the collation of material for the *Record* was Podhale, the mountain region at the foot of the Tatras, which was the focus of the most fervent fascination of the Polish intelligentsia with the folkways and the subsequent production of extremely picturesque highlander folklore. In this context, it is critical to distinguish between the type of contact "the lords" had with the peasants in the mountains as opposed to the lowlands. For a (noble) stranger visiting Podhale, the highlander was "a leisure-time peasant," a companion during a pleasant "natural

retreat," a caretaker on the rocky trails, and not a dangerous social problem or source of lingering guilt owing to the centuries of serfdom to which the nobility had subjected the peasantry.[6] At the same time, ethnographers eagerly explained this difference by way of history: Podhale peasants were never serfs, and it was serfdom that caused "the rural folk's melancholy, their apathy and idleness."[7] The mountain terrain, which looked so picturesque and sublime to the lowland city-dwellers, was, it was thought, reflected in the highlanders' nature. The inaccessibility of the mountain villages had facilitated the preservation of the most archaic—and therefore the purest—forms of Polish culture. In this way the highlanders became "the most Polish of the Polish tribes," to quote the nineteenth-century Kraków-based historian Karol Potkański.[8] In the 1800s and early 1900s, Poland also witnessed a proliferation of literary production spreading this stereotype of Podhale and its inhabitants, who were represented as peasants but with a lord's dignity, not disgraced by serfdom, and as heroically, fighting for Polish independence.[9]

In Andrzej Różycki's film *Nieskończoność dalekich dróg* [The Infinity of Distant Roads], dedicated to Rydet, the photographer is recorded saying that she began work on the *Record* in Podhale because the people there were different than in other parts of Poland: "They are people of great ambition [...] The highlander is proud of being a highlander. They have very characteristic faces there, very pretty faces. Because for instance in the Rzeszów region, or elsewhere, there are very many ugly faces, not expressing anything."[10] In my opinion, here Rydet is perceiving the village world through the *Volkskunde* lens, if not repeating outright a cultural cliché. As early as the nineteenth century, the handsome and proud *góral* [highlander] had become a fixture of the intelligentsia's imag-

6 See Antoni Kroh, *Sklep potrzeb kulturalnych* (Warsaw: Prószyński i S-ka, 1999), 133.
7 Zbigniew Libera, "Lud ludoznawców: Kilka rysów do opisania fizjognomii i postaci ludu naszego, czyli etnograficzna wycieczka po XIX wieku," in *Etnologia polska między ludoznawstwem a antropologią*, ed. Aleksander Posern-Zieliński (Poznań: Komitet Nauk Etnologicznych PAN, 1995), 147.
8 Quoted in Antoni Kroh, "Zbójnik podhalański w kulturze polskiej," *Polska Sztuka Ludowa* 25, no. 2/3 (1970): 84.
9 Ewa Korulska, "O chłopie – bez tytułu," *Konteksty. Polska Sztuka Ludowa* 48, no. 3/4 (1994): 127–32.
10 Różycki, "'Nieskończoność dalekich dróg,'" 184.

ination, while Podhale material culture and architecture had been subjected to reinvention in the form of highlander folk art and craft. At the beginning of the twentieth century, an artistic style resulting from the fascination with highlander material culture was developed by artist and architect Stanisław Witkiewicz, a follower of the Polish variety of the Arts and Crafts movement. The style was given its name, "Zakopane style," after the village in Podhale, a place that since the 1880s had been the most popular mountain resort for the Polish intelligentsia. Appropriating decorative motifs used by highlanders in metal, wood, textile, or leather craft, as well as learning from their approach to the materials they worked with, Witkiewicz created a new and very characteristic style in Polish architecture and design. In the early 1900s, the Zakopane style became one of the strongest pretenders to the position of Polish national style.[11]

The ethnographers' initiative of sparing the old folkways from modern change by documenting village life in the form of folklore[12] was then informed by the need to provide a source for the invented tradition to the imagined community of the modern nation, and additionally by the feeling of nostalgia felt by the modernizers themselves. Having already introduced what they thought to be civilizing and modernizing changes to the backward countryside, they tried to spare what was in their opinion the most valuable part of the village world—folklore. In this way, the elements of folklore collected under the auspices of nostalgic preservation

11 Other "candidates" included the neo-renaissance, supposed to express the grandeur of the Jagiellonian monarchy, and the so-called "Mazovian Gothic," associated both with the local, as a Central-European version of the Medieval red brick architecture, as well as with the spiritual, akin to the understanding of Gothic revival style during the nineteenth century.

12 The topic of folklore as a representation created by ethnographers and folklorists is immense and much has been written on it, both in the European and US contexts, by the most prominent authors of the discipline including Hermann Bausinger, Regina Bendix, Henry Glassie, and many others. My own interpretation concerning Poland can be found in "Lasting Images of Folk Things," in *Poland—A Country of Folklore?*, ed. Joanna Kordjak (Warsaw: Zachęta National Gallery of Art, 2016), 54–65, accessed November 12, 2017, https://zacheta.art.pl/public/upload/mediateka/pdf/584923b7923de.pdf.

became the essence of what was considered "rural," and therefore the focus of ethnography.

To a certain extent, Zofia Rydet shared this nostalgia for a bygone rurality insulated from the forces of modernization. She wanted to save the "vanishing world" of the countryside.[13] For Rydet, documentation meant advocating for traditional ways of life which, though irreplaceable, were in danger of disappearing. Even the documentation of rural poverty was, in her case, not based on an urge to acknowledge it, let alone to actively protest it, but to ennoble it by saving its image as an alien, exotic way of life, and one which she herself found to be interesting and worth preserving for the audience "back home."

To be sure, Rydet shared a *Volkskunde* vision of all things folk and it influenced how she approached the countryside in her *Record*. However, the *way* in which she worked placed her in much closer contact with the rural reality than a purely folkloristic vision could have allowed for. As a result, her initial project of "presenting the human through things they possess"[14] expanded, spawning an ever greater number of subseries. In many ways, her strategy is reminiscent of the task of the ethnographer as understood in accordance with the second meaning of the word—as a method of "being there," of providing an account for an audience "back home." While in the field—"there"—the ethnographer collects field materials, which may take alternate form, whether written, recorded orally, drawn, photographed, or filmed, and which, as a rule, are often undervalued. In the end, one never knows what the exact outcome of the fieldwork will be.

In the field, Rydet produces "sources" (to be distinguished from the "evidence" produced by the researched—the locals themselves—without the participation of the ethnographer) by inducing her protagonists to pose for her in their environment and taking literally hundreds of pictures. These are sure to be used in the later process of assembling the field research account, which,

13 Beata Skawińska, *Twórczość fotograficzna Zofii Rydet*, PhD thesis, Instytut
 Historii Sztuki Uniwersytetu Wrocławskiego, 2010, manuscript, 28.
14 Rydet, "O *Zapisie socjologicznym*," 192.

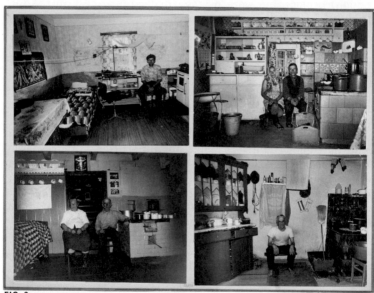

FIG. 2
ZOFIA RYDET, *ORAVA*, FROM THE *SOCIOLOGICAL RECORD*, c. 1980s

in her case, meant the selection and composition of sets and series. In ethnography (understood as a research method) it is usually only in the process of revising, regrouping, and rereading the field material at home that the form of the account and the interpretation of the field data are determined. "When I enter a village house," said Rydet, "I'm stressed and often don't see many things, while some I notice immediately. [...] I often notice how beautiful it is not when I'm taking pictures, but only afterwards, when I'm retouching prints."[15] Undoubtedly, it is presupposed that the ethnographer will attentively observe any details; however, doing fieldwork can be stressful and is always tiring, and the sense of the details one observed and transcribed in the field often becomes clear only upon returning home, when one is revising one's notes.

The majority of photographs presented at the 2015 exhibition "Zofia Rydet: *Record*, 1978–1990," were never even printed, much less exhibited. Photographs from the series *Sociological Record* were treated uniquely by Rydet; of those prepared for display, she would glue images on cardboard in sets of four. [FIG. 1–3] The few original sets provided in the exhibition show the great formal care she took juxtaposing her selected images. In the shots she chose for these compositions, the sitters are poised, proud, and do not appear uncomfortable or demure in front of the camera. However, most of the photographs displayed in "Record," in the dense section dedicated to the *Sociological Record*, feature sitters who appear to have been victims of a form of violence, as if a weaponized camera has inflicted pain upon them. At the very least, a sympathetic viewer might feel uncomfortable when confronted with their stupefied expressions and wooden poses. The presence of flash, close range, and the use of a wide-angle lens enhance this effect. Therefore, what we can see in Rydet's publications and the original sets she arranged is that she was apparently aware of this effect and in her "accounts from the field" she chose images in which her human subjects did not look objectified. Apparently, she worked as she did for the reasons of desirable formal effects, especially composition, but she must have taken into account the shortcomings in the appearance

15 Ibid., 193.

of her human models and tried to minimize them, if not from the field material itself, then at least from her account and interpretations.

What the exhibition made available to a public consisting of educated city-dwellers was the mass of Rydet's field material, not the account she wanted to present. In her eager attempts to "save" the vanishing world, she produced an enormous quantity of field material; consequently, we will never know which shots she would have selected, finally, in her own account. When commenting on her exhibition of *Sociological Record* at the 1st National Review of Sociological Photography in Bielsko-Biała, she said:

> I sent many of my pictures there, in sets of four: four women, four men, four children, etc. I had considered each set for a very long time, every set had its own sense; it also represented a particular region of Poland. And they mixed it all up and literally plastered the walls with those pictures. There were no spaces between them, just a crowd of different people and interiors. I couldn't look at that! It was a big mistake for them to show it like that, because a lot depends on how you present these pictures. I felt resentment toward them but they said that it was interesting that way. For me it wasn't. They didn't treat me fairly.[16]

The photographs of people in their homes—with their truncated geometry and deformed linear perspective by way of a wide-angle lens; interiors crowded with objects: souvenirs, gadgets, everyday things, religious imagery; the *horror vacui* that seems to animate a large part of them—are reminiscent of images produced in folk or popular art. In her photographs of the material world of her subjects, Rydet, aiming at reflecting the character of their relationship with matter and space, mimicked their own formal language of artistic expression. Polish photography historian and critic Adam Sobota compared the qualities of these photographs to the poetics of naive art. "The shortcomings in composition and lighting, exaggerations, all of them increase the feeling of authenticity and stimulate the viewer's emotional engagement; it is as in naive painting,

16 Ibid., 195.

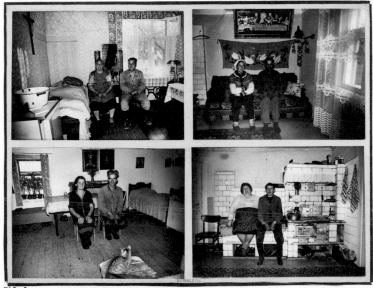

FIG. 3
ZOFIA RYDET, *SUWALSKIE VOIVODESHIP*, FROM
THE *SOCIOLOGICAL RECORD*, c. 1980s

where errors in perspective and a freedom of expression allow us to trust the author's sincerity."[17]

The way Rydet presented things in these pictures—never in the process of being used, static, sober, rock-solid, and concrete, amassed in vast numbers but individually exposed to the scrutinizing eye as in an enormous collection of portraits—brings to mind the concept of *chłopskie mienie* (peasant possessions) coined by the Polish ethnographer Piotr Szacki, an eminent specialist in material culture who produced very little in the way of academic writing. Working out of the State Ethnographic Museum in Warsaw, Szacki planned an exhibition of "peasant possessions" which would show the existential weight of things. He wanted a modern urban audience to experience the peasant sense of scarcity and opulence, to feel the materiality that was neither symbol nor abstraction—no transfiguration, but molded matter. In 1991, Szacki curated the exhibition "Mieć" [To Have], first shown at the State Ethnographic Museum in Warsaw, and later in Poznań and Radom. Sławomir Sikora, himself an anthropologist and a former collaborator of Szacki's, recalls that at the exhibition he was shocked by "the striking poverty of the sphere of material objects among which people once lived, that Piotr [Szacki] was so successful in evoking."[18] The exhibition was based on sequences of word-categories "organizing both the space of exhibition and the space of reflection ... separate-isolate-close / hold-secure-include / hide-conceal-steal."[19] According to Sikora, the exhibition was "exceptionally minimalistic."[20] A cobbeled together earthenware jug, decontextualized and enshrined in the exhibition, inspired him to the observation that what he experienced "was not a form, it was the matter of things."[21]

Objects of imagery—"things that represent"—are another type of matter. They abound in Zofia Rydet's interpretations

17 Adam Sobota, "Zapisy Zofii Rydet," in *Zofia Rydet (1911–1997). Fotografie*, ed. Elżbieta Fuchs, exhibition catalog (Łódź: Muzeum Sztuki in Łódź, 1999), 11; quoted in Skawińska, *Twórczość fotograficzna Zofii Rydet*, 115.
18 Sławomir Sikora, "On Film, On Anthropology... on Jean Rouch and Piotr Szacki," *Etnografia Nowa* 3 (2011): 229.
19 Ibid., 230.
20 Ibid., 229.
21 Ibid.

of the material culture of inhabitants of Polish villages. She was very keen on representing her models with their portraits, especially with a very particular kind of portrait produced by provincial photographers, called *monidło*. *Monidło* usually took the form of a large black-and-white print, later colored by the photographer. On most occasions the *monidło* represented the newlywed couple in their wedding attire, but it could also be a portrait of a single person. *Monidło* came too late to the village world to become folklore enshrined in the *Volkskunde* discourse. However, by the 1970s, it was already part of the discourse on kitsch, and therefore had a role to play in the modern phrasing of class exoticism and the romanticization of the rural. The presence of *monidło* in Rydet's photographs of people in their home interiors is overwhelming. On several occasions the arrangement of the room must have been deliberately altered to include the portraits, with the effect being that not only is the sitter multiplied, but the *monidło* becomes a Rydet sitter in and of itself.

Conversely, the interiors Rydet photographed often featured domestic exhibits of different visual material: the holy corners with representations of the Virgin, Jesus, and the Catholic saints, always decorated and arranged in consistent sets; imagery of the heroes of modern pop culture, mostly American, provided by family members working and living abroad; and decorative wall hangings with figurative scenes of paradisiacal nature (such as flowers) that already, in the very early debate on kitsch, were dubbed its model incarnation. By the 1980s, images of Pope John Paul II became a consistent and obvious element in the private altars of Rydet's sitters.

Zofia Rydet made and partially published a separate series of photographs dedicated to the pope's image, as it was presented both in the home as well as in public, mostly in shop windows decorated on the occasion of the pope's visit to Poland. Some of these photographs appeared, in 1988, in the photobook *Obecność* [Presence], in which Rydet's subjects emanate pride in the interiors of their homes adorned with images of Pope John Paul II. The cult of (the then still living) Pope John Paul II and its devotional expression in the 1980s and early 1990s was a phenomenon interpreted and discussed by several anthropologists and, consequently, an obvious

subheading under which the curators of the "Record" could group Rydet's photographs, describing this series as "exposing the superficiality of Polish Catholic religiosity." Unfortunately, such a reading betrays the prejudices of the urban intelligentsia readily dismissing the "mindless rosary reciting" and "magic approach to imagery" of so-called popular piety as ritualistic and superficial. An understanding of religion as a question of faith, or a neat distinction between the sacred and the profane, has been strongly contested in the anthropology of religion for at least two decades.[22] Rydet in her photographs seems closer to the character of this kind of imagery and its uses than the curators in their curatorial text, but she also aptly switches her focus from images in the holy corner to an imagery dispenser—the TV set—often placed in the same space and similarly decorated.

Yet another form of reflection on materiality and imagery is evident in Rydet's photographs from the series *Kitchen Windows*. In these, she captures objects grouped on a table, commonly placed under the kitchen window of a village house. Among the displayed objects are food utensils and simple, sometimes well-loved personal belongings such as glasses, plants, old radios, and books. The poetics of these sets differs from other representations of interiors crowded with goods and images. They are rather intimate, meditative still lives, closer in character to *vanitas* than solid and objective peasant possessions. Similarly, the series *Women on Doorsteps*, in which the human figures are treated differently than the rote "possesors of peasant possessions" of the interior shots, focuses on the gestures and postures of the featured subjects. To

22 What has been stressed in these discussions is the so-called "Protestant bias" resulting in the overestimation of that faith as the most valid, if not the single, foundation of religion, and a view of the cult as only a secondary outcome of faith and its expression. This way of reasoning can easily result in the underappreciation of religions focused on cult, dubbed "superficial," "mindless," or "lacking real faith." In the context of Polish ethnography similar reservations have been voiced (e.g. by Joanna Tokarska-Bakir and Magdalena Zowczak, but also by Anna Niedźwiedź, Magdalena Lubańska, and others), especially toward the concept of "popular religion," which has been criticized as a patronizing misrepresentation. It has been argued that the discursive construction of "believers of popular religiosity" uses the mechanisms of "othering" grounded in social distance between the researcher and the researched, similar to those present in representing the village life as folklore.

be sure, the threshold is a symbolic place and the gestures made on the threshold to somebody's home when facing an intruder equipped with a camera are open to yet another type of anthropological interpretation: one grounded in the human experience of inhabiting the world. In Polish ethnography it had its strong exponent in yet another outsider of the Polish discipline, Jacek Olędzki. Since his first works on angling to his research on village artists and their art, material "traces of identity and existence," and bodily gestures, Olędzki has followed the human experience of being-in-the-world. Although he never referred to Maurice Merleau-Ponty in his writings, he seems to have been surprisingly close to his phenomenology. It seems crucial for Merleau-Ponty's perspective that being-in-the-world be embedded in the material existence of the human body and its physicality. Humans experience and perceive the world because human life is inextricably linked with the material world: a human being is a part of the world, and the world is a part of being human; the human is submerged in the world through the mere experience of living. According to British anthropologist Tim Ingold, the world has no surface, and humans do not live *on* the world but *in* the world. "The forms of the landscape—like the identities and capacities of its human inhabitants—are not imposed upon a material substrate but rather emerge as condensations or crystallizations of activity within a relational field."[23]

Therefore, departing from the dominating *Volkskunde*-based and intelligentsia-originated discourse on the countryside and its inhabitants, Rydet contributed to it with images that resonate with the particular developments within the Polish discipline of ethnography of the late 1970s and 1980s, namely those voiced by its academic outsiders oriented against the straightjacket of folklore and toward the experiential, phenomenological approach to their ethnographic practices.

23 Tim Ingold, "Culture on the Ground: The World Perceived Through the Feet," *Journal of Material Culture* 9, no. 3 (2004): 333.

Krzysztof Pijarski is an artist working mainly with photography, assistant professor at the Łódź Film School, art historian, and translator. Author of *Archeologia Modernizmu. Michael Fried, fotografia i nowoczesne doświadczenie sztuki* [An Archeology of Modernism: Michael Fried, Photography, and the Modern Experience of Art] (Wydawnictwo Biblioteki PWSFTviT, 2017), *(Po)Nowoczesne losy obrazów. Allan Sekula/Thomas Struth* [The (Post)Modern Fate of Images: Allan Sekula/ Thomas Struth] (Wydawnictwo Biblioteki PWSFTviT, 2013). A collection of his translations of essays by Allan Sekula was published by the University of Warsaw Press in 2010. Editor of *The Archive as Project* (Archeology of Photography Foundation, 2011) and at the online academic journal *View. Theories and Practices of Visual Culture.*

SEEING SOCIETY, SHOWING COMMUNITY: "SOCIOLOGICAL PHOTOGRAPHY" AND ZOFIA RYDET'S *RECORD*

What is it to "unmask" an instance of oppression? What is the exact function of the mask? [...] This question is better formulated as follows: What is the relationship between the passion for the real and the necessity of semblance?[1] —Alain Badiou, *The Century*

And the analyst will never succeed in this enterprise of participant objectification so well as by managing to make self-evident and natural, even given, constructions that are wholly inhabited by critical reflection.[2] —Pierre Bourdieu, *The Weight of the World*

We Have Never Been Critical

"Has postwar Polish photography yielded an accurate image of social life?" "How can photography capture such an image in the coming years?" These were the questions *Fotografia* quarterly, the most important journal for ambitious photography in 1980s Poland, sent out to a number of critics, theorists, and acclaimed photojournalists in the aftermath of the 1st National Review of Sociological

1 Alain Badiou, *The Century*, trans. Alberto Toscano (Cambridge: Polity Press, 2007), 47.
2 Pierre Bourdieu, "To the Reader," in *The Weight of the World*, Bourdieu et al., trans. Priscilla Parkhurst Ferguson (Cambridge: Polity Press, 1999), 2.

Photography that took place in November, 1980, in Bielsko-Biała. The responses to this survey are immensely interesting, not only because they reveal the stakes of the discussions about the status and role of photography at that time of crisis in real socialist Poland, but also because they might help to shed new light on the work of Zofia Rydet, especially her *Sociological Record*, which she commenced in 1978, two years after retiring[3]: an immense inventory of people in their (mostly rural) homes, among the objects that accompany their lives, of the pictures that populate their walls, of their houses, and the landscapes they inhabited.

As to the questionnaire, the overall tone of the responses is rather somber, if not pessimistic. For instance, Krzysztof Barański, a reporter working for the progressive, youth-oriented illustrated weeklies *itd.* and *Razem*, wrote that "this photography, loftily understood as a record of an age, has been, and is not accurate; neither is our own stance toward the time we live in."[4] Bogusław Biegański, the staff photographer of *itd.*, and the center of a milieu that included the photographers Andrzej Baturo, Adam Hayder, Krzysztof Pawela, and Barański, also concurred that while there were individual photographers who tried to capture an accurate portrait of postwar social life, Polish photography in general had failed to do so. For Biegański, the 1980 Review of Sociological Photography had "proven that social documentary, that 'unwanted child' of Polish photography, had grown up, had come to know its worth, and is now conscious of its aims."[5] What are these aims, exactly, one might ask? "The photography of life serves to change social life," was the response of the critic, photographer, and founder of the Klub Krzywego Koła

3 In 1976, Rydet quit her teaching position at the Gliwice Polytechnic. It is this date that the Zofia Rydet Foundation, currently undertaking in-depth research into the life and work of the photographer, designates as her retirement. I would like to express my deepest gratitude to Maria Sokół-Augustyńska and Zofia Augustyńska-Martyniak of the Zofia Rydet Foundation, for the generous assistance and informative discussions provided while I researched this essay.
4 Marceli Baciarelli et al., "Zwierciadło życia społecznego," *Fotografia* 22, no. 2 (1981): 8.
5 Ibid., 11.

Juliusz Garztecki.[6] "There is no democracy without the freedom of
the press,"[7] he went on to say, stating that the photography of social
life can only thrive if socialism remains democratic.[8] The critic Szy-
mon Bojko addressed the problems of censorship directly ("the cen-
sorship of factual photography has always been more severe than
that which militates the circulation of the word"[9]), concluding that
it was censorship which accounted for there having been no "Poem
for Adults" in photography.[10] The philosopher and cultural theorist
Sławomir Magala went as far as stating that photographers should
not justify themselves by assuming avant-gardist "poses" (and get-
ting the idea of artistic autonomy all wrong), or producing explana-
tions that they were told to photograph "factory chimneys and blast
furnaces," concluding that "the way to convey the truth about us is
yet to be invented."[11]

The critical force and apparent sincerity of these dis-
cussions, held both publicly and internally at the Association of Pol-
ish Art Photographers (ZPAF),[12] the organizer of the Review of Soci-
ological Photography, suggests that the Review was a watershed

6 The Klub Krzywego Koła [Crooked Wheel Club], founded in Garztecki's
 apartment in 1955, during the so-called Thaw, and active in Warsaw until
 1962, was "a legal forum for ideological and political debate, exceptional
 for the whole socialist bloc." See Marek Rapacki, "Jak powstał Klub
 Krzywego Koła," *Gazeta Wyborcza*, December 13, 2004, accessed Novem-
 ber 27, 2017, http://wyborcza.pl/1,75968,2443926.html.
7 Baciarelli et al., "Zwierciadło życia społecznego," 12.
8 Ibid., 14.
9 Ibid., 12.
10 Bojko is refering to Adam Ważyk's poetic critique of the Polish People's
 Republic, published just before the Polish October of 1956, and
 described by Bernard Ziffer as a "courageous presentation and at the
 same time [...] [an] accusation of the true conditions and tendencies
 prevailing in Poland." Bernard Ziffer, "A Poem for Adults," *The Polish Review*
 1, no. 1 (1956): 61; Adam Ważyk's *Poemat dla dorosłych* [A Poem for Adults],
 published in the Warsaw literary weekly *Nowa Kultura*, on August 21, 1955,
 came as a shock, considering that Ważyk was a "Party poet," and was
 widely discussed. For more on the Polish October, see Tony Kemp-Welch,
 "Dethroning Stalin: Poland 1956 and Its Legacy," *Europe-Asia Studies* 58, no.
 8 (2006): 1261–84.
11 Baciarelli et al., "Zwierciadło życia społecznego," 20.
12 Indeed, issues of censorship, free speech, and artistic autonomy were
 intensively discussed within the ZPAF at the end of the 1970s and after
 August 1980, also in dialogue with other artists associations. See
 transcripts of the General Assembly of the Association, as well as the
 transcript of the Association's board meetings from that time. Archiwum
 Państwowe w Szczecinie, Kolekcja Krystyny Łyczywek, catalog no.
 65/994/0/31: Protocols of the board meetings of the ZPAF 1978–81.

moment in the conversation about the relationship between pho-
tography and society and, as a consequence, between photography
and state power in Poland; a moment of awakening that was to be
quickly suppressed by the imposition of martial law, on December
13, 1981.

The Review was structured around two exhibitions
centered on the recent, socialist past: "Z perspektywy lat" [Looking
Backwards], curated by Jan Kosidowski[13] and showing, predomi-
nantly, photojournalistic work from 1945 to 1970; and "Dokument
czasu" [A Document of Time], with work from the 1970s, curated by
Mariusz Hermanowicz, and the competition "Nowe aspekty fotografii
socjologicznej" [New Aspects of Sociological Photography[14]]. The
Review also included a rich accompanying program, with two histor-
ical shows[15] to give the main presentation a deeper background, fol-
lowed by a pair of post-competition presentations, and a pair of post-
competition presentations and a pair of projects I would like to
dedicate more space to at a later point: *Rodzina Szczecińska* [Szczecin
Family] organized by Krystyna Łyczywek, and *Huta-Dom-Rodzina*
[Foundry-Home-Family], devised by Paweł Pierściński. Additionally,
a three-day symposium inaugurated the event, with talks by Barański,
Magala, Vladimír Birgus, Urszula Czartoryska, the former editor-in-
chief of *Fotografia* and president of ZPAF, Zbigniew Dłubak, the soci-
ologist Andrzej Ziemilski, and the curator of the National Museum in

13 Together with Konstanty Jarochowski and Wiesław Prażuch, Kosidowski
 worked under Władysław Sławny as a photojournalist at *Świat*, a popular
 illustrated weekly modeled after *Life* magazine. (*Świat*'s logotype of white
 capital letters on a red background, positioned in the top left-hand
 corner of its front cover, was a clear visual allusion to the iconic Ameri-
 can weekly.)
14 The exhibition that followed the competition comprised sixty-four works
 and reportages by thirty-six photographers; in the catalog, a significant
 amount of space was dedicated to pictures related to Pope John Paul II.
15 "Polish Photography 1839–1979," an exhibition shown at the International
 Center of Photography, New York, in 1979, curated by Ryszard Borowski;
 and "Sztuka reportażu (z historii fotografii polskiej)" [The Art of Photo-
 journalism (From the History of Polish Photography)], spanning the years
 1861–1979, organized by the National Museum in Wrocław and curated by
 Adam Sobota.

Wrocław, Adam Sobota, thus providing some sort of discursive framework for the whole initiative.[16]

Zofia Rydet seems to have been at the center of this moment, at least in the eyes of her peers. For instance, Andrzej Baturo, the curator of the Review as a whole and a respected photojournalist himself, tried to keep his response positive, stating that all its shortcomings notwithstanding, photography has always "responded to Poland's most important problems by documenting them,"[17] and enumerating figures he deemed exemplary: Wiesław Prażuch, Sławomir Biegański, Krzysztof Barański—all photojournalists, naturally. But it was Zofia Rydet who took pride of place.

All of which begs the question of how the relationship between photojournalism and "sociological" photography was conceptualized, because they were not at all perceived as equivalent, despite press photographs constituting the bulk of the contemporary material presented. Baciarelli, for example, wrote that while in postwar Polish photography one could find "photographic informational notes, interventionist 'texts,' captioned photojournalism, real journalism even," there was a dearth of "exceptional essayistic work."[18] Referring to the photographs of the strikes of August 1980 at the Lenin Shipyard in Gdańsk, as presented in Bielsko-Biała, he lamented the absence of any attempt at interpreting these momentous events: "We should stop fetishizing the apparent objectivism of the photographic record. Social life, also as represented in photographs, requires *interpretation*."[19] Alfred Ligocki, on the other hand, took issue with the epithet "sociological." He insisted that what the Bielsko-Biała Review called "sociological photography" belongs to artistic rather than scholarly practice: "It is not about providing photographic 'index cards' for the purpose of scholarly research, but a specifically photographic process of cognition based on the revela-

16 The papers of Ziemilski and Magala were reprinted in the issue of
 Fotografia I have been referring to, while the other papers—at least to my
 knowledge—have remained unpublished.
17 Baciarelli et al., "Zwierciadło życia społecznego," 10.
18 Ibid., 8. He went as far as stating that only if the process of democratiza-
 tion, commenced in August 1980, were to be carried through, would "the
 magnificent essayistic work of Zofia Rydet [no longer] be a lone island in a
 sea of preliminaries." (Ibid.).
19 Ibid.

tory observation of real phenomena. What this process relates to is always the human being, even if the ostensible motif is landscape or collections of objects."[20] In his posthumously published book *Czy istnieje fotografia socjologiczna?* [Is There Such a Thing as Sociological Photography?] Ligocki concludes that he would rather call this type of practice that flourished in Poland in the late 1970s "social photography," and tries to map this phenomenon both in relationship to the Polish and Western traditions of social documentary, from Karol Beyer to the Review of Sociological Photography, from Jacob Riis and Lewis Hine to Michael Schmidt's Werkstatt für Photographie,[21] to the grand exhibitions of Edward Steichen and Karl Pawek.[22] Zofia Rydet is singled out once more—not only does a picture from her *Sociological Record* serve as the book's cover, but Ligocki discusses as many as three of her projects, alongside single works by Edward Hartwig and Edward Poloczek, as well as collective initiatives, such as *Szczecin Family* and *Foundry-Home-Family*.[23]

All in all, the debates revolved around the old problem of the role and definition of the documentary as autonomous practice. As Olivier Lugon has noted, it was exactly the difficulty in characterizing what documentary is—as opposed to both photojournalism and art—its "propensity to keep on discussing its methods and goals," that has been "the chief factor influencing its viability" and that distinguishes it in particular from photojournalism, with which it has sometimes been identified. In fact, photojournalism's codes have remained unchanged for decades, and it has exercised scarce self-criticism concerning the construction of authenticity of its images and the appositeness of its procedures (the snapshot

20 Baciarelli et al., "Zwierciadło życia społecznego," 18.
21 For more on the Werkstatt, see Maren Lübbke-Tidow's essay in this volume, "Concepts of Agency: Zofia Rydet from the Perspective of German Photographic Art of the 1970s," 179–213.
22 Alfred Ligocki, *Czy istnieje fotografia socjologiczna?* (Kraków: Wydawnictwo Literackie, 1987). While Ligocki's book is an accurate reflection and summary of the debates of the time, it is also misleading. Often he seems to be appropriating the work and enunciations of other authors, such as Garztecki or Magala. As it was published posthumously from his notes, it might also be the case that large parts of it were not ready for publication, but were included anyway.
23 Ligocki, *Czy istnieje fotografia socjologiczna?*, 102–24.

format as the undisputed symbol of immediacy). Quite
the opposite, the documentary has proven to be per-
manently in a state of flux and crisis.[24]

This unstable status might be one possible explana-
tion of why in Poland during the 1970s, the question of documentary
as a vehicle of truth, as "revelatory observation of real phenomena"
cropped up repeatedly, and was set, at least implicitly, against
"mere" photojournalism as unreflective at best and complicit at
worst. Hence Baciarelli's call for "exceptional *essayistic* work,"
Garztecki postulating a photographic practice that has the power to
change society, and Ligocki trying to disentangle what he called
"social photography" from the strictures of scientific knowledge in
favor of a mode of seeing that could be "revelatory."[25] At one point,
Adam Sobota even surmised that "the long-lasting and vital tradition
of constructivist ideology was connected with its role as an alterna-
tive to socialist realism. [...] In this way, experiments with form par-
tially overlapped with socialist photography," again enumerating the
names of Barański, Baturo, Pawela, and, "in particular," Zofia Rydet
and her *Sociological Record*.[26] The claim, advanced by Urszula Czarto-
ryska, one of the most important figures in the field of photographic
practice at the time, that the *Record*, as well as Rydet's earlier work,
is "more than mere reportage,"[27] is yet another indication that Rydet's
work was seen as exemplary in these debates, as a possible road sign
toward a new form of photographic practice.

24 Olivier Lugon, "'Documentary': Authority and Ambiguities," in *The
 Greenroom: Reconsidering the Documentary and Contemporary Art #1*, eds. Maria
 Lind and Hito Steyerl (Berlin: Sternberg Press; Annandale-on-Hudson:
 Bard College, 2008), 31.
25 In her review of the Bielsko-Biała "festival," the critic Barbara Kosińska
 explains the choice of the epithet "sociological." "Apparently it was safer
 that way (back then, two years ago, when plans for the event were
 submitted to the authorities for approval). Of course, the organizers had
 in mind social photography in a broad sense, but 'sociological' sounded
 more neutral to them. As to the exhibitions, they were supposed to
 present the most valuable and compelling of socially engaged photogra-
 phy." Kosińska, "I Ogólnopolski Przegląd Fotografii Socjologicznej w
 Bielsku Białej," *Fotografia* 22, no. 2 (1981): 29.
26 Adam Sobota, "In the Spirit of the Avant-Garde," in *Polish Perceptions: Ten
 Contemporary Photographers, 1977–88*, exhibition catalog (Glasgow: Collins
 Gallery, 1988), 20–23.
27 Urszula Czartoryska, "Time Intensified: Ten Photographers on Their Path
 of Time," in *Polish Perceptions: Ten Contemporary Photographers, 1977–88*, 12.

Taking the "Zosia" out of Rydet

The necessity of reintroducing Zofia Rydet into the context in which she once lived and worked in part stems from the fact that the perception of her work, especially the *Sociological Record*, and of Rydet herself as an individual and artist, is defined by other-worldliness or difference. To quote the critic Barbara Kosińska, writing in response to the Review: "Some outstanding, even extraordinary works were presented there, as for example Zofia Rydet's *Sociological Record*, a wonderful and unique phenomenon in our photography."[28] The fact that Rydet was a latecomer to the field of photography—she only took up the medium at the age of forty—has only reinforced this perception. Jerzy Busza, perhaps the most insightful contemporaneous interpreter of Zofia Rydet's work, underscored the importance of the circle of the Gliwice Photographic Society (or GTF, by its Polish acronym), which Rydet had joined by 1956. The GTF was unique, because although part of an amateur association, it was cofounded by prominent members of the Lviv Photographic Society, an important center for Polish interwar photography. On the one hand, there were the followers of Jan Bułhak, who developed a type of pictorialist *Heimatfotografie* that, conservative in essence, defined for many years the face of "artistic" photography in Poland; and on the other there was the modernist, Bauhaus tradition.[29] This context, as well as the ties, in the 1950s, with Zdzisław Beksiński and Bronisław Schlabs, culminating in the notorious "Closed Show" of 1958, dubbed by Alfred Ligocki "anti-photography," made the Gliwice circle one of the creative centers of photography in Poland, important above all for freeing themselves from the pictorialist legacy of Bułhak and embracing vernacular imagery. Zofia Rydet, however, according to Busza, "didn't have to 'cut herself free' from anything, since she was just making her debut. Hence she did

28 Kosińska, "I Ogólnopolski Przegląd Fotografii Socjologicznej w Bielsku Białej," 29.
29 See Jerzy Busza, "Zofia Rydet i mitologie dalekich podróży," in *Wobec fotografów* (Warsaw: Centralny Ośrodek Metodyki Upowszechniania Kultury, 1990), 98, as well as Anna Kwiecień, Katarzyna Kalina, and Jerzy Lewczyński, *Fenomeny i fantomy. Gliwickie środowisko fotograficzne w latach 1951–2000*, eds. Marcin Gołaszewski and Anna Kwiecień, exhibition catalog (Gliwice: Muzeum w Gliwicach, 2006).

not have compelling role models to emulate, remaining forever a sol-
itary, roaming 'artist with no master.'"[30]

Needless to say, such a separation of Rydet from her
surroundings was intended as utmost praise, and is a common stage
of art historical appreciation, but it also acts to cut her from the dense
tissue of relationships that connected her with the photographic
community. First, as a member of the GTF, together with figures like
Jerzy Lewczyński, Piotr Janik, and Władysław Jasieński, she took part
in regular presentations and discussions of the members' current
work, and—as the accounts go—these were very lively, and sometimes
very intense, exchanges. But not only their own work was discussed.
In a letter from 1965 to Krystyna Łyczywek, one of her closest friends
and another important figure in the photographic community, Rydet
wrote that "the new photographic exhibition 'Who Is Man?' (you do
know Pawek, don't you?[31]) has raised a whole storm of discussions
again. Not one week goes by without arguments about it. I think you
are on my side, because to me this is a fantastic, great thing."[32]

Contrary to many expressed opinions—like Rydet's oft-
cited biographical note prepared by Małgorzata Mach[33]—Zofia Rydet
cared deeply about the criticisms articulated during these discus-
sions, and the opinions of the important photography critics at the
time (Czartoryska, Busza, Garztecki, and Ligocki), who she remained
on good terms with. In a letter from 1968, she wrote:

> It is terrible, to feel so insecure about what one does,
> this fear of criticism paralyzes—in our circle it is very
> strong—and unfortunately I, too, am very sensitive,
> and tend to break down immediately. Before I was so

30 Busza, "Zofia Rydet i mitologie dalekich podróży," 98.
31 Rydet is talking about the 1965 "Weltausstellung der Photographie" by
 Karl Pawek. Seen by the creator as a response to Steichen's "Family of
 Man," he titled it "Who Is Man?"; see Sarah F. James, "A Post-Fascist Family
 of Man? Cold War Humanism, Democracy and Photography in Germany,"
 Oxford Art Journal 35, no. 3 (December 2012): 315–36.
32 Zofia Rydet, Letter to Krystyna Łyczywek from May 24, 1965, accessed
 November 27, 2017, http://zofiarydet.com/dokumentacje/pl/pages/
 research/letter/24-05-1965.
33 "Despite its dynamism, the Gliwice Photographic Society could not offer
 any new ideas attractive to a person with decided views and a mature
 outlook." Małgorzata Mach, "Biographical Notes," in *Zofia Rydet (1911–1997).
 Fotografie*, ed. Elżbieta Fuchs, exhibition catalog (Łódź: Muzeum Sztuki
 w Łodzi, 1999), 119.

"great," I didn't have any inhibitions, everything I did I liked, I felt more confident. Now I am constantly in doubt, searching for who-knows-what.[34]

To be sure, Rydet's "breakdowns" didn't have anything to do with insecurity, but rather with her absolute focus on the quality of her work. Moreover, she was not interested in the "quality" of the single image. "Only complex work, only elaborating a thought, in photography, showing something that speaks as a whole, is, it seems to me, worth anything,"[35] she wrote to Łyczywek in another letter. On one occasion, she declined Łyczywek's offer to do a joint show about Istebna, an old village in Cieszyn Silesia, in the south of Poland, on such grounds exactly:

> Above all, I think that such an exhibition will cost us a lot of work, and the effect will be meager. It would amount to mere impressions from Istebna—something the PTTK [Polish Tourist and Sightseeing Society] very often does—we don't have enough work to make this a first-rate show. [...] Let's not forget that here the critics will eat alive anything that is not modern. And even pictures that are not bad at all will be labeled as unprogressive by our Ligocki on the radio and in the press.[36]

After closing her stationery and toy shop in Bytom, in 1962, and moving to Gliwice to dedicate herself entirely to photography, her apartment quickly became a hub of the social photographic life in Gliwice. "The colleagues from the GTF keep visiting me," she writes in a letter from 1965. "My new apartment has become a place, where we often get together and I cherish these friendships. Although quite often it takes a lot of time."[37] Rydet wouldn't be her-

34 Zofia Rydet, Letter to Krystyna Łyczywek from January 20, 1968, accessed November 27, 2017, http://zofiarydet.com/dokumentacje/pl/pages/research/letter/20-01-1968.
35 Zofia Rydet, Letter to Krystyna Łyczywek from March 28, 1964, accessed November 27, 2017, http://zofiarydet.com/dokumentacje/pl/pages/research/letter/28-03-1964.
36 Zofia Rydet, Letter to Krystyna Łyczywek from February 10, 1965, accessed November 27, 2017, http://zofiarydet.com/dokumentacje/pl/pages/research/letter/10-02-1965.
37 Zofia Rydet, Letter to Krystyna Łyczywek from January 28, 1965, accessed November 27, 2017, http://zofiarydet.com/dokumentacje/pl/pages/research/letter/28-01-1965.

self if she didn't add this afterthought: time (or rather the lack
thereof) being the obsession of her life.

Rydet worked as if to make up for her coming to the
field so late, taking part in countless exhibitions and competitions,
and also doing a lot of commercial work, in addition to her day-to-
day teaching position at the Gliwice Polytechnic, where, from 1961
to 1976, she ran a course in photography (which also involved tend-
ing to possible new members for the GTF). Her saying that she
devoted her life to photography was no exaggeration. "Right now I
am devilishly busy," she wrote to Łyczywek in the summer of 1967,

> We're doing 240×120-cm boards—reproductions and
> large photographic enlargements [for] a massive
> industrial design exhibition. There's not a minute of
> free time in my day. I'm up at 7:30, I go to work at the
> Polytechnic, at 3 I go to Katowice, and there we do
> enlargements until 1 or 3 in the morning. I get back at
> 2 or 4 (an hour's drive), only to begin all over again the
> next morning. Yesterday I did forty meters. My hands
> are black, because everything has to be rolled.[38]

Zofia Rydet's institutional ties were very strong. Apart
from the GTF, which she very much identified with and where she
soon became a board member and head of the artistic section, in
1960 she was awarded the status of "artist" by the Fédération Inter-
nationale de l'Art Photographique (FIAP), and, in 1961, she was admit-
ted into the ZPAF. Jerzy Lewczyński, her longtime colleague and
respected peer, was engaged in the association's structures and, in
the late 1970s, became a member of the central board and of the cen-
tral artistic commission. As a member, Rydet was privy to the ongo-
ing discussions within the association, especially as concerned the
protracted struggle between those who believed ZPAF was above all
an artists' association, and those who saw its main role as being to
secure the professional, which is to say commercial, success of its
members. In 1979, in an atmosphere of escalating conflict, Zbigniew

38 Zofia Rydet, Letter to Krystyna Łyczywek from June 18, 1967, accessed
 November 27, 2017, http://zofiarydet.com/dokumentacje/pl/pages/
 research/letter/18-06-1967.

146 KRZYSZTOF PIJARSKI

Dłubak was installed as president, promising to uphold artistic values as central to the association's mission.[39]

Rydet had always found the keeping up of the pretense of artistic work—which she saw tolerated, and even promoted, within the association—to be "utterly depressing."[40] At the same time, she did not share the avant-gardist attitudes prevalent in the circles of advanced photographic practice, a point of divergence between herself, Dłubak (who wrote a negative review of her series *The World of Feelings and Imagination*), and Lewczyński (or Edward Hartwig, or Urszula Czartoryska), who, in Rydet's view, "accept only works that are made strange, and not felt."[41]

In 1965, toward the end of a public meeting with Rydet during her exhibition "Czas przemijania" [The Time of Passing] in Katowice, Lewczyński made "quite an appearance, stating ironically that after these beautiful words [after her talk there were some 'moving' comments] he should put on a monk's habit and only think about helping old people." He went on to say that what Rydet does "has nothing to do with art," that she is "sentimental and that real art is made not with feeling, but with reflection and intellect, with cool and calm."[42] In contradistinction to that "advanced" attitude, Rydet's understanding of art was populist: "To me, photography will never be a plastic, well-composed image. To me, photography is above all a language, with which I would like to speak out, to convince ordinary, normal people, and not great artists."[43] All this, of course, begs the question of what it is that Rydet wanted to speak out about, what


39 Soon, Dłubak would also have to struggle for the association's continued existence, as the authorities, perhaps realizing the potential of photography, threatened to dissolve ZPAF and incorporate part of its membership into the Journalists' Association, and the other part into the Artists' Association. See Archiwum Państwowe w Szczecinie, Kolekcja Krystyny Łyczywek, catalog no. 65/994/0/31: Protocols of the board meetings of ZPAF 1978–81.
40 Zofia Rydet, Letter to Krystyna Łyczywek from October 23, 1967, accessed November 27, 2017, http://zofiarydet.com/dokumentacje/pl/pages/research/letter/23-10-1967.
41 Zofia Rydet, Letter to Krystyna Łyczywek from February 4, 1969, accessed November 27, 2017, http://zofiarydet.com/dokumentacje/pl/pages/research/letter/04-02-1969.
42 Zofia Rydet, Letter to Krystyna Łyczywek from December 16, 1965, accessed November 27, 2017, http://zofiarydet.com/dokumentacje/pl/pages/research/letter/16-12-1965.
43 Ibid.

it is that she had to say. The easy answer would be to rely exclusively
on her own enunciations and simply state that—under the influence
of Edward Steichen's grand exhibition—it was all about "humanist
images of the equality of people,"[44] following her conviction that "we
are all alike."[45]

 And yet, if we pause to consider what was going on
around Zofia Rydet at the time she decided to call her project of doc-
umenting people in their interiors *Sociological Record*, it might be inter-
esting to ask why it took her so long to give shape to an interest she
had already been pursuing for more than a decade, and to look again
for a possible explanation as to why she decided to call her *Record*
"sociological."

 In fact, Rydet had expressed interest in the topic as
early as 1964: "At the moment I am very much interested in interiors—
which are reflections of the people—especially the rural ones which
are very decorative,"[46] and kept coming back to it over the years.[47]
Thus, it doesn't seem to be her subject that she had found in 1978,
but her way of approaching it. One way of trying to answer the ques-
tion of what happened in 1978 would be to frame it in terms of form:
in 1969, Rydet, then still working in the idiom of "neorealism,"[48] wrote
that she was "not satisfied with the old form."[49] We could say that she
had found a solution to that dilemma in adopting the wide-angle lens
with direct flash lighting and the 35mm format, which resulted in the
brutalist, quasi-amateurish snapshot aesthetic so characteristic of
her project.[50] This answer—still in want of an explanation as to *why*

44 Zofia Rydet, Letter to Jerzy Busza, undated, accessed November 27, 2017,
 http://zofiarydet.com/zapis/en/pages/sociological-record/letters/
 jerzy-busza-undated.
45 Rydet, Letter to Krystyna Łyczywek from October 23, 1967.
46 Zofia Rydet, Letter to Krystyna Łyczywek from May 2, 1964, accessed
 November 27, 2017, http://zofiarydet.com/dokumentacje/pl/pages/
 research/letter/02-05-1964.
47 "Right now, I am very involved with the human being and her house."
 Rydet, Letter to Krystyna Łyczywek from October 23, 1967.
48 See Rafał Lewandowski and Tomasz Szerszeń, eds., *Neorealism in Polish
 Photography: 1950–1970* (Warsaw: Fundacja Asymetria, 2015).
49 Rydet, Letter to Krystyna Łyczywek from February 4, 1969.
50 "My photographs of interiors with people have crystallized. I have a
 marvelous wide-angle (20 mm) lens for my Praktica, which lets me take
 whole rooms, even small ones." Letter to Krystyna Łyczywek from July 28,
 1978, accessed November 27, 2017, http://zofiarydet.com/zapis/en/
 pages/sociological-record/letters/krystyna-lyczywek-28-07-1978.

this formal decision seemed apposite to Rydet—only brings us closer to the "record" part of the *Sociological Record*, while leaving unaddressed the question of how to understand the "sociological."

Sociological Photography

The prevailing explanation of the title of Zofia Rydet's *Sociological Record*—granted, one she suggested herself—is that it was submitted by Urszula Czartoryska: "The whole series was supposed to have had a totally different title," she explained to Anna Beata Bohdziewicz, in 1988, "but I don't remember what it was. I think it was Urszula Czartoryska who came up with *Sociological Record*. Though this is not an academic piece, and I would not have wanted it to be 'academic.' I have the old title somewhere in my notes, but now I can't change it, the name has stuck."[51] And yet this explanation does not seem convincing at all, not only because Rydet herself contradicted it on more than one occasion, but also because, as I have already illustrated, "sociological photography" was a cipher for social documentary, a practice that "serves to change social life." Indeed, Zofia Rydet's statement might have been prompted by the publication, a year earlier, of Alfred Ligocki's book in which he is at pains to prove that the epithet "sociological" is misguided, and that what it designates should rather be called "social photography." In general, Rydet seems to have identified with this designation, and not only as a mere label. "For the first time I am convinced of the value of what I do, because I know that the value of this document is very great," she wrote to Jerzy Busza, in 1982: [...] "It ceases to be reportage, and becomes a scientific study."[52] What is more, "sociological photography" was not, in fact, a moniker the organizers of the 1st National Review of Sociological Photography came up with to deceive the authorities into thinking their intentions were "neutral," but rather

51 "Zofia Rydet on the *Sociological Record*," *Konteksty. Polska Sztuka Ludowa* 51, no. 3/4 (1997): 192–98; recording (1988), editing, and titles by Anna Beata Bohdziewicz, accessed November 27, 2017, http://zofiarydet.com/zapis/en/pages/sociological-record/notes/konteksty.

52 Zofia Rydet, Letter sent to Jerzy Busza from February 3, 1982, accessed November 27, 2017, http://zofiarydet.com/zapis/en/pages/sociological-record/letters/jerzy-busza-03-02-1982.

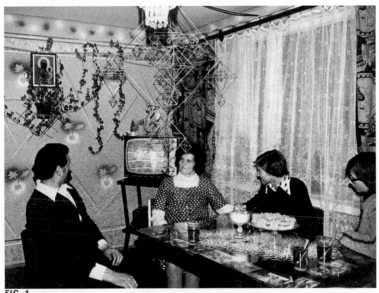

FIG. 1
STANISŁAW SUDNIK (AMATEUR), *REPORTAGE
ON STANISŁAW FRANCUZ, FOREMAN*, FROM
*THE WORKING CLASS FAMILY: FOUNDRY-
HOME-FAMILY*, 1978–79

a whole set of ideas and practices started in 1976, if not earlier, that many photographers responded to and identified with.

The discussions that took place during the 1976 General Assembly of the Association of Polish Art Photographers show both the ideological basis of the "sociological" tendency in the circles of advanced photographic practice, as well as the ambivalent political position this tendency seems to have occupied. During one of the sessions, Paweł Pierściński, a photographer especially well-known for his landscape work (he was the founding figure of the so-called "Kielce School" of landscape photography), took the floor stating that unfortunately, the efforts to document the life of the nation were isolated, and proposed that "the essential condition of integrating these scattered efforts is working out a unitary program that would take into account the cultural, social, and political needs of the country, while in its artistic aspect it would be based on the autonomy of the photographic medium."[53] Pierściński argued that it was "the idea of creating an artistic portrait of our homeland" that could develop into such a unitary program, integrating "all the artistic circles in the country," especially the avant-garde movement. The Minister of Culture and Art, Tadeusz Kaczmarek, who was present during the General Assembly, holding up as models the Bydgoszcz festival Reality vs. Art: The Art of Fact, and the Gdańsk-based Złocisty Jantar '74.[54] Kaczmarek declaimed:

> It is the task of socialist art to look into the urgent issues of today, for the mainstream of our creative powers to disseminate as far as possible the deep consciousness of the historic fate of the Polish nation, to shape the lifestyles, interpersonal relationships, and to show the perspectives of the socialist development of our country.[55]

53 Archiwum Państwowe w Szczecinie, Kolekcja Krystyny Łyczywek, catalog no. 65/994/0/30: Protocols of the ZPAF General Assembly in Warsaw, 1976–87.
54 While the former was organized throughout the 1970s, the latter was founded in the 1960s, as "Salon Fotografii Polski Północnej" [Salon of the Photography of Northern Poland].
55 Protocols of the ZPAF General Assembly in Warsaw, 1976–87.

While Pierściński's call for a universal effort at documenting the life of the nation—and establishing a central archive for the photographic output of the association's members—remained unanswered, various initiatives followed in response to these discussions.
In 1976, in the Kielce office of the association, Pierściński initiated a program for a series of exhibitions under the joint title "Rodzina robotnicza" [The Working Class Family], and founded the group 10×10, based on the idea of self-education and documentary photography. The group organized ten exhibitions in 1977–78, in the lead-up to the project *Foundry-Home-Family*. For this project, eight photographers—both professionals from ZPAF and amateurs working at the Marceli Nowotko Foundry in Ostrowiec Świętokrzyski—documented the lives of twelve workers from the foundry, which was undergoing a massive expansion at the time. [FIG. 1–3] The result was a set of twelve reportage portfolios, each by one photographer and dedicated to one worker, in which the protagonists where shown both in the workplace and at home, at leisure, and with their families. The project was framed as commemorating the thirthy-fifth anniversary of the establishment of the Polish People's Republic. And while the portfolios indeed make it evident that in each case the photographer has spent some time with the protagonist and his family, the final result is nevertheless awkward. Of course, this is due in part to the participation of amateurs, who had greater difficulty in assembling a reportage that would tell an uncoerced or natural story. As Pierściński recalls, his aim was to show "the statistical average, the furnishings," how people lived at the time. The everyday was what counted for him because the everyday is "what we have all the time."[56] It is worth noting that in *Foundry-Home-Family*, unlike in the *Record*, narration is at the center of the pictures showing the workers at home. An effort is made to record them entering their residences, sitting around the kitchen table with their families, talking, making beds, lighting cigarettes, etc. The rooms they inhabit serve only as a background, and the objects they possess appear as domestic marginalia without being

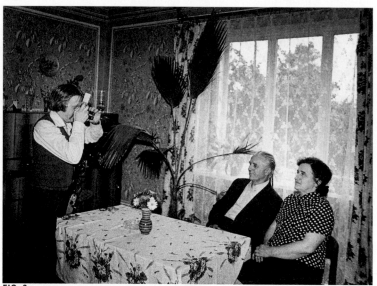

FIG. 2
PAWEŁ PIERŚCIŃSKI, *REPORTAGE ON EDMUND
ŻĄDŁO, FOREMAN,* FROM *THE WORKING CLASS
FAMILY: FOUNDRY-HOME-FAMILY,* 1978–79

spread out for us to examine; without, in other words, becoming the subject of the pictures.

The project was first exhibited, in May 1979, in two places at once: at the Museum of the Worker's Movement in Ostrowiec Świętokrzyski and during the Tenth Photographic Confrontations[57] in Gorzów Wielkopolski. The latter was also the first occasion for Rydet to present her *Record*. The exhibition went on to have as many as twenty-five iterations, including a traveling show at the KMPiK, Club of International Books and Press, and, in 1980, exhibitions in Prague and Bratislava, as well as during the 1st National Review of Sociological Photography in Bielsko-Biała, where not only the *Record* appeared,[58] but also the "Szczecin Family" exhibition, organized by Krystyna Łyczywek, to which I shall now turn.

In 1978, Łyczywek, head of ZPAF's Szczecin office, and, as already mentioned, a close friend of Rydet's, announced the exhibition "Szczecin Family," also a commemoration of the thirty-fifth anniversary of the establishment of the Polish People's Republic, and conceived as a follow-up to the ongoing competition for best diary, inaugurated in 1969 to document the colonization of Szczecin,[59] "The History of Szczecin Families in the Twentieth Century." [FIG. 4] The popularization and propagandistic power of the collected documentation, Łyczywek wrote in an informational note for the exhibition,

57 An important event on the map of photographic culture at the time, the "Confrontations" were initiated in 1969, and from 1977 also included symposia about the current state of photography and art.

58 According to Pierściński, he had met Zofia Rydet and Krystyna Łyczywek during plein-air events organized by ZPAF, at which they were photographing together, and during one such meeting in Silesia, Rydet decided to embark on her project. Pierściński didn't want to abandon his landscape work, but still went on to develop "Foundry-Home-Family," treating it as an extension of landscape, or "social landscape," as he would call it. He also claimed that Łyczywek, in organizing "Szczecin Family," was the only person to respond to his call to "creat[e] an artistic portrait of our homeland." Łyczywek invited him to participate, and he ended up producing a portrait of the Zawistowski family, often singled out as one of the more compelling contributions.

59 Szczecin, or Stettin, a German city that, as a result of the moving of Poland's borders westward after the Second World War, became part of Poland, together with the so-called "Recovered Territories." While some of this territory could be claimed as having been Polish all along, Szczecin, Bolesławiec, or Wrocław (Breslau) for that matter, couldn't. This was Poland's "Wild West," hence many Szczecin families were dubbed "pioneers."

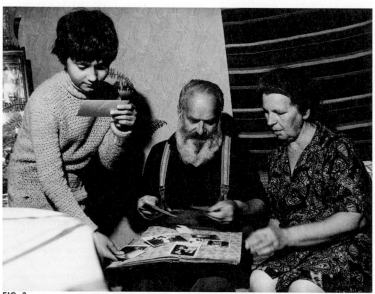

FIG. 3
ALEKSANDER SALIJ (AMATEUR), *REPORTAGE ON
JÓZEF ZBOROWSKI, RETIRED FOREMAN*, FROM *THE
WORKING CLASS FAMILY: FOUNDRY-HOME-FAMILY*,
1978–79

is not sufficient in relationship to their value. [...] The
organizers aim to collect the photographic documen-
tation of the lives of the Szczecin families, presenting
work and rest, living conditions, and leisure activities,
understood both as hobby and social work in the work-
place, university, housing projects, etc.[60] [FIG. 5]

The exhibition closely adheres to the program pro-
posed during ZPAF's 1976 General Assembly. As Łyczywek had previ-
ously faced difficulties in securing a space to house the exhibition,
"Szczecin Family" was shown for the first time only in March 1980,
and not in Szczecin, but in Warsaw as the sixth installment in a series
of exhibitions devoted to the family at KMPiK on Marszałkowska
Street. The exhibition was eventually opened in Szczecin on May 13,
1980, at the Pomeranian Dukes' Castle; it showed some 400 photo-
graphs of thirty-six families by twenty authors. The exhibition also
traveled, in June 1981, to East Berlin.

In the meantime, in January 1979, ZPAF's subsequent
General Assembly was held, with the president, Stefan Figlarowicz,
declaring that the Association ought to "strive toward raising aware-
ness of visual culture in society," informing the members that "we
have managed to gain government approval for our plans for the
Association to preside over the artistic documentation of the times
we live in." Edmund Kupiecki, a well-known photographer of Polish
cities and architecture, and head of the audit committee at the time,
concurred: "In artistic and curatorial activity there has been a dearth
of centrally-organized events and manifestations of importance [...]
'The Polish Family,' an exhibition now in the works, could rectify that
situation."[61] In December of that year, ZPAF announced a nationwide
competition under the motto "The Polish Family." The simultaneous

60 Personal archive of Krystyna Łyczywek. The catalog is more convoluted in
 this regard: "The aim of this exhibition is to show by way of the photo-
 graphic image the documentary value of both the diaries of the Szczecin
 families, and their unwritten accounts, from the family chronicles.
 Another aim is to show the processes of social integration at work in the
 Szczecin lands in the postwar era. Apart from its ambitious historical
 and sociological point of departure, the exhibition is artistic in charac-
 ter." Krystyna Łyczywek, *Rodzina szczecińska*, exhibition catalog (Wałbrzych:
 Wojewódzki Dom Kultury, 1981), n.p.
61 Protocols of the ZPAF General Assembly in Warsaw, 1976–87.

establishment of the Advisory Council for Family Affairs (active until 1988) by the government of Piotr Jaroszewicz might suggest that these events were somehow coordinated.

What is more, "Polaków portret własny" [A Self-Portrait of the Poles], one of the most popular and discussed art exhibitions of the Polish People's Republic, encompassing nearly 1,000 objects, and seen by some 80,000 viewers, was opened, on October 8, 1979, at the National Museum in Kraków. As Marek Rostworowski, the museum's director, and curator of the show, wrote in the book of essays accompanying it (not to be confused with the exhibition catalog; that publication, in two volumes, came later, in 1983), the exhibition was composed "not only of portraits, but also of various representations showing people from a wider perspective, bespeaking ideological and social structures, events, characters, affinities, myths," adding that "Poles have been particularly intense in this regard; we tend to resort to acting and taking on poses."[62] The aim of the book, with essays by prominent and esteemed historians (Aleksander Gieysztor, Janusz Tazbir, Stefan Kieniewicz), literary scholars (Jan Błoński), and sociologists (Stefan Nowak), was to "attend to the Polish collective imaginary, the stereotypes it produced, its sacred objects and ruins, both real and illusional, and finally to its great importance for contemporaneity and the future."[63] Most interestingly, Stefan Nowak's essay discusses questions of the values then held by Poles, the perceived structure of Polish society (stating that "the 'nation' is not identified with the 'state'"[64]), and the atomization of the society. According to Nowak, Polish society is split between "a 'federation' of primary groups" on the one hand, and the "nation" on the other, with a "sociological vacuum" in between, and no institution capable of assuming a community-building role.[65] Even religion, according to Nowak, has become "an element of private philosophy," in the sense that "the [Catholic] Church in Poland is not an institution that integrates religious people into a coherent social

62 Marek Rostworowski, "Polaków portret własny," in Polaków portret własny, ed. Marek Rostworowski (Kraków: Wydawnictwo Literackie, 1979), 7.
63 Ibid., 5.
64 Stefan Nowak, "Przekonania i odczucia współczesnych," in Rostworowski, Polaków portret własny, 127.
65 Ibid., 128.

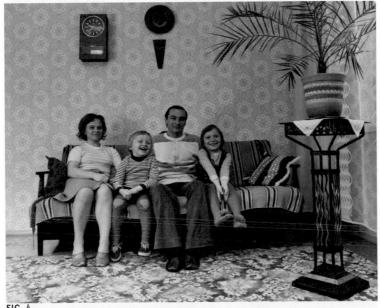

FIG. 4
ZDZISŁAW SIEŃKOWIEC, *SZCZECIN FAMILY*,
JARUZEL FAMILY, SZCZECIN, 1980

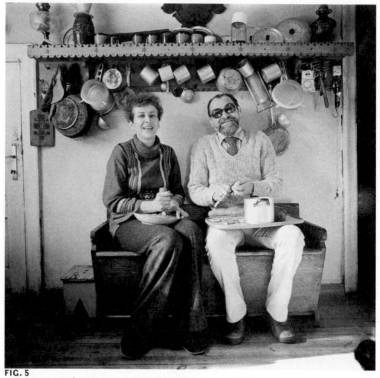

FIG. 5
WOJCIECH PRAŻMOWSKI, *SZCZECIN FAMILY*,
JOANNA AND JAN KULMA, STRUMIANY, 1980

group."[66] A very interesting claim, what with Karol Wojtyła, having just been elected pope, set to visit Poland when Nowak wrote his paper.

Whence this sudden need for self-reflection? What happened in 1970s Poland, known as the "Gierek decade," to inspire, or encourage, such forays into the Polish self? Edward Gierek came to power as the new first secretary after the massive wave of strikes and protests that swept through coastal Poland in December 1970, especially in the shipyards of Gdańsk, Gdynia, and Szczecin, leaving forty-one people dead, more than 1,000 wounded, well over 3,000 in custody, and the whole country in deep crisis. "Forward" seemed to be the way out, which at the time meant the "modernization of the economy, increased consumption, a quasi-managerial style of enterprise administration (by 'socialist captains of industry'), an opening up to Western markets and technology, and the modernization of agriculture,"[67] all toward a vision of "consumer socialism"[68] that promised an improved standard of living for everyone.[69] Unfortunately, the changes introduced by Gierek were shallow and implemented in a wasteful, incompetent manner, and—after a short period of relative prosperity—were soon followed by economic crisis and an abrupt increase in social discontent.[70] And so, although the standard of living was without question significantly higher than during the 1960s under Władysław Gomułka, the public perception of "a widening gap between a stratum of people who were politically and economically privileged and the rest of the population," together with the crisis of 1976, "to a large extent obliterated any sense of positive change in the broader society,"[71] paving the way for the events of August 1980.

To answer the question of whether the initiatives to document Polish society can be inscribed, in a meaningful way, in this

66	Ibid., 142.
67	Andrzej Paczkowski, *The Spring Will Be Ours: Poland and the Poles from Occupation to Freedom*, trans. Jane Cave (University Park: Penn State University Press, 2003), 354. Paczkowski calls this decade, not without irony, "La Belle Époque."
68	Paczkowski, *The Spring Will Be Ours*, 363.
69	See also Ewa Mazierska, *Poland Daily: Economy, Work, Consumption and Social Class in Polish Cinema* (New York: Berghahn, 2017), 181–222.
70	See Paczkowski, *The Spring Will Be Ours*, 359–60.
71	Ibid., 368.

decade of a seeming opening up but, in reality, an encroaching lock-ing down of the society, a look at the practices in the field of sociolog-ical inquiry of the time is in order. As it seems to me, the key phenom-enon here would be the anti-positivist turn in the social sciences in Poland, intimately connected with the founding, by Andrzej Siciński, of the Center for Research on Lifestyles at the Institute of Philosophy and Sociology of the Polish Academy of Sciences, in 1977.[72] It was this team that decided to depart from the established practice of "polls, planning, and social prognoses" in favor of lifestyle research, "a soci-ology oriented toward ethnography in the tradition of cultural anthropology."[73] The impulse to focus on lifestyles was founded on prognoses of the convergence between East and West as a conse-quence of modernization. In Poland, as the official discourse went, "the process of building a developed socialist society" would lead to the ultimate effacement of differences in lifestyle between working-class, peasant, and intelligentsia. In effect, a new, socialist lifestyle was to arise, based on "good work, social justice, the deepening of familial ties, and active participation in the social and cultural activ-ities of the country," contributing to, "the rise of the role of moral val-ues," before finally producing an increase in consumption.[74] All these predictions were voided with the onset of economic difficulty and the outbreak of social unrest in Radom and Ursus in June 1976, another step in the ongoing crisis, after which rationing was introduced, resulting in, among other things, queues and food shortages.[75]

72 Zakład Badań nad Stylami Życia [Center for Research on Lifestyles] evolved out of the Center for Social Prognoses founded by Siciński in 1969, after Stefan Żółkiewski's Laboratory for the Research of Contempo-rary Culture was dissolved in response to his support of the student strikes of 1968. I would like to express my thanks to Piotr Filipkowski, who suggested I take a look at this episode, one he has studied together with Małgorzata Mazurek, in preparing for "Z 'terenu' do archiwum – i z powrotem," an issue of Kultura i Społeczeństwo 59, no. 3 (2015).

73 Małgorzata Mazurek, "Rewizyta etnograficzna. Jak się wytawarza wiedzę socjologiczną," Kultura i Społeczeństwo 59, no. 3 (2015): 45.

74 Archiwum Akt Nowych, XIa/424, Sekretariat Edwarda Gierka, 11.05.1977, k. 407. Quoted after Mazurek, "Rewizyta etnograficzna," 45.

75 In June 1976, after the announcement, by prime minister Piotr Jarosze-wicz, of drastic rises in food prices, a wave of strikes swept through Poland, culminating in the June events in Radom, where the provincial office of the Polish United Workers' Party (PZPR) was set ablaze by protestors. See Paczkowski, The Spring Will Be Ours, 357–60.

In response to these developments, in 1977, the Team of Scientific Advisers to the First Secretary of the Central Committee was formed, with Siciński as member, whose aim was to discuss the future of consumer society in socialist Poland, as well as to diagnose the current political crisis that was seen as a crisis of socialist values. The discussion was based on the programmatic document "The Tasks of the Party in Shaping the Socialist Way of Life," naming two antagonistic phenomena as the source of social dissatisfaction and the escalation of conflict. First, that people with modest to low income had increasing problems with satisfying their basic needs, and second, that there was an observable increase in conspicuous consumption among the functionaries of the exponentially growing party apparatus, apposite to the petit bourgeois lifestyle. According to the sociologists, it was due to what Siciński dubbed the "television-cum-alcohol model of cultural participation" that resulted in the Poles losing themselves in mass culture and a lifestyle based on consumption, becoming alienated from the realm of spiritual, i.e. socialist, values.

The team of Gierek's advisers saw the need to produce a socialist pattern of consumption, and it was in this context that Siciński conducted his lifestyle research between 1976–80, focusing on seventy-two families from across Poland.[76] He defined lifestyle as "that community's characteristic 'way of being' in society."[77] That is, "a complex of everyday behavior of that community's members, expressive of their social standing, and thanks to that enabling their social identification,"[78] including the management of time, the structure of work, patterns of consumption, but also intellectual and aesthetic needs, participation in culture, professed values, participation in social and political life, and religiosity. What was revolutionary in Siciński's approach was the focus on the everyday and the choice

76 His team worked in four cities and towns: Bydgoszcz, Gdańsk, Lubin, and Dobre Miasto. In each location five to twenty-five families became the focus of the research, each visited multiple times by one researcher, resulting in a rich dossier of ethnographic and sociological material. Today, the research is available online for researchers, in the Qualitative Data Archive at the Institute of Philosophy and Sociology at the Polish Academy of Sciences.

77 Andrzej Siciński, "Wprowadzenie," in *Styl życia. Przemiany we współczesnej Polsce*, ed. Andrzej Siciński (Warsaw: Państwowe Wydawnictwo Naukowe, 1978), 13.

78 Ibid., 14.

of long-term observation, or ethnographic fieldwork, rather than polls, as method. [FIG. 6–7] The designation of the family as a "research unit" was an important move, because it showed—in opposition to research based on social class, professional groups, or individuals— the "family-centric" functioning of Polish society and economy. Most importantly, Siciński saw lifestyle as an individual rather than collective trait, departing from seeing lifestyle as a socially determined setting and character toward a subject conscious of his or her choices, hence Siciński's coinage of the category of *homo eligens*: the choosing man.[79] And despite "significant social and spatial mobility" in Poland, in the late 1970s, and "the developing of new rules of social stratification, in which the traditional class divisions lose validity," what Siciński called the first function of lifestyle was still predominant (its role is to "integrate society, furnish individuals with a sense of social belonging, of their place in society"). A third function—of "lifestyle as a framework for expressing personality"—was on the upswing.[80] Siciński understood this process as a consequence of "the rise in the standard of living, access to more free time, the intellectualization of work," better education, and so on.[81] His diagnosis was that "contemporary Polish society can be described as 'a society seeking a lifestyle of its own' (or rather, a set of variants thereof)"[82] and so the realization of a socialist type of lifestyle in Poland, one—as I understand it— that would not be focused primarily on consumption, would hinge upon the possibility of "making it the object of social aspirations, a model that would consciously motivate human behavior."[83]

All things considered, would it be misguided to see the above-described initiatives as attempts at trying to find new ways of channeling social energies, remaining in control of a society that was becoming more and more self-conscious, by substituting coercion with some semblance of choice? In general these initiatives were a double-edged sword: One could see them as attempts at producing

79 See Justyna Straczuk, "Andrzeja Sicińskiego badania stylów życia
 - spojrzenie z dystansu," *Kultura i Społeczeństwo* 59, no. 3 (2015): 68.
80 Siciński, "O funkcjach stylu życia," in *Styl życia. Przemiany we współczesnej
 Polsce*, 392.
81 Ibid., 393.
82 Ibid., 392.
83 Ibid., 393.

a strong social bond, or identification, that would fill in the social
vacuum described above, producing a sense of belonging among the
populace that would defuse possible upsurges of discontent; but at
the same time these very same initiatives might have helped people
to recognize each other, as citizens, as subjects with a voice.[84]
Regarding Andrzej Siciński's research, an insight by Zbigniew Bene-
dyktowicz—then a member of Siciński's team, and today editor-in-
chief of the journal *Konteksty*, which, already under his editorship,
published an issue dedicated to Zofia Rydet in 1997—is very telling:
"It was a discovery of Poland up-close. It was a shock!"[85] [FIG. 8]

What is important in the context of the *Sociological
Record* is the inclusion of photography among the research tools
deployed by Siciński's team. A set of research materials concerning
one individual family consisted of a so-called information pack about
the family (i.e. the particulars of each family member), a form with
more detailed data about the respondent, a biographical text based
on the accounts of the family members, additions to that account,
such as recorded conversations, a researcher's diary, and a so-called
interpreted description. Further, the researchers—depending on
their inclinations or capabilities—would include photographs of the
family members, their keepsakes, interiors, and sometimes the envi-
rons of the apartment or house.[86] This should sound familiar to any-
body who has had contact with Rydet's *Record*, and indeed, if juxta-
posed, the pictures exhibit many analogies in thinking about how to
record a life that is not ours. In the end, only fifteen out of the sev-

84 Siciński himself seems to have been optimistic regarding the existential
 implication of his concept of *homo eligens*, even in 1988: "The concept of
 homo eligens can be seen as an existential, or merely methodological,
 thesis. In the case of the former it is a conviction that the human being
 cannot be reduced to the sum of his reactions to given conditions, or
 stimuli, [and] that, on the contrary, the possiblity of making decisions, of
 exceeding his conditions, belongs to his very 'essence.'" Andrzej Siciński,
 "Typy stylów życia ludności miejskiej," in *Style życia w miastach polskich (u
 progu kryzysu)* (Wrocław: Ossolineum, 1988), 54.
85 Zbigniew Benedyktowicz, "Andrzeja Sicińskiego koncepcja otwartości i
 badań interdyscyplinarnych," in *Siciński i socjologia. Style życia. Społeczeństwo
 obywatelskie. Studia nad przyszłością*, eds. Piotr Gliński and Artur Kościański
 (Warszawa: Wydawnictwo IFiS PAN, 2009), 264. Quoted after Straczuk,
 "Andrzeja Sicińskiego badania stylów życia," 71.
86 In the case of some of the families, audio recordings of the interviews
 were preserved.

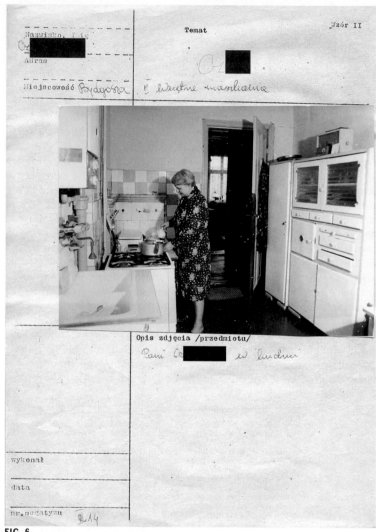

FIG. 6
"MG," FILE 41/B/I/MG, DOCUMENTING AN
INTELLIGENTSIA FAMILY FROM BYDGOSZCZ, FROM
ANDRZEJ SICIŃSKI, *LIFESTYLES IN POLISH CITIES*,
1978-80

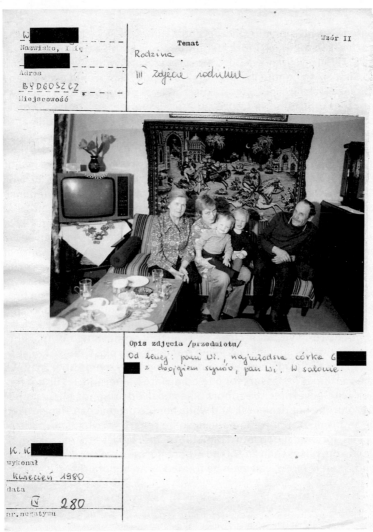

FIG. 7
**"PŁ," FILE 58/B/R/PŁ, DOCUMENTING A FAMILY OF
PENSIONERS FROM BYDGOSZCZ, FROM ANDRZEJ
SICIŃSKI,** *LIFESTYLES IN POLISH CITIES*, **1978–80**

enty-three files include photographs. However, Siciński's project was earmarked for much more elaborate photographic documentation. In 1979, the well-known portraitist Krzysztof Gierałtowski proposed to Siciński to conduct a "photographic poll" that would accompany his research into lifestyles, taking the work of Roy Stryker's FSA-OWI photographic unit, in Depression-era America, as a point of reference. He wanted the dossier of each of the researched families "to be complemented by fifteen photographs, chosen from a set of 150, realized according to a preestablished script."[87] All in all, more than 12,000 photographs were projected to be produced, without doubt to the great benefit of Siciński's project. It is difficult to say, why Gierałtowski's "poll" did not come to fruition, although the immense cost (nearly one million zloty) could certainly have been a factor.

What can be said, is that Zofia Rydet's *Sociological Record* was one among many coordinated efforts to produce a (self-)portrait of the Polish people at a time of heightened social and political crisis. It is only against this background that we can assess the *Record*'s "unique" status, because now we see that it was not the systematic, encompassing, essentially interminable nature of the project that makes it unique (it was Pierściński who most probably came up with the idea, but didn't get support, and Gierałtowski can be thought to have been close to realizing something comparably grand), but the specific way Rydet framed her project, chose her subject, and realized it single-handedly, doggedly, being able to make the sacrifices necessary for it to come into being, and, let us not forget, with government support (she received stipends allowing her to continue her projects). And while her life project can also be seen as ambivalent, or problematic in some regards,[88] what she made of it was, for one, much more difficult to appropriate for state propaganda purposes than any of the other efforts I have described above, and, what is more, can even be framed as an act of protest.

87 Krzysztof Gierałtowski, "Sonda fotograficzna – przyczynek do socjologii wizualnej," in Gliński and Kościański, *Siciński i socjologia*, 275.
88 Abigail Solomon-Godeau has pointed out these issues very perceptively, and incisively, in her essay in this volume, "Artist, Oeuvre, Corpus, and Archive: Thinking through Zofia Rydet's *Sociological Record*, 215–44.

Protest Photographs

One way of looking at Zofia Rydet's *Record*—if we are to
consider these images as critical images, and not exclusively as doc-
umentation—is to see them as protesting against the onset of (quasi-)
consumer society in Poland, of the "having" taking the place of
"being," to refer to one of Andrzej Siciński's most important sources
of inspiration, Erich Fromm. Then we could see Rydet pitting her
"authentic man" and his life world against the "modern man" and his
lifestyle. As Alfred Ligocki proposed:

> The *Sociological Record* is anything but ethnographic
> documentation. It shows with great candor and com-
> plexity man's struggle to preserve his individuality and
> to defend it against the encroaching uniformity
> brought about by contemporary technological civili-
> zation. The struggle persists with some success in the
> countryside.[89]

Such a reading suggests a "passion for the real"[90] driv-
ing Rydet, something she confirms when speaking about the feeling
of "truth" accompanying her meetings with her sitters.[91] On the one
hand this would dovetail with Ligocki's vision of the role of creative
photography as "dismantling the stereotypes of seeing, reacting, and
making value judgments," as a tool of "freeing contemporary man
from alienation,"[92] but on the other hand, this way of staging the dis-
appearing, old rural world as a last reservoir of the authentic can
have destructive, even reactionary implications: "There exists a pas-
sion for the real that is obsessed with identity," writes Badiou in his
reading of the twentieth century, "to grasp real identity, to unmask
its copies, to discredit fakes. [...] This passion can only be fulfilled as
destruction."[93] The danger in such a reading is that it posits an

89 Ligocki, *Czy istnieje fotografia socjologiczna?*, 110.
90 See Badiou, *The Century*, 48–57.
91 Zofia Rydet, "On Her Work," (Gliwice: Muzeum w Gliwicach, 1993),
 accessed November 27, 2017, http://zofiarydet.com/zapis/en/pages/
 sociological-record/notes/o-swojej-tworczosci.
92 Ligocki, *Czy istnieje fotografia socjologiczna?*, 26.
93 Badiou, *The Century*, 56. Ligocki seems to have been conscious of such a
 possibility: "This does not at all mean that today the village is an oasis of
 authenticity. It is just that it is easier to defend oneself against uniformi-
 zation there." Ligocki, *Czy istnieje fotografia socjologiczna?*, 110.

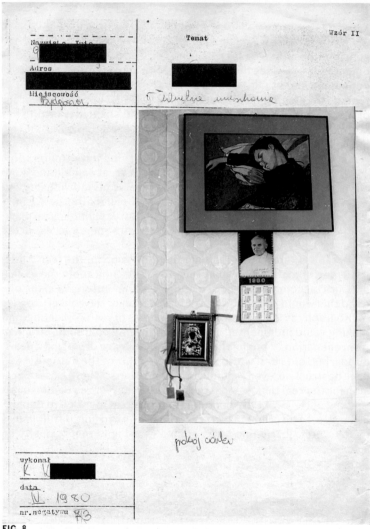

FIG. 8
"PŁ," FILE 58/B/R/PŁ, DOCUMENTING A WORKING CLASS FAMILY FROM BYDGOSZCZ, FROM ANDRZEJ SICIŃSKI, *LIFESTYLES IN POLISH CITIES*, 1978–80

already well-grounded vision of the Polish nation, an essentially
romantic vision, cemented in early twentieth-century modernism,
of the community arising out of a communion between the authen-
tic rural folk and the intelligentsia, assuming a leading role. The near-
unrepresented working class, implicitly labeled as inauthentic, is,
in such a scenario, removed to the margins of this "pure" vision.[94]
And yet, there is another way of looking at Zofia Rydet's life work, one
that instead of seeing the *Record* as laying bare an essence, insists
on it as delineating the home as a locus of resistance, and envisag-
ing, or at least suggesting, a commonality.

In 1988, "on the tenth anniversary of the pontification
of John Paul II," as the dedication would have it, Zofia Rydet published
Obecność [Presence], a book of photographs culled from the *Record*,
and focused on the presence of (images of) Pope John Paul II in the
houses of her sitters.[95] The book features three extended essays by
Józefa Hennelowa, a journalist and columnist associated for most of
her working life with the Catholic weekly *Tygodnik Powszechny*,[96] and a
sitting member in the two transitional terms of the Polish parlia-
ments of 1989–91 and 1991–93.[97] The essays, however, say nothing

94 See, by way of comparison, Ewa Klekot's essay in this volume, "Between
the Ethnographic and Material Culture," 120–21, footnotes 3 and 4.
95 Zofia Rydet and Józefa Hennelowa, *Obecność* (Kraków: Wydawnictwo Calva-
rianum, 1988).
96 Founded in 1945, and connected with the Catholic Church, it was
relatively independent from the state. As Adam Michnik reports: "*Tygodnik
Powszechny* was an asylum for the reader, who wanted to extricate himself
from the babble of the official discourse. [...] The accomplishments of a
group of editors from Kraków was no mean feat: renouncing the ideologi-
cal temptations of Stalinism (which was not easy at all), they managed to
escape annihilation as a community." Adam Michnik, *Kościół, lewica, dialog*
(Warsaw: Biblioteka Gazety Wyborczej, 2011), digital edition. The circle
of intellectuals around the "Znak" association, founded in 1956 and
composed of members of Klub Inteligencji Katolickiej [Club of the
Catholic Intelligentsia] and journalists of *Tygodnik Powszechny*, played an
important role in the formation of the opposition in the 1970s. Znak, as
an organization of lay Catholics, was granted representation in the Polish
parliament, and was the only group to protest the anti-intelligentsia and
anti-Semitic campaign of 1968, unleashed by First Secretary Władysław
Gomułka.
97 The first of these terms was the last of the Polish People's Republic, and
the outcome of partly-free elections, negotiated during the so-called
Polish Round Table Agreement of April 5, 1989. Józefa Hennelowa was
also member of the Polskie Porozumienie Niepodległościowe [Polish
Independence Compact], an underground opposition movement
founded in 1975–76.

about Zofia Rydet's work; rather, they have been chosen to serve as "accompaniment" to the pictures, to "underpin the small and great issues that we experience together, and that *define* us as community, among which St. Peter's Successor has the right to feel at home."[98]

"It was during John Paul II's second pilgrimage to his homeland,"[99] Hennelowa would reminisce in the introduction to the book: "I was returning home, at nighttime, from Warsaw, from where the pope had already moved on in the itinerary of his visit. Unendingly, one would notice from the train the windows of individual houses, alight with decorative lamps, illuminating holy pictures—and portraits of the Guest."[100] According to Hennelowa, Zofia Rydet's "artistic vision" disclosed something even more profound than this temporary uniting of the Poles around the figure of the "Visitor"—the fact that "John Paul had become deeply rooted under Polish roofs."[101]

And indeed, as Andrzej Paczkowski reports, the election, in 1978, of Cardinal Karol Wojtyła as the new pope—the first non-Italian to perform this role in 455 years—was an event whose consequences for the situation in Poland "are difficult to overestimate." "For many people, including opposition activists and dissident artists," Paczkowski concludes, "the elevation of a lecturer from the Catholic University [of Lublin] also elevated the prestige of Polish intellectuals, and the fact that Cardinal Wojtyła had collaborated closely with *Tygodnik Powszechny* was cause for hope that the Church would continue its discrete support of the opposition."[102] Indeed, the 1970s were a time when the Church was increasingly perceived as the only counterweight to the ruling party, and not only by believers, but also by what Adam Michnik, one of the most active participants of the opposition and later founder of *Gazeta Wyborcza*, called the "secular Left" (of which he was a part). In point of fact, Michnik's *Kościół, lewica, dialog* [Church, The Left, Dialogue], published in 1977, was among the first books to postulate a rapprochement between the different groups of Polish dissidents, regardless of whether sec-

98 Józefa Hennelowa, introduction to *Obecność*, 6. [Emphasis mine.]
99 June 16–23, 1983.
100 Hennelowa, introduction to *Obecność*, 5.
101 Ibid.
102 Paczkowski, *The Spring Will Be Ours*, 393.

ular or aligned with the Church. Michnik defined the program of the Left as one of "antitotalitarian socialism," a common platform "championing the ideas of freedom and tolerance, the idea of the sovereignty of the human being and of the liberation of work, the idea of the just redistribution of the nation's wealth and an equal start for everybody."[103] "I remember the shock I experienced in 1968," Michnik recalled in a recent discussion about his book, "when all these anti-intelligentsia and anti-Semitic stunts happened.[104] The voice of the Church was heard very clearly then. When the ZOMO[105] beat us up with their rubber batons, we hid in churches and they closed the doors behind us. This is something someone of my formation is not allowed to forget."[106] All this was only amplified by the election of Karol Wojtyła, and already his first pilgrimage, in June 1979, in spite of intense attempts of the state propaganda "to downplay the significance of the visit and, above all, to conceal the size of the enthusiastic crowds," turned out to be "one long string of triumphs,"[107]

103	Michnik, *Kościół, lewica, dialog*, 29/723.
104	See footnote 96. In a way it was Michnik, or rather his being expelled from the University of Warsaw, who precipitated the massive student protests of March, 1968.
105	Zmotoryzowane Odwody Milicji Obywatelskiej [Motorized Reserves of the Citizens' Militia], a paramilitary police formation used to stifle public unrest during the Polish People's Republic.
106	"Bomba liberalizmu! Adam Michnik w rozmowie z Jarosławem Kuiszem i Piotrem Kieżunem," *Kultura Liberalna* 175, no. 20, 2012, accessed November 27, 2017, http://kulturaliberalna.pl/2012/05/15/bomba-liberalizmu-adam-michnik-w-rozmowie-z-jaroslawem-kuiszem-i-piotrem-kiezunem. At the same time he acknowledges that looking back, there was "a certain logic to these developments," meaning the use the Catholic Church made of its immense social capital and symbolic power after the transformation. Directly meddling with politics, the Church became a major conservative, even reactionary, power in Polish public life, culminating in the role it plays in the current Law and Justice government, which, both in its discourse and attempts to create a new *nomenklatura*, is more and more reminiscent of the Polish People's Republic. At the same time it cannot be denied that the political affects—stemming from the marginalization and disenfranchisement of whole social groups—are real. Indeed, to nearly one third of the Poles, the social costs of the transformation were excessive. See "Was It Worth It? Opinions About Changes After 1989," an evaluation of the post-1989 transformation by the Public Opinion Research Center [CBOS], Warsaw, June 2013, accessed December 18, 2017, http://www.cbos.pl/EN/publications/reports/2013/073_13.pdf. This is something the elites have realized only too late, as conceded by the intellectual historian and one of the architects of the transformation, Marcin Król, in his book *Byliśmy głupi* [We Were Foolish] (Warsaw: Wydawnictwo Czerwone i Czarne, 2015).
107	Paczkowski, *The Spring Will Be Ours*, 394.

with between eight and ten million people participating in the papal masses, according to cautious estimates. The pope's visit, as Pacz-kowski insists, "changed the country's psychological climate." "It is easier to fight standing up," he states in response to the observation of a participant, and that "in bowing before the Holy Father, Poland got up off its knees."[108]

It was around this time that Zofia Rydet commenced and carried through most of the work on her *Record*, up to the pub-lishing of *Presence*. As a regular reader of *Tygodnik Powszechny* (she even photographed part of the editorial board for the *Record*, and more specifically for the *Presence* series), Rydet was aware of these devel-opments. And whereas there are no pictures of explicitly political content from her trip to Szczecin in 1980, in Gdańsk, in 1981, she would photograph political posters and graffiti, including a huge inscription on a wall bordering a street, "Free the political [prison-ers]! Away with terror and lawlessness!"[109] The visits of John Paul II left an immense impression on her, and even more so in that she noticed that they had changed something in the way people related to each other: "And now I'm in Rabka," she writes to Krystyna Łyczywek in a letter from July, 1983, during the pope's second pil-grimage to Poland. "I walk alone, but after the Holy Father's visit, complete strangers are so kind to me. I have never made contact with people so quickly before."[110] It seems to be this very recogni-tion that makes her dedicate her work to him: "Now, however, I'm mainly doing it for the Holy Father—that's my task. I want to give these hundreds of people to him, so he can see how this nation loves him. And now there's an altar in almost every home. If only I had the strength to develop it all later."[111] In the same letter, she expresses "the profound hope" of being able to create an account "full of opti-mism and beauty, and human truth, *that will speak to others in this way,*

108 Ibid., 395.
109 See archive signatures zr_20_007_23, zr_20_007_27, and others, in the Zofia Rydet archive, accessed November 17, 2017, http://zofiarydet.com/zapis/pl/library?page=2&per_page=120&preselect=off®ions=20&photo=zr_20_007_28.
110 Zofia Rydet, Letter sent to Krystyna Łyczywek from July 18, 1983, accessed November 17, 2017, http://zofiarydet.com/zapis/en/pages/sociological-record/letters/krystyna-lyczywek-18-07-1983.
111 Ibid.

communicating what I have experienced."[112] Would it be too much
to say that what she had experienced back then was a sense of com-
munity, which she wanted to convey to others?

The essays of Józefa Hennelowa accompanying Rydet's
photographs could suggest an interpretive inclination to follow. As
she states in the introduction to the book, they were put together
mostly from her writing "devoted to the home and hearth."[113] After a
sequence of photographs from the *Record*—starting with a picture of
a dense arrangement of images with John Paul II and the Polish state
emblem at the center, followed by a juxtaposition of pictures featur-
ing calendars (showing 1982 and 1983), then a juxtaposition of an old
woman with a young girl, and culminating in a portrait of Rydet's
niece in the artist's own home—Hennelowa begins her reflections on
a bold note:

> What is specifically dangerous is the "ideology of pri-
> vacy." Too often it has already been a tool, and for too
> many. It was advocated so that people cease to see the
> broader picture and to care more. It almost always
> works. [...] But this means to be led astray. And we need
> not end up like this. A true return to the nest is a return
> to fortified positions. *In the end it is always about the
> human being.*[114]

Read alongside the sudden interest of the authorities
in the family, and their attempts at focusing public interest on the
private sphere of family, identity, and consumption, it is difficult to
see Hennelowa's remarks as other than an act of resistance against
this "ideology of privacy," and as an attempt at inciting protest, one
that would start out of the privacy of the home. The subsequent parts
of Hennelowa's essay only reinforce this reading. To give an example:
in the second part, dedicated to the importance of memory and
fidelity (where quoting John Paul II's "Nations, in losing memory, lose
life," she comments that "our homes are there to remember"[115]), Hen-
nelowa dwells on the question of how to raise a willful, as opposed

112 Ibid. [Emphasis mine.]
113 Hennelowa, introduction to *Obecność*, 6.
114 Józefa Hennelowa, "Wymiar domu," in *Obecność*, 13–14.
115 Józefa Hennelowa, "Pamięć i wierność," in *Obecność*, 41.

to polite, child. A child unable to bear injustice, becoming, when the time comes, *"the first who stops clapping."*[116] And in the third part, dedicated to the everyday as the arena of our struggles, she reflects on the concept of solidarity, defining it as:

> the ability to be with others in the name of values surpassingly larger than our own private lives. A conscious experiencing of community. Back then, during the pilgrimage, this ability and experience had its source in the person of the pope. He knew how to enliven, or mobilize, it in us. But it cannot be always only Him. We need to do it by ourselves. In defiance of fear, isolation, bitterness.[117]

Hennelowa names what is already present in Zofia Rydet's pictures: the figure of the pope as a mediator, inaugurating a new sense of community, which needs to be upheld also in his absence; a figure that fills the social vacuum that has already been referred to. In the closing paragraphs of her contribution to *Obecność*, a book that should be seen as co-authored by both women, Hennelowa speaks of the need to "defy the feeling of powerlessness," asserting that one "need not stand among the orchestra, going down with the deck of the Titanic,"[118]and give up.

If I were to draw analogies between Zofia Rydet's *Sociological Record* and other bodies of work, it would be first and foremost Chauncey Hare's *Protest Photographs* I would turn to. Although conceived and carried out in a radically different context—that of the advanced capitalism of 1960s and 1970s America—Hare's project is analogous to the *Record* both in its scope and in its questioning of the existing social structure, especially its hierarchical order. Setting out "to protest and warn against the growing domination of working people by multinational corporations and their elite owners and managers,"[119] Hare produced a body of approximately 3,325 silver gelatin photographs, 50,000 negatives, and 3,000 35mm slides, all of

116 Ibid., 48–73. [Emphasis in the original.]
117 Józefa Hennelowa, "Zwyczajnie," in *Obecność*, 81.
118 Ibid., 119.
119 Jack von Euw and Steven Kasher, eds., *Chauncey Hare: Protest Photographs* (Göttingen: Steidl, 2009).

which he later donated to the Bancroft Library. What is striking in
Hare's approach, considering he used a view camera, is his "indeli-
cate use of artificial lighting," as if "he wished for every hard edge to
be revealed in crisp uncompromising detail"[120]—there should be no
need to explain at this moment, why this brings us very close to Zofia
Rydet's work. [FIG. 9] But it is his stubborn emphasis on the subjec-
tivity, the individuality, of each depicted sitter, and at the same time
an appeal to a sense of community ("For all working people," reads
the dedication of his book[121]) that draws the strongest parallel; his
appeal to the lived world of America's working class as something real
and experienced, and not abstract and disposable.

As Badiou asserts, "There is another passion for the
real, a differential and differentiating passion devoted to the con-
struction of a minimal difference," one that is other than destructive,
because "instead of treating the real as identity, it is treated right
away as a gap."[122] What he describes is the mechanism of distancing
characteristic of modern art, insisting that "the question of the real/
semblance relation will not be resolved by a purification that would
isolate the real, but by understanding that the gap is itself real."[123] It
is my deepest conviction that Zofia Rydet worked right in this thresh-
old, searching for that which connects us, for what makes us human,
but always through proxies, masks, the play of immediacy, brutality
even, and distance, "participant objectification:"[124] the encompass-
ing character of the project in tension with the individual focus, the
objectifying, unifying logic of the lens in tension with photography's
tendency to invite the contingent, material accumulation of the expe-
rienced world, the presence of the sitters in tension with the pres-
ence of their past selves, the logorrhea of the objects in tension with
the enigma of Rydet's sitters as embodied beings.

120 "Protest Photographs by Chauncey Hare," *5B4: Photography and Books*,
 accessed November 17, 2017, http://5b4.blogspot.com/2009/11/
 protest-photographs-by-chauncey-hare.html.
121 Von Euw and Kasher, *Chauncey Hare: Protest Photographs*.
122 Badiou, *The Century*, 56.
123 Ibid.
124 For more on this concept of Pierre Bourdieu's in the context of Zofia
 Rydet's work, see Maren Lübbke-Tidow's essay in this volume, "Concepts
 of Agency: Zofia Rydet from the Perspective of German Photographic Art
 of the 1970s," 179–213.

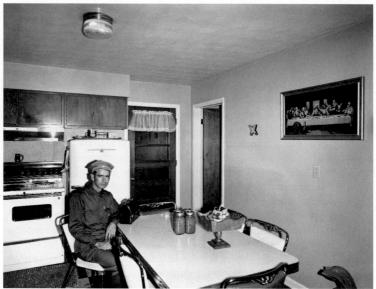

FIG. 9
CHAUNCEY HARE, *WINTERSVILLE, OHIO*, 1971.
THIS PHOTOGRAPH WAS MADE BY CHAUNCEY
HARE TO PROTEST AND WARN AGAINST THE
GROWING DOMINATION OF WORKING PEOPLE BY
MULTI-NATIONAL CORPORATIONS AND THEIR
ELITE OWNERS AND MANAGERS.

And while the current position of the Church in Polish public life (hegemonic), and the state of the Left (in ruins), might suggest that such a reading is entirely unfounded, even counterproductive, it is exactly the unstable status of the *Record*, together with the fact that its visual excess—as regards both the content and the number of the photographs—frustrates and surpasses any attempts at single-mined readings, that makes it such a compelling, and important, work. This is not to say that *any* readings are possible, or apposite, but rather that it is our task to frame her work responsively, both with respect to who Zofia Rydet was, *and*, at the same time, in response to current issues. Looking at the *Sociological Record* does not tell us anything about ourselves, about our relationships to each other, as a community. What such a reading shows is above all an unrealized potentiality in the moment of its full force, one allowing for an alternative vision of the contemporary situation, for a glimpse, maybe, of a different community. Zofia Rydet's lesson is one of openness toward the other, rather than an attempt at (re)constructing a social schema; of empathy, rather than judgment or classification. And although it might seem paradoxical, it is exactly her cool, objectifying, "conceptual" framework that allows for such a reading. The "humanist" mode she abandoned on her way allows for too easy an identification, and hence for fantasies of sameness and totality to arise. Participant objectification calls for acknowledgement. A lesson we seem to be in need of more than ever before.

Maren Lübbke-Tidow is a writer, editor, curator, and lecturer. Her research concerns contemporary photography and its modes of representation in the field of visual art. From 1997 to 2017 she was part of the project Camera Austria, and from 2011 to 2014 she was editor-in-chief of the magazine *Camera Austria International*. She has realized several solo exhibitions and group shows and has worked closely with many artists including Wolfgang Tillmans, Annette Kelm, Tobias Zielony, Michael Schmidt, Erik van der Weijde, and Friedl Kubelka. She has contributed texts to a range of international magazines, books, and catalogs. She is currently lecturer at the School for Artistic Photography in Vienna and at the University of Cologne.

CONCEPTS OF AGENCY: ZOFIA RYDET FROM THE PERSPECTIVE OF GERMAN PHOTOGRAPHIC ART OF THE 1970s[1]

If one is to imagine the approximately 27,000 photographs from Zofia Rydet's *Sociological Record* scattered on a large table, and then to go about organizing them, different systems of navigation are likely to emerge. To arrange them according to their date of origin, it is possible to follow the chronology of the photographer's travels through different countries, especially Poland and its southern and southwestern regions (but also beyond), noting the localities and dwellings of inhabitants specific to the geographic location. Beyond what the artist shows in her photos lurk different biographical moments from Rydet's life, which trace her movements in space and her encounters with people.

If one arranges the photographs according to geography, not only do region-specific features emerge, but it also becomes apparent that Zofia Rydet visited certain places, houses, and people multiple times, sometimes after very long intervals. Then the focus is not so much on the movement of the photographer through space as on the comparative observation of changes in the depicted space

1 I would like to thank Christine Frisinghelli and Tobias Zielony for their advice and discussions.

itself; perhaps it is precisely the last pictures, taken around 1991, shortly after the political transformation, that represent the already changed social orders: possibly the first signs of the modernization of specific landscapes, or vice versa (and more likely), their increasing desolation due to decay and departure, a rejuvenated, or, on the contrary (and also more likely), an aged rural society.

If one arranges the photographs according to specific structural features, which are prominent in the exterior or partly in the interior views of the houses photographed by Rydet, the question arises as to whether, as expected, regional specificities and similarities in the construction methods come into view, which differ considerably from other regions. With all their subtleties, these are often very difficult to distinguish for the lay observer (it would take an architectural historian to see them). According to this criterion, which leaves space aside, selection is difficult: the body of images begins to proliferate as it expands beyond specific regions.

Finally, if one arranges the images according to formal similarities in terms of a specific composition of the picture, then the protagonists in Rydet's photographs quickly come to the fore. Thus, the photographs organize themselves depending on the houses in which these protagonists live, where they are situated in the picture, how they appear there, what they do there. With this principle of order, the radius of perception narrows, as well. Observation becomes more differentiated: for instance, various attributes with which the inhabitants of the houses are shown come into focus, such as handwork and craftsmanship, kitchen utensils or technical objects (TV sets), decorations and images of political or spiritual leaders, tools and implements in and around the house. A large number of small groups emerge, through which the individuals' social and societal relations become visible.

Zofia Rydet conceived her own idiosyncratic way of organizing her pictures. She also developed a variety of navigational aids. As a rule, the photos are marked with the date and place of origin, as well as the names of the depicted persons. Thus, the artist set up a rudimentary archive. However, it is also clear that this itself does not impose a mandatory direction of reading. Zofia Rydet

arranged some of the photographs into groups that go beyond this
first simple system of ordering by time and place (and person), and
she gave additional hints on how to read the *Sociological Record*
through subheadings including, *Women on Doorsteps*, *Professions*, *Land-
scapes & Ceremonies*.

However, she neither wanted nor was able to establish
a system, just as she was unable to complete her manic project of docu-
menting all the houses of rural Poland and their inhabitants. How
could she succeed? After all, she began her project only in the later
years of her life.

Today, from a vantage point of almost three decades
after the forced ending of this project, an encounter with *Sociologi-
cal Record* clearly shows the great responsibility entailed in giving it
direction and continuing to explore it as an artistic project. The dig-
itization of data and the availability of this archive via a dedicated
homepage,[2] which also contains interviews with the artist, a selec-
tion of her letters, and some secondary material, is a first step
toward making the artist's great life's work accessible. The structure
of the website allows the user to apply the various criteria mentioned
above, to reconstruct the artist's handling of the material, and to
arrange the images in ever new orders. As Allan Sekula once observed,
the camera with its functional principles and its pictorial products
is only a part of a larger structure: "The central artifact of this sys-
tem is not the camera," he noted, "but the filing cabinet."[3] This cer-
tainly applies to Rydet's project, involving as it does more than the
optical model of the camera itself, which creates a "truth-appara-
tus"; it also brings with it systems of archiving. The digital process-
ing and organization of Rydet's data focuses on this moment of the
variability of orderings. The question is, which folder do we want to
pull out to further classify Rydet's project, which story is to be told,
do they all consolidate into a "grand narrative"? In other words, how
does one get a grasp of the artist and her project, and make certain
statements about the *Sociological Record*?

2 See http://www.zofiarydet.com.
3 Allan Sekula, "The Body and the Archive," *October* 39 (Winter 1986): 16.

It is now possible, as it has been in a variety of artistic projects, especially photographic ones, over the past two decades, to place Rydet's approach in the context of conceptual practices which began to establish themselves in the 1960s. It is not the artistic desire for expression that is the focus of such projects, but rather the idea itself, the implementation of which is carried out according to a preestablished set of rules: with a sober documentary roughness, temporally linear photographic images form a series without a hand that would arrange them so. Indeed, Rydet had the idea to document all the houses of (rural) Poland and their inhabitants. She pursued this project as long as physically possible for a period of thirteen years. Her approach to this idea does not lack a conceptual core; on the contrary, the artist is strikingly systematic, beginning, at sixty-seven years of age, to snap some locations with the camera, developing different modes of the pictorial process, and continually maintaining these until the end. All throughout, there are neutral, objective exterior views of houses, photographed from a distance, which almost always show the entire home (and hardly any details, such as architecturally interesting peculiarities or signs of decay, etc.). All throughout, she shows householders in the doorframes of their houses. All throughout, she shows workers and villagers with their tools. All throughout, she places householders in their living quarters on armchairs, sofas, or beds, either alone or in pairs, depending on who she encountered during her expeditions. All throughout, they are surrounded by things which characterize the particular ambience of their living quarters more specifically. She achieves this with the formal and pictorial decision not only to show parts and details but to be as comprehensive as possible. She places her protagonists in front of a wall and photographs them in their entirety. Through this stylistic means, she achieves the effect of people in her pictures beginning to merge with the sometimes over-decorated walls. It is often not at all clear what is at the center of the image: the householders placed in the middle of the picture and portrayed in this way, or the living environments that surround the sitters. Her decision to visit and photograph various places after an interval of

sometimes ten years or more, and to capture changes, is also a typical conceptual approach, in terms of both idea and methodology.

Rydet has therefore developed a methodically strict pictorial method for her *Sociological Record*, a set of rules that extends even beyond the above-mentioned patterns of site visit and image structure. For instance, her protagonists look at the camera with a stern face and, despite the special situation of sitting for the photograph, they wear their everyday clothes.

All these moments make it seem legitimate to place the work of Zofia Rydet in the context of historical conceptual art. At the same time, however, the very title of her project, *Sociological Record*, indicates that underlying her work is a clear intention which may run counter to conceptual practices. She does not limit herself to soberly naming what she captures in her pictures according to her subcategories, but instead assigns it a "sociological" function from the very beginning, with the adjective applied to the overall project. Her *Record* (a project that she had already outlined in the early 1970s in her letters) is therefore to be understood as a study by which she wants to reach conclusions about rural Poland and its inhabitants, from 1978 onwards; however, not without having first set predefined "objective criteria" for her photographic empirical investigation, which led to her specific pictorial procedures (see above). One can indeed describe these strictly regulated pictorial methods as a conceptual method. However, is Rydet's approach to her theme, i.e., her wish to gain an insight into the social structure of rural Poland in 1978 and to describe the living conditions and lifestyles within this specific space, as the title of the work suggests, also compatible with the deeper principles of conceptual art as they had already been established? Not really. Rather, her work seems to come from a sociodocumentary approach (emerging from the tradition of amateur photography), whose status was well-established specifically at that time (1970s). At this point, one must recall that with the emergence of conceptual art (in the US), the already prevailing ideas about the effects of the photographic image as a (social and political) pictorial document were largely undermined from the 1960s onwards. Benjamin H. D. Buchloh writes about "de-skilling," and the

de-historicization of the historical (but significant) photographic document, in relation to the conceptual practices that emerge from this time onwards, including in the work of artists such as Ed Ruscha, Dan Graham, and Douglas Huebler. He describes their style as a form of "anti-photographic photography"[4] arising from the negation of technically sound and skilled access to the photographic apparatus. However, it is with this negation, Buchloh argues, that historical documentary photography is not only de-skilled as an artistically or technically important medium, but also depoliticized.[5]

Is such an idea of conceptual art compatible with how Zofia Rydet saw her own work, although she started it much later, only in the late 1970s? Does not Rydet's passionate devotion to her medium, which she tirelessly and repeatedly emphasized in interviews, speak another language? And are the goal-oriented objective criteria of image structure not to be understood as stylistic features of a specific sociodocumentary approach, which emerges from the late 1970s on and allows her, for example, to work with her photographs against how socialist Poland saw itself and the concomitant image of the heroicized working class? Conceptual art corroborated the assumption that work can be carried out as if by itself thanks to mechanical access to the photographic apparatus; and that narrative forms and subjectivation can thus be circumvented. Photography, as a universally available medium whose handling was made "easy" by its technical features, and which could be used by almost anyone thanks to the industrial development of film, was also close

4 See Benjamin H. D. Buchloh, "Darcy Lange: Paco Campana," in *Darcy Lange: Study of an Artist at Work*, ed. Mercedes Vicente (New Plymouth: Govett-Brewster Art Gallery; Birmingham: Ikon Gallery, 2008), 50.

5 "[...] it should be understood that they [Victor Burgin, Jeff Wall, Fred Lonidier, Martha Rosler, Allan Sekula—addition mine] shared not only an interest in the history of documentary photography and its recovery, but also the historical urgency with which they wanted to redefine questions of photography theory and artistic practice in opposition to the massive de-skilling and de-historization that photography had suffered at the hands of Pop artists and the conceptualists assault on the referentiality and historicity of photography [...]. Yet all of these artists initiated various projects of the recovery of the documentary dimension of photography and its tradition, the recovery of the photographic referent, and of narrative, in short, the recovery of all of the social and political functions photography had once presumably performed." (Ibid.).

to conceptual art. Other stylistic features of conceptual art are resistance to the picture's compositional qualities; its archival aesthetics, which begin to establish themselves spontaneously and decentrally by means of the serial and mechanical exercise of previously established rules, and the question of how one is to "read" photographs.[6] Thus, we have learned to read, for example, Ed Ruscha's serial photography work *Every Building on the Sunset Strip*—now an icon of American conceptual art—neither as a typological study of the most famous street in Hollywood and its buildings, nor as a photographic documentary of specific social and societal relations that are communicated in the images. Rather, Ruscha's aggressively banal—and yet formally effective—pictorial methods reveal the desolation of the Strip, by which he succeeds in debunking a much-touted American myth.

At the center of all these moments characterizing conceptual art lies the rejection of a mediating authority between the author of the image and the viewer. Again, citing Buchloh: "The programmatic absence of agency and the elision of authorial determination were thus common to all of these operations. In fact, precisely these absences made up the radicalism of these artistic practices, imbuing them with a momentary critical potential."[7]

The advent of conceptual art in its radicalism implies a decisive paradigm shift in twentieth-century art. As already noted, the documentary image is put in doubt as a reality-imbued medium. Can it still claim to be of meaning, as image? The question arises with later artists, such as Allan Sekula and Martha Rosler, who perpetually tackle it in their theoretical writings. Not only is there, at the time, little explicitly political critical reflection on the genre of documentary photography, but their works specifically aim to reexplore the space of photographic images in order to make the documentary productive (once again) as a site of political intervention.

Sekula's theoretical writings, in particular his essay "Dismantling Modernism, Reinventing Documentary (Notes on the

6 "Furthermore [conceptual art] supposedly liberated both the author and
 spectator from reading conventions tied to the privileges of an educated
 audience." (Ibid., 54).
7 Ibid., 53.

Politics of Representation),"[8] first published in 1978, are exhorta-
tions to reappropriate the documentary image as a place of politi-
cal commentary in social contexts. However, Sekula saw no need to
criticize conceptual art in this vein. Despite the historical documen-
tary image successfully entering the museum space, where it was
stripped of its social effectiveness and turned into an icon, Sekula's
profound analysis allowed him to make the contingency of a photo-
graphic image productive. The simple realization that different con-
texts of presentation decisively determine how the work is received
allowed him not only to highlight the representative character of the
photographic image but also to emphasize social responsibility in
the field of image-making and display, suggesting the possibility of
an intervention. He provided a resounding no to the aestheticized
political nostalgia that predominated the reception of documentary
photography at the time, and not only through its visual presenta-
tion in the context of the museum (which in the field of conceptual
art may have contributed to its disavowal):

> Documentary photography has amassed mountains of
> evidence. And yet, in this pictorial representation of
> scientific and legalistic "fact," the genre has become a
> much more spectacular spectacle, contributing to ret-
> inal excitation, to voyeurism, to terror, envy and nos-
> talgia, and only a little to the critical understanding of
> the social world. A truly critical social documentary is
> the framework of the crime, the trial, and the system
> of justice and its official myths. Artists working toward
> this end may or may not produce images that are the-
> atrical and overtly contrived, they may or may not pre-
> sent texts that read like fiction. Social truth is some-
> thing other than a matter of convincing style.[9]

In the field of art, therefore, Sekula appeals for a
(renewed) critical and reflexive approach to the photographic image,
emphasizing the necessity for objective criteria and for the "fram-

8 Allan Sekula, "Dismantling Modernism, Reinventing Documentary (Notes
 on the Politics of Representation)," *The Massachusetts Review* 19, no. 4
 (1978): 859–83.
9 Ibid.

ing" of images as a central issue, and thus calling for the kind of art
"that points openly to the social world and to possibilities of con-
crete social transformation."[10]

 Sekula's own photographic work will later not only be
accompanied by text, which represents a critical commentary on the
depicted social and political conditions and at the same time deter-
mines the reading of his pictures, but its themes will concentrate on
the subject of work and working conditions: "As a whole we can say
that labor has been absent from the representational field of mod-
ernism and Allan Sekula is one of the first artists [...] who has broken
with this prohibition and made it evident that labor is of course the
central condition of human self-constitution and self-definition."[11]

 Rydet begins her *Sociological Record* exactly at a time
when the discussion about the status of documentary image as a
social document is rekindled by artists such as Sekula. Additionally,
Pierre Bourdieu's *La distinction. Critique sociale du jugement*[12] is pub-
lished in 1979, a comprehensive empirical study of different lifestyles
in (French) society, whose specific characteristics (in terms of taste,
religion, and politics) are attributed by the sociologist to the respec-
tive social status of humans in a society steeped in hierarchies and
values, of which he gives an impressive account in his study based
on in-depth interviews.

 If one wants to make room for these two moments in
the study of Rydet's photographs—Sekula's call to comprehend pho-
tography as a socially effective medium and Bourdieu's methodol-
ogy of an "interpretative sociology whose aim it is to apprehend
social actors in their respective necessity and to comprehend why

10 Ibid.
11 Benjamin Buchloh, speaking at "Forgotten Spaces: Discussion Platform
 with Benjamin Buchloh, David Harvey, and Allan Sekula," at a screening of
 The Forgotten Space (dir. Allan Sekula and Noël Burch), at The Cooper Union,
 New York, May 2011, accessed October 10, 2017, https://vimeo.
 com/24394711.
12 Pierre Bourdieu, *Distinction: A Social Critique of the Judgement of Taste*, trans.
 Richard Nice (Cambridge, MA.: Harvard University Press, 1984). Originally
 published in French as *La distinction. Critique sociale du jugement* (Paris:
 Éditions de Minuit, 1979).

they act and live as they do and not differently"[13]—then the archive of Zofia Rydet's images clearly appears as a project that is guided by a specific interest in knowledge, even though she formulates it exclusively through her images and has hardly ever expressed her intentions clearly in political terms (for example, in interviews).

In contrast to Sekula, the images by Zofia Rydet are only sparingly framed by textual material. Nevertheless, she typologizes the apparatus of her photographic documents with the paths she takes into the picture and with her textual categorizations, since this apparatus organizes itself through internal similarities, no matter how the viewers enter the archive. The photographs begin to depict social orders in which people and their work are at the center; people who have neither the material nor the symbolic means to— yes, why not resort to a little exaggeration—leave a trace in history. In the sense of Bourdieu's concept of "participatory objectification,"[14] Rydet succeeds with her *Record* in taking the presumed uniqueness of an experienced moment—a moment that the artist, as we know from her own accounts in interviews, conjures up over and over again during the brief interaction with her protagonists, for example, highlighting the individual beauty of the person and their home environment as her motivation for taking the photograph and justifying it in the same way to her protagonist—and using it to establish a kind of universally accessible memory trace bearing pictorial witness. At the same time, her typologizing photographic approach is crucial. Thanks precisely to the interweaving of individual interest with the distance established by the formal devices of the camera lens, the images are endowed with a context-specific social meaning in Sekula's sense, their political dimension impossible to deny. The *Sociolog-*

13 Franz Schultheis, "Objectification as a Profession: Pierre Bourdieu's Photographic Testimonies of Algeria in the Sixties," *Camera Austria International* 76 (2001): 4.
14 "If Bourdieu has long preferred the concept of 'participatory objectification' instead of the usual concept of 'participatory observation' to describe his own idea of field research, this preference assumes even greater consistency in view of the analogy emerging now between the photographic and sociological view: in both cases the aim is to lend the supposed uniqueness of a subjectively experienced moment the character of a permanent and intersubjectively accessible mnemic trace, a 'testimony' as Bourdieu will say four decades down the road in his famous study *The Weight of the World*." (Ibid.).

ical Record provides a wealth of evidence for grasping the specific
habitus of Poland's rural population: the individual lives, molded by
harsh, exclusively physical/manual work, poverty, simplicity, and
religiosity.

I am hardly aware, in the history of German photogra-
phy of the 1960s and 1970s, of a photographic project with the enor-
mous scope (without being divided into individual work series) of
Zofia Rydet's *Sociological Record*. One exception—drawn from the wider
field of art—can be found in the work of Marianne Wex, which displays
similar intensity and intransigence in the face of confrontation,
although Wex's project was based on a completely different intention.
In the period from 1972 to 1977, the artist took over 5,000 photo-
graphs of men and women and introduced an extensive image order-
ing system of typology, by means of which she examined the different
body languages of the sexes. Her project culminated in the publica-
tion *"Let's Take Back Our Space": "Female" and "Male" Body Language as a Result
of Patriarchal Structures,*[15] a self-explanatory title that describes the
results of her photographic expeditions and makes the artist's posi-
tion with respect to her pictures very clear. The book appeared in
1977, at a time when Marianne Wex resigned from artistic pursuits.
Nevertheless, this work—which was to be her only photographic
work—remained for a long time an enormously important reference
point for feminist studies then slowly developing in the German-
speaking world. As with the work of Zofia Rydet, the work of Marianne
Wex is now, after four decades, undergoing an international renais-
sance, as demonstrated by a large number of individual exhibitions
and contributions to exhibitions. Today's reception of Wex's work is
that of an individual emancipatory gesture of the liberation of the
artist from social norms, or else it puts her work in the realm of con-
ceptual art—an obvious option, especially because it seems (and is)

15 Marianne Wex, *"Let's Take Back Our Space": "Female" and "Male" Body Language as a
Result of Patriarchal Structures* (West Berlin: Frauenliteraturverlag Hermine
Fees, 1979).

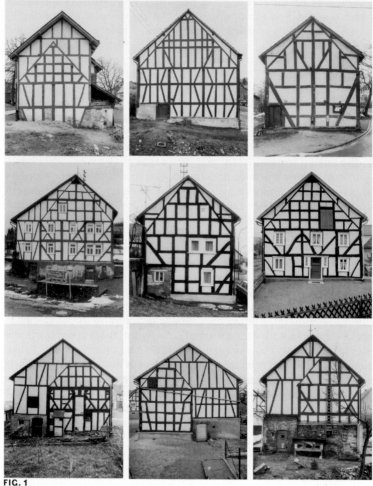

FIG. 1
BERND AND HILLA BECHER, *FRAMEWORK HOUSES OF*
***THE SIEGEN INDUSTRIAL REGION*, 1960–73**

difficult today to turn heteronormativity, which emerges from her photography series, into something productive in any other way.

The reference to Marianne Wex, however, should remain a marginal note. Despite the impressive scope of Wex and Rydet's respective projects, their typologizing processes are not really related to each other because their subjects are very different. While Wex simply "sees" the differences between the sexes and uses the photographic results of her targeted search as an admittedly more or less unequivocal proof of the patriarchal social order, Rydet approaches her project in the opposite way: not only does she introduce the "objective" criteria of site visit and image structure, which she conforms to in her photographs in any situation, no matter what or who she meets, but she also presents her project from the outset as interminable. Only with the photograph of the last house in Poland and its inhabitants would her project theoretically come to an end—practically an unattainable goal, especially if the reexploration of almost forgotten regions and locations of equal conceptual importance was conceived in order to keep a record of changes in social order and communal life.

If, nevertheless, one wants to see the work of Zofia Rydet *also* in the context of conceptual practices and make a comparison with the scene in Germany at that time, then, against this background, surely a reference to the work of Bernd and Hilla Becher would be most promising. [FIG.1] The comparison involves not only their typological recording process, which they had pursued since the 1960s until the end of their activities, but also, and above all, their insistence on the technically perfect picture. It was precisely with the latter that the Bechers clearly distinguished themselves from the conceptual principle that had emerged in the United States, which rejected a technically sound and crafts-based photographic style. On the contrary, the artist couple explicitly linked their work to New Objectivity and achieved a synthesis of tradition and concept with a combination of a strongly objective photographic style and the arrangement of images into sober documentary series.[16] The inclu-

16 See Susanne Lange, *Bernd & Hilla Becher. Leben und Arbeit* (Munich: Schirmer Mosel, 2005).

sion of their oeuvre in the context of international conceptual art from 1972 onward, with their participation that year at Documenta 5 and a subsequent exhibition at the Sonnabend Gallery in New York, in 1973, has, above all, helped us to understand and appreciate the Bechers' documentary photographic work as an *artistic* practice, with the reception of their work contributing significantly to an understanding of contemporary photography as art.

And indeed, Bernd and Hilla Becher and Zofia Rydet followed similar interests: the Bechers have, among other subjects, systematically photographed industrial plants in the Ruhr region and beyond, including mining towers, blast furnaces, and coal bunkers. They were documenting structures slated to be demolished in the wake of the steel and coal crisis of the 1970s and 1980s, and in so doing created an impressive testimony of a disappearing industrial culture. Likewise, Rydet's project was driven by the sense that the rural structures of Poland would radically change. Rydet's deliberate and repeated reexamination of various rural dwellings, which she often found in ruin during her repeated visits, clearly shows that specific architectural styles, typical of farm life in Poland, were at a risk of disappearing from the map.

Just like the Bechers, Rydet worked with the understanding that changes over time would pose a threat to the function of various structures, but that it was still worthwhile to capture these structures in pictures, as memories of a bygone era. And just like the Bechers, who compiled their pictures into tableaux, Rydet also embraced the concept of the series, with which she systematized her access to pictorial objects and mapped out typologies. The Bechers understood their work as a form of archaeological practice. Such an understanding can also apply to Zofia Rydet and her working style, though with the focus on typical rural architecture. A link can also be traced here to the Bechers' *Framework Houses* series (1960–73), in which they photographed traditional half-timbered houses in the Siegerland region of Germany.

There is, however, a fundamental difference between Rydet and Bernd and Hilla Becher. Although Rydet also places her pictorial objects almost continuously in the center of the image,

works with the means of a central perspective, and largely finds a neutral sky, her images—unlike those of the Bechers—are far from being devoid of human presence. If, from the great body of Zofia Rydet's pictures, one was to first eliminate all those images which show people, one would arrive at a most sober typology of lost Polish rural architecture. At the same time, it is clear that Rydet could not decide, at the pictorial level, for the erratic sublime emerging for the viewer from the industrial facilities photographed by Bernd and Hilla Becher and from the half-timbered houses they photographed. This may be credited first and foremost to the fact that in rural areas there is always something more than a pictorial ideal: the houses are surrounded by odd objects, they are embedded in nature with all its unevenness and growth. In addition, there is nature shaped by human hand, inevitably also present in the picture, like mown meadows or parcels of land demarcated by fences, gates, and hedges. Materials of handicraft, wood piles, equipment, and furnishings complete the picture. All these things, which are simply out there, too, and which are clear evidence of a different (living and working) reality than an industrial plant that has been planned and operated by a company, in which people spend only part of their time, almost always inevitably slip into Rydet's pictures. Not only would the photographer not have been able to decide which "objective" representation belongs to the picture, and which does not; even if she were concerned "only" with the photographic representation of pure architecture, it would be hardly possible for this nomad to create such a situation: on the one hand, the intervention into private living space would have been too massive; on the other hand, the burden of labor too excessive. In Zofia Rydet's *Record*, the focus of the work of photography is on an approach that typologizes the photographed objects, but the conditions of the photographic situation as well as the formal aesthetic concepts differ from those of the Bechers.

If one attempts a deeper comparison with typologizing photography, and at the same time seeks further references to the so-called Düsseldorf School, as it began to establish itself with Bernd and Hilla Becher, there follows a comparison with Thomas Ruff's *Inte-*

riors, which he photographed from 1979 onward in the apartments of his family and friends in southern Germany. The extensive series offers detailed views, as well as full room views, of German interior living culture with its typical styles from the 1950s to the 1970s. However, as early as his colleague, Andreas Gursky, Ruff turned to a photographic style with which a single image is conceived as exemplary of a situation. Here, typology is not established with the bundling of different views of one and the same subject into a series; what is typical of a given time results, rather, from the search for something representative, something "average," which is schematically zoomed in on and showcased specifically in the detailed views. Despite his objective photographic style, Ruff does not, therefore, objectively present what he finds. With this stylistic means, in his series *Interiors*, Ruff succeeds in producing atmospheric images, causing a certain discomfort and invoking the inhibited petit-bourgeois postwar atmosphere which prevailed until the late 1970s. For Rydet, too, the furniture and decor that she found in houses may have been a decisive factor in how she framed her picture, thus putting her formally in close proximity specifically to the series of *Interiors* by Ruff. Contrary to Ruff, she withdraws herself from valuation; nothing in her pictures generates resistance to what is seen, a resistance that underlies the Ruff series like an accompanying sound.

Although Rydet's pictures can be compared with examples such as the Bechers' and Ruff's, where the typologizing character of her works becomes palpable through such comparison, it is at the same time hardly possible to look at her work in a way which puts people aside. Even though the works of Bernd and Hilla Becher show that the imminent demolition of industrial architecture is also an expression of changing production conditions and the resulting changes in working relations which have an impact on the population structure of whole regions, what is central in the works of the Bechers is their view of architectural manifestations. They are depicted not only as an expression of a specific time coming to an end, but they also assert themselves in terms of their beauty. It is precisely with the ever-increasing temporal distance, as the origi-

nal use or function of the industrial plants recedes, that the build-
ings' individual beauty comes to the fore.

Rydet, however, does not prioritize aesthetic choices
or beautify her subject, even if in interviews she always talks about
the beauty of the simple things that sparked her interest in the pro-
ject and which, for her, was reason enough to pay attention to the
objects in her images. Rather, she wants to get closer to the concrete
realities of her protagonists.

Against this background, the sociodocumentary pro-
jects which emerged from the 1970s onwards in Germany are even
more useful as material for comparison, because here, the social sit-
uation—something Rydet was conscious of and that transpired in her
work—is always directly present in the pictures. The Werkstatt für
Photographie [Workshop for Photography] founded in 1976 by Michael
Schmidt at the Volkshochschule in Berlin-Kreuzberg, and active until
1986, provided the stylistic foundation. The fact that the achieve-
ments of this Berlin training facility for photographers (at this time,
the study of photography was not yet part of the curricula at art acad-
emies in Berlin) was only extensively presented in a three-part exhi-
bition, in Berlin, Essen, and Hanover, in 2016, accompanied by the
first survey catalog,[17] not only furnishes evidence around the debate
on sociodocumentary imagery in the German context, but also today
expands the view on contemporary photographic art from Germany
beyond the Becher School by adding important and decisive facets.[18]

17 The exhibitions, organized around the "Werkstatt für Photographie
 1976–1986," include: The Rebellious Image, Museum Folkwang Essen,
 December 9, 2016–February 19, 2017; Kreuzberg – Amerika, C/O Berlin,
 December 10, 2016–February 12, 2017; Und plötzlich diese Weite, Sprengel
 Museum Hannover, December 11, 2016–March 19, 2017; joint publication:
 Florian Ebner, Felix Hoffmann, Inka Schube, Thomas Weski, eds., Werkstatt
 für Photographie 1976–1986 (London: Koenig Books, 2016).
18 Florian Ebner, Felix Hoffmann, Inka Schube, and Thomas Weski, "Einfüh-
 rung," in Ebner et al., Werkstatt für Photographie, 13: "From the dialogue
 between recognized photographers and amateurs, between technical
 mediation and content criticism, and on the basis of documentary
 approaches, a special artistic attitude emerges, which will be character-
 ized by its specific take on reality over a long period of time. The Photog-
 raphy Workshop, which operated until 1986, attained international
 recognition thanks to intensive mediation work through exhibitions,
 workshops, and specialized courses, and initiated a transatlantic
 dialogue on photography in Europe."

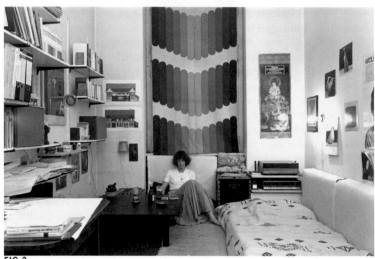

FIG.2
WILMAR KOENIG, *HEIDI*, 1975

FIG.3
WILMAR KOENIG, *SCHOSEL FAMILY*, 1976

Michael Schmidt, who himself had completed no academic training as a photographer but found his medium and style as an autodidact, gradually withdrew as director a few years after the successful initiation and institutionalization of the Werkstatt to devote himself to his own artistic practice. Wilmar Koenig, one of his earliest pupils, became a central figure in the instruction process (later to be joined by the artist Gosbert Adler). Koenig had an important mediating function, especially since he strengthened the transatlantic dialogue and brought several American photographers (Ralph Gibson, Larry Clark, William Eggleston, etc.) for workshops at the small school in Berlin. However, it was Koenig's early work, which he showed in the Werkstatt's gallery, in 1977,[19] that became, specifically in this context, an important bridge between an objective photographic style (as it also applies to the Bechers) and a human-oriented sociodocumentary approach. The approximately 145 Portraits (1976–77) in which Koenig shows people in their living environment, emphasize, on the one hand, the artist's strictly objective documentary approach based on technical skills. On the other hand, his works, just like Rydet's project, are sociologically motivated. His protagonists, who unlike the people photographed by Rydet emanate a high degree of urban-coded individualism, provide direct hints—through the things with which they surround themselves, their personal clothing preferences, their location in the room—as to their taste and lifestyle, and thus the social relations in which they operate. Thanks to the photographs, their social habitus in Bourdieu's sense crystallizes, leaving a trace in the photographic document. [FIG. 2–3]

Michael Schmidt's wanderings through the city of Berlin and especially "his" districts of Wedding and Kreuzberg can also be interpreted as sociological investigations of urban space (in this case) and its inhabitants (in Rydet's sense). Schmidt's 1978 book Berlin-Wedding,[20] for example, is divided into two sections, one of which shows city views of the district of Wedding and the other, portraits of its inhabitants. Schmidt does not in any way work toward a picto-

19 "Wilmar Koenig und Jürgen Frisch," Werkstatt der Photographie der
 Volkshochschule Kreuzberg, Berlin, October 31–December 2, 1977.
20 Michael Schmidt, Berlin-Wedding (Berlin: Galerie und Verlag A. Nagel, 1978).

rial ideal, although the technical quality of this work in grayscale and
the formal elegance of the images remain impressive. Schmidt
rejects traditionally representative views of the city and its architec-
ture, which rely on an overview, completeness, and finality, even if
his image composition always remains formally captivating thanks
to the geometry and structural cohesion of the image. He deliber-
ately brings the abyss of the urban space to the pictorial surface:
brownfields, fire walls, crumbling concrete, irregularities in the road
surface, etc., all lead him through city space, also in detailed views,
and leave it as an open, constantly evolving (or eroding) project with
loose ends. With this approach to the picture, in which technically
generated objectivity and subjective views closely intertwine,
Schmidt creates a kind of critical commentary on the concept of land
rehabilitation which prevailed at that time, with the then-peripheral
districts (what is today, after the fall of the Berlin Wall, Berlin's center)
being demolished and rebuilt, a phenomenon the district was partly
able to resist.[21] [FIG. 6]

 Michael Schmidt is clearly pursuing a sociodocumen-
tary project here, as illustrated by the second section of *Wedding*, at
the center of which are the district's residents. [FIG. 4–5] Interest-
ingly enough, his conceptual approach emerges here once again,
determined not by meandering through the urban areas of residen-
tial life but with clear targets. Not only does he seek out people in
their home environment, he also portrays them at their respective
workplaces and names their job positions in the titles: *Chief City
Inspector, Social Worker*. He places the resulting images one next to
another, a decision with which he not only tries, as comprehensively
as possible, to represent the social situation in which his protago-
nists stand; he also provides the viewer with an opportunity to adopt
ideas about these people by offering a comparative view. However,
one thing is clear in Schmidt's projects and in those of numerous
other artists' linked to the Werkstatt für Photographie: their photo-
graphic style is not underpinned by a typologizing procedure but

21 See Felix Hoffmann, "Über Grenzen," in Ebner et al., *Werkstatt für Photogra-
phie*, 232.

FIG. 4
MICHAEL SCHMIDT, *LOCAL POLITICIAN OF THE*
***CDU PARTY*, FROM THE SERIES *BERLIN-WEDDING*,**
1976–78

FIG. 5
MICHAEL SCHMIDT, *LOCAL POLITICIAN OF THE CDU
PARTY*, FROM THE SERIES *BERLIN-WEDDING*, 1976–78

FIG. 6
MICHAEL SCHMIDT, *MÜLLER-/SEESTRASSE*, FROM
THE SERIES *BERLIN-WEDDING*, 1976–78

results from a combination of technical skills and a strictly objec-
tive, yet also subjective, regard of the preexisting situation:

> Perhaps it's time to remember that the "aesthetics
> from a distance" and the photographers working on
> the *subjective view* and the *apparatus image* had their
> common roots in the aspiration to leave behind, by
> expanding beyond, the classic documentary paradigm
> and the topographic image of the 1970s.[22]

From this dialectics of presumed objectivity and sub-
jective detail emerged the social documentary of the image and a
new photographic style in Germany. With this development, the
social situation and societal reality that characterized West Germany
at that time became tangible, unlike in the purely typologizing pro-
cess such as that of the Bechers.

In East Germany, artists were also looking for ways of
visualizing the social or sociopolitical situation in documentary pro-
jects: images in which "neither the objective content nor the subjec-
tive intent of these works was really compatible with the triumphant
rhetoric so prevalent in the mass media."[23] In this context, sketching
the similarities between Zofia Rydet and the photographers and art-
ists Christian Borchert and Ulrich Wüst is particularly relevant.

In 1978, at the same time as Zofia Rydet, Christian
Borchert decided to create a series of group portraits: his "family
portraits." [FIG. 7–8] At first he carried on with the project until 1984.
Previously, he was forced to abandon his profession as a photore-
porter for political reasons and worked as a freelancer starting from
1975. His objective, detached documentary photographic style is
similar to that of Wilmar Koenig, who was more or less contempora-
neously preoccupied with his series of *Portraits* taken in his friends'
homes in West Berlin. Borchert portrayed families, mostly in their

22 Florian Ebner, "Was hat das Bild mit Dir zu tun? Über eine rebellische
 Generation und ihre Suche nach einer anderen Fotografie," in Ebner et
 al., *Werkstatt für Photographie*, 285.
23 Ulrich Domröse, "Reality, Engagement, Critique," in *The Shuttered Society:
 Art Photography in the GDR: 1949–1989*, exhibition catalog (Berlin: Kerber,
 2012), 300. The catalog accompanied the first comprehensive survey of
 art photography in the GDR, "Geschlossene Gesellschaft. Künstlerische
 Fotografie in der DDR 1949-1989," at the Berlinischen Galerie in Berlin
 (October 5, 2012–January 28, 2013), curated by Domröse.

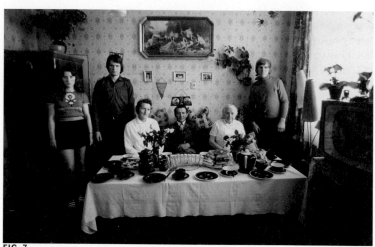

FIG. 7
CHRISTIAN BORCHERT, *CELEBRATION WITH THE FAMILY ON THE OCCASION OF THE SUCCESSFULLY PASSED EXAM (SKILLED WORKER FOR TELECOMMUNICATIONS INSTALLATION)*, 1974

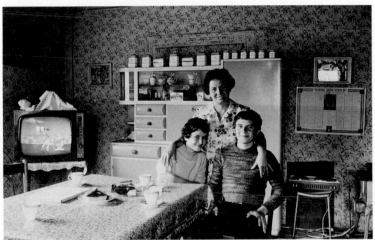

FIG. 8
CHRISTIAN BORCHERT, *MOTHER WITH
CHILDREN IN THE KITCHEN ("THE FLINTSTONES"
ON TELEVISION)*, 1977

homes. In contrast to Koenig, he did not refer to his protagonists by name but used the professional titles of the parents in the pictures to hint at their activities and thus to indicate their social standing. It seems plausible that Borchert's models collaborated in defining the form of their own visual representation as they showed themselves in different rooms: sometimes in the living room, sometimes in the kitchen, sometimes in bed; oftentimes standing, sitting, or lying down. The motivations that led Koenig and Borchert to their images share a familial link: the desire to provide information about the social relations in which people operate. At the same time, the way of life depicted in their respective photographs is rather different, likely due to the different political systems in which people in a divided Germany lived at that time. In West Germany, especially in the late 1970s and particularly in the leftist, alternative West Berlin, expressions of individualization were of significance. As a matter of fact, Koenig encountered hardly any couples or children during his expeditions. His pictures speak to the fact that it was "a room of one's own" that was important, one in which working, living, and sleeping often blended seamlessly. The pictures taken by Borchert, on the other hand, testify to early family planning, which was customary in many parts of East Germany (among other reasons, in order to receive one's own living space from the state, outside the parental home). This difference also informs the way in which social relations are described: in the case of Koenig, the individual (clothing) style of the people and their posture in space are foregrounded, while in Borchert it is more the interaction of the family members that organizes one's perception of the image. The respective living environments also play a part, as identity also expresses itself in the things people surround themselves with. With a view to the work of Borchert, Ulrich Domröse notes that his concept of serial work opens up possibilities of a comparative view which goes beyond the individual family portraits, recognizing the societal critique inscribed in this work. However, Borchert did not stop at the 180 pictures that he had taken up until 1984. In 1992–93, he reinitiated his "hand-

crafted precise [...] social protocols"[24] and visited once again the
same families to document the changes in their lives after the fall of
the Wall. Borchert's biography as a photographer, connected to his
personal quest for an unmoored existence, but also to the manner
he himself used to describe his photographic endeavor, makes it
clear that he was committed to creating sociodocumentary images:

> What interests me in photography is to establish com-
> munication. But I wish that it should be just, precise,
> and without exaggeration or fireworks, in keeping with
> the situation, so that others—now or later, or in other
> places—can get an idea of situations and circum-
> stances. It is a photography against disappearance.[25]

Not only did Borchert's perception of his own work
dovetail with Rydet's approach, but so too did his conceptual intent.
Both photographers used sober, documentary stylistic means ena-
bling them to adopt an objective distance to the place where the
photograph is being taken and to the people being depicted. Both
worked in serial relations in which a comparative view becomes pos-
sible, but did so without leaving out the specificity of the situation.
Both decided to visit the places they had photographed after an
interval of time in order to document changes. They were able, as a
result, to gain a deep insight into the life and reality of their protag-
onists, free and independent of a superficially agitative assignment.

Ulrich Wüst also began to take photographs in the
1970s. He was an architect by training but "[...] the futility of his pro-
fessional efforts drove him away from this career."[26] People are rarely
present in his photos; until this day, he concentrates mainly on archi-
tecture, a decision which Felix Hoffmann explains, on the one hand,
in formal terms, with the architectural vision of Wüst's, and on the
other hand, in political terms, as a pictorial language which makes
palpable "the absence of civic society in the GDR."[27] Unlike Rydet,

24 Detlev Lücke, "Protokollist der Städte und Familien. Nachruf auf Chris-
tian Borchert," *der Freitag* (Berlin), July 21, 2000.
25 Ibid.
26 Domröse, "Reality, Engagement, Critique," 303.
27 "Ulrich Wüst: Stadtbilder/Spätsommer/Randlagen." Exhibition curated
by Felix Hoffmann. Berlin: C/O Berlin, 2016. Press release notes.

FIG. 9
ULRICH WÜST, *KARL-MARX-STADT*, FROM THE
SERIES *STADTBILDER*, 1982

Wüst's pictures communicate a direct and radical dissatisfaction with the preexisting situation. [FIG. 9]

Ulrich Wüst captures immediate surroundings in a manner that is not neutral but prevalently austere. The city of Magdeburg is a constant in his work, during and beyond the times of the GDR. But his recurring worlds include the rural area of Uckermark, small towns in the East, as well as East and (after the reunification) West Berlin, too. His photographs present orphaned East German urban landscapes and, from the 1970s onwards, over a long period of time, gradually but decisively transform them into a vast series of pictures. In their motifs and compositional focus, they constantly speak to moments of stagnation in the era of Brezhnev. In this, Wüst follows a clear pictorial principle: "His compositions are thoroughly articulated, thought out down to the smallest detail, and influenced by a clear architectural sensibility. A defining quality of his work is the dialectic between ostensible objectivity and a precise attention to detail that is both subjective and subversive."[28] This striking characterization of the visual language of Wüst's suggests that his work should (finally) be read in the context of international debates on sociodocumentary images, while recognizing that this approach began to establish itself internationally from the 1970s onwards, not least in Zofia Rydet's *Sociological Record* in Poland. In contrast to Rydet and other photographers of the time, Wüst impressively succeeded in capturing societal reality almost exclusively by means of constructed surrounding space, a circumstance due to which Wüst's work has so far been considered mainly in the context of the pictorial worlds of Bernd and Hilla Becher. The absence of people, however, is more an expression of a "collective feeling of privacy and its culmination in emptiness and futility."[29] Or, to put it in the words of Dieter Roelstraete, who, in 2017, brought Wüst's work to Documenta 14 (curated by Adam Szymczyk), where it finally received

28 Ibid.
29 Ibid.

belated international acknowledgement: "It is quite telling that, in portraying this republic of idealized farmers and workers, Wüst opted to forego direct human presence in his imagery altogether: the *sozialistischer Staat der Arbeiter und Bauern* is symbolically devoid of its titular workers and farmers."[30]

If Christian Borchert says of his photographs that he wants to work with them "against disappearance," that is, to capture memory traces, then one must say of Wüst's images that they are surrounded from the outset by an "aura of loss."[31] Despite their documentary character, they are by no means "objective." Wüst worked hard with a sense of surrounding desolation and produced its image but without distorting it pictorially:

> To avoid accusations of obvious polemics, which would have undermined his efforts to spread enlightenment and provoke change, he offset his sober depiction of austerity with a strict but aesthetically persuasive idiom. Developing a preference for classical diagonal compositions with layered depth and a grey light that was richly nuanced and yet artistic in feel, he now dispensed with the strong black-and-white contrasts that he had been applying to his photographs of fragmented architecture.[32]

In line with this view, he is formally close to Michael Schmidt. But what also connects the two artists is the seriousness and reflexivity of confrontation, which will lead Michael Schmidt to his art book *Waffenruhe* [Ceasefire],[33] which presents a psychogram of the divided city of Berlin.

It must have been difficult for Ulrich Wüst to come up with his pictures as an artist, as demonstrated by the fact that their very first publication was a catalog of the Werkstatt für Photogra-

30 Dieter Roelstraete, "Ulrich Wüst," in *Documenta 14: Daybook* (Munich: Prestel, 2017), n.p.
31 Ibid.
32 Domröse, "Reality, Engagement, Critique," 303.
33 Michael Schmidt, *Waffenruhe* (Berlin: Dirk Nishen Verlag, 1987).

phie in West Berlin, *DDR FOTO*,[34] published in 1985 by the artists Cos-
bert Adler and Wilmar Koenig, who at that time directed the Werk-
statt and participated in an exhibition entering into a dialogue with
Wüst (and other photographers from the GDR).[35] It seems justified
to read together various works from that time, especially those by
Ulrich Wüst and Michael Schmidt.

However, concerning Zofia Rydet, it is by no means
merely an idea or central conceptual theme that stands behind
Rydet's project, through which her lifework would have been carried
out "almost by itself." On the contrary, Rydet insists on a technically
accomplished and crafts-based photographic document as a picto-
rial and artistic testimony. With her medium, she exposes memory
traces of a disappearing rural peasant culture. In doing so, she sys-
tematically focuses the lens of her camera on the decisive stylistic
features of buildings, both interiors and exteriors, producing typol-
ogies in the German tradition of the Bechers by way of arranging
interventions in the archive of images. At the same time, there is
much more to see in her photographs than sober observation. Were
that the case, if the perimeter of traces of the immediate "natural"
environment and the associated daily life was excluded from view by
the process of photography, the historicity of each individual build-
ing would have been equalized. This, however, is not what Rydet was
about. In her work, every building is an expression of an individually
lived biography.

At the same time, generalized social and societal rela-
tions are evident in the overview of her pictures, above all due to the
inclusion of people in their pictorial worlds. This allows for conclu-
sions to be drawn about the living conditions, working environments,

34 Cosbert Adler and Wilmar Koenig, eds., *DDR FOTO* (Berlin: Werkstatt für
Photographie, 1985).
35 The exhibition "DDR FOTO" was postponed several times. It was preceded
by extensive research and fieldwork by Gosbert Adler and Wilmar Koenig
in the GDR. Finally, the project was canceled as the GDR Staatlicher
Kunsthandel refused to export the pictures for the exhibition. In
response, Adler and Koenig decided to break up some of the already
printed catalogs and to hang the pages on the walls of the gallery. This
was the last exhibition at the Werkstatt für Photographie gallery. See also
Thomas Weski, "Kreuzberg – America," in Ebner et al., *Werkstatt für
Photographie*, 120.

tastes, and lifestyles of a specific population, even if it was not com-
pletely representative of rural Poland in its entirety between 1978
and 1990. What remains is a picture of life permeated by hard work
in all of its parts, characterized by conditions of poverty, with a sim-
ple lifestyle and a specific taste. With her systematizing effort, the
artist withdraws herself from valuation; nothing appears drastic,
deplorable, or necessarily lacking, even if this is objectively the case.
The artist neither glosses over nor glorifies the situation. Especially
with the last sociodocumentary projects of both East and West Ger-
man photographic art, Zofia Rydet's *Sociological Record* can be placed
firmly in an international context, in which technical mastery is at
the center of access to the photographic apparatus, in a character-
istic stance arising from the tradition of amateur photography find-
ing itself, in the 1970s, on the threshold of a slowly self-asserting
artistic autonomy. Thus, and with the systematic approach that the
artist deploys to control her project, Rydet succeeds in providing an
objective photographic record of the given situation. At the same
time, the pictorial research takes place in a specific social and socio-
political space, which inevitably positions itself before the camera
lens. The preexisting situations are simply too complex, but Rydet
did not want to yield to any limitations. On the contrary, she wished
to comprehensively "record" and bear witness, in all directions. The
artist must have acted in this spirit, even if she has left no refer-
ences—unlike her colleagues from the rebellious West Berlin and the
oppressed East Berlin—be they written or oral, that would suggest
an explicitly critical political stance.

Finally, the unequivocally open ends of the archive, in
the sense of the contingency of images already rendered productive
by Sekula, turn into a statement on the incompleteness of history
and historical connections. The paths already referenced in the
archive of the *Sociological Record* make it clear that various stories
begin to overlap. It remains difficult, if not impossible, to complete
the narrative in one direction and to affix it a meaning. Conversely,
the apparatus that exists beyond the photographs, the archive of
images, makes different interventions possible, and this is precisely
where its productive potential lies. However, no matter which path

we take to enter the archive of the *Sociological Record* and its images, the memory of a time can be read as a common vanishing point on the horizon of these photographs; a time which we may have not experienced ourselves or learned about from another perspective, but one which Zofia Rydet makes suddenly conceivable and tangible. All of this, thankfully, has as little to do with an aesthetic purism as with a propagandistic image of the world.

Abigail Solomon-Godeau is Professor Emerita in the Department of Art and Architecture at the University of California, Santa Barbara. Her fields of research include photography, feminist theory and criticism, contemporary art, and nineteenth-century French visual culture. Author of the books *Photography at the Dock: Essays on Photographic History, Institutions, and Practices* (University of Minnesota Press, 1991), *Male Trouble: A Crisis in Representation* (Thames & Hudson, 1997), and the forthcoming *The Face of Difference: Gender, Race and the Politics of Self-Representation* (Duke University Press). She has published widely, including in such journals and magazines as *Art in America*, *Artforum*, *Afterimage*, *October*, and *Screen*.

ARTIST, OEUVRE, CORPUS, AND ARCHIVE: THINKING THROUGH ZOFIA RYDET'S *SOCIOLOGICAL RECORD*

Yet the essence of a nation is that all individuals have many things in common, and also that they have forgotten many things... every French citizen has to have forgotten the massacre of Saint Bartholomew, or the massacres that took place in the Midi in the thirteenth century.[1] —Ernest Renan, "What is a Nation?"

The photographic archive assembles in effigy the last elements of a nature alienated from meaning.[2] —Siegfried Kracauer, "Photography"

Zofia Rydet called her massive photographic project depicting people, their homes, objects, furnishings, and other aspects of domestic space and environments *Sociological Record*. But when conceptually and physically integrated with her other photographic projects, artworks, memorabilia, correspondence, notebooks and so

1 Ernest Renan, "What is a Nation?" (1882), trans. Martin Thom, in *Becoming National: A Reader*, eds. Geoff Eley and Ronald Grigor Suny (New York: Oxford University Press, 1996), 45.
2 Siegfried Kracauer, "Photography" (1927), trans. Thomas Y. Levin, *Critical Inquiry* 19, no. 3 (Spring 1993): 435.

forth, it serves as a posthumous archive of an individual photographer's life and work. Simultaneously, if one considers exclusively her post-1958 photographic materials exemplified by the *Record*, begun in 1978, and putting aside the archive's other contents, it serves also as an *impersonal* visual archive. This double function is a common attribute of photographic archives, inasmuch as the content of the imagery is often at least as significant as the identity of the photographer. Especially with the passage of time, these archives come to be imbued with nostalgia or historical interest. Many of Rydet's photographs depicting the inhabitants in the poorest rural enclaves of Poland seem closer to the nineteenth-century than to other representations of the Polish People's Republic in the 1960s and '70s. Thus, whatever the motivations behind Rydet's *Sociological Record*, it had nothing to do with a propagandistic celebration of a socialist utopia.

Had Zofia Rydet spent her entire career photographing only children (the subject of her first exhibition in 1961 as well as her first published book in 1965), it is doubtful she would have achieved the same prominence she now occupies in the annals of Polish photography. But by chronicling particular sectors of Polish society and their surroundings during more than two decades of economic, political, and cultural upheavals and transformations, Rydet's *Record* is now valued, in part, for its

> scholarly relevance to researchers in other disciplines: anthropologists, ethnographers, sociologists, cultural theorists, and so on. [...] A banner headline or sweeping sociopolitical narrative, after all, loses historical weight if it isn't grounded in the sort of quotidian minutiae underpinning Rydet's *Sociological Record* tableaux.[3]

But the usefulness of the *Record* for social scientists or, for that matter, historians, is debatable. In this respect, the question of photography's utility for interpretive historical investigation has been long subject to debate, whereas its effectiveness for propagating dominant ideological formations is self-evident. As early as the 1920s, critics and theorists addressed the distinctions between

3 "Zofia Rydet: *Sociological Record*," *LensCulture* Projects, accessed August 9, 2017, https://www.lensculture.com/projects/5572-zofia-rydet-sociological-record.

the mechanisms of personal memory and those of photographic representation, most famously perhaps in Siegfried Kracauer's eponymous essay on the medium. In seeking to distinguish the nature of subjective/experiential memory (what he called memory-images) from what is provided by the historical photograph, Kracauer put some emphasis on the limitations of the atemporal and static appearance of a photographic image:

> *Memory* encompasses neither the entire spatial appearance nor the entire temporal course of an event. Compared to photography, memory's records are full of gaps. [...] Memories are retained because of their significance for that person. Thus they are organized according to a principle that is essentially different from the organizing principle of photography. Photography grasps what is given as a spatial (or temporal) continuum; memory-images retain what is given only insofar as it has significance. Since what is significant is not reducible to either merely spatial or merely temporal terms, memory-images are at odds with photographic representation. From the latter's perspective, memory-images appear to be fragments but only because photography does not encompass the meaning to which they refer and in relation to which they cease to be fragments.[4]

Kracauer's photographic example, one that he returns to in several parts of the essay, is anecdotal; a photograph of a notional grandmother, taken in her twenties, but viewed from a perspective of more than sixty years, long after her death. But his arguments have relevance to the status of photography if it is imagined to be a means of historical recovery, especially now in the context of "memory wars" playing out throughout Eastern Europe, and, of course, in other places as well. Richard S. Esbenshade quotes the narrator in György Konrad's novel *The Loser* as saying "History is the forcible illumination of darkened memories." Thus, according to Esbenshade "it is not only state-sponsored forgetting but individual

remembering itself that can reconcile citizens with the system and foil their resistance."[5] Furthermore he observes: "Various totalizing claims on the construction and determination of the national narrative have called forth equally totalizing counterclaims."[6] In terms of recent Polish history, and its conflicting versions of its own history, it is likely that the contents of the *Record* is received differently according to the age, the class, the politics, and indeed the personal memories of its viewers. But to take Rydet's subjects at face value, reducible to what the photographs literally represent, is to obscure important issues that exist at the intersection of photographic imagery, national history, collective (and selective) memory, and nationalist ideologies, as these are elements in the making of the *Record* and inform its current reception.

First conceived in 1978 when Rydet was sixty-seven, the *Record* continued to expand through the 1990s, although in the last years of her life, she was not sufficiently mobile to continue photographing *in situ*. As of 2017, nearly 19,000 of her photographs have been digitally scanned. By the time of her death, in 1997, the *Record* alone had come to encompass approximately 27,000 negatives, many of which she had never printed. But whether designated as archive or *Record*, Rydet's project most closely resembles the venerable category of the photographic survey. If the category of "archive" is the most inclusive of applicable designations (anything relating to its subject may be placed within it), and if her chosen term—"record"—lacks the specific information normally expected of this more bureaucratic or administrative category, it is perhaps the notion of "survey" that provides a more useful frame with which to consider the nature, terms, and instrumentalities of Rydet's vast corpus.

As a noun, in its *Oxford English Dictionary* definition, the word survey derives from the Latin *videre*—to see. ("The act of viewing, examining, or inspecting in detail, esp. for some specific purpose; usually a formal or official inspection of the particulars of something, e.g. of an estate, of a ship or its stores, of the adminis-

5 Richard S. Esbenshade, "Remembering to Forget: Memory, History, National Identity in Postwar East-Central Europe," in "Identifying Histories: Eastern Europe Before and After 1989," special issue, *Representations*, no. 49 (Winter 1995): 75.
6 Ibid., 84.

tration of an office, etc."[7]) Unlike the word archive, however, which may refer to written records or other texts, the root meaning of the survey is that which is given to see, even if surveys may, in fact, be non-visual, as is the case with polls, statistics, or topographic measurement. Nonetheless, because the *Record* is part of a larger ensemble and the production of a named subject, one can see why it is being discursively and practically organized to cohere as an archive and simultaneously to be celebrated as an oeuvre.

In this respect, an archival collection of an individual photographer's production, one whose scale is as vast as Rydet's, confronts us with numerous contradictions and an array of epistemological complexities. All the syntactic and discursive distinctions between the words record, archive, and survey, as well as those of corpus and oeuvre, signal fault lines or incoherencies that appear when massive photographic outputs are variously organized under these latter, much older conceptual categories.

Accordingly, in proposing the category of the survey as a way to "think" Rydet's project, I would suggest that this permits us to better historicize her enterprise in terms of photographic history. Furthermore, considering it as a survey helps to situate it within the context of post–Second World War Poland and its "imagined communities" (as well as its effacement of those "other" communities, transferred, expelled, liquidated or otherwise eliminated from Poland's official postwar imagery).[8]

Where photographic survey projects have been of many types, purposes, and subject matter and possessed of a long history, most often these have been the product of official commissions—often governmental—and were usually the work of multiple photographers.[9] Although certain mid-nineteenth-century photographers given official commissions worked alone—for example,

7 The French language does not employ survey as a noun, but in English it
 derives from the Middle English *surveyen* and from Old French, *sourvoir*,
 and *surveer*.
8 The term is, of course, from Benedict Anderson's important study, to
 which I will return to at a latter point in this essay. Benedict Anderson,
 Imagined Communities (London: Verso, 1983).
9 Massive survey projects such as that of the US Farm Security Administra-
 tion, the British Mass Observation, the French Mission photographique
 de la DATAR, or the Standard Oil project are emblematic of such official
 enterprises.

Charles Marville (charged with documenting Baron Haussmann's transformation of Paris), or Thomas Annan, commissioned in 1866 by the Glasgow Town Council City Improvement Trust to document slum housing—most survey-type projects have been collective enterprises.[10] As individual initiatives—think here of August Sander or Eugène Atget—these have various motivations. To a certain extent, and with the exception of Atget (who continued to use glass plates and a large format view camera), these ever-proliferating surveys, official or not, were progressively facilitated by newer technologies: faster cameras, magnesium flash and other lighting techniques for interiors, roll film, industrial processing of negatives, and other technical advances.

Among the earliest of state sponsored photographic surveys was the 1851 Mission Héliographique, inaugurated by the Commission des Monuments Historiques to record a selection of French architecture, monuments, and historic sites and assigned to five photographers. This was succeeded by other survey projects of many types—topographic, taxonomic, ethnographic, colonial, medical, industrial, military, and so forth—extending from the nineteenth century on. Certain of these surveys were conceived by amateurs, such as that proposed, in 1889, by W. Jerome Harrison, a British geologist and teacher, enjoining amateurs to collectively produce *A True Pictorial History of the Present Day*.[11] As Elizabeth Edwards remarks in her study of the amateur survey movement in Britain, "[It] was part of that much broader cultural matrix in which both a pride in history and a sense of the loss of Britain's tangible past was entangled with shifting national identity in the age of rapid social and economic change."[12]

But other examples are readily found elsewhere, whether launched by individuals such as Solomon D. Butcher in nineteenth-century Nebraska (3,500 glass plates, many depicting home-

10 See in this regard, John Tagg, "God's Sanitary Law: Slum Clearance and Photography," in *The Burden of Representation: Essays on Photographies and Histories* (Amherst: The University of Massachusetts Press, 1988).
11 This project and others are discussed in Elizabeth Edwards, *The Camera as Historian: Amateur Photographers and Historical Imagination, 1885–1918* (Durham: Duke University Press, 2012), 123–62.
12 Ibid., 9.

steaders posed in front of their dwellings [FIG. 1]) or in large-scale projects originating with governments or industries, such as *The People of India: a series of photographic illustrations*, eight volumes compiled by the British India office between 1868 and 1872, or the eleven-volume *The Bantu Tribes of South Africa: Reproductions of Photographic Studies* (1928–54) by A. M. Duggan-Cronin initiated by the De Beers Mining Company.[13] The desire to visually record any and all aspects of the world, its peoples, and its objects is thus part of an archival impulse that is anything but contemporary.[14] On the contrary, it is fair to say that from the beginning, photography was fundamentally oriented toward both survey and archive, as is clear from the well-known text by François Arago introducing the new technology in 1839. It is perhaps also fair to say that in the broadest sense this

13 The full title is *People of India: a series of photographic illustrations with descriptive letterpress, of the races and tribes of Hindustan*. With respect to Solomon Butcher (1856–1927) and apropos of his own concept of a photographic survey, there exist striking parallels to Rydet's conception of her *Record*: "Somehow, Butcher hit on an amazing idea—he would produce a photographic history of Custer County. He must have realized that he was living in a time and place that were important to the history of the country. There is also evidence that he thought this was an idea he could sell. For whatever reason, it was an idea that seized him. 'From the time I thought of the plan, for seven days and seven nights it drove the sleep from my eyes. I laid out plans and covered sheet after sheet of paper, only to tear them up and consign them to the waste basket. At last, Eureka! Eureka! I had fount (sic) it. I was so elated that I had lost all desire for rest.' Beginning in 1886, Butcher began to travel all across the county by horse and wagon, taking photographs of his friends and neighbors. These are the photographs that now illustrate many history texts about the settlement period." "Solomon Butcher Photographs the Sod House Frontier," accessed October 10, 2017, http://www.nebraskastudies.org.

14 I refer to a bibliography that identifies an "archival turn" with recent art and photography, as opposed to its normative histories. See, for example, the useful survey provided by Cheryl Simon, "Following the Archival Turn," *Visual Resources* 18, no. 2 (2002): 101–07. See also Hal Foster, "An Archival Impulse," *October* 110 (Autumn 2004): 3–22; Ingrid Schaffner and Matthias Winzen, eds., *Deep Storage: Collecting, Storing, and Archiving in Art*, exhibition catalog (Munich: Prestel, 1998); *Interarchive: Archival Practices and Sites in the Contemporary Art Field* (Cologne: Walther König, 2002); Charles Merewether, ed., *The Archive*, Whitechapel Gallery's Documents of Contemporary Art Series (London: Whitechapel Ventures, 2006); Okwui Enwezor, *Archive Fever: Uses of the Document in Contemporary Art* (Göttingen: Steidl, 2008); and Krzysztof Pijarski, ed., *The Archive as Project* (Warsaw: Archeology of Photography Foundation, 2013). The recognition of the way archives can function as a form of raw material for artistic purposes was emphasized in such major exhibitions as Owkui Enwezor's Documenta 11 and many others.

FIG. 1
SOLOMON D. BUTCHER, *THE CHRISMAN SISTERS*
ON A CLAIM IN GOHEEN SETTLEMENT ON LIEBAN
(LILLIAN) CREEK, CUSTER COUNTY, 1886

archival impulse is underpinned by the binary of the "one" (us) and the "other" (them).

Thus, the Mission Héliographique functioned as a form of nationalist *self*-representation of the French architectural patrimony whereas *The People of India* or *The Bantu Tribes of South Africa* were equally nationalistic representations of Britain's and South Africa's colonial subjects.

As one of the modern technologies of nationalism, photography can be a consolidation (or invention) of collective identity and belonging, or, somewhat crudely stated, it can implicitly support this project by representing what is outside, excluded, inferior and "other," but variously appropriated (or possessed) by "us." Whether this is literally the case, as in the photographic representation of colonial subjects, [FIG. 2] or purely ideological, does not alter the structure of what are in their various incarnations effectively regimes of representation. One approach is thus rooted in the honorific sense of nation and nationalism (i.e., "our" culture, ethnicity, language, patrimony, race, and so forth) as exemplified by the Mission Héliographique or the British amateur survey movement.[15] Another approach might be categorized as the product of what Michel Foucault called "governmentality"—the organized practices and systems by which the state governs internally or externally, including its modes of information gathering, as with *The People of India*, or, for that matter, the Farm Security Administration's Photography Division.[16] These distinctions, as I would suggest, are worth considering in relation to the *Sociological Record* begun in 1978 in the Polish People's Republic, and continuing in the aftermath of the col-

15 As Anderson remarks, one of the difficulties of theorizing nationalism is its too-easy assimilation to concepts of ideology. "Part of the difficulty is that one tends unconsciously to hypostasize the existence of National-ism-with-a-big-N (rather as one might Age-with-a-capital-A) and then to classify "it" as *an* ideology [...] It would, I think, make things easier if one treated it as if it belonged with 'kinship' and 'religion,' rather than with 'liberalism' or 'fascism.'" Anderson, *Imagined Comminities*, 5.

16 The US Resettlement Administration and, later, the Farm Security Administration developed photography projects between 1935 and 1944. The Information Division of the FSA, under Roy Stryker, was responsible for providing educational materials and press information to the public. See, for example, Maren Stange, *Symbols of Ideal Life: Social Documentary Photography in America 1890–1950* (Cambridge: Cambridge University Press, 1989).

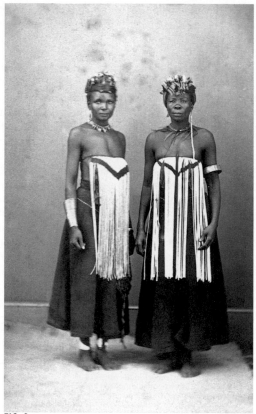

FIG. 2
G. F. WILLIAMS, *STUDIO PHOTOGRAPH OF TWO
UNIDENTIFIED WOMEN*, SOUTH AFRICA, LATE
NINETEENTH CENTURY

lapse of the USSR and the emergence of a new political order in Poland, capped with Poland's admittance into the EU seven years after Rydet's death.

As with any other photographic corpus, the acknowledgment of the interaction of meaning, function, and historical significance needs to be grounded in the context of its production. In this respect, we might note that it was primarily in the twentieth century that individual photographers have created immense bodies of work made outside of institutional or commercial assignments (e.g., Atget, or Garry Winogrand and the recently discovered Vivian Maier). In the case of Atget, the production was entrepreneurial, for Winogrand, it was an artistic project, and for Maier, a private obsession. This is not to deny the existence of aesthetic qualities that any of their works might provide, but merely to specify the material circumstances of its production, leaving aside the issues of dissemination and reception. And while the motivations or intentions of these photographers were different, such production, by virtue of its very scale, puts pressure both on the abstract concept of the archive and on the art-historical notion of the oeuvre.[17]

In his influential 1983 essay, "Photography Between Labour and Capital," Allan Sekula remarked on the essential contradictions that underlie all types of photographic archives:

> Within their confines meaning is liberated from use, and yet at a more general level an empiricist model of truth prevails. Pictures are atomized, isolated in one way and homogenized in another […] but any archive that is not a complete mess establishes an order of some sort among its contents. Normal orders are either taxonomic or diachronic (sequential); in most archives both methods are used, but at different, often alternating, levels of organization. Taxonomic orders might be based on sponsorship, authorship, genre, technique, iconography, subject matter, and so on, depending on the range of the archive.

17 Rydet's own organization of her material was generally topographical, and then defined and organized by subject matter.

Diachronic orders follow a chronology of production or acquisition. Anyone who has sorted or simply sifted through a box of family snapshots understands the dilemmas (and perhaps the folly) inherent in these procedures. One is torn between narration and categorization, between chronology and inventory.[18]

Sekula was here addressing the contents of one particular photo archive, the twenty-year production of a commercial photographer, Leslie Shedden, based in Cape Breton, Nova Scotia, whose photographs were made between 1948 and 1968. [FIG. 3]

Although Sekula was writing well before the advent of digitalized archives (which raise certain issues specific to this technology), much of what he has to say is as apposite now as when the essay was written. The vast photographic production of Rydet, still in the process of being catalogued and scanned, and notwithstanding its distance and difference from the work of Shedden, poses many of the same practical, material, interpretive, and indeed epistemological problems as his. Although Shedden was unambiguously a "professional" photographer who managed a brick-and-mortar photographic studio, and whose work was typically commissioned by individuals (e.g., portraits), collective entities (e.g., sports teams), and corporations (especially those of the mining industry that dominated the economy of Cape Breton), much of Rydet's activity, especially in the earlier years of her practice, is better characterized by the more amorphous category of amateur photographer. In the sense I am using the term, "amateur" does not imply any lack of vocation, commitment, or expertise. For this and other reasons, it needs to be understood in its particular temporal and national/cultural specificity. And, in the specific case of Poland during the years of Rydet's activity, it would describe those who produced both artistic and/or

18 Allan Sekula, "Photography Between Labour and Capital," in *Mining Photographs and Other Pictures: A Selection from the Negative Archives of Shedden Studio, Clace Bay, Cape Breton 1948–1968*, eds. Benjamin H. D. Buchloh and Robert Wilkie (Halifax: NSCAD/UCCB Press, 1983), 197.

FIG. 3
LESLIE SHEDDEN/SHEDDEN STUDIOS, *NO. 26
COLLIERY*, 1963

documentary forms of photography outside regulated bodies, i.e.,
state or party institutions.

It would seem that Rydet's initial photographic forma-
tion—begun seriously when she was middle-aged, when she became
a member of the Gliwice Photographic Society in 1956—conforms in
certain ways to Pierre Bourdieu's observations on the amateur photo
clubs and circles that flourished in post–Second World War France:

> But if the photography that [the members of the clubs
> and circles] want to make is not justified by this per-
> sonal content, and the system of values to which it
> refers, what new function does the camera club fulfil?
> Apart from the desire for a certain consensus appro-
> priate to any secondary leisure group, one would be
> tempted to answer that its purpose is to allow its mem-
> bers "to take photographs," "quite simply." This answer
> would be neither wrong nor necessarily tautological.
> It is their interest in photography that unites the mem-
> bers of a camera club in the first place, and they have
> in common a rate of practice which is higher than that
> of the set of the population which takes photographs.
> The camera club provides a means of moving from a
> naive practice to a scholarly practice within a group
> which supplies formulas and tips in order to intensify
> photographic activity.[19]

In a certain sense then, Bourdieu is describing a non-
instrumentalized activity, which is by no means to say that it is out-
side issues of class or social relations. Certainly and according to
the accounts of those who knew her, Rydet's assertiveness in enter-
ing the homes of those she wished to photograph (including the indi-
gent, the ill, and the dying) suggests something like class privilege,
notwithstanding the particularities of her personality or character.
But given the various perspectives with which we might consider
Rydet's photography, it is worthwhile to reflect on how photogra-

19 Robert Castel and Dominique Schnapper, "Aesthetic Ambitions and
 Social Aspirations: The Camera Club as a Secondary Group," in *Photogra-
 phy: A Middle-brow Art*, ed. Pierre Bourdieu, trans. Shaun Whiteside
 (Stanford: Stanford University Press, 1990), 104.

phers define for themselves the domain of their activity. In this regard, Rydet's technical formation was facilitated by her inclusion in the Gliwice Photographic Society, and her supportive relationships with its entirely male cohort. [FIG. 4] Rydet therefore occupies a fluid area between the photographic categories of "vernacular," "artistic," "official," and "documentary/survey" production depending on the nature of each body of her work. Working within the milieu of the Society, outside the salaried ranks of photojournalism (although from 1961 on, she was a member of the Association of Polish Art Photographers, the pinnacle of professional and artistic legitimization in Poland at the time, and sole official source of commissions), Rydet's encyclopedic project was of her own invention, and like Harrison's, it was essentially boundless. Moreover, and in regard to her stated desire to record the actuality of Polish life (in the *Record*, largely but not exclusively rural or *villageois*), it seems that despite the scale of the production, and given the absence of accompanying texts, recordings, or ancillary description, the *Record* is consequently one of appearance rather than analysis.[20] While it is the case that the discipline of sociology and the invention of photography share the same birth date (but were only conjoined in the 1960s), they operate on very different registers of knowledge production.[21] This accounts for some of the difficulty of assimilating the *Record* to a sociological study in its more professionalized or scientific sense inso-

20 Asked in an interview why she didn't use a tape recorder to record something of the individual lives she was photographing, she remarked that "a tape recorder makes people freeze up." Answering the question whether she kept records with names, locations, or descriptions, she said, "Unfortunately, I have no time for that, but every picture has its data: year, full name, location." Zofia Rydet, interview by Krystyna Łyczywek, *Conversations on Photography 1970–1990* (Szczecin: Voivodeship Council in Szczecin and the Association of Polish Art Photographers [ZPAF], 1990), 33–37; accessed August 9, 2017, http://zofiarydet.com/zapis/en/pages/sociological-record/discussions/rozmowy-o-fotografii.

21 Auguste Comte coined the term, with the idea of unifying history, psychology, and economics to produce a scientific understanding of society and social relations. With respect to the integration of photography with modern sociology, see Howard Becker, "Photography and Sociology," *Studies in the Anthropology of Visual Communication* 1 (1974): 3–26.

FIG. 4
MEETING OF THE GLIWICE PHOTOGRAPHIC
SOCIETY, 1950s

far as it lacks the "thick" description that would enable analysis or interpretation of what is represented.

Judging from the evident freedom Rydet enjoyed as a photographer, the activities of both amateur photographers and those with artistic legitimation seem to have been fully tolerated, even encouraged, by the Polish authorities, even before the post-1956 Thaw—at least as long they did not treat topics with clearly political implications. However, after the declaration of martial law on December 13, 1981, by General Wojciech Jaruzelski and the Military Council of National Salvation, there was a dramatic crackdown on all aspects of cultural as well as civil life. It was during the three-year-period of martial law that Catholic churches became venues for exhibitions of various types, including at least one where Rydet was included.

It is unclear how the years of martial law may have impacted upon Rydet or the Gliwice Photographic Society in terms of what they could or could not do (although they too exhibited in churches, faute de mieux). But as the author of the lauded 1965 book *Little Man*, featuring her photographs of children accompanied with excerpts from the pedagogical writings of Janusz Korczak and an innovative design by Wojciech Zamecznik, she became well known in Poland.[22] [FIG. 5] Rydet had the freedom to travel widely and was accorded, early on in her career, official, i.e., state recognition.[23]

Photographic archives are of striking diversity, and it goes without saying that they do very different kinds of work. There exist archives that have been assembled over time, even in piecemeal fashion, there are those that contain materials from different sources, there are those that are repositories of the work of individ-

22 One of the stranger aspects of *Little Man*, whose book design was considered to be highly innovative at the time, was Rydet's choice of author to accompany the photographs. Janusz Korczak, the pen name of Henryk Goldszmit, was a Polish-Jewish pediatrician, writer, and educator, who during the Second World War directed a Jewish orphanage that was relocated to the Warsaw ghetto. He and approximately 190 of his orphans were killed in Treblinka, in 1942. No reference is made in *Little Man* to his life or fate. Andrzej Wajda made an eponymous film about Korczak, in 1990.

23 See Adam Mazur's essay in this volume, "Perhaps the Greatest Polish Woman Photographer: Problematics of Research into the Life and Art of Zofia Rydet," 79, footnote 22.

FIG. 5
ZOFIA RYDET, *MEDITATION*, FROM THE SERIES
LITTLE MAN, 1961

ual photographers, of studios, photography agencies, corporations, libraries and museums, governmental organizations—the list is vast. Once the generic photographic archive is folded within the generic archive (and it is this latter that has been primarily the subject of theorization) it takes on many of the ur-archive's properties. As Peter Fritzsche observes:

> The history of the archive is embedded in the recognition of loss. For archives to collect the past, the past has to come to mind as something imperiled and distinctive. This presumes a dramatization of historical movement that fashions temporal periods based on the radical difference between now and then, which, in turn, invites the recognition of radical difference between here and there. The feverish part of archival activity is to distinguish difference in order to create a bounded national subject characterized by a separate history that is held in common by contemporaries.[24]

However, photographic archives (notwithstanding the extrinsic materials, including textual ones that may be integrated within them) and which are organized around an individual photographer, as with Shedden or Rydet, raise issues specific to this type of archive. Here, too, the rhetorical questions Sekula poses in his essay are pertinent:

> Are [Shedden's] photographs to be taken as transparent means to a knowledge—intimate and detailed even if incomplete—of industrial Cape Breton in the postwar decades? Or are we to look at these pictures for "their own sake," as opaque ends-in-themselves? This second question has a corollary. Are these pictures products of an unexpected vernacular authorship: Is Leslie Shedden a "discovery" worthy of a minor seat in an expanding pantheon of photographic artists?[25]

24 Peter Fritzsche, "The Archive," in "Histories and Memories of Twentieth-
 Century Germany," special issue, *History and Memory* 17, no. 1/2 (Spring–
 Winter 2005): 18.
25 Sekula, "Photography Between Labour and Capital," 198.

234 ABIGAIL SOLOMON-CODEAU

Substituting the name of Rydet for that of Shedden, and with respect to the ongoing project of cataloging, scanning, preserving, exhibiting, and, needless to say, funding these activities (especially the archiving of Rydet's *Record*), it appears that the Rydet archive has already been positioned within aesthetic discourse. Currently, five institutions are involved in these various operations: The Foundation for Visual Arts, the Zofia Rydet Foundation (responsible for maintaining the physical Rydet archive itself), the Museum in Gliwice, the Museum of Modern Art in Warsaw, and most recently, Raster gallery in Warsaw. On their respective websites or in mission statements, and in those catalogs that feature her work, Rydet's work is fully granted its "documentary" status as a now historical record of Polish life, but much of the emphasis falls on claims for her artistic significance. This is itself a complicated claim insofar as it leaves unresolved the relation of content/subject matter, form or format, and that bugbear of photographic aesthetics—style. In much of the *Record*, Rydet employs a predetermined approach. For example, in many of the interiors, the individual or individuals are seated or standing frontal to her camera; according to available light, the exposure and focus were set in advance to encompass the maximum space of the visual field. In the interiors, which often had little light, Rydet used a flash and a wide-angle lens, and insofar as these were effectively default settings, this accounts for the formal homogeneity of so many of her pictures. Which in turn raises the question as to whether such a choice is an intentional "style" or a technical necessity. In those unpeopled photographs whose subject is decor, wall decorations, memorabilia, pictures and photographs mounted on walls, the ubiquitous photographs of the Polish pope, Karol Wojtyła (John Paul II), TV sets, and other elements of the living space (as well as the signs of modernization and increasing prosperity), it seems evident that her primary concern was with content.

Nevertheless, much of the tenor of the writing on Rydet suggests that the institutional means of support for both preservation and exhibition is predicated on the greater legitimacy of the category artist/photographer as opposed, for example, to an alternative archival categorization under historical, geographical, chronologi-

cal, or topical designations. In other words, heightened value is conferred on Rydet's photographs when they are seen as properly authorial: the product of individual intention, subjectivity, empathy and expression, rather than a partial and idiosyncratic documentation of Polish postwar society with a particular emphasis on rural and village communities.

As it happens, this epistemological trajectory—from archive to author—is well-traveled ground, for it is a discursive process that ultimately produced the canonical figures of Charles Marville, Eugène Atget, and Timothy O'Sullivan, to take only three figures whose photographic production lay outside the purchase of artistic production or artistic discourse.[26] Rydet's position within Polish photography fell under the rubric of "artist," with respect to institutional legitimization, but this category has to be considered in relation to specific national, political, and cultural contexts. She herself was unsure about the status of her work but tended to emphasize its documentary aspects.

In his 1983 essay "The Museum's Old, the Library's New Subject," Douglas Crimp considered one of the ramifications of this process, taking as his example the New York Public Library's decision to cull photographs from multiple classificatory sites (including books and albums), thereby establishing a discrete photography collection based on photographers, not their subjects. As Crimp argued, such a reordering illustrated the passage of photography from discourse value to exhibition value. (And, of course, to commodity value.)[27]

Following the commercial success of her *Little Man*, which had numerous re-printings, Rydet produced several more photography books. The pictures reproduced in *Little Man* are in the photographic mode that characterized postwar, so-called humanist photography, a fully international approach popularized by the Museum of Modern Art (New York) with its 1956 traveling exhi-

26 See in this regard, Rosalind E. Krauss, "Photography's Discursive Spaces: Landscape, View," in *The Originality of the Avant-Garde and Other Modernist Myths* (Cambridge, MA: MIT Press, 1985).
27 Douglas Crimp, "The Museum's Old, the Library's New Subject," in *On the Museum's Ruins*, Douglas Crimp and Louise Lawler (Cambridge, MA: MIT Press, 1993).

bition "The Family of Man" (exhibited in Warsaw, in 1959, during its travels, and which she evidently saw).

In the immediate prewar period, 1935 to 1939, Rydet worked for the Orbis Polish Travel Office under her brother Tadeusz, and it was with his encouragement that she began to photograph in the 1950s, initially the children in the villages of the Hutsul region, now part of present-day Ukraine. In these same years, Rydet ran two stationery/toy shops in the town of Bytom owned by her brother, but in 1962, having been accepted into the Association of Polish Art Photographers, she closed the shop and moved to Gliwice, obtaining a job at the Silesian University of Technology teaching photography. After her membership in the Gliwice Photographic Society, her work developed in various forms of synergy with the more established men of this milieu: Jerzy Lewczyński, Władysław Jasieński, and Piotr Janik. As the lone woman in this group, she was truly anomalous, but the available bibliography in English does not elaborate on the circumstances that enabled her to be integrated within this all-male cohort.

After she started work on the *Record*, Rydet also experimented with other styles, such as photo-collage, the creation of photo objects, self-consciously "artistic" approaches and surrealist-influenced compositions, manipulations of negative or print, and the like.

But if the *Record* is now to be regarded as her key work (and this not necessarily because it contains the greatest number of images, although this aggregation is a factor), insofar as no individual photograph can be considered a singular "masterpiece" (as is often the case with a photographic archive), it is the ensemble itself that constitutes the "work." This is the case with Atget, Sander, Winogrand, Maier, et al., and entirely in keeping with Rydet's own open-ended conception of her project *qua* project. But whether this vast accumulation of imagery has a real sociological function, much less a relation to historical events, is, as I have indicated, open to question, especially that given the lack of aural recordings, textual, or other informational components, it is difficult to imagine their use

for actual sociological or ethnographic research.[28] As an image rep-
ertoire, the *Record* offers only the mute testimony of what the sub-
jects, their houses, their furnishings, and their interiors looked like
at a certain moment in time.

The Rydet archive, of which the *Record* constitutes a dis-
crete part, exists in sites both virtual and material, and is fundamen-
tally plural in terms of its contents, its different media (books, prints,
ensembles of pictures she herself organized, correspondence, note-
books, etc.). Moreover, photographs made in other circumstances
could be rerouted into the *Record*. That any of the various projects can
be said to constitute an artistic unity, that is, an oeuvre, secured by
the author/artist's name, opens up to larger issues, insofar as archive
and oeuvre, corpus and collection, author and producer are not nec-
essarily synonyms for one another. Framing Rydet's archive so as to
place emphasis on its authorial components—subjectivity, vision,
point of view, empathy with her subjects and so forth—does not nec-
essarily accord with Rydet's own view. In at least one interview, Rydet
dismissed the designation of her *Record* as an artistic project as if
acknowledging that what was at stake was an endeavor closer to that
of a collector or archivist than to that of the self-discriminating and
self-critical practice of an artistic creator.[29]

Be that as it may, to my own way of thinking, one of the
most interesting aspects of this life and this archive are to do with
the obsessiveness that animates its production. It is sheer coinci-
dence that one of the women photographers whose work I recently
addressed was Vivian Maier, who notwithstanding the secrecy with
which she hoarded her photography and her extreme social isola-
tion, was equally obsessive in her photographic production. Accord-
ing to the accounts of those who knew her, Rydet chafed at the real-
ization that given her age, her self-defined project could not be

28 Rydet noted the place and date of her photographs, but little other
 information. However, Ewa Klekot has argued eloquently for the *Record*'s
 use value for an ethnological approach using its emphasis on material
 culture. See Ewa Klekot's essay in this volume, "Between the Ethno-
 graphic and Material Culture," 117–33.
29 Consider the difference between Robert Frank, who selected only
 eighty-three of more than 27,000 exposures for the making of his 1958
 book *The Americans* as opposed to Rydet's entirely inclusive relation to her
 own photographs.

completed. But what would have been a "completed" *Sociological Record?* What fantasy of comprehensiveness or totality could inform this kind of documentation? Realistically, it would seem that by definition the *Record* could only be an ongoing and never-ending pursuit, a race against time and her own mortality. It is as though Rydet herself became a functionary of her own overarching archive.

Any sustained aggregation of photographs, as I have indicated, is necessarily shaped by time, place, and circumstance—all that comprises the specific context of a specific practice. In placing some stress on both the contradictions and complexities that constellate around photographic archives constructed under the author-function (as Sekula did with Shedden, Rosalind Krauss with Atget and O'Sullivan, Crimp with the NYPL), we touch on an issue that constantly arises when archive or survey-type photographic projects become, so to speak, re-archived. And here it is necessary to distinguish the concept of the archive as a theoretical object from actual, existing photographic archives, be they individual, institutional, or commercial. That said, it is very much the case that even if we are to focus only on the *Record* from its launch in 1978 and its continuation through the 1980s, we run into the difficulties of reconciling notions of "style" (the index by which authorial/artistic sovereignty is conventionally secured) with its relation to contents, especially when the "contents" are a priori determined by the project itself.

Archives, including photographic archives, obviously have very diverse origins, purposes, instrumentalities, and uses. Archives in their most abstract sense have informed the work of both Michel Foucault and Jacques Derrida—the former describing the rules governing the emergence of enunciations in the discursive field; the latter proposing psychoanalytic theory as itself a theory of the archive, and hence formulating an "archival" theory of the subject. These conceptualizations have engendered an immense corpus of commentary and interpretations. Specific archives, or specific types of archives have equally been subject to both scholarly and historiographic investigation. This field of inquiry now boasts a substantial bibliography as well. The interrogation of archives has expanded well beyond sociology, anthropology, ethnography, and

historiography to become a "discursive object" for geographers, postcolonial theorists, as well as a topos for at least three genera- tions of visual artists, with older artistic precedents located in sur- realism and in the work of Marcel Duchamp and Marcel Broodthaers. This is by no means to endorse some notion of Rydet, at least her *Record*, as a proto-conceptualist project, akin to the American con- ceptualist artist Douglas Huebler's grandiose project, *Variable Piece #70 (In Process), Global, November 1971*, whose stated aim was to photo- graph every human being in the world.[30] On the contrary, I think that one aspect of Rydet's enterprise (despite her claim of recording— memorializing—what was about to vanish) could be interpreted as a conscious or unconscious forgetting, or, at least, a form of not remembering.

There is thus a paradoxical element in the *Record*. On the one hand, we are given a collective representation of what seems to be "Polishness" (especially in those parts of the country such as the Podhale region, remote from the metropolis), and judging from many of the houses, extremely poor. But on the other hand, this implicit affirmation of Polish identity obscures not only the histori- cal heterogeneity of Poland overwritten by the affirmations of an integral Polish nationality and ethnicity, but equally the circum- stances of its demise. Instead, what if we hazard the notion that this ambitious survey/archive project was a form of overwriting the most traumatic aspects of Poland's pre-1946 histories?

Writing in 1989, Pierre Nora grasped the centrality of archive formation to contemporary life:

Modern memory is, above all, archival. It relies entirely on the materiality of the trace, the immediacy of the recording, the visibility of the image. What began as writing ends as high fidelity and tape recording. The less memory is experienced from the inside the more

30 In his own words: "Throughout the remainder of the artist's lifetime he will photographically document, to the extent of his capacity, the existence of everyone alive in order to produce the most authentic and inclusive representation of the human species that may be assembled in that manner." Mark Godfrey, "Across the Universe," in *Light Years: Concep- tual Art and the Photograph, 1964–1977*, ed. Matthew Witkovsky (Chicago: Art Institute of Chicago, 2011), 62–63.

it exists only through its exterior scaffolding and out-
ward signs—hence the obsession with the archive that
marks our age, attempting at once the complete con-
servation of the present as well as the total preserva-
tion of the past.[31]

There are echoes here of Kracauer's arguments, but
where both of these essays are relatively abstract in relation to pho-
tographic archives, Rydet's *Record* should be situated within the his-
torical context of her life and work in Poland. In her efforts to regis-
ter the actuality of the Polish present, a present that in the very act
of photographing instantly becomes the past, there thus hovers
around Rydet's project another past that is an invisible but haunting
presence. I refer both to Rydet's own biographical past, as a woman
who lived through two world wars, consecutive occupations by Ger-
many and Russia during the Second World War, the liquidation of
Polish Jewry, several changes in the geographical borders of Poland,
including that of her natal town, forced expulsion or displacements
of ethnic Polish, German, and Ukrainian populations at the end of
the war, the imposition of communist rule (including the declaration
of martial law, in 1981), the rise of Solidarity, and in 1989, the col-
lapse of communism—the list is easily extended. There is nothing in
Rydet's *Record*, or in any other of her photographs, that provides the
barest traces of these epochal events. It is precisely here where one
may identify the limitations of photographic imagery in general,
especially when devoid of textual supplement, and thus it is incum-
bent upon those in the present to supply what could not be repre-
sented in a photographic survey like Rydet's.

During the war years, Rydet, her parents, and brother
lived in Stanisławów, a town subjected to successive Russian and
German occupations. Stanisławów was duly incorporated into the
Ukrainian Soviet Socialist Republic in 1947, but prior to that, tens of
thousands of Polish civilians died in this region in massacres com-
mitted by the Ukrainian Insurgent Army (UPA) together with the

31 Pierre Nora, "Between Memory and History: *Les Lieux de Mémoire*," in
 "Memory and Counter-Memory," special issue, *Representations* 26 (Spring
 1989): 13.

Organization of Ukrainian Nationalists (OUN).[32] In 1944, Rydet's fam-
ily moved to Rabka, a well-known spa town and the "City of the Chil-
dren of the World," after Poland's borders were again redrawn as a
consequence of the war. Nothing in Rydet's photographic projects,
and little in the biographical information available in English, refers
to traumas of war, the Holocaust, or any of the subsequent upheav-
als in Poland that marked her or her work.[33] Was it possible for a
bourgeois provincial family to live "normal" lives under German and
Russian occupation?[34] Is it possible that Rydet's imagery of rural mis-
ery or middle-class prosperity, kitsch religious images, the display
of family photographs on walls, the omnipresence of the Polish pope,
folk decoration, disappearing crafts, and of course, children in all
their diversity, operated as a form of denial of what she herself, or
those close to her, might have experienced directly or indirectly?
What if Rydet consciously wished to reconstruct, or invent, or affirm
a reassuring image of the everyday, of everydayness (even amidst
grinding poverty) that while refusing the propaganda imagery of

32	See Timothy Snyder, "Ethnic Cleansings," in *Bloodlands: Europe Between Hitler and Stalin* (New York: Basic Books, 2010), 313–37.
33	Here is Uilleam Blacker's succinct description of what occurred in Poland after 1942: "During and after the [Second World] war, many cities, villages and towns were moved from one state to another, and entire populations were transferred. Towns that had been Jewish *shtetls* for centuries suddenly became entirely Ukrainian or Polish. The cities of Poland's eastern borderlands were no longer dominated by a Polish majority and a large Jewish minority, with Ukrainians usually the third group by size, but became almost entirely Ukrainian, while German cities and towns in Poland's 'recovered territories' became entirely Polish. Similar situations arose in Lithuania or in postwar Czechoslovakia. Ukrainian villages in Southeastern Poland also saw their populations vanish as a result of deportation in 1947, and were resettled by Poles or abandoned." Uilleam Blacker, "Living among the Ghosts of Others," in *Memory and Theory in Eastern Europe*, ed. Uilleam Blacker, Alexander Etkind, and Julie Fedor (London: Palgrave Macmillan, 2013), 45.
34	The story of the Rydet family's relocation to Rabka might be of interest here: Zofia Rydet's brother, Tadeusz, a lawyer by education, knew German very well and thus was able to find work under the German occupation in a German company that specialized in trading under-growth. With the front drawing near, and the Rydets unwilling to live through another Soviet occupation, Tadeusz organized a transfer to the company's Rabka office, taking, of course, his family with him. After the war the office was nationalized, with Tadeusz as founder and first director of the Las [Forest] company. Because this was an official transfer, the family, together with a few others, managed to procure a train coach, allowing them to flee with all their belongings to what was soon to become the Polish People's Republic. (Account provided by Zofia Augustyńska-Martyniak of the Zofia Rydet Foundation.)

communist Poland, and its sentimental celebration of *völkisch* cul-
ture, the heroic worker, and other icons of socialism, wished to
redeem the notion of "Polishness"? And if this was so, was it perhaps
overdetermined that the only "differences" in Poland in the 1960s
and '70s that she would represent were regional and economic, rural
or urban, traditional or modern? Did such a project occlude the eth-
nic cleansings of the war and the postwar order in the desire to pro-
duce a unified realm of unproblematic, Catholic, Nationalist Polish-
ness? Were the photographs of Roma people, or those of poor rural
folk that Rydet made in other Eastern Bloc countries Rydet's substi-
tutive "others"?

 In the particular case of Rydet, there exist competing,
or even incommensurate narratives around the work, the biography
(such as it is), and thus the discourses within which it is variously
positioned. In the pre–*Sociological Record* years, and with respect to
her biographical representation, much of her life remains elusive.
For a non-Polish reader like myself, it is unclear from the various
sources in English (I have not found any in French) whether she had
an independent income, made sufficient money from her stationery
shops, or later, her teaching, that enabled her to travel widely, to
support herself; what kind of income she gleaned from her photo-
graphic activities; how significant was her religious identification;
what were her relations with her family (only her brother is men-
tioned); what were her relations with officialdom (especially during
the period of martial law), with the communist party; what was the
nature of her teaching activities (technical? artistic?); how much of
her work was reproduced in the press or magazines; was she ever
married or otherwise partnered—all the basic information one would
expect to be in the public record of a recognized figure is not yet
available. And while the origins of her obsession to take pictures,
manifested so late in her life, is ultimately impossible to understand,
it would seem that the larger issues I have outlined here—discursive,
political, historical, and contextual—are the more substantial ones
to consider.

 As critics and theorists from Kracauer to Pierre Nora
have observed, a visual archive—in this case, that of Zofia Rydet's—

is as much about the loss of memory as its recovery, for these can be cleansed of the more problematic aspects of its history, as Renan indicates in his notion of obligatory forgetting. Although many of the villages whose inhabitants and homes Rydet photographed did not have significant Jewish communities, there were many others whose Jewish populations were destroyed. But from the *Record*, in terms of its visual evidence, no one would ever know that there had previously existed other ethnic or religious communities within these villages, or that the very map of postwar Poland was the result of forced expulsions, transfers, and expatriation of diverse communities. Not to mention the enduring legacy of anti-Semitism, manifest in postwar pogroms and easily summoned into new life by successive reactionary political formations. Poland today, with its right-wing government and its fanatic Catholicism reminds one of the enduring tension between what Adam Michnik called "Polonophiles" and "Europhiles."[35] This too involves a memory war in which nationalism papers over the complexities, awkwardness, and guilt of others' memories.

During the 2015 exhibition of the *Sociological Record* in Warsaw, which featured a selection of 486 prints and 505 slides, I was struck by the way both old and young viewers were clearly fascinated by Rydet's photographs (organized in the exhibition according to her own categories). My visit coincided with a weekend of pro- and anti-government demonstrations following Jarosław Kaczyński's Law and Justice party's virtual takeover of the country's public broadcasting system, claiming the right to appoint and dismiss TV and radio broadcasters, one of a series of continuing attempts to curb democratic processes. Peering intently at each image it was as though the viewers felt that in the act of intense scrutiny, the picture might yield up a meaning that lay behind its nominal subject. What old and young viewers may have been looking for the pictures to reveal may not have been the same thing, but it is in the very nature of the photographic image that there exists nothing "behind" what is given to see. Nevertheless, the experience of viewing photographs from the *Record* cannot but evoke the ways by which the "imagined community" of

35 Cited in Esbenshade, "Remembering to Forget," 86.

postwar Poland can draw upon the photographic record to establish a sanitized and nostalgic representation of a national "Polishness" that effaces its unresolved past, whether during German or Russian domination. How Rydet's *Record* will figure in the ongoing project of constructing or reconstructing Polish history and identity is inevitably contingent on the larger political forces that are always active in constructing the mythologies of nationhood and the determinations of who is "us" and who is "them."

ZOFIA RYDET
SOCIOLOGICAL RECORD
PHOTOGRAPHS SELECTED BY
KRZYSZTOF PIJARSKI

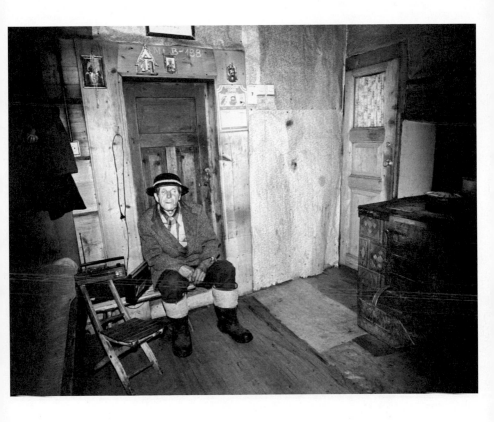

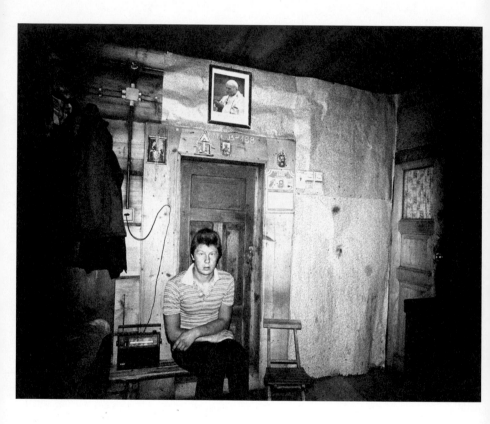

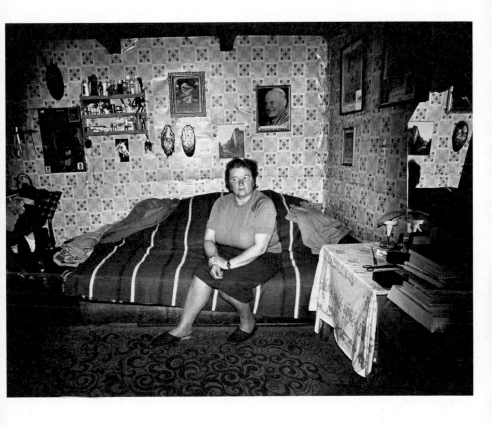

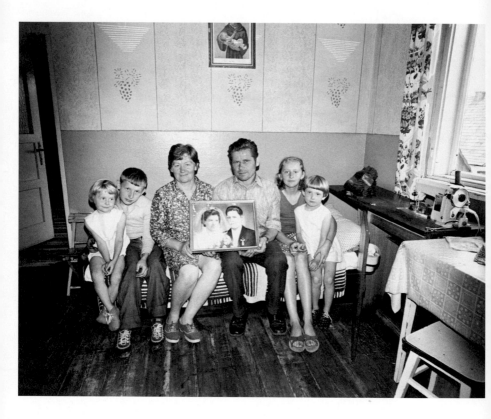

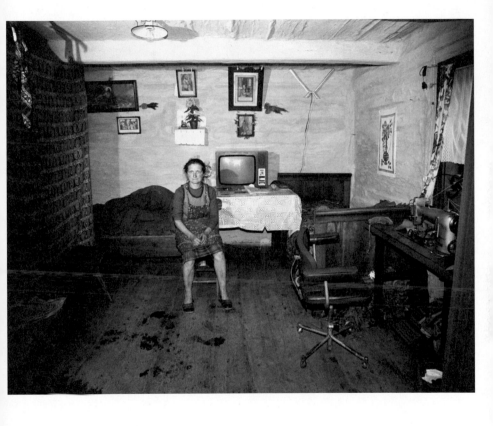

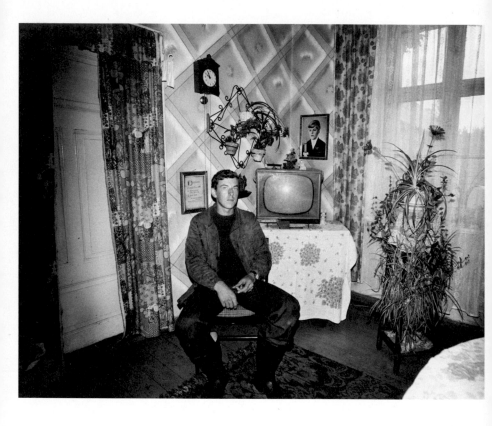

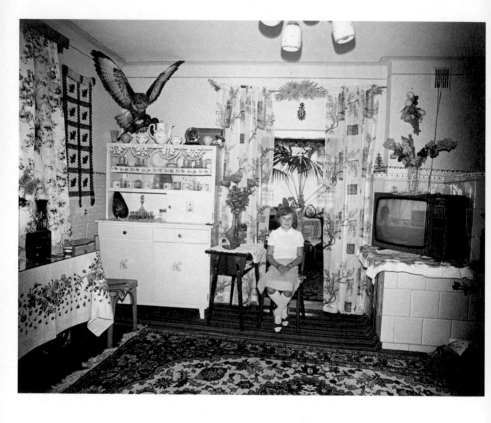

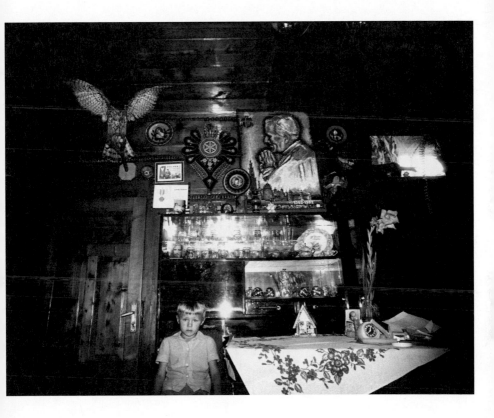

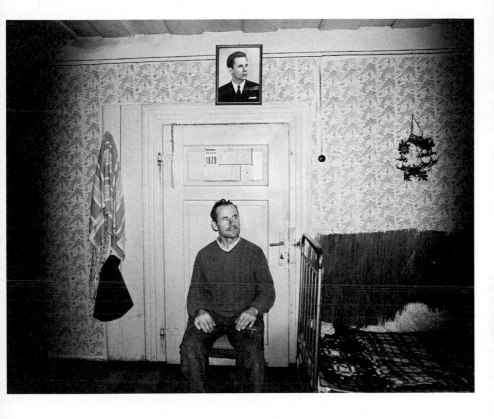

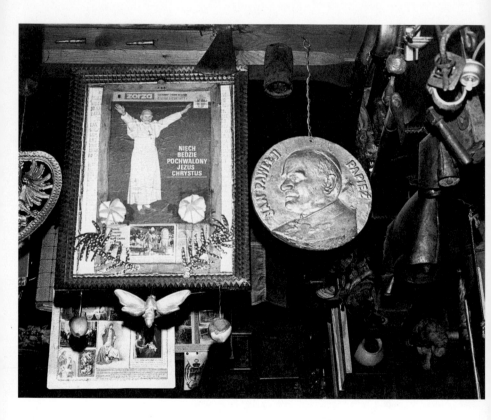

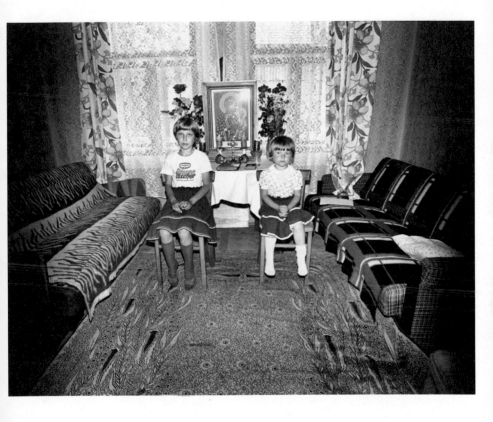

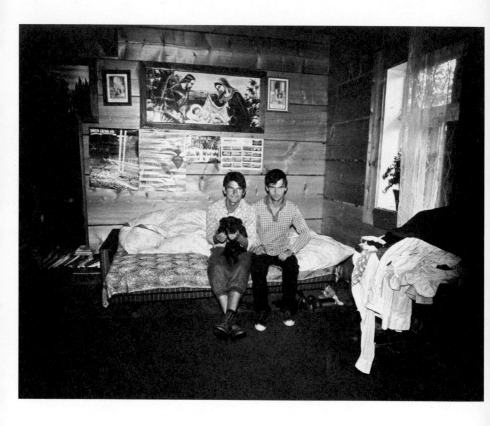

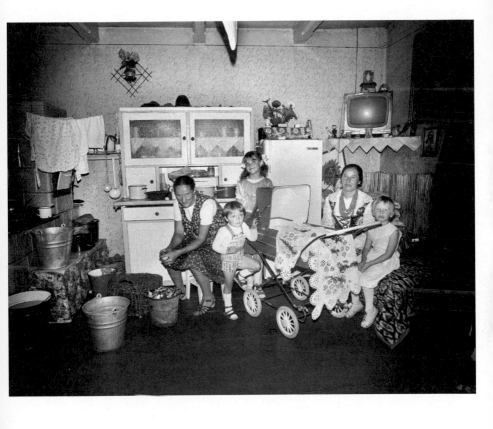

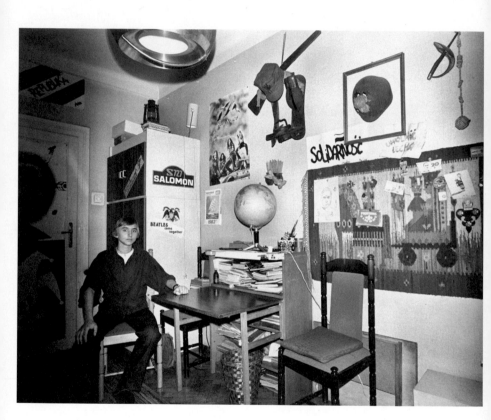

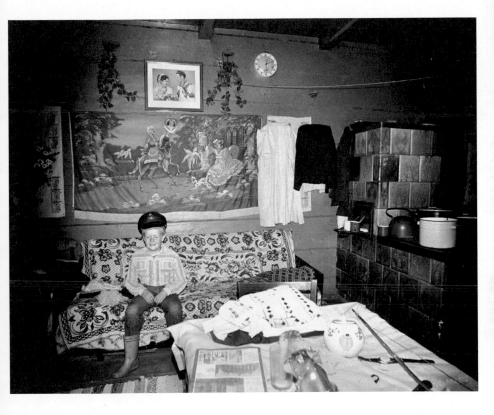

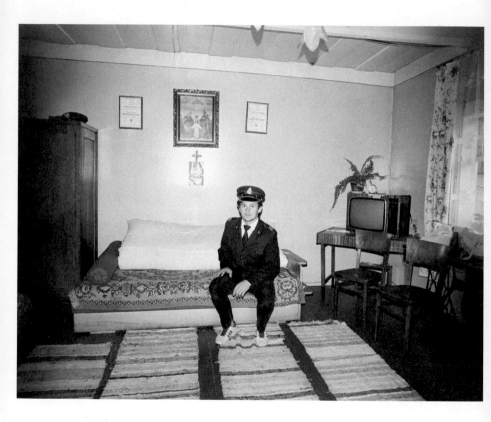

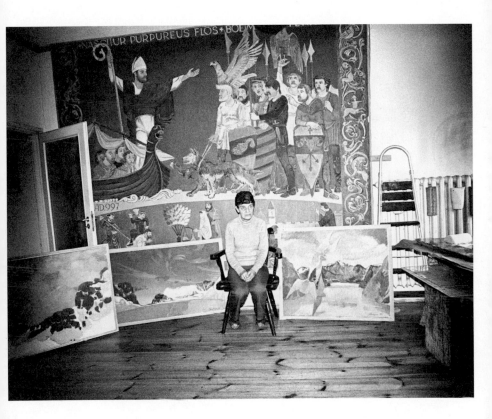

Régis Durand is a photography critic, theorist, and independent curator. Author of many texts on photography, collected among others in the volumes *Essais sur l'expérience photographique* [Essays on Photographic Experience] (Editions de La Différence, three volumes: 1990, 2002, 2006). *Images-mondes. De l'événement au documentaire* [Images-Worlds: From Event to Documentary] (Monografik Editions, 2007) is a record of his dialogue with art historian Paul Ardenne. During his career he was university professor, director of the Centre National de la Photographie and the Galerie Nationale du Jeu de Paume in Paris. Régis Durand's most recent book is *Un art incertain—mutations de l'image photographique* [An Uncertain Art: Mutations of the Photographic Image] (Filigranes Editions, 2007).

RECORDING, REPRESENTING, REFLECTING: ZOFIA RYDET AND THE "REFLECTING SUBJECT"

In a video by Józef Robakowski with Zofia Rydet, we see the latter discussing the time-worn question of document versus art—in her case, more precisely, the body of work entitled *Sociological Record* as opposed to more "creative," more "artistic" series such as *The World of Feelings and Imagination* (1975–79) or *The Infinity of Distant Roads* (1980). Throughout that part of the interview she appears serious, almost grave. At the same time, she seems to have doubts about the more explicit aim or aims of her photographic project.[1]

At times, these contradictions or doubts seem to bear on the project in general, raising questions of definitions and method including, for instance, the possibility of having a "sociological record" made by a person who is not a sociologist by training, or, perhaps, simply the adequacy of the title itself. But then, one can think of counterexamples, such as the photographic work of Pierre Bourdieu made during his Algerian period. [FIG. 1] Bourdieu's work, too, raises many questions of methodology. For one thing, it is probably more ethnographic than sociological, properly speaking. But what is more impor-

1 Józef Robakowski, "Interview with Zofia Rydet," FF gallery, Łódź, 1990, accessed August 5, 2017, http://zofiarydet.com/zapis/en/pages/ sociological-record/media/wywiad.

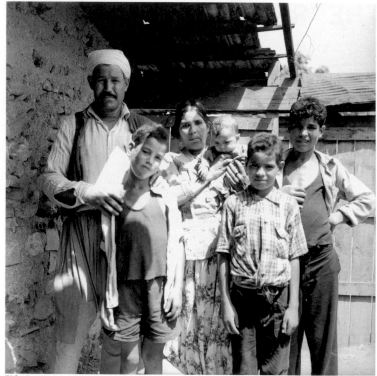

FIG. 1
PIERRE BOURDIEU, *AÏN AGHBEL, COLLO*, 1958–61

tant, it is not so much the intellectual project which stands out in his work, as the encounter with an "overwhelming, oppressive" reality.[2] Photography functions as a screen, a shield against the violence of the situation, just as "academic decorum" attempts to mask the implacable logic of the colonial war—the massive displacement of persons, the misery of the new shantytowns which replace destroyed traditional villages, the arrests and humiliations.[3]

Bourdieu's work, as always, is both a documentation and a reflection on the material itself, as well as on the operator, his own position in the field. Bourdieu was able to achieve such a reflective turn by relying, in this particular case, on photography's own ambivalence. Despite its invaluable descriptive powers, it is as if something were lacking, the capacity precisely to tell a story, to narrate. This was to be John Berger's obsessive quest, a subject I will return to later in this essay. But even Bourdieu, in a major work such as *The Weight of the World*[4] would admit that there was no need to show images, to document photographically. Verbal description would seem to be enough, as if one alleged power of photography, its narrative capacity, had been superseded by language's own superior capacity to narrate. Perhaps the sheer weight of representation, of photographic appearances, made it difficult for images to free-float and transform themselves into so many "sentences."

Rydet did not share Bourdieu's intellectual framework, his passion for systems. But she thought intensely about the contradictions she was facing. In essence, these revolved around questions of form and her own ambivalence toward them. As she observed, "The most important is not *how* but *what* one wishes to

2 Franz Schultheis, "Pictures from Algeria: An Interview with Pierre
 Bourdieu," in *Picturing Algeria: Pierre Bourdieu*, ed. Franz Schultheis and
 Christine Frisinghelli (New York: Columbia University Press, 2003), 22.
3 Ibid., 16–20.
4 See Pierre Bourdieu, ed., *La Misère du monde* (Paris: Éditions du Seuil,
 1993); Bourdieu, ed., *The Weight of the World: Social Suffering in Contemporary
 Society*, trans. Priscilla Parkhurst Ferguson (Cambridge: The Polity Press,
 1999).

say," and quoting Harry Callahan, "It is not composition that is important, but motivation."[5]

These words, Callahan's, and her own, appear to point to a form of spirituality in her work, an almost abstract dimension which contrasts with the precise and intense realism of her *Sociological Record*, in which the subject (I mean the *subject matter*) is at the center. Yet simultaneously she acknowledges the constant search for form as her foremost preoccupation ("All the time I was looking for new means of expression"[6]), as when she decided to take up composite photography, which gave birth to the series entitled *The World of Feelings and Imagination* and *The Infinity of Distant Roads*. When *Sociological Record* was initiated, in 1978, her approach to this set of questions had shifted. If the purpose was still to "uncover some great truth about human fate,"[7] the search for adequate form had evolved considerably. It was no longer a question of composite photography or of devices more or less inspired by surrealism. The role of photography had become, as she put it, an act of rescue, an attempt to arrest the flow of time. The human figure was becoming an object among others, a part of the paraphernalia of peasant interiors, its anonymity emphasized by the identical pose the subjects were asked to take, the same frontal wide-angled frame, the same slightly tilted, upward camera facing the person sitting or standing on the threshold or in the recesses of the house. The thousand-time repetition of this particular form had something obsessively uncanny about it, as if the photographer was attempting to seal the human figure in a preset dispositive: to seal it like a fly in amber. It was as if the sheer multiplicity of nearly identical items would guarantee that some kind of truth could thus be attained, which the individual picture, any individual picture, somehow refused to deliver.

There is indeed something obsessive in this process ("like a drug," she would say at one time[8]); a process in which we experience form, used in such a repetitive manner, as a kind of violence

5 Zofia Rydet, "Zofia Rydet on Her Work," in *Zofia Rydet (1911–1997). Fotografie*, ed. Elżbieta Fuchs, exhibition catalog (Łódź: Muzeum Sztuki in Łódź, 1999), 116.
6 Ibid.
7 Ibid., 117.
8 Ibid., 118.

exerted against the subject. So that the cluster of contradictions might read as this: on one hand, the strong documentary impulse, the need to capture and compare the almost numberless occurrences of the human condition, with all its particularities; and on the other hand, the same impulse in danger of losing its moorings, of being caught in the gyre of reality, having only a rigorous formal bulwark to offer against chaos, but a formal bulwark which at the same time annihilates the individual subject.

But precisely, can we ask, what *is* the subject in this case? The *Sociological Record* offers the interesting characteristic of proposing various possible answers, none of which appear satisfactory enough. Among them, we find of course the classic reference to photography's alleged capacity to arrest time, and to capture something of the "truth" of a particular subject (that which Roland Barthes identified as "punctum"). Each photograph appears as a foray into a mass of details, each potentially capable of producing a variety of narratives. The decorations on the walls, religious pictures or artifacts, family photographs, paintings: all seem to be fairly identical from one house to another, probably because of the geographical and sociological proximity. Yet, if examined closely, they all tell a different story. Each person thus becomes the owner, the bearer, the "author" one might even say, of a life of her own; a life story which carries the weight of the world (to allude again to Bourdieu's masterwork).

The enigmatic intention at work in this process ("a life story") is in contradiction with a sharp sense of opportunity, as evidenced by what Rydet explains in various places about her strategy to overcome the subject's resistance or initial refusal to be photographed—the banter and the barter which take place, the desire to give something in return for what she was taking (but what did she take from her subjects exactly?), the sheer speed with which she took the photo, almost without aiming, at random, as if she had become a part of the dispositive of the whole apparatus itself.

If a comparison with August Sander comes to mind, it serves only to underline the differences; the subtle construction and powerful organization of the German artist in his attempt to map the

whole spectrum of humanity—German humanity, to be sure, but considered as a metonymy of the entire human race, or as Sander would say, "People of the Twentieth Century." The world then, neatly mapped out by one of its most powerful social organizations, the profession, the trade, but in the case of the Polish artist, reduced almost to one—peasantry; a class of its own perhaps more than a trade. Rydet's attempts at picturing representatives of other trades are few and generally unconvincing, showing that those signs, those markers of a profession remained for her superficial. Whereas Sander used such traits to plumb the depth and subtlety of the social structure, she took them as signs, among others, of the general paraphernalia that constituted their common habitus. This, she seemed to be saying, is how it is, the human condition in a state of silent expectancy, waiting for some kind of renewal which may or may not come in due time—in a few years' time perhaps, or in centuries after centuries. Meanwhile, each individual narrative may proliferate into innumerable details yet never reach the core, never let through what constitutes the "authority of the story." Only time, the passage of time, she seems to be saying (and does say at one point) can effect change: people die, houses go to ruin, thatched roofs are no longer taken care of, etc. Her vision is one of decay, of the disappearance of a familiar state of things. Time is the master, a version of God himself, and her vision is more spiritual than materialistic, whatever statements to the contrary. Consider for example, to pursue the parallel with Sander, his well-known picture of the three young peasants going to a fair or to a dance, and the reading John Berger has attributed it.[9] [FIG. 2] By analyzing the aspect of the suits they are wearing, and the manner in which they wear them, Berger shows quite convincingly how

> the working classes [...] came to accept as their own certain standards of the class that ruled over them [...]. At the same time, their very acceptance of these standards, their very conforming to these norms which had

9 John Berger, "The Suit and the Photograph," in *Understanding a Photograph*, ed. Geoff Dyer, rev. ed. (1979; repr. London: Penguin Books, 2013). The essay has appeared in different publications; I quote from the most recent occurrence.

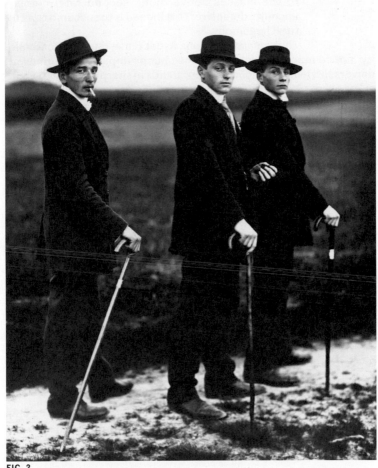

FIG. 2
AUGUST SANDER, *YOUNG FARMERS*, 1914

nothing to do with either their own inheritance or their daily experience, condemned them, within the system of those standards, to being always, and recognizably to the classes above them, second-rate, clumsy, uncouth, defensive. That indeed is to succumb to a cultural hegemony.[10]

The *catholicity* of Zofia Rydet (I use the term "catholicity" not so much in a religious sense but as implying, or aiming at, universality)—her catholicity, then, stands in sharp contrast to Sander's view of society: the former drowns differences in a vision of similar appearances, while the latter explores differences, producing a kind of "comparative photography." Seventy years apart, both are aware that the world is about to change radically. In Sander's vision, social classes stand firm and would continue to do so, were it not that it is not only Germany, but the whole world which is about to collapse, making it impossible to carry on with the metonymy I spoke about earlier. Those are not images of the world but remains of a vacillating social order once believed to be eternal, naturally eternal. With Zofia Rydet, the implosion has already taken place, and all there is to record is what's left after the collapse. And it is certainly not Berger's Marxist-inspired analyses, subtle as they are, that can serve in the case of the Poland of the 1970s. Instead, Berger's analyses come very close to a kind of aporia, something that cannot be resolved, that does not find its way to dialectical resolution. Photography's very existence, its capacity to vouch for that which exists is reminiscent of the remark Berger quotes after Walter Benjamin: "There is a delicate form of the empirical which identifies itself so intimately with its object that it thereby becomes theory."[11] John Berger attempts to come to terms with that permeability between

10 Ibid., 42.
11 Ibid., 36. This is, in fact, Benjamin quoting Goethe's *Scientific Studies,* where this sentence is translated as follows: "There is a delicate empiricism which makes itself utterly identical with the object, thereby becoming true theory." J. W. von Goethe, *Goethe: Scientific Studies,* ed. and trans. Douglas Miller (New York: Suhrkamp, 1988), 307; Benjamin quotes this passage in his "Little History of Photography" (1931), trans. Edmund Jephcott and Kingsley Shorter in *The Work of Art in the Age of Its Technological Reproducibility, and Other Writings on Media,* eds. Michael W. Jennings, Brigid Doherty, and Thomas Y. Levin (Cambridge, Mass: Belknap Press of Harvard University Press, 2008), 287: "There is a delicate empiricism which so intimately involves itself with the object that it becomes true theory." —Ed.

empirical material and theory by developing a concept I find some-
what enigmatic—the reflecting subject. Berger returns to it in differ-
ent places, most notably in the short essay entitled "Stories" from
his and the photographer Jean Mohr's exploration of a "possible the-
ory of photography," *Another Way of Telling*.[12] The concept, if it is a con-
cept, is complex and elusive, and the reason I return to it after briefly
touching on it in a previous study,[13] is precisely because I do not quite
know what to make of it, except that it helps in understanding what
a photograph does.

Berger begins with the gap ("the abyss") that separates
the moment recorded in the photograph and the moment of looking
at the photograph. The term "reflecting" carries, of course, a load of
ambiguity, deliberately I imagine, but not without consequence. Are
we to understand that the "reflecting subject" reflects the way a mir-
ror does, i.e., merely reflects the appearances which Berger is con-
cerned with showing are indeed the crux of the matter? Or are we
rather to understand "reflecting" in the sense of thinking and pro-
ducing thought? Or possibly a combination of both? John Berger has
been concerned, in that essay in particular but also in various other
places, with establishing a central narrative agency, whose role
would be to organize and "fuse" photography's various narrative
capabilities (for instance, the ability to narrate without the support
of language, the way Berger himself tried to do together with the pho-
tographer Jean Mohr in the photographic essay "If Each Time," also
part of *Another Way of Telling*). Clearly, Berger is trying to save or to
redeem all of photography's narrative powers by proposing an amal-
gam (the word appears often) of the traditional narrative agencies:
teller, listener, and protagonist. This last agency is to be understood
as the "voice" of what is being photographed, and Berger appears to
be advocating a new kind of realism, a realism which does not fall
back on itself but which remains aware that it creates discontinui-
ties, while attempting to fuse and create an amalgam. "A photograph,"
he observes, "presents us with two messages: a message concern-

12 John Berger, "Stories," in *Another Way of Telling*, John Berger and Jean Mohr,
 rev. ed. (1982; repr., New York: Vintage Books, 1995), 277–89.
13 Régis Durand, "Notes on Neorealism" in *Neorealism in Polish Photography:
 1950-1970*, eds. Rafał Lewandowski and Tomasz Szerszeń (Warsaw:
 Fundacja Asymetria, 2015).

ing the event photographed, and another, concerning a shock of discontinuity."[14] Realism, as seen by Berger, is first and foremost a question of finding an "adequate" narrative form, if such a form does exist, in a medium which is at best "a half-language." And because photography is so imperfect as a language, there appears the need to make sense of its discontinuities and inadequacies, rather than subsuming them under a ready-made unifying process (to put it another way, of sweeping them under the rug of one unifying theory or another...).

What we have here is an attempt at universalizing narration in photography—an impossible gambit which would amount to inventing "a narrative form specific to photography," encompassing the various narrative agencies at work, and ensuring that what they produce is transformed into experience. In a sense, it would be an impossible, philosophically impossible, process including both operations and results, a theoretical chimera. Something Berger suggests could be closer to the idea of montage as defined by Sergei Eisenstein.

But to return to Zofia Rydet, she did put montage to the test in some of her series, and it did not prove an entirely convincing experiment. Her idea of montage seemed closer to the superimpositions and fusions of images inherited from Surrealism, than to the complexities of Eisenstein's notion. The obsessive manner in which she pursued the *Sociological Record* would seem to indicate that there she was finding, or hoped to be finding, something similar to the multiplicities Berger, after Deleuze, wrote about. In a sense, each of the thousands of photographs that constitute the *Sociological Record* are so many narrative hypotheses put to trial. And, of course, never succeeding, never, in isolation or in aggregate, providing the answer to what this extraordinary amalgam, the reflecting subject, might in fact be. All we can observe, in passing so to speak, is once more the evidence that photography is never quite that, never quite there, and never quite how things once were, either. To cite Berger's words once more, "photographs so placed are restored to a living

Berger, "Appearances," in Berger and Mohr, *Another Way of Telling*, 86.

context," and "appearances become the language of a lived life."[15]
They pass into experience, they are recovered as experience, and
this recovery, this silent connection between images, may perhaps
come close to the return of the real which "the reflecting subject"
may be all about. What is interesting here is the encounter with a
form of reality which insists, which will not be denied, but at the same
time exceeds understanding and escapes dialectical thinking.

 "The reflecting subject," then, has to do with a similar
form of aporia. One important element in its definition is that it
appears in the context of a narratology of images, accounting for
what happens when, as Berger puts it, "a story makes sense of its
discontinuities."[16] Two conflicting forces are at odds with each other:
the first would see the photograph as an amalgam, a fusion of the
three forces at play; while the other would maintain the ambiguities
of appearances and the play of discontinuities. At the start, Berger's
theory seems to rest on a very traditional tripartite conception,
teller/listener/protagonist. It is the fusion of the three, their amal-
gam that he calls "the reflecting subject."

 But the amalgam does not hold, its surface authority
comes constantly apart at the seams; as if there was something
inherently discontinuous at the heart of the story, something that
eludes us. This is how Berger puts it:

> All stories are discontinuous and are based on a tacit
> agreement about what is not said, about what connects
> the discontinuities. The question then arises: who
> makes this agreement with whom? One is tempted to
> reply: the teller and the listener. Yet neither teller nor
> listener are at the center of the story, they are at its
> periphery. Those whom the story is about are at the
> center. It is between their actions, attributes and reac-
> tions that the unstated connections are being made.[17]

What Berger seems to be advocating, then, is a kind of
materialism, the belief that photographs all have a subject (or sub-

15 Berger, "Stories," 289.
16 Ibid., 285.
17 Ibid.

jects), something they can be said to be about, something that happens in them or to them. This should not however be seen as a form of regression, a return to the old realism or literalism. Rather, what is being attempted is the description of a new kind of experience, destined to take us to the core of the "authority" of the story. Ultimately, Berger's problem is one that may seem secondary to us—that of the possibility or impossibility of a purely photographic narrative. And if we exclude the simple model of the photonovel, the best manner of having an answer of sorts may be to come up with a narrative structure in general, of which the photographic narrative would be a particular example. Hence the use of the generic term of "story" and the tension, the play, between discontinuities and authority: "The discontinuities of the story and the tacit agreement underlying them fuse teller, listener and protagonists into an amalgam. An amalgam which I would call the story's reflecting subject. The story narrates on behalf of this subject, appeals to it and speaks in its voice."[18]

"If Each Time" seems to put this theory to the test. Does a photograph say enough about what Berger calls "protagonists" or "what the story is about"? Suddenly the question becomes more general and more complex as it moves beyond the examination of the traditional narrative agencies. The "agreement about discontinuities,"[19] Berger suggests, is similar to montage, "a montage of attractions" which does not result in an organized sequence but becomes "a field of coexistence like the field of memory."[20] There is, of course, the more immediate sense in which photography is memory or a substitute to memory, as it preserves an event's "instantaneous appearances."[21] In that case, it is essentially fragmentary and discontinuous. But at the same time, photographs work dialectically. They record appearances but also point to "a greater extension of meaning."[22] Through them, not unlike "the reflecting subject" of which they seem to be an active part, time is constantly being reorganized, re-elaborated. The narrative utopia John Berger is pursuing, that "truly photographic narra-

18 Ibid.
19 Ibid., 286.
20 Ibid., 288.
21 Berger, "Appearances," 121.
22 Ibid., 128.

tive form,"[23] supposes that there be an amalgam of those different levels, different times, different narratives, different fragments being connected. Photography, through the agency so understood, accomplishes all: it records appearances but also, like a sentence, it brings together different levels (of time, of experience). As Berger put it, "the half-language of appearances continually arouses an expectation of further meaning."[24] This brings to mind the distinction made by Walter Benjamin between the nature and the role of memory in the novel and in the story respectively. In the novel, we are dealing with remembrance, a selected, centered form of memory, as opposed to the multiple dispersive operations in the story. Clearly, photography is on the side of the multiple, the half-formed. Zofia Rydet, especially in the *Sociological Record*, places us at a crossroad of questions and experimentations. I have chosen to complicate these issues a little bit, by making extended references to the work of John Berger who was an interesting case of critic and artist at the same time, and to a lesser extent to the photographic work of Pierre Bourdieu.

Berger, for one, is searching for a specific form of photographic narration, in order to demonstrate that photography can be a way of reflecting on the world itself, and not merely of reflecting the world as it appears to be. This specific narration relies on sequencing, juxtaposition, a complex form of montage, and of making discontinuities meaningful.

As far as Zofia Rydet is concerned, her work seems to rely on (potentially) unlimited, inexhaustible repetition. But the paradox is that repetition offers a background, a framework for individual images to acquire and reveal meaning, as John Berger himself demonstrates when he analyzes some of André Kertész's images (such as the Red Hussar taking leave of his family). If John Berger's work matters in this context, it is because it places us at the heart of the tension between the world as it is made to appear, for instance in the *Sociological Record*, and the power of photography to take those appearances apart, and make of each separate photograph a world of its own.

23 Berger, "Stories," 279.
24 Berger, "Appearances," 129.

Helen Petrovsky is Head of the Department of Aesthetics at the Institute of Philosophy of the Russian Academy of Sciences. Her major fields of interest are contemporary philosophy, visual studies, and North American literature and culture. Among other books, she is author of *Neproyavlennoye: Ocherki po filosofii fotografii* [The Unapparent: Essays on the Philosophy of Photography] (Ad Marginem, 2002), *Antifotografiya* [Anti-photography] (Tri kvadrata, 2003, 2015), *Teoriya obraza* [Theory of the Image] (RGGU Press, 2010), *Bezymyannyye soobshchestva* [Anonymous Communities (Falanster, 2012), and *Chto ostayetsya ot iskusstva* [What Remains of Art] (ICA, 2015, co-authored with Oleg Aronson). She is compiler, editor, and co-translator of Jean-Luc Nancy's *Corpus* (Ad Marginem, 1999) and Gertrude Stein's selected writings (BSG-Press, 2001). Since 2002, she has been editor-in-chief of the theoretical journal *Sinii Divan*. She is laureate of the 2011 Andrei Bely Prize (theory category).

EXPLORING
THE PHOTOGRAPHIC SIGN[1]

Inspired by the many photographs that constitute Zofia Rydet's extensive oeuvre, I will try to develop the following thesis: far from being a sociologist or conceptual artist, Zofia Rydet confronts us with the photographic sign. The photographic sign undoubtedly has a dimension of its own that sets it apart from those sign systems and even signifying practices that we have been using as our most reliable explanatory models. In fact, the photographic sign seems to challenge our ideas about the linguistic or prelinguistic matrix of the world that surrounds us, be it nature or culture. Instead it points to a multiplicity of relations captured in every single photograph and given all at once, in their totality. Since we are clearly dealing with an image, I would like to retain the notion "sign." However, it is our task to explore the nature of this specific kind of image and its relation to reality.

It is well known that photography, albeit a relatively late discovery, has been able to teach us impressive lessons about ourselves and our ways of cognizing the world. It has done so at a twofold level, namely, in the form of a critical discourse about pho-

1 In preparing this essay I am very much indebted to Oleg Aronson for his valuable insights and helpful discussions.

tography and in the silent form of the image itself, calling for the development of ever new descriptive and analytical tools. It is no secret that photographic discourse may be much closer to the prevailing paradigm of human knowledge at a given historical moment than to the mute message emitted by the photograph. Rydet's work is compelling in the sense that it renders the instruments we already have ineffective. It hints at different possibilities and yet, somehow, it surpasses them all. Among those possibilities are portraiture, classification, ethnographic and anthropological exploration, sociological and typological investigation, conceptual art.

Rydet was absolutely convinced of the power of photography. Even a twenty-six-minute documentary gives one a perfect sense of her priorities and the role that she attributed to her chosen medium. "Everything will go, the only thing to remain is photography, so please, no smiles, none of that self-appealing psychological nonsense—you are surrounded by meaningful things and the task before you is to live up to the moment."[2] It doesn't really matter what Rydet says to her models, how she explains why she needs this or that composition or why smiles are so detrimental to her project. She is not afraid to correct herself, saying that she was wrong and thus admitting that her explanation was not very convincing. What matters is the photographic impulse itself, a sense of the utmost importance of taking pictures, an ongoing practice, which, as we know from the *Sociological Record, The Infinity of Distant Roads*, and other series, cannot be stopped. [FIG. 1–3] It will stop, no doubt, but the death of an individual will not put an end to the infinity of relations that he or she is a part of. Although, of course, it will terminate and reconfigure the series that was until then in the making. But is this so certain, after all?

"I am looking at you, right? In that way I can cast a spell over you," says Rydet to one of her models. It is hard to say what she has in mind. In fact, she is still explaining why she prefers a serious face to a smiling one. Perhaps, all photographers manipulate their models in one way or another. What is important, though, is the establishment of a relation between photographer and the photo-

2 See Andrzej Różycki, *The Infinity of Distant Roads*, 1990, accessed August 2, 2017, https://vimeo.com/24091206.

FIG. 1
ZOFIA RYDET, *SIGNS*, FROM THE SERIES
***THE INFINITY OF DISTANT ROADS*, 1980**

graphed. In the case of human beings this relation might be negoti-ated and it often is. It can become the object of a dialogical exchange, thus duplicating and highlighting the dialogue itself. But dialogue, a unit of human social and linguistic interaction, is only one recogniz-able instance among the many relations that connect animate and inanimate objects alike. My contention is that Zofia Rydet explores and expresses this truth: The human has no priority over the inhu-man, and if photography conveys any message at all, it is about the infinity of relations, as well as the basic equality of persons and things in the world. It is a way in which the world gives itself to us, directly, without mediation (if we remain faithful to the phenomenological vocabulary at least at this point).

Let us stop to consider the photograph as a special kind of sign. It is worth keeping this notion not out of a general love of semiotics and the belief that reality speaks to us in a language proper to itself (although this thesis may be the subject of further discussion), but simply because photography is one of the most potent and ubiquitous visual images. It is quite clear that photogra-phy has always created that strongest documentary effect, which may be called "the reality effect," "the referential illusion," and the like.[3] Despite the changing technical parameters of the camera, the image it produces has the concreteness of an object. This definition formulated by Pier Paolo Pasolini regarding cinematic images[4] is exactly what a cinematic image has in common with a photograph: there is nothing abstract or transcendental about photographs, they are a cross section of the visible world as if this world could be cut—or sliced—into images. Perhaps it is, by means of the camera that shows us, much more than we in fact are ready to perceive.

The dominant photographic discourse tells us that photography is too late in its arrival: the presence it captures is always already deferred.[5] Photography, according to this viewpoint,

3 See Roland Barthes, "The Reality Effect," in *The Rustle of Language*, trans.
 Richard Howard (New York: Farrar, Straus and Giroux, 1986), 141–48.
4 See Pier Paolo Pasolini, "The 'Cinema of Poetry,'" in *Heretical Empiricism*,
 trans. Ben Lawton and Louise K. Barnett (Washington, DC: New Academia
 Publishing, 2005), 169.
5 See Roland Barthes, *Camera Lucida: Reflections on Photography*, trans. Richard
 Howard (New York: Farrar, Straus and Giroux, 1981), 77.

has a powerful connection to the past, indeed, it is the theater of shadows in the broadest possible sense. This is so, if we continue insisting that photography is a duplicate of reality or, to use Barthes' famous definition, its "perfect *analogon*." But what does this mean exactly? We do find a hint as to the irreducible nature of the visible when we turn to another well-known formula, namely, that photography is "*a message without a code*."[6] This seems to distance photography from language or at least to suggest that photography speaks a different language, that at its very core there remains a truth that can be grasped neither by theory in the habitual sense nor by the semiotic tools that critics are so keen on applying. For Barthes, this truth clearly boils down to affect that paradoxically dispenses with the very image that happened to trigger it off.

But to return to analogy. Does it necessarily imply a mimetic relation? In other words, is the photograph doomed to be a mere representation, if by representation we mean the age-old divide between subject and object, as well as the subject's pretension of mastering the world? Recent work on photography seems to be pointing in a different direction. I will confine myself to a brief comment on Kaja Silverman's alternative history of photography which has come out under the title *The Miracle of Analogy*. From what I know of this work, an excerpt of which is available online,[7] Silverman contests such approved notions as sameness, symbolic equivalence, logical adequation, and even the rhetorical figures of metaphor and simile, in which one term, she explains, "functions as the provisional placeholder for another." Instead analogy is the intricate web of relationships that make up the world and connect all the living and non-living beings together. For Silverman, connectedness has a clearly ontological status: "Each of us is connected through similarities that are neither of our making or our choosing to countless other beings. [...] the smallest unit of Being is two interlocking terms. [...] Analogy runs through everything-that-is like a

6 Roland Barthes, "The Photographic Message," in *Barthes: Selected Writings*,
 ed. Susan Sontag (New York: Fontana/Collins, 1982), 196.
7 Kaja Silverman, "The Miracle of Analogy," *Nonsite.org*, issue no. 11, March
 14, 2014, accessed August 2, 2017, http://nonsite.org/feature/the-mira-
 cle-of-analogy.

shuttle through a loom, weaving its threads into the All, or what I call the 'world.'"[8]

This is the theoretical premise that allows Silverman to sketch out a different understanding of photography. For her, photographs are "reminders" of that non-hierarchical and total relationality that governs the "world." Photography's function is to "disclose" the world, to demonstrate that it is "structured" by analogy. (One cannot help thinking of analogue—or analogical—photography, obviously an intended pun.) Analogy also stands for the *medium* of photography, because, first, it is set in contrast with representation and index as ways of defining the specific nature of the photograph and, second, it is the "fluid," or the ever-expanding context, in which that very medium develops over time. One of her most striking examples is the fate of the famous photograph *View from the Window at Le Gras* taken in 1826 by Joseph Nicéphore Niépce.

I will leave out the details of this very exciting account. What we learn from it, however, is the following: Photography develops not only and not chiefly in the darkroom. As all the efforts to preserve and analyze Niépce's exemplary photograph have shown, chemical photography is no stranger to digital photography and even drawing. Niépce's heliograph is not so much reproduced as it expands itself in the drawings of the photograph meant to make it closer to the elusive original, as well as in the high-tech renditions of this pewter plate so reminiscent of a mirror in an Empire frame. To make a long story short, this is a lesson in the heterogeneity of relations that the photograph enters with the other media that were previously considered separate and also specific. In other words, Niépce's photograph is confined neither to itself (the concept of identity) nor to the moment of its execution (the linear schema of time plus the concept of source). Instead it develops over time, and does so only in relation with the other media and even as relational in its own right. Among other things, this surely frees photography from being anchored in the past.

So let me underline: analogy might give way to or be dissolved in relationality, and the relations that the photograph brings

8 Ibid.

forth (develops) are always multiple and heterogeneous. According to Silverman, they unravel themselves in an infinite historical perspective. Here I will part ways with the American interpreter. As I have already implied, these relations can be given all at once—in a single image. This brings us back to Zofia Rydet and her copious body of work. In order to clarify this point, we will need to take a fonder look at Charles Sanders Peirce and particularly at his concept of the sign. It is no secret that his highly dynamic schema has been replaced with a series of static notions that have been set apart and cruelly disconnected from each other. However, Peirce's strength lies precisely in the assertion of relationality regarding the various signs, and I will briefly recall some of these points relevant to our analysis.

The photograph is usually interpreted in terms of the index. As we learn from Peirce, "An *Index* is a sign which refers to the Object that it denotes by virtue of being really affected by that Object."[9] Since the indexical sign is understood to be actually modified by its object, it is used to explain the photograph as trace or imprint,[10] resembling footprints on the beach. This viewpoint, however, narrows the possible application of Peirce's ideas. We know that he is the author of a complex semiotic system that divides signs into classes, each of which has a tripartite structure (to be quite exact, he develops three trichotomies of signs). Thus, the indexical sign is surrounded (and supported) by Icon and Symbol, the first being based on likeness to its object, the second linked to it through a general law. Whatever the peculiar characteristics of Index, Icon, and Symbol taken by themselves, it should be remembered that *every* sign is a combination of the three distinct types, although one of them might in fact prevail over the others.

If every sign is a coexistence of these three poles, in the words of Roman Jakobson, then it would be hard to relegate photography simply to what-has-been, if only because the index has to do with a present experience while the symbol is a form of rational

9 Charles Sanders Peirce, "Logic as Semiotic: The Theory of Signs," in *Philosophical Writings of Peirce*, ed. Justus Buchler (New York: Dover Publications, 1955), 102.

10 See Rosalind E. Krauss, "Notes on the Index: Part 1 & 2," in *The Originality of the Avant-Garde and Other Modernist Myths* (Cambridge, MA: MIT Press, 1985), 196–219.

anticipation.[11] But this is something I will not elaborate on at the moment. Instead I would like to turn to the rather complicated concept of the sign relation that one discovers in Peirce. As we can expect, this relation is triadic and includes such elements as representamen, interpretant, and object. One thing (the object) is represented by another thing (the representamen) and is represented to a third thing (the interpretant). What is of utmost importance is that the object is represented in such a way that the third thing (interpretant) is necessarily also a representamen of the object to yet another interpretant. In other words, being connected with the original object, the interpretant represents the object to another interpretant, etc., so that the representing chain stretches to infinity.

In order to apprehend the true implications of this somewhat technical description, let us lend an ear to Peirce himself, reflecting on the role of the interpretant:

> The meaning of a representation can be nothing but a representation. In fact, it is nothing but the representation itself conceived as stripped of irrelevant clothing. But this clothing never can be completely stripped off; it is only changed for something more diaphanous. So there is an infinite regression here. Finally, the interpretant is nothing but another representation to which the torch of truth is handed along: and as representation it has its interpretant again. Lo, another infinite series.[12]

Peirce understands meaning as the translation of the sign from one sign system into another. Therefore, it does not reside in any given concept, but is, properly speaking, the effect of relations among concepts or, in his vocabulary, "signs." To put it differently, it

11 See Roman Yakobson, "Neskol'ko slov o Pirse [Peirce'e], pervoprokhodtse nauki o yazyke," trans. K. Golubovich, in *Yazyk i bessoznatel'noye* (Moscow: Gnozis, 1996), 168–69.
12 Charles Sanders Peirce, *Collected Papers of Charles Sanders Peirce*, eds. Charles Hartshorne and Paul Weiss (Cambridge, MA: Harvard University Press, 1960), 1. § 339, cited in Beatriz Penas Ibáñez, "Kristeva's *Desire In Language*: A Feminist Semiotic Perspective on Language and Literature," in *Gender, Ideology: Essays on Theory, Fiction and Film*, eds. Chantal Cornut-Gentille D'Arcy and José Ángel García Landa (Amsterdam: Rodopi, 1996), 98.

is the effect of their very relational *dynamic*, since nothing can outlive the making of signs.

 This is exactly where the photographic sign comes in and along with it the stakes of Rydet's project. Every sign is a multiplicity—of referents, relations, etc. In stating this, Peirce's model proves invaluable and surprisingly up-to-date. However, for Peirce this multiplicity (or infinity) is an abstraction, because in his doctrine the sign is a mental construct addressed to the cognizing mind.[13] The photographic sign, in its turn, knows nothing of this otherworldliness: it is completely devoid of transcendence. It belongs to *this* world, bringing forth its multiplicity in each and every photograph. It is a sign that is blind to the differentiating practice of semiotics in its traditional guise: there is no straightforward relation between the signifier and the signified, between the image and its referent. Also, it makes no distinction whatsoever between animate and inanimate objects. Instead it displays them as a distribution of forces in a prelinguistic universe. Indeed, a cross section of matter—the photographic image itself.

 No abstract truth, all this can be *seen* in Zofia Rydet's photographs. For it is impossible to do away with the index in the image, or, to remember Pasolini, its visual concreteness. Regarding the relations it captures, every photo is a concrete universal. To clarify this point, let us take a closer look at some of the series in Rydet's *Sociological Record. People in Interiors* is indeed very telling. Those are not portraits, strictly speaking, but exactly what the artless title announces: people amid or on a par with things, people *as* things. Of course, Rydet allows her models to dress up, she assures them that they are beautiful and deserve being photographed for eternity. But what kind of testimony is she offering her future spectators? Her

13 Although it must be said that Peirce's model is a highly formal one. It follows the rules of logic and not those of psychology. The interpretant, therefore, is not necessarily human: it is that which, broadly speaking, results from an inference. It is no accident then that in his influential interpretation of cinema, Gilles Deleuze makes use of Peirce's "semiotic" by transposing it into an immanentist setting. Here is a brief but helpful explanation: "Immanence is not related to Some Thing as a unity superior to all things or to a Subject as an act that brings about a synthesis of things." Gilles Deleuze, *Pure Immanence: Essays on a Life*, trans. Anne Boyman (New York: Zone Books, 2001), 27.

FIG. 2
ZOFIA RYDET, *SIGNS*, FROM THE SERIES
***THE INFINITY OF DISTANT ROADS*, 1980**

camera is usually placed in a frontal position and she is careful to include as many objects as possible in the picture she takes with her wide-angle lens. It has been noticed that Rydet could not stick firmly to her own classifications; while photographing people in interiors, for example, she would instantaneously slip to objects and decorations (the name of another series) only to be replaced with pictures of the pictures of the pope (a point of intersection of two other series—*Presence* and *Myth of Photography*). It is quite clear that her photographic world is impervious to names, that names are just a way of putting pieces of her work together for the sake of coherence. What we discover there is not a cult of objects, but a "confrontational arrangement which does not differentiate between the thousand details of the world."[14] This description of Jean-Luc Godard's cinematic vision and technique applies perfectly well to Zofia Rydet.

 I would like to linger on the picture of the pope that we find in many of her photos. Of course, John Paul II is an important historical figure and it is hard to overestimate his role for Catholics, especially Polish Catholics, worldwide. For Rydet, however, he is not so much an object of reverence or icon as some sort of "presence." But what exactly is this presence and what function does it carry out? In order to understand it better in light of what has already been said about the photographic sign, let us recall Jakobson's remarks about shifters, constituting a specific "class of grammatical units"[15] (the term itself belongs to another linguist, namely, Otto Jespersen). First of all, shifters are *relational parts of speech* in that they indicate or specify some relation without having any meaning of their own. The example that Jakobson elaborates on is that of personal pronouns. He observes that the difficulty of the terms *I* and *you* is that they signify "the same intermittent function of different subjects."[16] Indeed, in the course of a conversation the referents of the *I* and *you* are con-

14 Pasolini, "The 'Cinema of Poetry,'" 181.
15 Roman Jakobson, "Shifters, Verbal Categories, and the Russian Verb," in *Russian and Slavic Grammar Studies 1931–1981*, eds. Linda R. Waugh and Morris Halle (Berlin: Mouton, 1984), 42.
16 Ibid., 43.

stantly shifting from one interlocutor to another (if I am speaking, I am the referent of *I*, but if you are speaking, then it goes over to *you*).

The personal pronoun has no constant, general meaning existing outside of an actual piece of dialogue as a form of linguistic exchange. However, it has its own general meaning defined precisely by that context. This brings us back to the notion of a concrete universal. To repeat, this time in Peircean terms: The sign *I* is in dual relation to its object—it represents its object both by way of a conventional rule *and* existentially, that is, by being tightly linked to its utterer. Therefore, it is symbolic and indexical at the same time. Now what is the function of the pope in Rydet's series? Photograph, person, sacred symbol all in one, the pope is clearly a shifter. The latter is saturated with various significations precisely because it is a sign that has no meaning of its own. Instead it is entangled in a web of relations, revealing them to the viewer. You can say so many things about the pope, this pope, including his origin. And yet in Rydet's photographs the pope is only a presence, that is, a photograph among other unremarkable, humble objects decorating peasants' homes. A photograph inside a photograph, the pope ceases being a devotional object. This sign (and it is a powerful sign) becomes desacralized and begins to function in a wholly different fashion.

It is much closer to what St. Augustine called the "natural sign,"[17] suggesting that the true way of deciphering unintentional, therefore meaningless signs is human experience. The picture of the pope in Rydet's series breaks down all the signifying conventions. Instead of maintaining a relation with its referent (as is the case of a "straight" or "normal" image of the pope), it points to a multiplicity of relations by which those who display this photograph in their interiors, as well as those who do not, are always already united. To put it in plainer terms: The usual sign structure establishes a one-way relation between the sign and its concept, creating the illusion of depth. The photographic sign—the pope as photographic sign—retains the multiplicity of actual relations that point to nowhere beyond them-

17 See *Stanford Encyclopedia of Philosophy*, s.v. "Medieval Semiotics," accessed July 15, 2017, http://plato.stanford.edu/entries/semiotics-medieval/#2.1.

selves. It will thus be no exaggeration to assert that the photographic sign, affirmatively superficial, challenges the very fundament of culture. But in doing so it restores our intimate and multiple connections with the world, a sense of secular communion with its myriad inhabitants.

It seems that Rydet's series *The Infinity of Distant Roads* is a remarkable illustration of the notion of natural sign mentioned above. Of course, St. Augustine's emphasis lies elsewhere, for although natural signs have nothing to do with "any intention or desire of using them as signs," still they lead to the knowledge of "something else," as is the case of smoke being an indication of fire. Clearly, smoke has no independent meaning; indeed, it is from human experience that we learn that fire is beneath. This holds true of every sign, which affects us on two distinct levels, namely, that of perception, when an impression is made on the senses, and that of (re)cognition, when we discover something else that comes into the mind as a "consequence" of the sign itself.[18] One might suggest that it is meaning accumulated in human experience. But what if the sign remains, so to speak, inconsequential? This seems to destroy the very concept of sign. And yet Rydet's *The Infinity of Distant Roads* is an amazing collection of imprints that haphazardly fall under two main categories, that is, of natural (we might as well call them elemental) and conventional (or man-made) signs.

Of course, we can read the English word "start" painted in white capital letters on the road and we know perfectly well what it means, especially when it is situated right above a line that can be nothing other than a start line. This immediately points to a whole series of implied significations: outdoor sporting activities, races, the communal and educational value of sports under socialism, etc. But next to that picture there is another one that shows an intricate pattern of cracks in the asphalt, obviously depicting the joint workings of nature and time. As a true contemporary photographer, Zofia Rydet does not allow her spectators to treat these and other images

18 Augustine, "On Christian Doctrine (Book II)" in *New Advent*, ed. Kevin Knight, trans. James Shaw, accessed July 27, 2017, http://www.newadvent.org/fathers/12022.htm.

as if they were isolated from each other and endowed with some spe-
cial meaning of their own, serving an external—edifying, allegoric, or
poetic—purpose. She produces images that exist only in concatena-
tion with others, that are never any better or any worse than those
that have been taken before and will be taken after. Of course, she
would sort out her own production and choose among the negatives
by appealing to a sense of taste or some kind of aesthetics. But that
is definitely not what governs the series as a whole. *The Infinity of Dis-
tant Roads* appears blatantly and mercilessly equalizing: It tells us
neither a story of human endeavor nor that of natural decay; rather
it refrains from pronouncing any judgment whatsoever.

So what is the crux of the matter? According to Rydet,
she is interested in "mysterious" signs[19]—signs that are simply there:
they might be interpreted (and they often are) and yet do not read-
ily disclose their meaning. However, this reticence or reluctance has
nothing to do with mysticism, even when Rydet focuses her atten-
tion on what she calls "signs of religion" that can be found along so
many roads in the Polish countryside. Signs that persist in their
obstinate existence without leading to any knowledge, supplemen-
tary or otherwise, that do not even lean on experience, although
associated with some sort of habit[20]—what kind of signs are they?
Indeed, if this puts the concept of sign to the test, it also points to a
new understanding of photography. Photography seems to estab-
lish a horizontal relationship between multiple cultural and acul-
tural signs instead of relying on the signifying vertical: signifier—sig-
nified, sign—meaning, photo—referent, etc. It is not Rydet's
idiosyncratic ("subjective") vision that destroys the vertical in ques-
tion, but her faultless use—and comprehension—of the medium:
There is no meaning outside the material sign as it lends itself to the
spectator. And she is clearly dealing with the sign in a twofold man-
ner: the sign as object of depiction and the photographic sign itself.

What can we make out of the sign, if it is given to us in
its material denseness? First of all, returning to Rydet's series *The
Infinity of Distant Roads*, this would probably mean exactly what she

19 Różycki, *The Infinity of Distant Roads*, 1991.
20 Ibid. Rydet mentions signs of "certain old habits" in the same documen-
 tary.

herself tried to express in words and what she has plainly shown in her pictures: The distinction between natural and conventional signs is not all that important. A sign seems to exist independently of any possible classification and is not necessarily meant to be deciphered by the human mind. Which is not to say that it is divine or is part of some secret book of nature. Indeed, it leads us nowhere beyond itself, but it is exactly the surface of the photograph or, to be more precise, a combination of elements that come to be read as meaningful (the picture as some sort of message) that might be so telling to the spectator, if he or she decidedly suspends their knowledge in favor of the photographic sign. Zofia Rydet was first and foremost a populist artist treating photography as a universal means of communication; yet, she made use of very different methods of picture-making, such as collage that in her time amounted to cutting out elements of different photographs and combining them together in a way not unlike surrealist painting or montage. Her *Sociological Record* can even be seen as a response to a challenge coming from Polish conceptualism and the desire to overcome its sometimes alienating complexity. But no matter what principle she actually espoused, her camera did the work that remains to be appreciated, and for that we need to refine—perhaps even invent—proper conceptual tools.

So, once again, what is the specificity of the photographic sign as we get to know it from Rydet's work? One way of explaining it would be to prioritize the prelinguistic without thinking about it in terms of passive inarticulate matter that has to be organized according to preexisting rules. In fact, the duality of matter and form in this version of language formation may be further augmented by the instance of substance which appears to be the result of their combination.[21] But if we remain on the level of the prelinguistic, moreover, if we regard it in its own right, that is, as something that is capable of self-organization (self-modulation), then we do not have to treat it as an inert substratum waiting to be shaped into a meaningful whole. According to Gilles Deleuze, the

21 For a more detailed account of this triad and its genesis, see Roger Dawkins, "Making Sense of Matter in Deleuze's Conception of Cinema Language," accessed November 17, 2017, http://heavysideindustries.com/wp-content/uploads/2014/05/Making-Sense-of-Matter-in-Deleuzes-Conception-of-Cinema-Language.pdf.

prelinguistic, which he prefers to call "plastic mass," is neither amorphous nor signifying (syntactic). Instead, it is involved in a process of unfolding and expansion.[22] The sign may be seen then as precisely a moment of such transformation when a number of heterogeneous elements (qualities, shapes, possibly colors) enter into a relationship with each other. This meaningful relationship, in its turn, transforms the elements taken by themselves into a combination that Deleuze has famously termed an *assemblage*.[23] Therefore, the sign is indicative of both transformation and difference: On the one hand, it points to nothing other than the unfolding of the "plastic mass" itself, while on the other it shows that an assemblage is not the same as its prelinguistic components.

But, and most importantly, a sign is how a subject makes sense of an encounter,[24] which brings us back to Charles Sanders Peirce. One might say that a subject itself is part of an assemblage, so that there is nothing extrinsic in its relation to a sign. Everything seems to boil down to the material properties of one's encounter with the sign; meaning is never found outside or beyond this type of experience. Yet what is truly located "outside" is the relation of representation, something that we have come to associate with both photography and the general structure of signs. The sign as assemblage calls for an immanent reading. Among other things it would mean that universal categories *actually* exist. Such are Peirce's fundamental categories of Firstness, Secondness, and Thirdness (again a triadic relation), standing respectively for existence in-itself ("qualities of feeling, or mere appearances"), actual existence ("brute actions of one subject or substance on another"), and logical existence ("the mental... influence of one subject on another relatively to

22 See Roger Dawkins, "Deleuze, Peirce and the Cinematic Sign," *The Semiotic Review of Books* 15, no. 2 (2005): 8.
23 Here is one possible clue to the notion in question: "You are longitude and latitude, a set of speeds and slownesses between unformed particles, a set of nonsubjectified affects. You have the individuality of a day, a season, a year, *a life* (regardless of its duration)—a climate, a wind, a fog, a swarm, a pack (regardless of its regularity). [...] A cloud of locusts carried in by the wind at five in the evening; a vampire who goes out at night, a werewolf at full moon. [...] ...it is this assemblage that is defined by a longitude and a latitude, by speeds and affects, independently of forms and subjects, which belong to another plane." Gilles Deleuze and Felix Guattari, *A Thousand Plateaus: Capitalism and Schizophrenia*, trans. Brian Massumi (Minneapolis: University of Minnesota Press, 1987), 262.
24 See Dawkins, "Deleuze, Peirce and the Cinematic Sign," 9.

a third").[25] Evidently it is not by chance that a sign eventually materializes. It does so the moment it begins to express a category of Being, if by expression we understand the formation of signs that follows a logic of its own, namely, that of the unfolding and self-organization of matter (or the prelinguistic) itself.[26]

Matter as expressed in signs and first of all in the photographic sign—such is the basic lesson we learn from Rydet's series. In this sense her work is indeed anterior to all possible classifications and namings that it will be subject to at a later date. I have mentioned earlier that Rydet's own classifications are rather tentative. She begins with a certain motif (let's say, people in interiors) only to drop it in favor of some sudden extension (for instance, objects and decorations), which in its turn might instantaneously give way to something else (professions or women on doorsteps). Of course, when grouped together according to a certain principle (the object of depiction), the photos display a recurring motif, which makes it possible to distinguish between clear-cut thematic series. But the taking of pictures remains itself unsystematic. We have already noted Rydet's drive, her compulsion to photograph, her mastery over the medium, and the circumstances she would find herself in. Out of the countless times she boldly walked into peasants' homes when working on the *Record*, she was turned down only once.[27] There was no time to focus properly on the chosen person or object, no money to buy color film with, no patience to wait for the peasants to put on whatever Sunday best they had. But there was this world around full of speeds and slownesses, of the permanently changing networks of

25 Charles Sanders Peirce, "Pragmatism" (manuscript, 1907), under the term "Firstness," in *The Commens Dictionary: Peirce's Terms in His Own Words*, eds. Mats Bergman and Sami Paavola, rev. ed. (2003; repr., Commens, 2014), http://www.commens.org/dictionary/entry/quote-pragmatism. See, by way of comparison, Charles Sanders Peirce, "On a New List of Categories," accessed July 17, 2017, https://en.wikisource.org/wiki/On_a_New_List_of_Categories.

26 On the concept of expression and its implications, see Gilles Deleuze, *Expressionism in Philosophy: Spinoza*, trans. Martin Joughin (New York: Zone Books, 1992).

27 This insight comes from Anna Beata Bohdziewicz who gave a penetrating talk entitled "Wanderings with Zofia Rydet" at a symposium on Zofia Rydet's *Sociological Record* (Museum of Modern Art in Warsaw, January 8–9, 2016); see also 49–67, in this volume. I am also grateful to one of the curators of the eponymous show, Sebastian Cichocki, for his valuable comments on Rydet's life and work.

FIG. 3
ZOFIA RYDET, *SIGNS*, FROM THE SERIES
THE INFINITY OF DISTANT ROADS, 1980

relations that she could not *not* photograph. 27,000 pictures of the *Record* do not actually combine into an archive, be it something still in the making or irreversibly complete, but are instead so many signs, each of which seems to present a slightly changed configuration of material bodies whose interaction never stops.

It is as if Rydet knows: The meaning of the sign has nothing to do with transcendence, it is contained in the material properties of the sign itself. It might be worthwhile to recollect a brief remark made by Peirce who at some point appears to be interested in the semiotic status of photography:

> Photographs, especially instantaneous photographs, are very instructive, because we know that they are in certain respects exactly like the objects they represent. But this resemblance is due to the photographs having been produced under such circumstances that they were physically forced to correspond point by point to nature.[28]

This means that we might be heavily inclined to think of photographs as icons (the relation of representation based on resemblance, similitude, analogy, etc.), whereas we should look upon them as preeminently indices, that is, signs that are *directly affected* by the object they denote. It seems that the prevailing notion of photography as index in contemporary critical discourse distrusts what is so obvious in Rydet's photographs: a world that unfolds itself before our eyes while remaining essentially nonhuman; a prelinguistic world whose essence is expressed in denseness; a world of speeds, relations, and affects. This world, as Rydet clearly shows, is populated with *lud*, which in Polish means the "people," all those living bodies that affect and are themselves affected, that experience and resist encounters, that increase their power or lose it when entering into a composition with other bodies, animate and inanimate alike. The photographic sign is precisely this combination of forces and relations, of forces *as* relations, and it is nothing less than the infinity of Nature that Rydet participates in and renders so well.

28 Peirce, "Logic as Semiotic," 106.

Łukasz Zaremba teaches at the Institute of Polish Culture, University of Warsaw, and is also active as a translator. His interests include the theory of visual culture and the methodology of visual research. He has published in numerous academic journals including *Konteksty, Kultura Współczesna, Dialog, Kultura Popularna*, and *Dwutygodnik.com*. He is the recipient of a Ministry of Science and Higher Education Scholarship and the Foundation for Polish Science START 2012 Scholarship. Co-translator of Jonathan Crary's *Suspensions of Perception*, translator of W. J. T. Mitchell's *What Do Pictures Want?* and Nicholas Mirzoeff's *How to See the World*. Co-editor of the academic reader *Antropologia kultury wizualnej* [Anthropology of Visual Culture] (2012).

Witek Orski is an artist and academic. He is a graduate of the faculty of Philosophy at the University of Warsaw, receiving an MA in 2011. Currently a PhD candidate in Philosophy at the University of Warsaw and the faculty of Multimedia Arts at the Academy of Fine Arts in Poznań. Lecturer at the Academy of Fine Arts in Szczecin, the Polish-Japanese Institute of Information Technology, and the Academy of Photography in Warsaw.

"When, in 2015, Łukasz and I began our conversation on Zofia Rydet's work, we played with the idea that the *Sociological Record* might be viewed as a sequence of multilayered 'pictures on pictures.' In my visual response to Łukasz's essay, I wanted to emphasize this aspect of Rydet's work. To accomplish this, I used the sense-making technique that is specific to the creative process of a photographer: cropping."

ZOFIA RYDET:
PICTURES ON PICTURES

It may well be that similitude in photography—the likeness that characterizes individual photographs in a series—can tell the suggestive story of homogeneity, identicalness, a common image arising out of singular pictures, as well as a story of multitude. Zofia Rydet's endless archive, *Sociological Record*, is filled with uncountable repetitive forms, visual motifs, figures, and views of interiors. And yet both a cursory overview and an in-depth analysis leaves one with the irrefutable feeling that Rydet's work cannot be unified into a single image and shouldn't be analyzed according to a single visual pattern emerging from the endless copies. A photograph from Rydet's archive, and its multiple forms of presentation, inevitably exists in the company of other pictures, stands between specific photographs, is a follow-up, a part of a sequence or some other not necessarily linear visual arrangement. As I will argue, repeatability of visual motifs is a testament to the multitude, circularity, movement, and diversity characteristic of this particular world of images that Rydet's photographs both constitute and represent. The diversity that interests me has less to do with the repeatable character of spatial arrangements and human relations visible in the photo-

graphs, but rather the diversity of the pictures themselves—the photographs taken by Rydet, as well as the varied pictures existing within the context of local, Polish visual culture, captured by Rydet in her photographs.

The Photographed Subjects and the Photographer

Adam Mazur, Polish photography critic and art historian, has noted: "Without a doubt, it is people who are the focus of Rydet's art."[1] Indeed, it would be difficult to disagree that the *Sociological Record* is an anthropological, or maybe even humanist, undertaking of sorts. It is thus unsurprising that people are always at the center of most interpretations of the project. Such interpretations also align with the photographer's own intentions. As Rydet wrote in 1967 in a letter to Krystyna Łyczywek—literary scholar, photographer, and Rydet's friend (and this quotation almost seems to undermine my claims about the multitude of images as the central feature of the project): "My way of looking at the world [has] expanded greatly, yet I increasingly [...] feel as if we are all the same. I am now very interested in people and their homes."[2] Rydet seems to be partially reiterating the manifestos of the Gliwice Collective from ten years earlier, in which she and Jerzy Lewczyński emphasized that "the human being should be the deciding element—a living human being, as seen, for example, by Italian neorealism. It may be that this human is incomprehensible, but he is always down-to-earth."[3] Fortunately, the risky belief in photography's ability to capture the essence of humanity voiced in the manifesto ("we are all the same")

1 See Adam Mazur's essay in this volume, "Perhaps the Greatest Polish Woman Photographer: Problematics of Research into the Life and Art of Zofia Rydet," 69–92

2 Zofia Rydet, "Excerpt from a Letter to Krystyna Łyczywek," Gliwice, October 23, 1967, accessed January 5, 2017, http://zofiarydet.com/zapis/en/pages/sociological-record/letters/krystyna-lyczywek-23-10-1967.

3 Gliwice Collective founding document, from the Jerzy Lewczyński Institute archive, quoted after Rafał Lewandowski, "Neorealism as a Language," in *Neorealism in Polish Photography 1950–1970*, eds. Rafał Lewandowski and Tomasz Szerszeń (Warsaw: Fundacja Asymetria, 2015), 7. [Translation modified.]

ZOFIA RYDET, *SOCIOLOGICAL RECORD*, **NAPRAWA, 1978**

is partially undermined by the ethnographic and ethical potential of the *Sociological Record*.

As a side note, it is worth emphasizing that Rydet's decision to concentrate on people is possible to accomplish precisely thanks to photography's potential endlessness. The scale of the *Sociological Record* becomes visible today mostly as a result of the ongoing project of digitizing Rydet's archive—we are confronted with thousands of photographs of faces and bodies. Most critics focus on the difficult balance between documenting a meeting with another human being and using her subjects,[4] between the aggressive character of the photo camera, intruding upon the private space of another person, and the community created through a similar cultural experience.[5] The stakes are particularly high, since Rydet focused on groups that had heretofore been objectified and exoticized through the medium of photography: inhabitants of rural regions, peasants, especially peasant women, and children. The ability to walk this fine line allowed Rydet to avoid essentializing human experience (which could lead to the creation of a crystallized, Galtonesque, composite portrait of the Polish "other"[6]) and to grant each of her subjects an individualized image.

A different critical approach to Rydet's work, and a position which can be seen as the verso of the "humanist," anthropological or sociological interpretation described above, is the critic's concentration on the author of the *Record* herself: her life, approach, and myth. And so Rydet herself becomes a person of interest for so many commentators, fascinated by this fearless woman traversing the Polish countryside, entering private homes and art galleries with the same composure and effectiveness. "Who was Zofia Rydet?" they ask. How can her project be categorized? The

4 Iwona Kurz, "Nie wyrzucajcie tego wszystkiego," *Dwutygodnik.com* 172, 2015, accessed January 5, 2017, http://www.dwutygodnik.com/artykul/6229-nie-wyrzucajcie-tego-wszystkiego.html.

5 Krzysztof Świrek, "Co odtwarza *Zapis*?," *View: Theories and Practices of Visual Culture* 9, 2015, accessed January 5, 2016, http://www.pismowidok.org/index.php/one/article/view/288/531.

6 On Galton's composite photography see, among others, the essay by Allan Sekula, "The Body and the Archive," *October* 39 (Winter 1986).

myth of "the old lady with a photo camera," who passed, among many, as a naive "eccentric," an "amateur,"[7] and thus as someone rather innocent and harmless, shielded Rydet from accusations of objectifying her "models." The inquiry into the status of Zofia Rydet herself, the person, usually results in trying to determine her "real" status and professional identity: either she was an artist (then we should add, naive or amateur); or a sociologist (homegrown); or maybe a documentarian or ethnographer. Either way, the definition is always derived from her experience, education, social skills, routes of travel, and places (dominated by rural landscapes and houses), written sources, spoken memories, and finally, the contexts of presenting the project.

If the photographs are treated as testimonies of the nature of the project—or of the discipline it belongs to—then it is again because of the people that are captured in them (as other essays in this volume show, representations of peasant families may be compared to a wide range of images: documentary, ethnographic, and artistic photographs from various times and contexts). Taking one of those interpretative contexts, for example, the one that classifies *Sociological Record* as documentary photography, allows us to see that focusing on people presented within the photographs, or trying to read Rydet's archive as a source of knowledge about individuals, pulls the interpretative process out of the picture frame, and invites us to search for a picture's meanings mostly outside of the picture itself (e.g., in the social reality of 1960s, 1970s, or 1980s Poland). It can also turn the photographs into documents of a certain era, useful in the analysis of historical life and customs.

The repetitive, sometimes even obsessive, character of discussions aiming to secure a single disciplinary frame for Rydet's archive—defining it once and for all as either artistic or sociological, or maybe ethnographic, as "naive conceptualism" or "old objectivity"—proves how ambiguous Rydet's photographs are, but

7 Adam Mazur, "Zofia Rydet 'Zapis Socjologiczny,'"*Dwutygodnik.com* 8, 2012, accessed January 5, 2017, http://www.dwutygodnik.com/artykul/3828-zofia-rydet-zapis-socjologiczny.html.

equally, how important it is to search for new ways of looking at them. One way leads from classifying Rydet's work as existing at "the junction between art, cultural animation, and sociology"[8] to researching it as an interdisciplinary project. An alternate route leads to an analysis constituted by the radical concentration on an element that has heretofore been surprisingly ignored: the pictures themselves.

Theory of the Image Worlds

Although humanist and anthropological approaches remain legitimate and well grounded, they tend to restrict the field of interpretation to two elements: the photographer and the photographed subjects. In both cases, such a limitation erases that which mediates the relationship between the photographer and her subjects and that which is the condition of interpretation—the pictures themselves; individual photographs, but also the series, the collection, the seemingly endless archive.

Would it be possible to return to these pictures and what would this mean? To achieve this, we will have to transgress one more distinction, which may avert our gaze away from the pictures themselves. While not trying to search for any sort of intrinsic meaning inscribed in Rydet's *Sociological Record*, I would like to trust the pictures—not to personify or treat as fetish, but to see them for what they are: the core of this project. The obsessive and systematic production of pictures, their classifying and arranging, their multitude or even excess, surplus, and redundancy, can and should become a subject of study. No matter if we decide that Rydet's project is documentary or artistic, we cannot ignore the fact that it is first and foremost iconophilic.

As Bruno Latour writes in his famous essay "What Is Iconoclash?": Iconophilia means moving from one image *to the next*. Iconophiles *"do not* cling to one image in particular but move from

one to another. [...] They do not want the image production to stop forever [—] they want it to resume as fast and as fresh as possible."[9]

Of course, in Latour's definition of iconophilia the image is either an element of a larger set of all sorts of mediations or a figure of mediation in the metaphorical story about the necessity of accepting—or even coming to like—"mediators." To quote art historian Andrzej Leśniak: "We are iconophiles if we acknowledge that mediation is the key phenomenon in the process of establishing the world."[10] And so when Latour prompts his readers not to focus on a single image (idolatry), but to pay attention to the movement of images (iconophilia), to avoid "freeze-framing," he is warning us against taking mediation at face value, viewing it as the truth or reality itself. The author of "Iconoclash" is not interested in images particularly, but in mediation generally.

In the context of Rydet's practice, the term iconophilia should be understood in a very literal manner: as the refusal to focus on a single image. Adapting Latour's commandment "Thou shall not freeze-frame any graven image!"[11] to the process of analyzing Rydet's photographs means that they can be understood only in a group, that the interpreter cannot stop moving from one to the next in her analysis. None of the photographs give a definitive insight into the project, because its essence is pictorial multitude.

At the same time, there is no story to be read. Rydet's pictures are fundamentally nonnarrative or could even be interpreted as being against narrativization. Recalling the categories of traditional communication theory, one could say that Rydet compiles elements, which are usually, or should be, interchangeable. This means that the elements, which typically stay in a paradigmatic relation (either this or that will be used; newer, both, or all) create a quasi-syntax. This time the syntactical relation, usually built of dif-

9 Bruno Latour, "What Is Iconoclash?" in *ICONOCLASH: Beyond the Image Wars in Science, Religion, and Art*, eds. Peter Weibel and Bruno Latour (Karlsruhe: ZKM; Cambridge, MA: MIT Press, 2002), 27. [Emphasis in the original.]
10 Andrzej Leśniak, *Ikonofilia. Francuska semiologia pikturalna i obrazy* (Warsaw: Wydawnictwo IBL, 2013), 64.
11 Latour, "What Is Iconoclash?," 37.

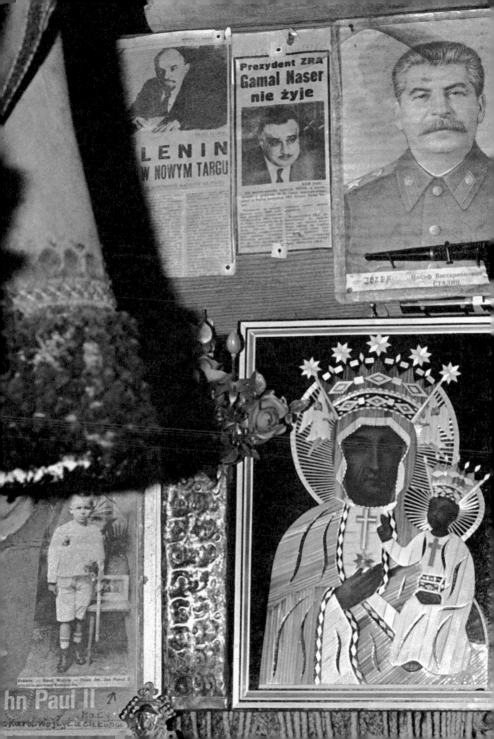

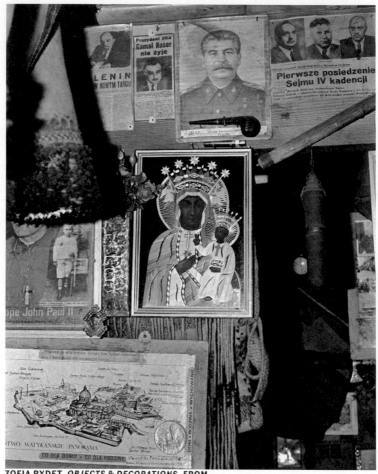

ZOFIA RYDET, *OBJECTS & DECORATIONS,* **FROM
THE** *SOCIOLOGICAL RECORD,* **CHOCHOŁÓW, 1982**

ferent and logically consecutive elements (composing a sentence, a story, a narration), is inserted among elements that stay in "grammatically" similar position. We are thus left with a paradigmatic row or rows or other combinations and arrangements—a sequence or swarm of even, homogenous elements. Of course, this strategy is often (but not always) present in photographic series (and may be a mode of presenting an archive); but Rydet's *Sociological Record* seems to be one of its most radical examples. First, because the consecutive elements do not constitute a story, and the series itself can be seen as the opposite of a narrative. Second, as the "content" of the photographs is static, the photographs do not pretend to be telling a story. The photographed subjects do not act as if the photographer was not present, or as if the images were still frames extracted from the normal flow of life.[12]

When there's nothing to "watch," no story to follow, we are forced to look. As it is, this nonnarrative, iconophilic series is also iconological (if we understand iconology as the general knowledge of images[13])—it is a series of images about image production and circulation, or even about the worlds of images. Rydet's photographs are self-conscious and capable of self-reflection; they are pictures on pictures, pictures "that refer to themselves or to other pictures, pictures that are used to show what a picture is."[14] Furthermore, Rydet's pictures on pictures, her "metapictures," to use the term coined by visual culture scholar W. J. T. Mitchell, are not limited to these photographs in the *Sociological Record* that show typical signs of self-reflexivity such as mirrors or self-portraits.

An equally important source of this project's capability to reflect on the world of pictures rests in its iconophilic potential, the unprecedented and endless multiplicity of pictures: both

12 Strategies that use photography to capture the flow of life are visible in other examples of sociological photography. See Krzysztof Pijarski's essay in this volume, "Seeing Society, Showing Community: 'Sociological Photograph' and Zofia Rydet's *Record*," 135–77.

13 W. J. T. Mitchell, *Iconology: Image, Text, Ideology* (Chicago: University of Chicago Press, 1986).

14 W. J. T. Mitchell, *Picture Theory: Essays on Verbal and Visual Representation* (Chicago: University of Chicago Press, 1994), 35.

photographs taken by Rydet and the many pictures—entire complex picture worlds—presented in her photographs. The imposing number of pictures is in itself an important diagnosis about visual culture, about the nonlinear, complex, diverse world of images, images that constantly stay in motion and cannot be freeze-framed. Perhaps Rydet's *Sociological Record* can provide us not only with metapictures, but also with an outline of image theory.

Iconophilia Against Idolatry

When we ask about images, pose the question "what is an image?," wonder about its power, meaning, possibilities, or place in social life, we usually receive—and I am thinking here of such examples as David Freedberg's *The Power of Images* or Hans Belting's *Likeness and Presence*—a story about the most important and most powerful pictures. A question about the image is usually answered with a description of an exceptional image. Its remarkable character can be derived from its theoretical or aesthetic value, or its status as a source image (an image perceived as essential, either historically or metaphorically), or, finally, a technologically advanced image, the image of the future, which usually awakens iconoclastic fears. The next theoretical step often proposed is to take the features of an exceptional picture and turn them into a universal model, one that seemingly applies to all images, and the image as such. One exceptional image is cast in the role of the representative image. Instead of analyzing typical images we focus on the singular, powerful, or extraordinary picture. Such a perspective has the potential to reduce images, resulting in a lack of analysis of the differences among them, their multiplicity and diversity, leading us toward the neglect of the visual majority. One such example of an image often cast as a representative of all images, leading to idolatric adoration or iconoclastic fear of images, is the icon, a sacred image that protects societies during wars and crises, and which plays both a political and religious role. This image is power-

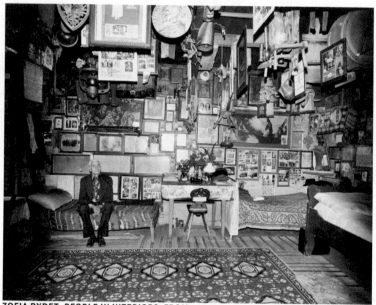

ZOFIA RYDET, *PEOPLE IN INTERIORS*, FROM THE *SOCIOLOGICAL RECORD*, KAROL SKORUSA "MACHAJCOK," CHOCHOŁÓW, 1982

ful, exceptional, and possesses agency. Despite its exceptionality, the icon is often treated as the model image.

If we were to construct an image theory based on Rydet's visual archive, we would see that instead of focusing on one sacred image (for example, the "original" Black Madonna of Częstochowa, the most important Polish religious and state icon), Rydet presents the icon's multiple copies. However, the word "copy" may not be the right word here. Neither, but for different reasons, is the English phrase "devotional image." Instead, one should probably use the Polish phrase *święte obrazki*, where "obrazki" is a diminutive form of picture, and "święte" means sacred. The multiplicity of sacred imagery is not criticized as naive or less serious; rather the diminutive form indicates a familiar, "homely," and accessible form of pictorial sanctity. In Rydet's photographs, we see hundreds of reproductions of well-known images and motifs of religious iconography. We see homemade altars and collages, mixtures of diverse pictorial genres and media—family photographs, TV sets, music posters, and kitschy landscapes form harmonious visual gatherings with images of Jesus, Mary, and the saints. Perhaps the most fitting term to describe this type of sacred image would be a slight modification of Hito Steyerl's category of "poor images."[15] The images photographed by Rydet are poor sacred images that pay the price of quality, material condition, resolution, and durability for being a part of everyday practice and presence of religion in these homes.

Rydet's take on vernacular sacred imagery avoids a judgmental perspective toward folk religious experiences. But its message may be even stronger. Rydet's *Record* could be viewed as a claim that the source of power of the sacred image does not rest in the original (in the case of the icon, an original created without the intervention of the human hand), but in its multiple repetitions. The visual repetitions are not lesser forms of images, ones indicating less advanced forms of religious practices. They are rather present in everyday practices, and they gain their importance precisely via

15 Hito Steyerl, "In Defense of the Poor Image," *e-flux* 10, 2009, accessed January 5, 2017, http://www.e-flux.com/journal/10/61362/in-defense-of-the-poor-image/.

circulation, repetition, relocation, and reproduction, as well as maintaining relations with other pictures.

Unlike many other image theorists, Rydet, even when focused on sacred images, shows the multiplicity and, by extenstion, the presentness of the image in everyday life. Furthermore, all individual pictures and visual genres exist among other pictures and are embedded within the everyday world. Following Rydet, we see pictures as elements of the lived world and not solely as its external representation, floating in a sphere cut off from lived experiences. The interiors of village houses are filled with an excess of pictures (at least in the eyes of a contemporary city-dweller). The visual landscape is dominated by religious iconography, family portraits, and dormant television sets—objects indicating a potentially endless flow of images. Landscapes, posters of music and pop culture idols, and nature shots are sometimes added to the mix. Treating these pictures separately, as individual representatives of certain genres, would also be a difficult feat as they often literally overlap— as in the case of an embroidered peacock from the *Record*, whose feathers are decorated with small sacred pictures.

The images portrayed by Rydet formed an everyday living environment, constituted an element of religious and commemorative practices, and provided their owners with models of constructing their identities. Rydet's photographs bring forth their more than decorative function while simultaneously not suggesting that the inhabitants of these spaces experience their images as exceptional works of art or miraculous sacred images. However, their vernacular character does not make them less worthy of our attention. It could be said that through the multiplication of the photographs within the *Sociological Record* and the images visible within, Rydet's project ultimately leaves behind an interest in any singular picture. Simultaneously it shows that the circulation of images—their creation, acquisition, and arrangement—is an important element of everyday life and an important mechanism in identity-forming processes. The pictures shown in Rydet's photographs, pictures existing in homely, everyday environments, shouldn't be perceived as representations of specific views—be it religious,

national, aesthetic—but rather a way in which these views are mate-
rialized. After all, why would you need to represent, that is prove,
your religious views inside your own home? As the *Record* shows, it
is through images that views and ideologies exist in people's lives.

That is why Rydet never shows pictures in complete
isolation, as abstract phenomena, cropped from their context and
location. They are always either a part of a collage of pictures or at
least presented in a large passe-partout of a wall, an element which
reminds us that a picture always exists in a material surrounding
and not as an isolated, abstract phenomenon. It could be said that
in some of Rydet's photographs, pictures construct the walls, form-
ing their building material. It would be hard to imagine a stronger
visual expression of the centrality of images in everyday lives.

No doubt, my diagnosis of this image world must also
be "localized" and seen as an insight into the Polish iconosphere (to
apply a concept of the late Polish art historian Mieczysław Porębski),[16]
that is, the visual culture of a certain period. As such, Rydet's photo-
graphs show pictures as elements—in my opinion, key elements—of
the Polish private sphere, the inside spaces and everyday individual
lives (though at the same time common elements, as the repetitive
character of the series unambiguously demonstrates). Rydet's "pic-
ture theory" insists on the importance of images in Polish culture,
although not—or rather not yet, as most of the photographs were
taken before 1989—in the public sphere, but in a closed-off space
of private, everyday existence. *Sociological Record* can be seen as a
unique insight into the status of images in Polish culture, in which
the public sphere, at least until the late 1980s, was dominated by
verbal messages. Contrary to the popular image of the communist
era as a time of visual boredom and "grayness," Rydet shows us a
vibrant world of images of multiple origins—Western pop culture
mixes with devotional imagery and stereotypical landscapes, fam-
ily portraits mingle with portraits of American presidents. They are
proof of a bricoleur's visual creativity in times of shortage of means
and tools of reproduction. On the other hand, the lack of official

16 Mieczysław Porębski, *Ikonosfera* (Warsaw: Państwowy Instytut
Wydawniczy, 1972).

state propaganda proves the unimportance of visual media propaganda for the Polish ruling party (with the notable exception of television). Rydet's photos present an everyday world, existing alongside the dominant political sphere.

An example of an image that escapes traditional categories of analysis—in this case the opposite categories of the original and the copy, as well as the category of the sacred image—is the recurring image of John Paul II. In *Sociological Record* Rydet documents—perhaps not entirely consciously—the beginnings of the cult of the pope's sacred image. This cult and passion has its sources not in the theological declarations, rituals, and decisions of the Catholic Church, but in private practices, which appear long before John Paul II's canonization and even long before his death. Since the beginning of his pontificate, the image of John Paul II was distributed in the form of small and large sacred images. These diverse and multiple images (very often one image of the pope is not enough) appeared in Polish homes long before the arrival of the official holy image of the "Polish Pope"; the original, proper sacred image would be established by the Catholic Church many years later, during his canonization process.

One of the things that this particular example teaches us about the general theory of images visible in Rydet's photographs is that the image is not ruled by media classifications. The papal image can be a cut-out from the newspaper or a magazine, folded many times, ripped around the edges and then pasted on the wall. Poor quality or weak material form does not change its place in the society of images. Rydet's "picture theory" is also not ruled by media in the sense that the circulation and reproduction of images (their multiplication) is not just an outcome or function of media development (technical advantages that supposedly allow and drive reproduction), but of people's practices with images—practices that cut through lines of media difference and divisions.

It is not technological reproducibility that is responsible for the presence of the representations of the Black Madonna or John Paul II in so many of the Polish homes photographed. Their images are often created using traditional techniques—embroi-

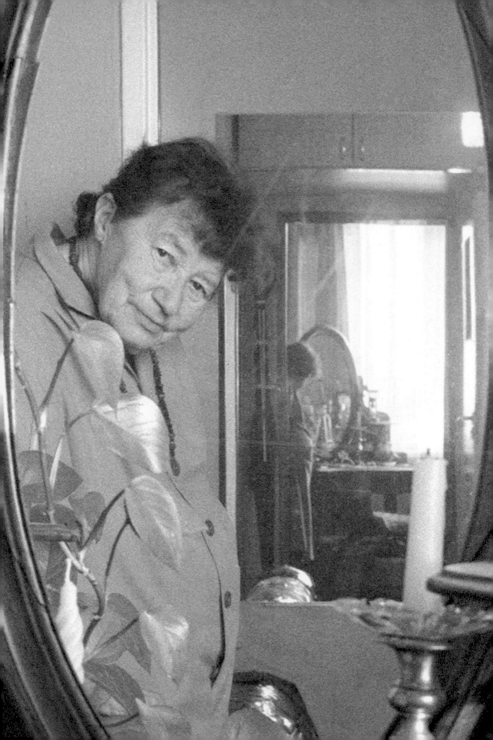

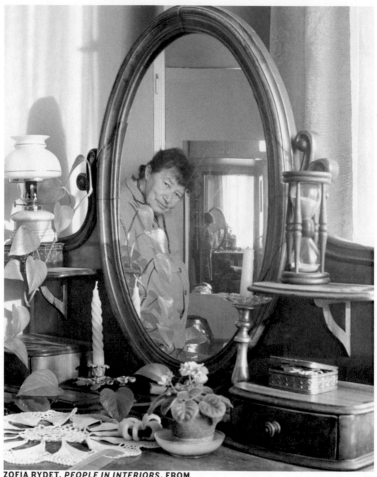

ZOFIA RYDET, *PEOPLE IN INTERIORS*, FROM
THE *SOCIOLOGICAL RECORD*, SELF-PORTRAIT,
KRAKÓW, 1987

dered in fabric or sculpted in wood. It is people that are responsible both for the circulation of images and for creating relations between them. Of course, one could argue that there are many more pictures in Rydet's photographs than there are people. In the end, however, it would be difficult to deny that Rydet's photographic practice centers on people, even when the photographs themselves show images only. It is people that create the images, and it is people who look at them, arrange, and juxtapose them. It is important to remember that the relations between humans and images are not one-sided—images are more than a mere backdrop for human existence; they are also not only its documentation.

The laws of the picture world, recognized and shown in the *Sociological Record*, pertain also to Rydet's photographs themselves. Although in this essay, the photographs from the *Record* are interpreted as metapictures, it would be naive to think that they are situated on the outside of the iconosphere, the world of images and people. This is most visible thanks to the element of the frame, often visible in the photographs. Door and window frames guide the viewer's gaze into the framed interior and onto the bodies of the photographed subjects, mimicking the frame of the photograph itself. Other times photographs show empty frames, as if wanting to remind us of the limited character of the frame of the image, never able to capture everything. Sometimes the light beam creates a black frame, rendering the borders of Rydet's photograph already visible in the same picture. Her frame becomes one of many; this time the sequence of pictures goes into the picture, creating an impression of depth.

The large number of photographs created, and the obsessive nature of Rydet's practice, also seems to place *Sociological Record* within a chain of images, whose meanings will be created and recreated in their myriad use. The photographs are also elements of the circulation of images; they do not constitute "the picture," the essence of the *Record*. Rydet's image theory incorporated in photographs cannot exist outside of the picture world, of the traffic in photographs. This does not mean that exhibiting singular photographs from the series as works of art or reading them as docu-

ments of social history is inappropriate. It does, however, mean that
every attempt to subscribe them to a single category of images,
every attempt to stop and freeze-frame them, will be against the
principle that these pictures themselves fulfill and comment on.
Zofia Rydet's *Record* puts forward not so much the principle of insta-
bility as governing the meaning of images, but rather claims that
their movement is what grants them their vitality.

Agnieszka Pajączkowska is a freelance researcher, curator, creator, and community artist interested in vernacular photography and local history (including, and especially, the memory of the Holocaust and postwar migrations in Poland). She was awarded a PhD from the Institute of Polish Culture, University of Warsaw. Her work concerns institutional and private photographic archives. She has collaborated with the Association of Creative Initiatives "ę," the Zofia Rydet Foundation, the History Meeting House in Warsaw, the Museum of Modern Art in Warsaw, the Museum of the City of Gdynia, TIFF Festival in Wroclaw, the Archeology of Photography Foundation, and the Association "Katedra Kultury," among others.

"SOMETHING THAT WILL REMAIN": LOCAL ACTIVITY BASED ON ZOFIA RYDET'S *SOCIOLOGICAL RECORD*

The *Sociological Record* Online

Zofia Rydet left behind a large closet full of some 27,000 negatives, envelopes, folders, prints, blow-ups, and contact sheets. For three years—2012 to 2014—the Zofia Rydet Foundation, the Foundation for Visual Arts, the Museum of Modern Art in Warsaw, and the Museum in Gliwice collaborated on a project that involved the sorting, digitizing, and annotation of Zofia Rydet's photographs in the series *Sociological Record*. The website that makes the fruit of their labour accessible to the public, including the digital photographic archive, went live in December 2013. With the help of the notes that the author left behind, it was possible to identify some of the photographs from the names of specific villages or regions, and all of them were tagged so as to make it possible to browse through the collection by selecting a specific theme or criterion.

Three months later, in March 2014, a resident of Chochołów accessed the site zofiarydet.com and viewed all the photographs marked as having been taken in his village.[1] He then

1 Chochołów is a village in the south of Poland, close to the Tatra National Park. It is renowned for its traditional, wooden architecture. The majority of its 1,300 residents are related, having descended from the few families which have lived in Chochołów for generations.

published them on his community Facebook page.[2] The photographs taken three decades earlier acquired a new lease on life, generating a flood of comments from the followers of the Chochołów fanpage (mainly from those who had emigrated, the majority of them to the United States), as well as posts identifying personal links with the people in the photographs, such as "My darling Grandma," "This is my mom, God rest her soul," "Our beloved Polish teacher," "My uncle's sister-in-law," "These were your neighbors, don't you remember them?" Under a photograph showing a boy seated on a sofa bed with a large teddy bear, one of the site's users added a comment: "And that's me—Jaś, with my teddy bear called Kuba." [FIG. 1] A few days later, "Jaś"—or Jan Szeliga, a thirty-three-year-old owner of a food store in Chochołów—telephoned the Zofia Rydet Foundation with the names of people that he had identified with the help of his family and neighbors, and pointed out that captions ought to be provided for the photographs that had been published online. The President of the Foundation, and Zofia Rydet's grandniece, Zofia Augustyńska-Martyniak, went to Chochołów to meet with Jan Szeliga and the other residents who had offered their comments. The Szeliga family had printed select photographs at their own expense and annotated them. Zofia Szeliga, Jan's mother, was also present. It turned out that she had rented out a room in her house to Zofia Rydet, when the photographer visited Chochołów two or three times in the 1970s. Zofia Szeliga reminisced:

> I remember that lady. She arrived and rented the room. A bit hunched, with a camera, she wasn't saying a lot. She was elderly, and dressed very modestly, she didn't stand out in any way. I can't remember very well, but she may have had two cameras. She did have one for sure, strapped to her front. She paid for the room and went off to walk around the village—I thought she was on vacation. She did not confide in me about what she was up to. And then she came and asked if she

2 Chochołów community Facebook page, accessed July 25, 2017, https://www.facebook.com/pg/Chocholow1846/photos/?tab=album&album_id=703623733032044.

FIG. 1
ZOFIA RYDET, *PEOPLE IN INTERIORS*, FROM THE
SOCIOLOGICAL RECORD, JAN SZELIGA,
CHOCHOŁÓW, 1982

could take a snap. I remember that I wore a house-
dress, a green one, and I was peeling potatoes. And
I say "OK, go ahead." Why wouldn't I? I didn't know that
she went to my mom's as well. So, I knew that she was
taking snaps, but not what for. And I have no idea
when she snapped Jan. As for the teddy bear, we still
have it.[3]

A Lasting Legacy

Following the visit to Chochołów, Zofia Augustyńska–
Martyniak and I embarked on a project that involved taking particu-
lar photographs from the *Sociological Record* and visiting the places
where they had been taken. The first place that we visited was in fact
Chochołów, where I went in December 2014. Just as Zofia Rydet used
to, I went house to house, knocking on doors and straight away show-
ing the occupants a stack of black-and-white photographs. I
observed their reactions, jotting down key points, and recording
their statements. The photographs triggered emotions and memo-
ries but also generated a need for clarification and annotation.[4]

During the mere four days that I spent in Chochołów,
I managed to identify the people and places in over 300 shots, organ-
ize a slide projection in a local school attended by a few dozen res-
idents, and run a photographic workshop related to Zofia Rydet's
methods of work.[5] This latter experience, designed for a group of
children, made it obvious that local action related to photographs
from the *Record* could be a method of work combining research with
artistic and educational activity—an event that powerfully involves

3 Zofia Szeliga, Chochołów resident, in discussion with the author,
December 2014.
4 Film documentation of the project can be accessed online. "Coś, co
zostanie – działania wokół 'Zapisu socjologicznego' Zofii Rydet," *Vimeo*,
uploaded January 19, 2015, accessed July 25, 2017, https://vimeo.
com/117158240; "Powrót z 'Zapisem socjologicznym' – Chochołów 2014,"
Vimeo, uploaded January 25, 2015, accessed July 25, 2017, https://vimeo.
com/117730916.
5 One outcome was the portraits of select Chochołów residents. The
photographs were printed on the spot and given to the sitters, as well as
placed online in a dedicated gallery on the Zofia Rydet Foundation's
website; Zofia Rydet Foundation, "Coś, co zostanie," accessed July 25,
2017, http://fundacjarydet.pl/cos-co-zostanie/.

the local community, awakening individual memories and problem-
atizing the status of photographs which are part of a monumental
project.

We titled the project *Something That Will Remain: Local
Activity Based on Zofia Rydet's* Sociological Record.[6] "Something that will
remain" are Zofia Rydet's own words, a definition of photography
uttered in the opening scene of Andrzej Różycki's film *Nieskończoność
dalekich dróg* [The Infinity of Distant Roads].[7] We decided to visit five
places where Rydet had shot her *Record*. We based our plans on a
key premise: a photograph—even one that has the status of a work
of art—functions not only in the field of art but is, primarily, a social
practice, closely linked to ordinary life. We adopted a literal inter-
pretation of Steven Wright's postulate, outlined in *Toward a Lexicon of
Usership*, to change the reception of artistic practice that Zofia Rydet
undoubtedly belongs to. In reference to one's relationship with art,
Wright invokes Wittgenstein: "Don't ask for the meaning; ask for the
use."[8] We used the *Record*, by taking it on a field trip, strongly con-
vinced that the manner in which we employed the photographs on
the ground could help redefine the entire project as transcending
the boundaries of art, while at the same time casting new light on
the question of the relationship of photography to art—a question
that is not novel, but nevertheless imperative in the context of Zofia
Rydet's life project.

Something That Will Remain is an interdisciplinary pro-
ject and deserves to be described as such from an artistic-research

6 The project was cofinanced by the Ministry of Culture and National
 Heritage under the auspices of a grant competition for cultural institu-
 tions and NGOs in the category "Cultural Education."
7 Zofia Rydet's full statement in this scene is as follows: "You have to sit in
 such a way that you realize that this is a solemn moment, that we are in
 fact doing something that will remain. I won't be here, you won't be here,
 but the photographs will remain." *Nieskończoność dalekich dróg*, directed by
 Andrzej Różycki, 1990.
8 See Steven Wright, *Toward a Lexicon of Usership* (Eindhoven: Van Abbemu-
 seum, 2013); see also Kuba Szreder in conversation with Steven Wright,
 "Nie pytaj co to znaczy, zapytaj jak tego użyć," *Notes na 6 tygodni*, no. 97,
 2014, 100–11.

and social-cum-educational point of view.[9] In the first place, our vis-
iting a location bearing prints of photographs with artistic status in
order to attempt to identify their subjects and to give them the pho-
tographs is a conceptual action, a gesture with a "high artistic
coefficient."[10] Secondly, the project was a revisit, as it were, provid-
ing new knowledge about the subject of the photographs and their
location and settings, as well as about the work method of the pho-
tographer herself. Repeat reconnaissance or a revisit is a well-
established research method in ethnography, one that is part of the
"usual research praxis of this discipline, if not part of the anthropo-
logical canon."[11] As Piotr Filipkowski adds, the "aim of a revisit is to
look for differences rather than similarities,"[12] thus leading to a revi-
sion—whether reinterpretation or reanalysis of the previously gath-
ered material. While describing return visits to the locations sub-
ject to ethnographic research in order to develop a sociological
understanding, Małgorzata Mazurek observes that a "revisit is an
opportunity for a more self-aware implementation of theory in a
tame location."[13] "Self-aware" not only in the sense of being open to
a revision of the conclusions arrived at in previous research, but

9 A short documentary film about the project is available online. Zofia
 Rydet Foundation, "Coś, co zostanie 2015," *Youtube*, uploaded November
 26, 2015, accessed July 25, 2017, https://www.youtube.com/
 watch?v=Jmb_Kru9_0c.
10 As the curators of the exhibition "Making Use: Life in Postartistic Times"
 (Museum of Modern Art in Warsaw, February 19–May 01, 2016, curators,
 Sebastian Cichocki and Kuba Szreder, shadow curator, Stephen Wright)
 observe, drawing on suggestions by Steven Wright and Marcel Duchamp:
 "Some practices deemed as non-artistic do have a high degree [of the]
 coefficient of art." They go on to point out that this leads to a perplexing
 question, "Is there more art within or outside the walls of the museum?"
 "Making Use: Life in Postartistic Times," Museum of Modern Art in
 Warsaw, accessed July 25, 2017, https://makinguse.artmuseum.pl/
 slownik-wspolczynnik-sztuki/. I see the giving back of Zofia Rydet's
 photographs as a conceptual action with a high coefficient of art, since
 we used photographs considered artistic, but outside a gallery and
 museum context, beyond the art circuit, all in order to gauge their
 utilitarian potential.
11 Piotr Filipkowski, "Archiwizacja, reanaliza, rewizyta. O nowych pojęciach
 i nowych podejściach w badaniach jakościowych," *Kultura i Społeczeństwo*
 59, no. 3 (2015): 10.
12 Ibid., 13.
13 Małgorzata Mazurek, "Rewizyta etnograficzna. Jak się wytwarza wiedzę
 socjologiczną," *Kultura i Społeczeństwo* 59, no. 3 (2015): 37–38.

also in the sense of being able to reflect on the very status of the researcher and their relationship with the subject of the research.

The repeated reconnaissances that we undertook as part of *Something That Will Remain* were also, as Filipkowski puts it, a "new reading of the old data."[14] Setting off on a field trip we were aware that the majority of the houses photographed by Rydet were no longer standing and many of the people she had taken portraits of would likely be dead (and must have been for a long time, as Rydet had a penchant for photographing the elderly). When planning our action, however, we had a distinct sense of creating quite a unique situation: we would be bringing with us photographs removed from the collection-exhibition circuit, as it were—prints which had never before been seen by the people in them. The selected photographs from the *Record*, which have been presented in museums and galleries thoughout Poland and internationally as well as reproduced in numerous publications and placed online, had been removed from their original context and the memory of their subjects. The situation of revisiting photographic subjects after three decades and bringing them photographs that had meanwhile achieved the status of works of art was unprecedented—and we were convinced that this had considerable interpretative potential.

Finally, the project *Something That Will Remain*, as an example of an educational, integrative, intergenerational activity that involves the local community, allows one to form conclusions about the role of photographic activity in the field of broadly understood cultural activism, and in working with the local community.[15] We established a team, whose members double as cultural activists, photographers, ethnographers, researchers, educators, and artists. We assumed that two team members would spend approximately ten days in each village. We set three basic tasks to com-

14 Filipkowski, "Archiwizacja, reanaliza, rewizyta," 6.
15 In Polish, such activity inspired by, among others, the British practice of community arts, is referred to as "cultural animation." For clarity, in this essay, I've used this form as well as "cultural animator" to describe an agent of this practice. See Iwona Kurz, ed., *Lokalnie: animacja kultury/ community arts* (Warsaw: IKP UW, 2008).

plete during the field trip: (1) identification of the people and places photographed by Zofia Rydet; (2) handing over the photographs to either the people photographed or their relatives; and (3) running an educational workshop (photographic-cum-journalistic) for a group of children and teenagers, leading to the production of contemporary portraits, which were given to local residents. Herein, my aim is to describe the project *Something That Will Remain*, and at the same time to show how the findings of the field-based, local actions related to Zofia Rydet's *Record* have affected my interpretation of the photographer's grand project.

Reanimation of the Archive

To work with the *Sociological Record* is to work with an archive. One of the essential methods of creative work with photographic collections in Poland concerns the archeology of photographs. According to Jerzy Lewczyński, the point of the concept is to "discover, investigate, and comment on events, facts, and situations that took part in the so-called photographic past."[16] Jerzy Lewczyński was a singular figure in the world of Polish photography—an artist, collector, archivist, and researcher. He went beyond classifying photographs into purely aesthetic categories; he was interested in what was marginal in photography—material that was rejected, random, or found. Today, echoing Clément Chéroux, we could say that Lewczyński was interested in vernacular photography, which, as one of its pioneers in Poland, he introduced to the world of art. As Krzysztof Pijarski observes, "For Lewczyński, metaphorically, the magic light of the negative, when transferred to the print, becomes a conduit for memory. It survives in objects—especially in photographs, which are after all a record of light—and, mediated through them, demands to be deciphered and brought to life."[17]

16 Jerzy Lewczyński, "Archeology of Photography," trans. Hanna Korolczuk, in *Jerzy Lewczyński: Archeologia fotografii* (Września: Wydawnictwo Kropka, 2005), 39. [Translation modified.]

17 Krzysztof Pijarski, "Archeologia fotografii: czy można zarchiwizować gest?," *Kultura Współczesna*, no. 4 (2011): 124.

Jerzy Lewczyński's archive is far from homogenous—it comprises his own prints and negatives but also others that he had found or copied from cuttings or drawings. Compared to Lewczyński's, Rydet's *Sociological Record* archive is coherent and tightly structured; nevertheless, in its previously unexplored physical shape, it also demanded to be treated archeologically. The actions carried out within the project *Something That Will Remain* can be considered an attempt to establish a "continuity of the visual contact with the past"[18] and research into the "continuum between the past and the future of human existence"[19] that photography establishes, as well as an endeavor to "bring the past to life." The process of the identification of the photographs involved the interpretation both of the past reality as seen in the photographs and of the medium of photography itself, serving as it does to represent the past, and relate to the present.

"An archive without scholars researching it is as useless as a pile of dry leaves," as the French art historian André Gunthert puts it.[20] I would like to modify and expand this statement so as to change researching to "using" and "scholars" to "people." Our encounters with the residents—neither artists nor researchers but rather, in the context of our action, *users* of the archive—had the characteristics of photographic happenings[21] that not only brought to life specific photographs from the *Record*, but also shaped in a *performative* way the meaning of the photograph that, in the hands of the resi-

18 Lewczyński, "Archeology of Photography," 39.
19 Jerzy Lewczyński, "To Tell the Truth," in *Jerzy Lewczyński: Archeologia fotografii*, 43.
20 André Gunthert, "History as Guerrilla: The Discourse and Pragmatics of the Photographic Archive," trans. Krzysztof Pijarski, in *The Archive as Project*, ed. Krzysztof Pijarski (Warsaw: Fundacja Archeologia Fotografii, 2011), 83.
21 I suggest the term, echoing J. L. Austin's theory of speech acts. David Green and Joanna Lowry use his term "performativity" in relation to photography; David Green and Joanna Lowry, "From Presence to the Performative: Rethinking Photographic Indexicality," in *Where is the Photograph?*, ed. David Green (Brighton: Photoworks, 2003), 47–62.

dents, acquired, apart from its artistic status and function as a document, the status of a memento.

Performativity is sometimes postulated as a significant category[22] in which to interpret the medium of photography, but it is certainly not part of the canon of terms that operates in the theory of photography. More's the pity, because as Diana Taylor remarks in her book *The Archive and the Repertoire*, performativity has a revolutionary potential, in the sense that it sets in motion what had until then seemed taken for granted and static; it allows one to transform the prevailing paradigms, think through the canon, and set in place or discover new links between hitherto separate disciplines.[23] Employing the vantage point of performative studies, the author distinguishes between "the archive of supposedly enduring materials (i.e., texts, documents, buildings, bones) and the so-called ephemeral repertoire of embodied practice/knowledge (i.e., spoken language, dance, sports, ritual)."[24] It would appear, however, that an archive that is being used and can be employed to spur action acquires the character of a *repertoire*, in keeping with Taylor's premise, that the *"repertoire* requires presence; people participate in the production and reproduction of knowledge by 'being there,' being a part of the transmission."[25]

No doubt the use of the *Sociological Record* led to the creation of new knowledge precisely thanks to the participation of the people who felt involved; people who through their actions and their responses to the photographs created new meanings. Although Taylor does not single out photographic archives, one can posit that

22 An issue of the magazine *View: Theories and Practices of Visual Culture*, was, in its entirety, devoted to the relationship of photography and performativity; Krzysztof Pijarski, Paweł Mościcki, eds., "Photography and the 'Efficacy of Gesture,'" *View*, no. 12, 2015, accessed July 25, 2017, http://pismowidok.org/index.php/one/issue/view/16/showToc.

23 See Diana Taylor, *Archive and the Repertoire: Performing Cultural Memory in the Americas* (Durham: Duke University Press, 2003).

24 Ibid., 19.

25 Ibid., 20.

this kind of archive, perhaps more so than any other, lends itself to interpretation within the performative framework.

A revisit can be an example of such a performative interpretation—one that relies on using and breathing life into a photographic archive. The vast majority of the people whom Zofia Rydet photographed never saw themselves in the photograph that she had taken. Her project—utopian, comprehensive, large-scale—required her to be constantly on the move, exposing as many frames as possible, at the expense of not having the time to develop them as she went along. The time pressure resulted both from the artist's conviction that it was imperative that she photograph everything that was threatened with extinction, and from her awareness of her own advanced years and her mercilessly approaching demise. "And I always have the feeling that I have to hurry, because when I'm gone no one will do it for me"[26]; "I have so little time, it goes so quickly,"[27] the photographer wrote in letters to her friend. As she carried out her project on her own, and having to fall back on her own resources to develop the films and make the enlargements, Zofia Rydet was not in a position to revisit locations or to send copies of prints to her sitters.[28]

Although not a part of her original plan, she did end up visiting some places more than once—she wrote that her intention was to observe the passage of time, to find out whether the houses and people that she had "immortalized" still existed. In August 1988, together with Anna Beata Bohdziewicz, Rydet set off for a two-week tour of Podhale, so as to revisit places. "The majority of the old cottages, which Pani Zofia had photographed ten years earlier, were already gone! Those which remained were mostly

26 Zofia Rydet, Letter sent to Krystyna Łyczywek from January 12, 1982,
 accessed, July 25, 2017, http://zofiarydet.com/zapis/en/pages/sociologi-
 cal-record/letters/krystyna-lyczywek-12-01-1982.
27 Zofia Rydet, Letter sent to Krystyna Łyczywek from March 15, 1982,
 accessed, July 25, 2017, http://zofiarydet.com/zapis/en/pages/sociologi-
 cal-record/letters/krystyna-lyczywek-15-03-1982.
28 In her letters, Zofia Rydet mentions that the expectations of the sitters to
 receive prints were among the reasons why she rarely worked on her
 Record in cities. See Zofia Rydet, interviewed by Krystyna Łyczywek,
 Conversations on Photography 1970–1990, accessed July 25, 2017, http://
 zofiarydet.com/zapis/en/pages/sociological-record/discussions/
 rozmowy-o-fotografii.

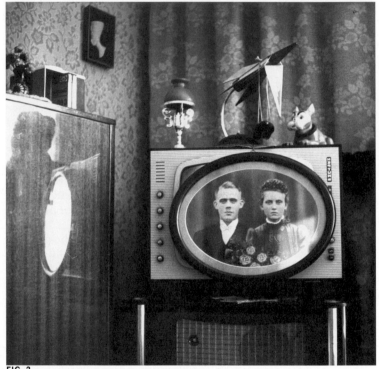

FIG. 2
ZOFIA RYDET, FROM THE SERIES *EPITAPH*, 1980

neighbored by newly-built 'modern' brick houses," Bohdziewicz recalls.[29] This experience reaffirmed for Rydet her conviction that photography is a medium with the power to safeguard and immortalize, and to in the process confront transience, the thought of which she abhorred. She wrote in a letter to a friend:

> Last year I started a new series. My *Record* is documented. Having kept careful notes, I decided to return to those homes and those people. That was a cruel experience; time is merciless, and everything changes. People die, and their homes die with them. Not only people vanish, but everything that once surrounded them. Only photography can stop time.[30]

In 1980, Zofia Rydet visited the house of the Biadacz family, whom she had photographed for the *Record* a year earlier. In the intervening period, both husband and wife had died. In the empty house, she shot the series *Epitaph*, with the leitmotif of Mr. and Mrs. Biadacz's wedding photo, which she placed in different parts of the house in lieu of, and as a personification of, her former hosts. However, the effect achieved is one of alienation (with the portrait shot at the head of the bed or on the TV screen); it emphasizes the absence of those portrayed. There is no going back to the situation in the photograph; the photograph has become a representation of this impossibility. [FIG. 2]

My interpretation of this series as a representation of absence flies in the face of Rydet's own intentions—fascinated by the tension between photography and transience, she believed that it was photography that had won the contest. If, however, we set aside Rydet's comments and notes, and treat her—as Łukasz Zaremba proposes[31]—as a theoretician of the image, we are able to

29 Anna Beata Bohdziewicz, "Zostały zdjęcia," *Konteksty. Polska Sztuka Ludowa* 51, no. 3/4 (1997): 189. See also Anna Beata Bohdziewicz's essay in this volume, "Wanderings with Zofia Rydet," 49–67.

30 Zofia Rydet, "On Her Work," excerpt from the publication of the same name, Wydawnictwo Muzeum w Gliwicach, 1993, accessed July 25, 2017, http://zofiarydet.com/zapis/en/pages/sociological-record/notes/o-swojej-tworczosci.

31 See Łukasz Zaremba's essay in this volume, "Zofia Rydet: Pictures on Pictures," 303–24.

perceive *Epitaph* as a set of meta images or, more precisely, meta photographs that, as "theoretical images," can be considered a visual definition of the photographic medium. When interpreted in this manner, *Epitaph* makes it possible to realize that what accompanies the photograph is the desire to make time stand still, a desire that nevertheless becomes no more than a photographic image, in however high regard we may hold photography. The "feebleness" of this desire in view of the prevailing conviction about the "power" of photography and our desire to consider it capable of preserving time intact is the essence of what makes the photographic medium such an interesting kind of representation. *Epitaph* leads to the conclusion that our idea of revisiting locations, which we carried out as part of our project *Something That Will Remain*, was an idea that Zofia Rydet was familiar with. Understandably, however, our conclusions and reflections that stem from that experience are distant from those that the artist herself formulated.

Materiality, or, a "Socially Salient Object"[32]

The experience of the revisit allows us to view Zofia Rydet as a sui generis itinerant photographer. Photo albums in Polish villagers' houses are full of portraits taken by just such door-to-door peddlers of memento photographs: snaps taken in front of the house, in the garden, or set against a painted backdrop. Taking photographs was a service provided for a fee, and it was the photographer's responsibility to make sure that the product reached the customer. Just like these wandering service providers, Zofia Rydet was taking photos in accordance with a specific, repetitive formula, using simple equipment and operating fast and efficiently, traveling from one location to another in search of "clients." Where she was very obviously different from these sellers of mobile photographic services—apart from defining herself as an artist—was her idiosyncratic manner of constructing the frame to suit her artistic vision rather than the expectations of the sitters or the aesthetic conven-

32 Elizabeth Edwards and Janice Hart, "Introduction: Photographs as Objects," in *Photographs Objects Histories: On the Materiality of Images*, eds. Edwards and Hart (London: Routledge, 2005), 2.

tions of a standard portrait or ID shot. She shot her models in situ, in the situation that presented itself rather than, as such service providers do, posing them prettily in their Sunday best against a backdrop very remote from their daily chores. Nor did she, as they did, sell the photograph to her models. To consider Rydet as an artist that draws on the craft of the door-to-door photographer is to recognize that—apart from their artistic, documentary, and academic value—the photographs that form the *Record* also possess value as mementos, just as much as those taken by commercial salesmen.

When we came to the selected villages with the prints,[33] we, in a sense, became such itinerant photographers ourselves, albeit some thirty years late in delivering the long-forgotten photographs. Our decision to provide hard copies of the digital files from the *Record* was a reference to the analogue experience of the photograph, an experience that belonged to Zofia Rydet's time. Our interlocutors were mainly the elderly, whose experience of photographs was based on a tangible object that one could handle, bring closer to the eye if necessary, share and show to others, and eventually annotate with a handwritten caption before hanging it on the wall or carefully setting it within a photo album.[34] By its very nature, the analogue technique limited the number of photographs that one could have, and the selected pictures, which in the context of the Polish countryside were chiefly portraits, became, alongside holy images, an important element of the home decor.[35]

Zofia Rydet's preoccupation with tactility can be seen in the way that she documented rustic domesticity using a wide-angle lens to capture a house's interior, and in how she produced series of photographs focused on a specific object or material motif.

33 As the Zofia Rydet archive has been made available under a Creative Commons 3.0 license, we were able to use simple printouts of individual images.

34 For more on the praxis of photography, see Marek Krajewski and Rafał Drozdowski, "Fotografia i materialność. Od zdjęć jako przedmiotów do urzeczowienia fotografii," in *Za fotografię! W stronę radykalnego programu socjologii wizualnej*, eds., Krajewski and Drozdowski (Warsaw: Bęc Zmiana, 2010), 156–98.

35 For more on the photography of farmers and related praxis, see Joanna Bartuszek, *Między reprezentacją a martwym papierem. Znaczenie chłopskiej fotografii rodzinnej* (Warsaw: Wydawnictwo Neriton), 2005.

This is palpable not only in *Epitaph,* but also in *Myth of Photography,* a series within the *Record,* which consists of photographs of portraits hanging on walls or held by those featured in them. This is a singular kind of meta picture[36]—photographs of photographs which constitute a visual definition of the photographic medium. Rydet created a situation that explored the function of photographic representations as, literally, utilitarian objects that served their owners by legitimizing their social relations (wedding photographs), keeping fresh the memory of their own appearance (snaps from their youth), or an important aspect of their identity (photographs from the army). The title of the series points to the author's intuition or awareness that in taking shots for her *Record,* she referenced the mythology of photography—the notions and practices stemming from photography's indexical nature, which leads to the belief in the "magical" qualities of the photographic picture. Shooting in rural Poland, Rydet emphasized the associations with folk faith in the photographic image, while she herself fervently believed in its redemptive power.

During the course of the project, we deeply appreciated the opportunity to return to the materiality of the photographs, particularly in this day and age when the majority of photographs are, and remain, digital. As Elizabeth Edwards and Janice Hart point out, the experiencing of a photograph as an object transforms the content of the photographic image; to be able to hold it in one's hand and bring it closer to one's eyes impacts what is seen and experienced through the experience of looking. According to Edwards and Hart, the definition of the photograph as an object should be created within the continuum of the process of creating it, changing it, and using it and its meaning.[37] We used the photographs from the *Record* as objects for the purpose of creating a situation of communal viewing and conversation. Significantly, the objects were copies of the originals—cheap printouts of online files, accessible to the general public; this made them utilitarian, devoid of what Walter Benjamin calls the "aura" of a work of art. As Benjamin notes, "Tech-

36 For more on meta images, see Łukasz Zaremba's essay in this volume, "Zofia Rydet: Pictures on Pictures," 303–24.
37 Edwards and Hart, "Introduction: Photographs as Objects," 1.

nical reproduction can put the copy of the original into situations which would be out of reach for the original itself. Above all, it enables the original to meet the beholder halfway [...]. And in permitting the reproduction to meet the beholder or listener in his own particular situation, it reactivates the object."[38] This reactivation was twofold: while the residents viewed the photographs looking *through* them—to use the distinction proposed by Terence Wright— in effect focusing on memories and emotions evoked by the photographed people and places, we focused *on* the photographs themselves, perceiving them, for it was they that were the subject of our activity.[39]

The Right to a Photograph

Zofia Rydet had uncritical faith in the power of the photographic medium and in her own mission to use photography to preserve the "truth of the modern-day man,"[40] explaining that it invested her with the "chance to stop time and overcome the specter of death. The simplest, most ordinary documentary picture becomes a great truth about human fate, and this is my constant struggle with death, with the passing of time."[41] This goal was heroic and noble enough to seemingly suffice as a justification for her controversial method of working. As we gather from the notes and recollections of the author of the *Record*, her modus operandi followed the same pattern: she would start off with a firm greeting, buttering up a potential sitter or sitters with compliments. She was certainly gen-

38 Walter Benjamin, *The Work of Art in the Age of Mechanical Reproduction*, trans. Harry Zohn, ed. Hannah Arendt, rev. ed. (1936; repr. New York: Schocken/ Random House, 2005), accessed August 4, 2017, https://www.marxists. org/reference/subject/philosophy/works/ge/benjamin.htm.

39 I am referring to Wright's methodological proposal that a photograph can be approached in three ways: by looking *through* it (to think about what it is a photograph is of), *at* it (to think about the photograph itself, as object), and *behind* it (to think about its determining context). See Terence Wright, *The Photography Handbook* (London: Routledge, 1999), 38. In his canonical text *Camera Lucida: Reflections on Photography*, Roland Barthes refers to a similar distinction between looking at and looking through when he writes about looking at a window pane versus looking through it at the landscape on the other side. See Barthes, *Camera Lucida: Reflections on Photography*, trans. Richard Howard (New York: Hill and Wang, 2010), 5–6.

40 Rydet, "On Her Work."

41 Łyczywek, *Conversations on Photography*.

uinely fascinated by the people she photographed and their environment, but she was also perhaps using—whether consciously or not—her symbolic and class vantage point over the simple country dwellers. She acted by surprise, counting on traditional rural hospitality. She rarely met with rejection—perhaps thanks to her direct approach, or perhaps because her advanced years and general frail demeanor evoked interest, respect, and sympathy. Her way of building a relationship with the sitters was ambivalent. One could say that, motivated by her drive to "save" and "ennoble" the marginalized group, she exoticized them, abusing the power relationship, and in effect used the countryside and its residents for her own artistic career. It is easy to formulate criticism of this statement as being patronizing toward those she photographed—after all, they were on their own territory, in their own house, surely they could have refused to pose, if they wanted? One could assume that, since the photographs show the subjects staring ahead directly at the camera, they must have chosen willingly to participate in the shot being taken. The question remains: Did they also agree to the circulation of the photo? This is a delicate subject, all the more so in that it concerns the images of simple peasants—a group poorly represented politically, economically, and symbolically.[42] Zofia Rydet's conviction that this ought to change, that they should be noticed, appreciated, and immortalized, and that the camera could be the tool of this change seems valid, in the sense that it broadened the "field of visibility" by including what had previously been left out. The price was secondary stigmatization: Here we have an artist, a member of the bourgeoisie and intelligentsia, who lowers herself to scrutinize sympathically the marginalized peasantry, holding her-

42 For more on the significant absence of peasants in photography, see Jan Wasiewicz, "Gdzie jest miejsce chłopów w pamięci zbiorowej współczesnych Polaków? Przypatrując się pewnej starej fotografii," *Kultura Współczesna*, no. 2 (2014): 82–100.

self out as the only one capable of appreciating their "simple world
[...] that is perhaps irretrievably vanishing."[43]
 One way to get out of this interpretative deadlock, in
which the difficult subject of the ethics of photography is compli-
cated by the excluding class and colonial perspective, is by viewing
Rydet herself as a representative of the excluded. Although she had
no peasant roots, hailing as she did from the prewar middle class,
the clerical intelligentsia, her postwar circumstances were such
that at the time she was beginning work on her *Sociological Record* she
was an elderly woman of sixty-seven, who had had to fall back on her
own resources to keep her body and soul together. As a photogra-
pher, she had no art training and her aesthetic predilections were
not to the general taste at the time. In the relatively young, male
community of the Gliwice Photographic Society, she was a curios-
ity. And in the broader context of the social reality of the Polish Peo-
ple's Republic, a childless pensioner of limited means, who under
her own steam was pursuing an artistic passion that went right
against the contemporaneous understanding of art, was someone
marginalized—despite all the recognition that she had gained in the
field of photography and among the general public after the success
of her *Little Man*.[44] One could say that trekking through rundown vil-
lages and visiting the poorest households, Zofia Rydet sought out
the "sight of the suffering of others"; equally valid, however, is the
hypothesis that this was her way of finding her own place in life.
 In the artist's lifetime, the circulation of the *Record*
amounted to a mere dozen or so exhibitions,[45] and after her death

43 Zofia Rydet, unpublished 1987 interview by Joanna Kubica for *FOTO*
 magazine, accessed July 25, 2017, http://zofiarydet.com/zapls/en/pages/
 sociological-record/discussions/foto.
44 The full list of awards and honorary mentions can be found on the
 website of the Zofia Rydet Foundation: http://fundacjarydet.pl/zofia-
 rydet/nagrody/?lang=en; in the present volume, Adam Mazur lists a
 selection of state and professional prizes awarded to Zofia Rydet, 79,
 footnote 22. An indication of Rydet's exalted status as an artist is
 indicated by the fact that all significant photography critics of the time
 wrote about her, including Urszula Czartoryska, Alfred Ligocki, Juliusz
 Garztecki, Adam Sobota, Jerzy Busza, and Krzysztof Jurecki.
45 The list of the exhibitions can be found online. Zofia Augustyńska-
 Martyniak, "Zofia Rydet—Individual and Collective Exhibitions
 (Selection)," Zofia Rydet Foundation, accessed July 25, 2017,
 http://fundacjarydet.pl/zofia-rydet/wystawy/?lang=en.

it became limited to a small selection of photographs that appeared repeatedly in ever more publications. It was only after the artist's archive had been placed online—in other words, fairly recently—that the ethical issues related not only to Rydet's method of work but also to how users/members of the public avail themselves of this collection have become particularly pertinent and interesting. In our project, we reached the conclusion that the doubts raised about Rydet's methods of work from a contemporary perspective involve the error of anachronism[46]—the right to one's own image, the critique of social relations, as well as critical, cultural reflection on photography as a tool for the shaping of such relations are all topics that did not exist in any significant way in Poland at the end of the 1970s and the beginning of the 1980s. It is therefore unreasonable to expect the artist to have addressed these issues and to have reflected on them critically in her praxis. Without a doubt, as things stand today in terms of law, social ethos, and the critical history of photography, Zofia Rydet's method would not be neutral and could not be continued without reflection. And this is not exclusively about the right to the protection of one's own image, which formally regulates the duty of the photographer toward the persons photographed, but also about the implicit obligation for a contemporary photographer to be aware of the ambivalent legacy of photographic practices that in the nineteenth and twentieth centuries also frequently relied on objectification, exoticization, and stigmatization of the photographed subjects.[47]

For this reason, in our project *Something That Will Remain*—both at the stage of the identification and handing back of the photographs, and during the educational activities—we adopted

46 Elżbieta Tarkowska, quoted in Małgorzata Mazurek, writes: "[...] regarding the archival material garnered in research into lifestyles through the prism of domination or symbolic oppression is a sui generis ahistorical usurpation." Mazurek, "Rewizyta etnograficzna," 52.

47 See John Tagg's *The Burden of Representation: Essays on Photographies and Histories* (New York: Palgrave Macmillan, 2002) and *The Disciplinary Frame: Photographic Truths and the Capture of Meaning* (Minneapolis: University of Minnesota Press, 2009), as well as Elizabeth Edwards, ed., *Anthropology and Photography, 1860–1920* (New Haven: Yale University Press, 1994), or Christopher Pinney, *Photography and Anthropology* (London: Reaktion Books, 2011).

an approach different to that of Zofia Rydet. In a sense, we did what
the author of the *Record* had not: we annotated and returned some
of her portrait photographs and began to create new ones, treating
her own method as a negative point of reference. Our motivation
was not, however, a desire to rectify Rydet's "errors" or "atone for
her tresspases"; rather, we did it because it is only now that this has
been possible and, secondly, because we felt that this was an inter-
esting experiment at the juncture of artistic research and educa-
tional activity. Our project takes a critical approach to the anony-
mous and ambivalent character of the *Record*, but it was not our aim
to moralize or criticize the artist herself—what spurred us on was
the publication of her archive online. Thus, if we have touched upon
ethical issues in our project, this was rather to question the status
of our contemporary view of these photographs and our contempo-
rary ways of using them: making them available online, exhibiting
them in art galleries, or reproducing them in academic publications.
Under Polish law, the right to protect one's image applies during
one's lifetime, but relatives can exercise these rights up to twenty
years after the person's death. This means that this protection con-
tinues to apply to some of the photographs in the *Record*. How can
these photographs then be used in a way that respects the subjec-
tivity of the people in them? Is it possible to look at these images
without falling into the trap of the colonizing gaze? What can we gain
thanks to the people who, during our revisit, we invite to look
through and identify the photographs? How can we return them,
while avoiding sentimentalization, paternalization, instrumentali-
zation, or bombast?

Thirty years is long enough for profound changes to
have taken place, yet short enough that there are still people out
there who remember the reality of being photographed by Rydet,
and who, as a result, double as experts in possession of first-hand
knowledge. Employing the method of ethnoanimation, or "local
action," described in the volume *Etnografia/animacja/sztuka. Nierozpo-
znane wymiary rozwoju kulturalnego* [Ethnography, Animation, Art: The

Unrecognized Dimension of Cultural Development],[48] we decided to turn our encounters with the local people into a form of barter that would have equal value for both parties involved—an exchange in which we would hand over photographs that had personal value, in return receiving information, which was precious, in terms of our research. We recorded the process to the extent that the participants agreed to it; we did this openly, without setting any conditions and with mutual respect. If at any point our interlocutor asked that we stop the tape recorder or not take a photo, we did as requested. Handing the photographs back, we observed the emotional response, but it was not our aim to record it. What mattered to us more was to gather information about the reality visible in these pictures and about Zofia Rydet herself. We also tried to identify the attitude of those that we talked to toward the medium of photography. When handing over the photographs, we were neither paying back a debt nor taking out a loan. The barter took place there and then, with satisfaction for both parties present.

Encounters on the Road
It was important that we work with communities small enough that the locals would recognize each other, based on neighborly, direct relations. Our choice was limited to the villages that had been identified on the basis of Rydet's notes. From this group, we selected the village where the photographer had taken at least a few dozen shots. Finally, from that shorter list, we focused on those villages with the potential to enter into local partnerships. What was crucial for the success of our enterprise was the presence of local representatives of cultural institutions such as a library, an association, or a cultural center, and that they should be willing to collaborate. We hoped that these bodies would provide support and help in our reconnaissance of their village, making contact with the locals and so on. We treated these partners as experts and advisers—mediators—but at the same time fellow workers in the cultural sector who

48 Tomasz Rakowski, ed., *Etnografia/animacja/sztuka. Nierozpoznane wymiary rozwoju kulturalnego* (Warsaw: Narodowe Centrum Kultury, 2013).

would gain new experience and competence or new knowledge about their community through working on our project.

Thanks to our work with local residents we managed to identify and hand back more than 600 photographs. Having listened to our explanations and seeing the pile of photographs that we had with us, the locals would stop whatever they were doing and ask us in. Usually, our first interlocutor, having identified some of those in the shots, would send us on to the next specific address.

The majority of those that we talked to did not remember being photographed by Rydet and were unaware that the photographs were being published online, and that some were in the collections of Polish and foreign museums. Thus, their surprise was all the greater when they recognized themselves or members of their family in the photographs.[49] Their reaction was not negative, just the opposite, in fact. They were moved, animated, incredulous: "But how have you come by these photos?"; "I remember nothing about this"; "When did this happen? My father never said anything." The emotions hit a real peak when the photograph that we brought turned out to be a real treasure—the only available picture of the father that had passed away or probably one of the last photographs taken before the husband had died a tragic death.

During these encounters, we were treated to tea and coffee. Other members of the family would be summoned and neighbors fetched. The prints would be passed round, glasses put on, and magnifying glasses reached for. On occasion, we would enlarge a photograph on a tablet, so that an important detail could be scrutinized. We could not keep up with jotting down the ever-changing versions of the recollections produced. Our interlocutors told one another off, argued about the correct version of a surname or the nickname of a particular person, and competed in coming up with yet more recollections. They set in motion the idiom of "high context," referring to family links, familiar local anecdotes, and local linguistic customs linked to descriptions of places or nicknames. When talking

49 Interestingly, sometimes recognition did not come easily, as in the case of a man who did not recognize his own mother. He claimed that the reason was that he had never seen her photograph from that time.

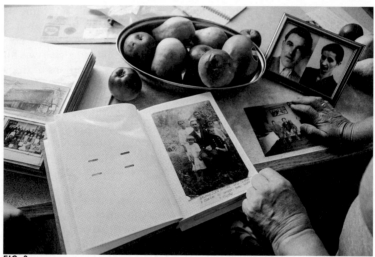

FIG. 3
HELENA KOCHMAŃSKA, INHABITANT OF
MARKOWA, IDENTIFIED HER PARENTS—JÓZEF AND
ZOFIA HOMA—IN ONE OF ZOFIA RYDET'S PHOTO-
GRAPHS [SIGN. ZR_11_009_37]. THE PHOTOGRAPH
IS ABOUT TO BE PLACED IN HER FAMILY ALBUM.
MARKOWA, SEPTEMBER, 2015

about relatives and neighbors, in the heat of the moment and with emotions running high, they would often share intimate or embarrassing details from their life, such as the story of an unhappy love, betrayal, murder, or life-long chastity. Their family photo albums would appear on the table—and the photographs taken by Zofia Rydet easily slotted into them, acquiring a similar, meta-artistic, personal value. [FIG. 3] They became mementos and as such they acquired a tremendous narrative power.[50] Some photographs turned out to be a pretext for sharing memories and telling microstories related to social processes: a typical bookshelf room divider, bought with the first wages earned; a pram for the twins that had to be brought all the way from Warsaw; amazement at their own poverty and how "we hardly had anything at all"—these are snippets of the major trends: the economic emigration of the 1980s, the time of political and economic transformation; and the changing social mores and appearance of the Polish countryside. In the backdrop of these individual stories of the photographs, there also lurked a political narrative: a photograph of a house where someone had helped Jews to hide during the Second World War; a photograph, sent from the US, of the courier who had helped the Marshal of Poland, Edward Rydz-Śmigły,[51] to reach Poland by way of the Tatra Mountains.

Our interlocutors adopted an interesting variety of strategies in trying to recognize and date the photographs. Key were biographical events. Typically, they would arrive at an approximate date on the basis of their own presence in the picture ("this must have been before 1982, because that was when I went to the US and didn't come back for ten years"); the age of their children ("the daughter can already walk in this one, so it must be 1979"); their own appearance ("I am pregnant, looks like seven months, so it must be the end of 1980"); the furnishings ("I bought a new set of furniture

50 On photographic interview as an ethnographic method, see Marisol Clark-Ibáñez, "Kadrowanie świata społecznego przy użyciu wywiadu fotograficznego," trans. Monika Rosińska in Frąckowiak and Olechnicki, *Badania wizualne*, 39–66.

51 Edward Rydz-Śmigły (1886–1941). Polish statesman, Marshal of Poland, and Commander-in-Chief of the Polish Armed Forces during the German invasion in 1939. When Soviet forces attacked Poland on September 17, 1939, he escaped to Romania. He returned to occupied Poland by foot, crossing the Polish border with Slovakia in October 1941.

with my first wages, and these are still the old ones, so it must have been before 1985"); internal decor ("I remember when we painted the stove, my mother repainted it in 1986, so it must be soon after that, you can tell the paint is still fresh"); the relationship between different elements ("if my daughter was already walking and the cow is still in the yard, then it must be 1982"); and the absence of significant persons ("this is Katarzyna, but without her sister, so it must be after she'd died, in 1979, otherwise they would've been in the photo together, for sure").

The stories that we were told significantly exceeded our objective, which was the rudimentary identification of the photographs.[52] The local residents who remembered the people, places, and situations photographed would describe them not through archival criteria, objectivizing and defining methodologically, but through the prism of their personal experience, remembered and articulated at the moment of seeing the photograph. Listening to our interlocutors, we did not create a "format" for the description of a photograph; their spontaneous narratives created unique forms of description and subjective hierarchies of value concerning the aspects of the photograph that they were describing; this cut across the systematic objectivization typical of procedures for cataloging works of art and materials referred to as historical sources. We considered it a description achieved in accordance with a different paradigm—the expert elucidating the meaning was not a research worker employed by an academic institution, but a user of the photograph who represented the reality that she was familiar with from personal experience; this was someone who was in a position to notice and name what a more "qualified" observer would have missed. In our predicament, where the goal of the action was both to garner information about the people and places in the photo-

52 We have been looking for ideas to continue the project and to share the collected stories. We have created some video footage of the people talking about the photographs: Zofia Rydet Foundation, "Coś, co zostanie 2015," *Youtube*, uploaded December 8, 2015, accessed July 25, 2017, https://www.youtube.com/watch?v=tzrlYEhXXiA.

graphs but also to reflect on photography as a medium, we consider
these personal narratives that accompanied the viewing to be fully
legitimate, academic descriptions appropriate for the examination
of commemorative photographs. In other words, the way in which
the residents described the photographs constituted, to my mind,
a hitherto undocumented methodology for working with photo-
graphs of a non-artistic nature; photographs that are, rather, memen-
tos or artifacts. Significantly, there is no room for such stories in the
online archive of the *Record*, where only simple, formatted data found
a place: first name and surname, location, and date. Following our
suggestion, the database was reprogrammed to include a new field,
allowing the entry of selected quotations from the statements of our
interlocutors.[53]

Observing Zofia Rydet

Until now, it has only been possible to reconstruct and
analyze Zofia Rydet through conversation with the people who
accompanied her on her photographic expeditions, or by scrutiniz-
ing her photographs. On closer inspection, it becomes clear that,
judging by the order of the negatives on a strip of film, some visits
resulted in the taking of no more than a single shot, whereas others
took longer and involved following the subject around the house,
taking a series of different frames. Scrutinizing the strips frame by
frame online, one can notice the small interventions and alterations;
for example, between one take and the next, a stool has disappeared,
the table has been moved, the flowerpot has changed position, the
white fridge has been covered up with a blanket. When viewed side
by side on the negative, the differences stand out, and the photo-
graphic background is revealed—as well as the photograph's precise
construction, composed like a theatrical stage.

During our fieldwork, we were able to discover other
aspects of how the photographer worked, in the process supplemen-
ting existing preconceptions on her method. In villages with an
unchanged layout, we were able to trace the path that Rydet herself

53 At the time of publication, this feature is unfortunately only available on
the Polish language version of the site.

had taken. As Joanna Mikulska and Alicja Szulc, the cultural anima-
tors who worked in Brzeziny Kieleckie, pointed out:

> In consultation with one of the residents, we drew a
> map of the households visited by Rydet. Comparing
> the numbered photographs with the order of the
> houses, we concluded that the photographer visited
> families living next to each other. The trail ran out half-
> way through the village.[54]

This had been quite the prevailing conviction—that
Zofia Rydet went door to door. We did find out, however, that there
was no consistency in her method. For example, sometimes she hap-
pened to take photographs only in the vicinity of the bus stop. It's
likely that she visited only a few houses in the village before catch-
ing the next bus passing through. Another time, she traveled through
the area, visiting a number of villages, but annotated all the result-
ing photographs with the name of a single village, the largest one.
She would avoid some houses, or be sent to another (probably by
the people that she had visited—perhaps to their relatives, who were
not necessarily next-door neighbors). Only in a few villages (such as
Biały Dunajec) did Rydet consistently visit one house after another.
We proved empirically what we had only suspected—that Zofia Rydet
did not act with academic rigor; she did not stick to any precon-
ceived premise or follow specific criteria. Instead, she relied on rec-
ommendations or her own intuition, in accordance with the condi-
tions on the ground, her own interests, and, one can guess, her
volition and physical stamina. Her method of work had no academic
rationale.

To explain more fully how we reconstructed our knowl-
edge about Zofia Rydet's method of work, let me describe a few sit-
uations that occurred during our fieldwork on the photographs from
the *Record*.

54 Joanna Mikulska and Alicja Szulc (cultural animators, Brzeziny Kieleckie),
 project field report courtesy the author (July 2015).

Verification of Location: Zalipie and Markowa

Among the photographs that the residents found easy to identify, there were three that proved mysterious. In the first one, we can see a Zalipie resident photographed entertaining visitors: an elderly woman and a man wearing a suit. ("She has a scarf on her head, and she is carrying a bag. He's wearing a suit. You can tell they are visiting. No village woman walks about with a bag in her own village," one local woman commented.) In the next shot, the woman who had previously been the visitor, is now posing on the doorstep of her own house which, as many people pointed out to us, was definitely not in Zalipie. That shot was followed by more photographs of residents identified as being from Zalipie. Who, then, were the man in the suit and the elderly woman with the bag? The mystery was solved when one of our interlocutors recognized the woman as his mother, who lived in a village situated some ten kilometers from Zalipie. Following his direction, we went to meet the widow of the man in the photograph. The woman that we met in the courtyard immediately recognized the man in the photograph as her husband who had passed away (she was so moved that she kissed the photograph), and the woman as her mother-in-law. She explained that her mother-in-law used to visit a friend in Zalipie as they both were active in the local crafts community. "My husband had a car, so he'd sometimes give her a lift.") We realized how the sequence of photographs must have been taken: Zofia Rydet had gone into a house, where the woman had been visiting. She had taken a photograph, and probably struck up a conversation, which had led to her getting a lift to the neighboring village. There she had taken two shots, then gone back to Zalipe—perhaps again getting a lift from the same man. Our fieldwork enabled us to find out, if only to an extent, what had been taking place outside the photographic frame.

Duration of the Encounter: Brzeziny Kieleckie

Joanna Mikulska also succeeded in reproducing the precise sequence of events of one such encounter. In the first photograph, taken in a house in Brzeziny Kieleckie, you can clearly see the wall clock showing 12:25. The next twelve frames are all of a sin-

gle family and single interior, which Joanna confirmed during her visit to the Kuta family, who recognized their parents, grandparents, and themselves. Further on, on the same strip of negatives, there are five shots of another family. Here, too, a clock can be seen, this time showing 12:55. These photographs were taken in the Pabian family home. On our field trip we established that both houses are next to each other. We concluded that the two visits to the two families and the taking of seventeen photographs in total took Zofia Rydet approximately thirty minutes. This demonstrates the intensive pace of her work.

"I Don't Remember This Lady"
Over the course of our visits to eight villages, and after talking to a few hundred people, we met only four that shared a personal memory of Zofia Rydet with us. "I only remember that she came into the house, that she wore glasses, and that she was an extremely nice person—you couldn't say no to her," a Brzeziny resident recalled. And a local woman from Biały Dunajec remembered that Rydet had happened upon her cleaning her shoes outside of the house. The photographer had complimented her on the shoes, and that was how the conversation had started. The documentation of the meeting remains in the archival negative. The first shot that the photographer took inside the house was of a row of shoes lined up along the top of a wardrobe. For Rydet, the shoes were a pretext, a starting point to a portrait of their owner.

Those we talked to tended not to remember the visit of an older woman with a camera around her neck, nor their own reaction to her offer to take their portrait. This again proved how speedy, and in fact unremarkable, the majority of these encounters had been. Zofia Rydet did not draw attention with her presence; she did not seek to get in touch with the local authorities, did not introduce herself as an artist, and left no forwarding contact details. This is hardly surprising—it would have been impossible for her to enter into an ongoing acquaintance with all of the people she met, nor was it her aim. Zofia Rydet wanted to be remembered, but it was not in the memories of the peasants that she photographed that she sought

her artistic "immortality." This could only happen within the art world, with its mechanisms for the creation of symbolic hierarchies through the organization of exhibitions and the publication of catalogs.

Social Action, Educational Action

Undoubtedly, the photographs from the *Record* livened up relations between neighbors who did not share many experiences on a daily basis. The pictures became a topic of conversation. Children and grandchildren were helping older family members to look up other photographs from the *Record* online. Sometimes, someone would get back to us after a few days and tell us that, on reflection or consultation with a neighbor, the information they had given us was not correct and they would like to set us straight, insisting that we introduce the changes in our notes. The public projections of Zofia Rydet's photographs also proved the social potential of the archive: to each session, dozens of local people would turn up, entire families with members of different age groups discussing the photographs and swapping memories.

Photography has a significant place in educational activity and in activating cultural and social community work. It is one of the tools of choice in achieving such social aims as integration of the community, building an intergenerational dialogue, discovering local history, empowering the excluded, and so on. "A photograph" can mean working with archival materials, or participants taking snaps of their own. In Poland, this is a relatively new way of approaching photography, which continues to be used in artistic and professional education as a goal per se rather than as an enabling tool.[55] Nevertheless, since 2000 there have been a few projects that have included photography in activities that combined art, journalism, education, and cultural activism. One of the first such projects was the photographic workshop led by Piotr Janowski in the villages of Jasionka and Krzywa, formerly part of a collective farm, in the Beskid Niski region of southeastern Poland. Talking to Maciej

55 An exception worth highlighting is the Laboratory of Creative Education, at the Center for Contemporary Art Ujazdowski Castle in Warsaw, which in the 1990s began initiating projects geared toward community arts.

Frąckowiak ten years later, this is how Janowski assessed that experience in hindsight:

> The most important thing for me was for each child to have its own camera. It had to be extremely simple, easy to operate and cheap, and, in those days, film-based. [...] Each child received four or five rolls of film for the one-week period. [...] At that time I wasn't aware that once I saw the ready material I would realize that I was holding in my hands an extremely valuable document of the time and place where all this happened. When I started to lay out the pictures, one by one, a different world suddenly emerged, a world that had not been previously well known.[56]

The children took over 3,000 photographs, of which almost one hundred were published in an album titled *Świat* [World].[57] In 2002, this was a pioneering project. Now, fifteen years later, the methods have been called into question, and the goal of the project and its social ambience interrogated. Tomasz Stempowski, a historian from the Institute of National Remembrance, commented:

> As a matter of fact, the children were set up as little agents. I assume that the purpose was to obtain images that could be given the status of documentary photographs and declared genuine. The snaps taken by untrained children were meant to have a visual authenticity of the sort that professional photographers spend long hours striving to achieve, making sure that their framing and composition are suitably awry. One can suspect that the goal was not merely truth, but also the effect of a certain exoticism—the curiosity that images from a poor Polish village in the

56 Maciej Frąckowiak, "On Auto-photography: Interview with Piotr Janowski," in *Kolaboratorium. Zmiana i współdziałanie / Collaboratorium. On Participatory Social Change*, eds. Maciej Frąckowiak, Lechosław Olszewski, and Monika Rosińska (Poznań: Fundacja SPOT., 2012), 84, accessed July 25, 2017, http://www.platformakultury.pl/artykuly/115841-kolaboratorium-zmiana-i-wspoldzialanie.html.

57 Piotr Janowski, *Świat* (Wołowiec: Wydawnictwo Czarne, 2002).

middle of nowhere would have for a member of the
big-city bourgeoisie.[58]

These doubts reflect a deeper awareness of the ten-
sion that is present in the photographic medium between its ten-
dency to colonize, exoticize, and stigmatize (as well as, significantly,
to see the "other" in the inhabitants of a postcommunist collectiv-
ized village, including the children, treated a little like primeval indi-
genes, completely devoid of any aesthetic awareness) and the ten-
dency to emancipate and create a grassroots, alternative visual
narrative.[59] And although Janowski did use the medium in a way that
appears naive from today's perspective, without noticing the une-
qual, hierarchic relationship between the "center" and the "periph-
ery," nevertheless, his gesture of "giving back" photography to the
children from a small village and adding value to their viewpoint
seemed revolutionary, because it broke away from the value-based,
judgemental and hierarchic division between what was considered
"professional" and "amateurish" in the photography of the time.

Today, Piotr Janowski's project is viewed as an auteur
artistic project.[60] Nevertheless, the idea of giving or lending children
a simple, compact camera (disposable or, later, digital), and encour-
aging them to document their immediate environment in a free and
intuitive manner, unhampered by aesthetic convention, became a
popular method of working with the local community.[61] The phenom-
enon was accompanied by reflections, albeit basic ones, as yet not
fully formed, on the medium of photography in cultural activism,
used as a tool to aid and empower critical thinking, to make one's

58 Tomasz Stempowski, "Świat. Fotografie dzieci z Jasionki i Krzywej,"
 Fototekst, December 5, 2012, accessed November 17, 2017, http://
 fototekst.pl/swiat-fotografie-dzieci-z-jasionki-i-krzywej/.
59 Tomasz Rakowski's numerous texts and public statement on this topic,
 based on the findings of his PhD thesis, are significant. See Tomasz
 Rakowski, *Łowcy, zbieracze, praktycy niemocy. Etnografia człowieka zdegradowa-
 nego* (Gdańsk: słowo/obraz terytoria, 2009).
60 *Świat* was included in the exhibition "Nowi dokumentaliści" (curator:
 Adam Mazur), presented at the Center for Contemporary Art Ujazdowski
 Castle in Warsaw, in 2006.
61 Maciej Frąckowiak writes frankly that in those days an artist who
 included this kind of photographic workshop in his project was almost
 guaranteed to be awarded a public grant.

voice heard, and to become aware of things that are ordinary, neutral, everyday, and marginal.

It is not only the documentary photograph but also, and perhaps especially, the portrait that is the kind of photograph that lends itself very well to social purposes. Juliusz Sokołowski, a photographer, philosopher, teacher, and one of the founding members of the group Latarnik, which held the theory that the photographic portrait was a way of getting closer to another person,[62] highlighted the singularly delicate relationship between the photographer and his model, the photographer being pivotal in forming the character of the relations. He wrote that, with portrait photography, "we can only be given someone's image, we can never just take it," and that the very situation requires an "ability to be among others who are not always like us," as well as "openness, humility, and the ability to listen and to talk."[63]

The purpose of the camera is not to produce images but social situations that arise out of the images, writes Maciej Frąckowiak.[64] In his view, the photograph is used to create a specific kind of relationship between the actors, in which the photograph itself may become the object of barter. It may, that is, but it need not—much depends on the intentions of the user, rather than on the properties of the tool itself. Again, quoting Frąckowiak, the photograph

[...] may service mutually exclusive goals—it may both help colonize and support processes of empowerment. It is possible for it to perform all these functions, because it has no inherent qualities of its own. Photography is a praxis and not a technology. If we have any complaints to make against it, we should blame ourselves. As is the case with a hammer—which can just as easily be used for knocking a nail in or knocking

62 The group Latarnik was founded, at the turn of the 1990s, by Juliusz Sokołowski, Andrzej Kramarz, Jacek Poremba, Paweł Żak, and Andrzej Georgiew. See *Powiększenie. Fotografie w czasach zgiełku*, exhibition catalog (Warsaw: Wydawnictwo Latarnik, 2002).
63 Sokołowski, *Powiększenie*, 121–23.
64 Maciej Frąckowiak, "Nie wińcie młotka, czyli do czego służy aparat," *Wizjonerzy*, accessed July 25, 2017, http://wizjonerzy.e.org.pl/Wizjonerzy/Teksty/Nie-wincie-mlotka-czyli-do-czego-sluzy-aparat/27.

someone's teeth out—the potential for the use rests above all with the user.[65]

The previous fifteen years has seen photography undergo a profound transformation as a consequence of the development of digital technology and the internet. The general availability of the mobile phone camera, available at all times and connected online, has altered both how photos are taken and their very function, including in the practice of children and young people. Only rarely is photography now a "passion" or a "hobby"; instead, it has become an everyday form of communication with one's peers, on par with text messages and irrevocably linked to the internet. The method that Jankowski used—giving children compact cameras and film and asking them to take photographs as they wished—has now become obsolete.[66]

What has not lost its topicality is the premise that we can aim to achieve social change on a micro scale, thus on the level of individual experience or way of thinking of individual participants. The "change" can, however, be related to different matters. Today, photography in educational activity can be used, as W. J. T. Mitchell advocates, to "show seeing"[67]—teaching how to perceive oneself as a looking subject and reality as mediated through different representations. Instead of aiming at simply photographing the "world," we can today instead use photography to work toward answering the eponymous question asked by Nicholas Mirzoeff in his book *How to See the World*.[68]

In our project *Something That Will Remain*, photographic activity aimed at children and youngsters was based on shared premises, the starting point of which was our way of thinking of photography as a tool and our critical interpretation of the *Sociological Record*. In our photographic workshop, we placed an emphasis on the

65 Frąckowiak, "Nie wińcie młotka."
66 On the practices linked to the use of photography by young people, see
 Mirosław Filiciak et al., eds., *Młodzi i media. Nowe media a uczestnictwo w
 kulturze* (Warsaw: Szkoła Wyższa Psychologii Społecznej, 2010), accessed
 July 25, 2017, http://bi.gazeta.pl/im/9/7651/m7651709.pdf.
67 W. J. T. Mitchell, "Showing Seeing: A Critique of Visual Culture," *Journal of
 Visual Culture* 1, no. 2 (2002).
68 Nicolas Mirzoeff, *How to See the World*, (London: Pelican, 2015).

awareness of the purpose of the photographs being taken, on the right to one's own image, the relationship with the person photographed, partnership, reciprocity, creating opportunities for conversation and responsibility for the published material. We decided to reference the aesthetic convention used by Rydet, but we went further and reinterpreted her modus operandi, customizing it to the context of the contemporary function of photography and the internet. First of all, our tool was not the camera or even the photograph, but rather photographic situations that relied both on making contemporary portraits or independently prepared exhibitions combined with the handing over of photographic prints. Second, the photographs were taken not by an artist photographer or a professional but by the participants of the workshop—local residents, and thus members of the portrayed community. The group worked as a task-sharing collective. Together, the members made decisions about whom to visit and invite to pose for photographs, and in what order. Third, the primary intention behind taking the portrait was to make a gift of it to the photographed person, and only as a second concern—to organize an exhibition of the photographs that the photographed people had agreed to allow to be made public.

Although the participants were taking photos of things familiar to them on a daily basis, they began to notice things that had passed them by unnoticed before. Their work with the archival photographs from the *Record* allowed them to become aware of how the look of the village had changed, and by the same token to scrutinize more closely its contemporary look. Visits to select residents enabled some of the participants to get to know their neighbors—often this was the first occasion to visit the home or backyard of someone they had "always" known, but without actually knowing their name. The children conducted short interviews with the photographed persons—usually the elderly, asking them about the jobs they used to perform and their memories of their youth. The photographic process required not only awareness and responsibility, but also patience; the models wanted to change clothes, to get ready properly, and they frequently asked for repeat shots—as many times as it took for them to be satisfied with the result. The residents whom we

visited were also quick to agree to take part in our action because it took place after the identification of Rydet's photographs and their public display.

One particular type of photograph that was produced as a result of the workshop was the re-photograph. This method, which relies on replicating the archival shot as precisely as possible, is used in artistic projects, archivizing practice, education, and online. If the goal of photography as an educational tool is the fostering of careful observation and the ability to perceive the changes and to adopt a different perspective, then the re-photograph certainly serves to develop such skills. The re-photographs that we took with the participants of the workshop were not just about noticing the changes that had taken place in their village over the last thirty years, but also about the changes in the technology, the quality and intention of the photographic gesture itself, as well as about the photographer's own role as a documentalist of the immediate environment. [FIG. 4]

As a result, the photographs that we took were similar to Zofia Rydet's but at the same time completely different, and not only for reasons formal (color photography) and technological (digital photography). The difference lay mainly in the process and context: the photographs were taken by people who had familial or neighborly links to the sitters. All were offered free prints of the photograph, permission for publication was requested, and attention to the psychological comfort of the sitter was a must. We also sought to ensure that the results were found pleasing. In some villages the local priest announced the exhibition of the portraits of the residents from the pulpit, and the invited visitors arrived in their Sunday best to view the photographs and collect their prints. The workshop participants took an active part in the preparation of the exhibitions, which they hosted, distributing the invitations, preparing captions, and hanging the prints on the wall.

The photographs taken by Zofia Rydet and the re-photographs taken during our workshop also differed in their circulation. At the time that Zofia Rydet was working on her *Record*, due to the analogue technology and limited possibilities for publication,

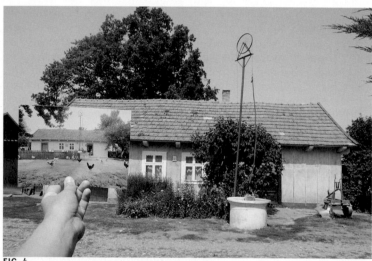

FIG. 4
THE HOUSE OF ROZALIA TRELA, ZALIPIE,
PHOTOGRAPHED BY ZOFIA RYDET, IN 1981
(SIGNATURE: ZR_10_001_20), AND BY AGNIESZKA
PAJĄCZKOWSKA, IN AUGUST, 2015

her photographs found their way to a relatively narrow group of visitors to art galleries and readers of the artistic trade press. Today, taking photographs is inevitably linked to their publication online, and as such, the indispensable skills, knowledge, and sensitivity that a photographer must possess cover issues that were practically nonexistent in Rydet's time.

The previously described dilemma relating to the ethical evaluation of Zofia Rydet's method of work also concerns the ambivalence that is part of the educational situation set up as a part of the project. Just as one can view with cynicism Zofia Rydet's decision to visit and photograph peasants because she thought that by doing this she would elevate them to the status of interesting people and add value to their lifestyle, a similarly paternalistic and colonizing premise underlies the notion that rural communities need activists from big cities to teach them social competence and facilitate integration. For this reason, what was crucial in our work was to create authentic, strong local partnerships with cultural institutions, and to customize the plan of action to the context and actual situation in a particular village, with an emphasis on observation and creating opportunities rather than attempting to introduce a permanent change, planned in advance.

Vernacularity as the Corollary

According to Clément Chéroux, vernacular photography is "useful, domestic, and heterotopic."[69] Thanks to their confrontation with the sitters or their relatives, Zofia Rydet's photographs have also proved to be personal. Earlier, they had been interpreted mainly as artistic, documentary, or academic, with an emphasis on these categories as mutually exclusive. To prove that the photographs from the *Record* are also mementos does not detract from their value; on the contrary, it reveals their great power as photographs that question the framework of the history of photography, which in the Polish context has, until now, overlooked vernacular photography. This tallies with Chéroux's findings; he points out its

69 Clément Chéroux, *Vernaculaires: Essais d'histoire de la photographie* (Cherbourg-Octeville: Le Point de jour, 2013).

peripheral quality vis-à-vis the official histories of photography which replicate the categories and schemes of art history. But, Chéroux points out, vernacularity is not art and for this reason it allows one to redefine art.[70] Indeed, says the French curator, such redefinition is inevitable; alluding to Baudelaire, he compares vernacular photography to a slave born in the household of art, aspiring for decades to achieve the status of master of the household. According to Chéroux, the essential liberation of the history and significance of photograpy from the yoke of art can take place precisely thanks to the recognition of the revolutionary function of the vernacular. If it is the case—as Allan Sekula puts it—that the "overall function of photographic discourse is to render itself transparent,"[71] then the project *Something That Will Remain* deliberately tampered with that transparency in that it brought to the fore questions and issues that until then had seemed absent—in the context of Rydet's *Record*, but also in the broader context of photography at large. The project revealed the archeological, performative, and vernacular potential of Zofia Rydet's project, demonstrating the significance of the *Sociological Record* in the analysis of the morphology of photography that Geoffrey Batchen refers to as "photographicness," the features that collectively constitute photography as a medium. As our project demonstrated, photographs that are part of a project generally considered artistic are also at the same time utilitarian, functioning as a family memento or tool in educational or social activity. *Something That Will Remain* has allowed us to discover that the "photographicness" of the *Record* stems from the project's borderline quality: these photographs are neither exclusively artistic or academic or mementos, but rather they simultaneously contain all three discourses. "A radial system has to be constructed around the photograph so that it may be seen in terms which are simultaneously personal, political, economic, dramatic, everyday and historic," wrote John Berger in his classic text

70 Ibid., 20.
71 Allan Sekula, *Photography Against the Grain: Essays and Photo Works 1973–1983* (Halifax: Nova Scotia College of Art and Design, 1984).

Uses of Photography.[72] Chéroux offers a similar thesis—to his mind, the uniqueness of photography rests in its traversal of different, often mutually contradictory, discourses that try to subjugate it. Let us repeat then: Photography is whatever it is used for. This conclusion reinforces the significance of the *Sociological Record* as a project that expands and dynamizes the definition of photography and its relationship with art which has been de rigeur in the Polish discourse. Simultaneously, our findings show that it is crucial to switch from recording the history of photography as subjugated to a single discourse toward an understanding that focuses on its diversity, including the vernacular threads in its field of vision.

72 John Berger, "Uses of Photography" (1978), in Berger, *Selected Essays*, ed.
 Geoff Dyer (New York: Vintage Books, 2003, epub edition).

From the series **EPITAPH** [z cyklu *Epitafium*] 1980, black-and-white negative, author copy, 30×40 cm, archive signature ZR002G **P. 338**

SIGNS from the series **THE INFIN- ITY OF DISTANT ROADS** [*Znaki*, z cyklu *Nieskończoność dalekich dróg*] 1980, black-and-white negative, vintage print, 30×40 cm, archive signature ZR003E03. **P. 285**

SIGNS from the series **THE INFIN- ITY OF DISTANT ROADS** [*Znaki*, z cyklu *Nieskończoność dalekich dróg*] 1980, black-and-white negative, vintage print, 30×40 cm, archive signature ZR007E03. **P. 300**

SIGNS from the series **THE INFIN- ITY OF DISTANT ROADS** [*Znaki*, z cyklu *Nieskończoność dalekich dróg*] 1980, black-and-white negative, vintage print, 30×40 cm, archive signature ZR011E03. **P. 292**

DRAMAS from the series **LITTLE MAN** [*Dramaty*, z cyklu *Mały człowiek*] 1961, black-and-white negative, author copy, 30×40 cm, archive signature ZR036A05. **P. 78**

DRAMAS from the series **LITTLE MAN** [*Dramaty*, z cyklu *Mały człowiek*] 1961, black-and-white negative, author copy, 30×40 cm, archive signature ZR044A05. **P. 83**

MEDITATION from the series **LIT- TLE MAN** [*Medytacje*, z cyklu *Mały człowiek*] 1961, black-and-white negative, author copy, 30×40 cm, archive signature ZR082A09. **P. 232**

ORAVA from the **SOCIOLOGICAL RECORD** [*Orawa*, z *Zapisu socjologicznego*] c. 1980s, four gelatin silver prints, each 18×24 cm, on cardboard 40×50 cm. **P. 126**

THE SILESIAN VILLAGE from the **SOCIOLOGICAL RECORD** [*Wieś śląska*, z *Zapisu socjologicznego*] c. 1980s, four gelatin silver prints, each 18×24 cm, on cardboard 40 ×50 cm. **P. 119**

SUWALSKIE VOIVODESHIP from the **SOCIOLOGICAL RECORD** [*Suwalskie*, z *Zapisu socjologicznego*] c. 1980s, four gelatin silver prints, each 18×24 cm, mounted on cardboard 40×50 cm. **P. 129**

SOCIOLOGICAL RECORD [*Zapis socjologiczny*] Naprawa, 1978, black-and-white negative, 24×35 mm, archive signature zr_03_002_03. **P. 306**

MYTH OF PHOTOGRAPHY from the **SOCIOLOGICAL RECORD** [*Mit fotografii z Zapisu socjologicznego*] Raba Wyżna, Podhale region, 1979–90, black-and-white negative, 24×35 mm, archive signature zr_03_065_02. **P. 257**

MYTH OF PHOTOGRAPHY from the **SOCIOLOGICAL RECORD** [*Mit fotografii z Zapisu socjologicznego*] Sieniawa, Podhale region, 1979–90, black-and-white negative, 24×35 mm, archive signature zr_03_069_38. **P. 250**

MYTH OF PHOTOGRAPHY from the **SOCIOLOGICAL RECORD** [*Mit fotografii z Zapisu socjologicznego*] Szczecin voivodeship, 1980, black-and-white negative, 24×35 mm, archive signature zr_18_009_12. **P. 252**

MYTH OF PHOTOGRAPHY from the **SOCIOLOGICAL RECORD** [*Mit fotografii z Zapisu socjologicznego*] Photograph depicting the family of of Ludwik Cudzich "Baca" (in the 1930s, governor of Biały Dunajec), Biały Dunajec, 1984, black-and-white negative, 24×35 mm, archive signature zr_01_007_33. **P. 96**

MYTH OF PHOTOGRAPHY from the **SOCIOLOGICAL RECORD** [*Mit fotografii z Zapisu socjologicznego*] Alwernia, Kraków voivodeship, 1985, black-and-white negative, 24×35 mm, archive signature zr_08_007_10. **P. 256**

OBJECTS & DECORATIONS from the **SOCIOLOGICAL RECORD** [*Przedmioty i dekoracje z Zapisu socjologicznego*] Kraczkowa, Rzeszów voivodeship, 1980, black-and-white negative, 24×35 mm, archive signature zr_11_003_27. **P. 28**

OBJECTS & DECORATIONS from the **SOCIOLOGICAL RECORD** [*Przedmioty i dekoracje z Zapisu socjologicznego*] Chochołów, 1902, black-and-white negative, 24×35 mm, archive signature zr_02_017_15. **P. 312**

OBJECTS & DECORATIONS from the **SOCIOLOGICAL RECORD** [*Przedmioty i dekoracje z Zapisu socjologicznego*] Biały Dunajec, 1984, black-and-white negative, 24×35 mm, archive signature zr_01_007_13. **P. 19**

PEOPLE IN INTERIORS from the
SOCIOLOGICAL RECORD [*Ludzie
we wnętrzach z Zapisu socjologicznego*]
Ludźmierz, Podhale region, 1978, black-and-white negative, 24×35 mm, archive signature zr_03_005_26. **P. 18**

PEOPLE IN INTERIORS from the
SOCIOLOGICAL RECORD [*Ludzie
we wnętrzach z Zapisu socjologicznego*]
Olszówka, Podhale region, 1978, black-and-white negative, 24×35 mm, archive signature zr_03_006_14. **P. 9**

PEOPLE IN INTERIORS from the
SOCIOLOGICAL RECORD [*Ludzie
we wnętrzach z Zapisu socjologicznego*]
Skomielna, Podhale region, 1978, black-and-white negative, 24×35 mm, archive signature zr_03_001_16. **P. 13**

PEOPLE IN INTERIORS from the
SOCIOLOGICAL RECORD [*Ludzie
we wnętrzach z Zapisu socjologicznego*]
Spytkowice, Podhale region, 1978, black-and-white negative, 24×35 mm, archive signature zr_03_010_08. **P. 101**

PEOPLE IN INTERIORS from the
SOCIOLOGICAL RECORD [*Ludzie
we wnętrzach z Zapisu socjologicznego*]
Raba Wyżna, Podhale region, 1978–90, black-and-white negative, 24×35 mm, archive signature zr_03_064_22. **P. 26**

PEOPLE IN INTERIORS from the
SOCIOLOGICAL RECORD [*Ludzie
we wnętrzach z Zapisu socjologicznego*]
Smolnica, Silesia, 1979, black-and-white negative, 24×35 mm, archive signature zr_04_070_04. **P. 10**

PEOPLE IN INTERIORS from the
SOCIOLOGICAL RECORD [*Ludzie
we wnętrzach z Zapisu socjologicznego*]
Czarny Dunajec, Podhale region, 1980, black-and-white negative, 24×35 mm, archive signature zr_03_015_13. **P. 259**

PEOPLE IN INTERIORS from the
SOCIOLOGICAL RECORD [*Ludzie
we wnętrzach z Zapisu socjologicznego*]
Ostropa, Silesia, 1980, black-and-white negative, 24×35 mm, archive signature zr_04_072_35. **P. 11**

PEOPLE IN INTERIORS from the
SOCIOLOGICAL RECORD [*Ludzie
we wnętrzach z Zapisu socjologicznego*]
Szczecin voivodeship, 1980, black-and-white negative, 24×35 mm, archive signature zr_18_009_25. **P. 253**

PEOPLE IN INTERIORS from the
SOCIOLOGICAL RECORD [*Ludzie
we wnętrzach z Zapisu socjologicznego*]
Wojtokiemie, Suwałki voivodeship, 1980, black-and-white negative, 24×35 mm, archive signature zr_21_008_08. **P. 25**

PEOPLE IN INTERIORS from the
SOCIOLOGICAL RECORD [*Ludzie
we wnętrzach z Zapisu socjologicznego*]
Danuta Krupa (pictured), Chochołów, 1981, black-and-white negative, 24×35 mm, archive signature zr_02_002_06. **P. 22**

PEOPLE IN INTERIORS from the
SOCIOLOGICAL RECORD [*Ludzie
we wnętrzach z Zapisu socjologicznego*]
Zofia Blaszak (pictured), Chochołów, 1982, black-and-white negative, 24×35 mm, archive signature zr_02_008_29. **P. 99**

PEOPLE IN INTERIORS from the
SOCIOLOGICAL RECORD [*Ludzie
we wnętrzach z Zapisu socjologicznego*]
Józefa Błazończyk (pictured), Chochołów, 1982, black-and-white negative, 24×35 mm, archive signature zr_02_006_25. **P. 98**

PEOPLE IN INTERIORS from the
SOCIOLOGICAL RECORD [*Ludzie
we wnętrzach z Zapisu socjologicznego*]
Maria Ewina (pictured), Chochołów, 1982, black-and-white negative, 24×35 mm, archive signature zr_02_012_16. **P. 249**

PEOPLE IN INTERIORS from the
SOCIOLOGICAL RECORD [*Ludzie
we wnętrzach z Zapisu socjologicznego*]
Kazimierz Frączysty (pictured), Chochołów, 1982, black-and-white negative, 24×35 mm, archive signature zr_02_011_10. **P. 264**

PEOPLE IN INTERIORS from the
SOCIOLOGICAL RECORD [*Ludzie
we wnętrzach z Zapisu socjologicznego*]
Stanisław Jaworczyk (pictured), Chochołów, 1982, black-and-white negative, 24×35 mm, archive signature zr_02_014_28. **P. 248**

PEOPLE IN INTERIORS from the
SOCIOLOGICAL RECORD [*Ludzie
we wnętrzach z Zapisu socjologicznego*]
Aleksandra Krupa (pictured), Chochołów, 1982, black-and-white negative, 24×35 mm, archive signature zr_02_017_23. **P. 100**

PEOPLE IN INTERIORS from the
SOCIOLOGICAL RECORD [*Ludzie
we wnętrzach z Zapisu socjologicznego*]
Stanisława Leja (pictured), Chochołów, 1982, black-and-white negative, 24×35 mm, archive signature zr_02_017_24. **P. 254**

PEOPLE IN INTERIORS from the **SOCIOLOGICAL RECORD** [*Ludzie we wnętrzach z Zapisu socjologicznego*] Jacek Maryniarczyk and Jan Maryniarczyk (pictured), Chochołów, 1982, black-and-white negative, 24×35 mm, archive signature zr_02_005_15. **P. 260**

PEOPLE IN INTERIORS from the **SOCIOLOGICAL RECORD** [*Ludzie we wnętrzach z Zapisu socjologicznego*] Karol Skorusa "Machajcok" (pictured), Chochołów, 1982, black-and-white negative, 24×35 mm, archive signature zr_02_017_16. **P. 24**

PEOPLE IN INTERIORS from the **SOCIOLOGICAL RECORD** [*Ludzie we wnętrzach z Zapisu socjologicznego*] Karol Skorusa "Machajcok" (pictured), Chochołów, 1982, 24×35 mm, archive signature zr_02_023_17. **P. 316**

PEOPLE IN INTERIORS from the **SOCIOLOGICAL RECORD** [*Ludzie we wnętrzach z Zapisu socjologicznego*] Anna and Jan Styrczula "Chruściak" (pictured), Chochołów, 1982, black-and-white negative, 24×35 mm, archive signature zr_02_020_38. **P. 21**

PEOPLE IN INTERIORS from the **SOCIOLOGICAL RECORD** [*Ludzie we wnętrzach z Zapisu socjologicznego*] Jan Szeliga (pictured), Chochołów, 1982, 24×35 mm, archive signature zr_02_024_15. **P. 329**

PEOPLE IN INTERIORS from the **SOCIOLOGICAL RECORD** [*Ludzie we wnętrzach z Zapisu socjologicznego*] Wojciech Szwab (pictured), Chochołów, 1982, black-and-white negative, 24×35 mm, archive signature zr_02_014_25. **P. 247**

PEOPLE IN INTERIORS from the **SOCIOLOGICAL RECORD** [*Ludzie we wnętrzach z Zapisu socjologicznego*] Anna Zaborska [née Klejka] (pictured), Chochołów, 1982, black-and-white negative, 24×35 mm, archive signature zr_02_011_38. **P. 261**

PEOPLE IN INTERIORS from the **SOCIOLOGICAL RECORD** [*Ludzie we wnętrzach z Zapisu socjologicznego*] Zubrzyca, Podhale region, 1982, black-and-white negative, 24×35 mm, archive signature zr_03_019_26. **P. 102**

PEOPLE IN INTERIORS from the **SOCIOLOGICAL RECORD** [*Ludzie we wnętrzach z Zapisu socjologicznego*] Jakub Gujda (pictured), Kraków, 1983, black-and-white negative, 24×35 mm, archive signature zr_09_007_10. **P. 262**

PEOPLE IN INTERIORS from the **SOCIOLOGICAL RECORD** [*Ludzie we wnętrzach z Zapisu socjologicznego*] Robert Gil (pictured), Biały Dunajec, 1984, black-and-white negative, 24×35 mm, archive signature zr_01_004_10. **P. 255**

PEOPLE IN INTERIORS from the **SOCIOLOGICAL RECORD** [*Ludzie we wnętrzach z Zapisu socjologicznego*] Podhale region, 1984, black-and-white negative, 24×35 mm, archive signature zr_01_012_19. **P. 15**

PEOPLE IN INTERIORS from the **SOCIOLOGICAL RECORD** [*Ludzie we wnętrzach z Zapisu socjologicznego*] Podhale region, 1984, black-and-white negative, 24×35 mm, archive signature zr_01_009_24. **P. 97**

PEOPLE IN INTERIORS from the **SOCIOLOGICAL RECORD** [*Ludzie we wnętrzach z Zapisu socjologicznego*] Podhale region, 1984, black-and-white negative, 24×35 mm, archive signature zr_01_012_21. **P. 263**

PEOPLE IN INTERIORS from the **SOCIOLOGICAL RECORD** [*Ludzie we wnętrzach z Zapisu socjologicznego*] Zofia Rydet (self-portrait), Kraków, 1987, 1982, 24×35 mm, archive signature zr_09_012_25. **P. 322**

PEOPLE IN INTERIORS from the **SOCIOLOGICAL RECORD** [*Ludzie we wnętrzach z Zapisu socjologicznego*] Zofia Rydet (self-portrait), Rabka, Podhale region, 1988, black-and-white negative, 24×35 mm, archive signature zr_03_047_11. **P. 105**

PRESENCE from the **SOCIOLOGICAL RECORD** [*Obecność z Zapisu socjologicznego*] Chochołów, 1982, black-and-white negative, 24×35 mm, archive signature zr_02_021_04. **P. 258**

PRESENCE from the **SOCIOLOGICAL RECORD** [*Obecność z Zapisu socjologicznego*] Podhale region, 1984, black-and-white negative, 24×35 mm, archive signature zr_01_012_18. **P. 17**

PRESENCE from the **SOCIOLOGICAL RECORD** [*Obecność z Zapisu socjologicznego*] Kraków, 1984, black-and-white negative, 24×35 mm, archive signature zr_09_008_18. **P. 266**

PROFESSIONS from the **SOCIO-LOGICAL RECORD** [*Zawody z Zapisu socjologicznego*]
Jan Śliwka (pictured), Gliwice, Silesia, 1978–90, black-and-white negative, 24×35 mm, archive signature zr_04_038_12. **P. 12**

PROFESSIONS from the **SOCIO-LOGICAL RECORD** [*Zawody z Zapisu socjologicznego*]
Kazimiera Moskała (pictured), Katowice, Silesia, 1978–90, black-and-white negative, 24×35 mm, archive signature zr_04_051_07. **P. 108**

PROFESSIONS from the **SOCIO-LOGICAL RECORD** [*Zawody z Zapisu socjologicznego*]
Suwałki voivodeship, 1978–90, black-and-white negative, 24×35 mm, archive signature zr_21_019_24. **P. 114**

PROFESSIONS from the **SOCIO-LOGICAL RECORD** [*Zawody z Zapisu socjologicznego*]
Szczecin voivodeship, 1978–90, black-and-white negative, 24×35 mm, archive signature zr_18_022_08. **P. 14**

PROFESSIONS from the **SOCIO-LOGICAL RECORD** [*Zawody z Zapisu socjologicznego*]
Kielce voivodeship, 1979, black-and-white negative, 24×35 mm, archive signature zr_13_004_23. **P. 251**

PROFESSIONS from the **SOCIO-LOGICAL RECORD** [*Zawody z Zapisu socjologicznego*]
Iwona Górska (pictured), Gliwice, Silesia, 1982, black-and-white negative, 24×35 mm, archive signature zr_04_045_01. **P. 107**

PROFESSIONS from the **SOCIO-LOGICAL RECORD** [*Zawody z Zapisu socjologicznego*]
Bolesławiec, Lower Silesia, 1983, black-and-white negative, 24×35 mm, archive signature zr_05_002_11. **P. 109**

PROFESSIONS from the **SOCIO-LOGICAL RECORD** [*Zawody z Zapisu socjologicznego*]
Józefa Wnukowa (pictured), Gdańsk, Pomerania, 1983, black-and-white negative, 24×35 mm, archive signature zr_20_019_09. **P. 265**

PROFESSIONS from the **SOCIO-LOGICAL RECORD** [*Zawody z Zapisu socjologicznego*]
Klikuszowa, Podhale region, 1983, black-and-white negative, 24×35 mm, archive signature zr_03_028_04. **P. 103**

PROFESSIONS from the **SOCIO-LOGICAL RECORD** [*Zawody z Zapisu socjologicznego*]
Ruda Śląska, Silesia, 1985, black-and-white negative, 24×35 mm, archive signature zr_04_055_31. **P. 23**

PROFESSIONS from the **SOCIO-LOGICAL RECORD** [*Zawody z Zapisu socjologicznego*]
Suwałki voivodeship, 1987, black-and-white negative, 24×35 mm, archive signature zr_21_014_27. **P. 20**

WOMEN ON DOORSTEPS from the **SOCIOLOGICAL RECORD** [*Kobiety na progach z Zapisu socjologicznego*]
Ostropa, Silesia 1978–90, black-and-white negative, 24×35 mm, archive signature zr_04_073_25. **P. 27**

WOMEN ON DOORSTEPS from the **SOCIOLOGICAL RECORD** [*Kobiety na progach z Zapisu socjologicznego*]
Podhale region, 1979–89, black-and-white negative, 24×35 mm, archive signature zr_07_004_27. **P. 111**

WOMEN ON DOORSTEPS from the **SOCIOLOGICAL RECORD** [*Kobiety na progach z Zapisu socjologicznego*]
Poznań voivodeship, 1979, black-and-white negative, 24×35 mm, archive signature zr_17_002_32. **P. 110**

WOMEN ON DOORSTEPS from the **SOCIOLOGICAL RECORD** [*Kobiety na progach z Zapisu socjologicznego*]
Żubrówka, Suwałki voivodeship, 1980, black-and-white negative, 24×35 mm, archive signature zr_21_006_17. **P. 112**

WOMEN ON DOORSTEPS from the **SOCIOLOGICAL RECORD** [*Kobiety na progach z Zapisu socjologicznego*]
Mszana, Podhale region, 1983, black-and-white negative, 24×35 mm, archive signature zr_03_032_19. **P. 104**

WOMEN ON DOORSTEPS from the **SOCIOLOGICAL RECORD** [*Kobiety na progach z Zapisu socjologicznego*]
Anna Stachowiec (pictured), Biały Dunajec, 1984, black-and-white negative, 24×35 mm, archive signature zr_01_003_21. **P. 95**

WOMEN ON DOORSTEPS from
the **SOCIOLOGICAL RECORD**
[*Kobiety na progach z Zapisu socjolo-
gicznego*]
Rzeszów voivodeship, 1984, black-and-white
negative, 24×35 mm, archive signature
zr_11_015_06. **P. 16**

WOMEN ON DOORSTEPS from
the **SOCIOLOGICAL RECORD**
[*Kobiety na progach z Zapisu socjolo-
gicznego*]
Suwałki voivodeship, 1987, black-and-white
negative, 24×35 mm, archive signature
zr_21_019_24. **P. 113**

WOMEN ON DOORSTEPS from
the **SOCIOLOGICAL RECORD**
[*Kobiety na progach z Zapisu socjolo-
gicznego*]
Tokarnia, Podhale region, 1988, black-and-
white negative, 24×35 mm, archive signature
zr_03_049_04. **P. 106**

EXPECTATIONS from the series
**THE WORLD OF FEELINGS AND
IMAGINATION** [*Oczekiwania* z cyklu
Świat uczuć i wyobraźni]
1975–79, diapositives, vintage prints (includ-
ing vintage prints mounted on cardboard) in
different formats (18×24 cm, 24×30 cm,
30×40 cm, 40×50 cm, 50×60 cm, 70×90 cm,
70×100 cm), ZR003D04. **P. 87**

Bernd and Hilla Becher
FRAMEWORK HOUSES OF THE SIEGEN INDUSTRIAL REGION [Giebelseiten Fachwerk], 1960–73, gelatin silver prints, each 41.2×30.5 cm, © Estate Bernd & Hilla Becher, courtesy of Die Photographische Sammlung/SK Stiftung Kultur, Cologne. **P.** 190

Anna Beata Bohdziewicz
PORTRAIT, Podwilk, Podhale region, 1988, courtesy of Anna Beata Bohdziewicz. **P.** 71
WANDERINGS WITH ZOFIA RYDET, a photo essay, all images courtesy of Anna Beata Bohdziewicz.
ZOFIA RYDET IN THE DOORWAY, 1988, Podwilk, Podhale region. **P.** 49
ZOFIA RYDET ARRANGES HER PICTURES, 1983, "Znak Krzyża" exhibition at the Church of Our Lord's Mercy, Żytnia St., Warsaw. **P.** 51, *top*
ZOFIA RYDET'S PICTURES SURROUNDING AN ALTAR, 1983, "Znak Krzyża" exhibition at the Church of Our Lord's Mercy, Żytnia St., Warsaw. **P.** 51, *bottom*
NOWY TARG, 1988, in a department store. **P.** 53, *top*
PARIS, 1988. **P.** 53, *middle*
PARIS, at Zbigniew Dłubak's, 1988. **P.** 53, *bottom*
EXHIBITION OPENING, 1988, Zofia Rydet forces the organizers to rehang her pictures during the opening of "Zwischen Elbe und Wolga" at the Lenbachhaus, Munich. **P.** 55, *sequence*
PODWILK, 1988, Podhale region. **P.** 58, *top*
OBIDOWA, 1988, Podhale region, Zofia Rydet and Zofia Huzior. **P.** 58, *middle* and *bottom*; **P.** 59, *top* and *bottom*
PODHALE REGION, 1988. **P.** 61, *top*
PODWILK, 1988, Podhale region, at a smithy, Zofia Rydet and Linus Grzybacz. **P.** 61, *middle*
PODWILK, 1988, Podhale region, in the home of the smithy's owner, Zofia Rydet photographs his wife Mrs. Chowaniec. **P.** 61, *bottom*
PODWILK, 1988, Podhale region, Zofia Rydet and Mr. Grzyb. **P.** 63, *sequence*

NAPRAWA, 1988, Podhale region, Zofia Rydet and Mrs. Anna Worwa. **P.** 65, *top*, *middle*, and *bottom*
PODWILK, 1988, Podhale region, at Mrs. Chowaniec's. **P.** 66, *top* and *bottom*

Christian Borchert
CELEBRATION WITH THE FAMILY ON THE OCCASION OF THE SUCCESSFULLY PASSED EXAM (SKILLED WORKER FOR TELECOMMUNICATIONS INSTALLATION) [Beschreibung: Feier anläßlich der Übergabe des Facharbeiters für Fernmeldebau im Kreis der Familie], 1974, gelatin silver print, 14.6×23.1 cm, © SLUB Dresden, Deutsche Fotothek, Christian Borchert. **P.** 204
MOTHER WITH CHILDREN IN THE KITCHEN ("THE FLINTSTONES" ON TELEVISION) [Mutter mit Kindern in der Küche, in der ein Fernseher läuft (Trickfilm "Fred Feuerstein")], 1977, gelatin silver print, 12.8×19.3 cm, © SLUB Dresden, Deutsche Fotothek, Christian Borchert. **P.** 205

Pierre Bourdieu
AÏN AGHBEL, COLLO, N 6/7, 1958–61, Archive Pierre Bourdieu, Images d'Algérie, 1958–61, black-and-white negative, 6×6 cm, © Pierre Bourdieu/Foundation Bourdieu, St. Gall., courtesy of Camera Austria, Graz. **P.** 270

Solomon D. Butcher
THE CHRISMAN SISTERS ON A CLAIM IN COHEEN SETTLEMENT ON LIEBAN (LILLIAN) CREEK, CUSTER COUNTY, 1886, glass plate negative, 6×8 cm, courtesy of the Nebraska State Historical Society. **P.** 222

Chauncey Hare
WINTERSVILLE, OHIO, 1971. This photograph was made by Chauncey Hare to protest and warn against the growing domination of working people by multi-national corporations and their elite owners and managers, Chauncey Hare photograph archive [graphic], BANC PIC 2000.012 13:001-ffALB, © The Regents of the University of California, The Bancroft Library, University of California, Berkeley. **P.** 176

Wilmar Koenig
HEIDI, 1975, courtesy of Wilmar Koenig. **P.** 196
SCHOSEL FAMILY [Familie Schosel], 1976, courtesy of Wilmar Koenig. **P.** 197

Agnieszka Pajączkowska
Helena Kochmańska, inhabitant of Markowa, identified her parents—Józef and Zofia Homa—in one of Zofia Rydet's photographs (sign. zr_11_009_37). The photograph is about to be placed in her family album, Markowa, September, 2015, courtesy of Agnieszka Pajączkowska. **P. 350**
The house of Rozalia Trela, Zalipie, photographed by Zofia Rydet in 1981 (sign. zr_10_001_20), and by Agnieszka Pajączkowska, in August, 2015, courtesy of Agnieszka Pajączkowska. **P. 364**

Paweł Pierściński
REPORTAGE ON EDMUND ŻĄDŁO, FOREMAN from **THE WORKING CLASS FAMILY: FOUNDRY-HOME-FAMILY** [Rodzina Robotnicza. Huta-Dom-Rodzina], 1978–79, gelatin silver print, 17×23 cm, courtesy of private collection. **P. 152**

Wojciech Prażmowski
SZCZECIN FAMILY [Rodzina szczecińska], Joanna and Jan Kulma, Strumiany, 1980, gelatin silver print, 17.2×17.2 cm, courtesy of Wojciech Prażmowski. **P. 158**

Aleksander Salij (amateur)
REPORTAGE ON JÓZEF ZBOROWSKI, RETIRED FOREMAN from **THE WORKING CLASS FAMILY: FOUNDRY-HOME-FAMILY** [Rodzina Robotnicza. Huta-Dom-Rodzina], 1978–79, gelatin silver print, 17×23 cm, courtesy of private collection. **P. 154**

August Sander
YOUNG FARMERS [Jungbauern], 1914, gelatin silver print, 23.3×17 cm, © J. Paul Getty Trust; Die Photographische Sammlung/ SK Stiftung Kultur – August Sander Archiv, Cologne; VG Bild-Kunst, Bonn, 2018, courtesy of The J. Paul Getty Museum, Los Angeles. **P. 275**

Michael Schmidt
LOCAL POLITICIAN OF THE CDU PARTY from the series **BERLIN-WEDDING** [Kommunalpolitiker der CDU, Berlin-Wedding, Stadtlandschaft und Menschen], 1976–78, gelatin silver prints, 23.8×16.2 cm, © Foundation for Photography and Media Art with the Michael Schmidt Archive. **PP. 200–201**

MÜLLER-/SEESTRASSE from the series **BERLIN- WEDDING** [Müller-/Ecke Seestraße, Stadtlandschaft und Menschen], 1976–78, gelatin silver prints, 23.8 ×16.2 cm, © Foundation for Photography and Media Art with the Michael Schmidt Archive. **P. 202**

Leslie Shedden/Shedden Studios
NO. 26 COLLIERY, 1963, Shedden Studios, MG 21.26.C, cellulose acetate film-based negative, digitized for public access purposes, courtesy of the Beaton Institute, Cape Breton University. **P. 227**

Zdzisław Sieńkowiec
SZCZECIN FAMILY [Rodzina szczecińska], Jaruzel Family, Szczecin, 1980, gelatin silver print, 14.7×18.1 cm, courtesy of Zdzisław Sieńkowiec. **P. 157**

Stanisław Sudnik (amateur)
REPORTAGE ON STANISŁAW FRANCUZ, FOREMAN from **THE WORKING CLASS FAMILY: FOUNDRY-HOME-FAMILY** [Rodzina Robotnicza. Huta-Dom-Rodzina], 1978–79, gelatin silver print, 18×23.5 cm, courtesy of private collection. **P. 149**

Unknown Photographer
Meeting of the Gliwice Photographic Society, 1950s, gelatin silver print, 8×14 cm, courtesy of the Zofia Rydet Foundation. **P. 230**

Zofia Rydet in her apartment in Gliwice, early 1970s, gelatin silver print, 13×18 cm, courtesy of the Zofia Rydet Foundation. **P. 74**

"MG," II apartment interior, Ms. Cz[redacted] in the kitchen, Bydgoszcz, 1978–80, gelatin silver print, 23×17.5 cm; file 41/B/I/MG from Andrzej Siciński's research project **LIFESTYLES IN POLISH CITIES 1976–80** [Style życia w miastach polskich], documenting an intelligentsia family from Bydgoszcz, courtesy of the Qualitative Data Archive, Institute of Philosophy and Sociology, Polish Academy of Sciences. **P. 164**

"PŁ," III family photograph, in the living room, from the left: Mrs. Wł., the youngest daughter, G[redacted] with her two sons, Mr. Wł., photo by K. K[redacted], Bydgoszcz, April 1980, gelatin silver print, 12.5×17.5 cm; file 56/B/REN/PŁ from Andrzej Siciński's research project **LIFESTYLES IN POLISH CITIES 1976–80** [Style życia w miastach polskich], documenting a family of pensioners from Bydgoszcz, courtesy of the Qualitative Data Archive, Institute of Philosophy and Sociology, Polish Academy of Sciences. **P. 165**

"PŁ," II apartment interior, the daughter's room, Bydgoszcz, April 1980, photo by K. K[redacted], gelatin silver print, 12.3×17.5 cm; file 58/B/R/PŁ from Andrzej Siciński's research project **LIFESTYLES IN POLISH CITIES 1976–80** [Style życia w miastach polskich], documenting a working class

family from Bydgoszcz, courtesy of the Qualitative Data Archive, Institute of Philosophy and Sociology, Polish Academy of Sciences. **P. 168**

G. F. Williams
STUDIO PHOTOGRAPH OF TWO UNIDENTIFIED WOMEN, South Africa, late nineteenth century, carte de visite, paper size 8.9×5.5 cm, card 10.3×6.2 cm, courtesy of The Walther Collection. **P. 224**

Ulrich Wüst
KARL-MARX-STADT from the series **STADTBILDER**, 1982, © Ulrich Wüst, courtesy of Loock Galerie, Berlin. **P. 208**

BOOKS

THE MUSEUM UNDER CONSTRUCTION
BOOK SERIES

EDITED BY MARTA DZIEWAŃSKA
AND KATARZYNA SZOTKOWSKA-BEYLIN

No. 1 **1968–1989: POLITICAL UPHEAVAL AND ARTISTIC CHANGE**
Edited by Claire Bishop & Marta Dziewańska
Museum of Modern Art in Warsaw, 2009
The texts assembled in this reader are a selective record of presentations from the "1968–1989" seminar, held as a comparative reflection on the artistic significance of 1968, the political transformation of 1989, and methods of communication in art.
ISBN 978-83-924044-0-8

No. 2 **ION GRIGORESCU: IN THE BODY OF THE VICTIM**
Edited by Marta Dziewańska
Museum of Modern Art in Warsaw, 2010
This book is an attempt to read the work of one of the most charismatic and original artists from the former Eastern Bloc, who worked in relative isolation until 1989, and whose art can be viewed in relation to similar positions artists have taken in other parts of the world.
ISBN 978-83-924044-1-5

No. 3 **WARSZAWA W BUDOWIE 2009**
[Warsaw Under Construction 2009]
Edited by Marcel Andino-Velez
Museum of Modern Art in Warsaw, 2010
This book is a record of events that took place as part of the "Warsaw Under Construction" festival's first edition, focused on design, architecture, and town planning and attempting to capture the spirit and creative energy that had then begun taking over the city. Book in Polish language.
ISBN 978-83-924044-2-2

No. 4 **AS SOON AS I OPEN MY EYES I SEE A FILM. EXPERIMENT IN THE ART OF YUGOSLAVIA IN THE 1960S AND 1970S**
Edited by Ana Janevski
Museum of Modern Art in Warsaw, 2010
This book is inspired by the first exhibition organized by the museum. It is a journey to a country that has ceased to exist, but which gave rise to the most important art myth in our part of Europe: the myth of radical art.
ISBN 978-83-924044-3-9

No. 5 **ALINA SZAPOCZNIKOW: AWKWARD OBJECTS**
Edited by Agata Jakubowska
Museum of Modern Art in Warsaw, 2011
Seen as a great artist in Poland, elsewhere Szapocznikow has remained relatively unknown. Today she enjoys the status of a discovery, her sculpture entering museum collections worldwide. An artist who always put herself in the difficult position of pioneer heading towards the new and unknown, in 1972, near the end of her life, she confessed: "As for me, I produce awkward objects." Here that life and work is addressed by, among others, Griselda Pollock, Sarah Wilson, and Ernst van Alphen.
ISBN 978-83-924044-6-0

No. 7 **POST-POST-SOVIET? ART, POLITICS & SOCIETY IN RUSSIA AT THE TURN OF THE DECADE**
Edited by Marta Dziewańska, Ekaterina Degot & Ilya Budraitskis
Museum of Modern Art in Warsaw, 2013
By placing emerging artists in their political and social contexts, this book attempts to confront the activist scene that has arisen in today's art world in Russia. A criticism by writers and scholars plus an extensive timeline of artistic and sociopolitical context.
ISBN 978-83-933818-4-5

No. 8 **OSKAR HANSEN: OPENING MODERNISM**
Edited by Aleksandra Kędziorek & Łukasz Ronduda
Museum of Modern Art in Warsaw, 2014
The book analyzes diverse aspects of the architectural, theoretical, and didactical oeuvre of Oskar Hansen, Polish member of Team 10, and chronicles the impact of his theory of Open Form on architecture, urban planning, experimental film, and visual arts in postwar Poland.
ISBN 978-83-641770-5-7

No. 9 **TEAM 10 EAST: REVISIONIST ARCHITECTURE IN REAL EXISTING MODERNISM**
Edited by Łukasz Stanek
Museum of Modern Art in Warsaw, 2014
Team 10 East never existed. The volume develops that term as a conceptual tool to discuss the work of Team 10 members and fellow travelers from socialist countries—such as Oskar Hansen of Poland and Charles Polónyi of Hungary, along with a number of architects from Czechoslovakia and Yugoslavia.
ISBN 978-83-641770-3-3

No. 10 **ANDRZEJ WRÓBLEWSKI: RECTO/VERSO**
Edited by Éric de Chassey & Marta Dziewańska
Museum of Modern Art in Warsaw, 2015
One of Poland's preeminent postwar artists, Andrzej Wróblewski (1927–57) created a highly individual and prolific form of abstract and figurative painting. His output reflects the original solutions he devised to address the personal and public issues of his time, in ways that are very relevant today and continue to inspire artists.
ISBN 978-83-64177-16-3

No. 11 **MARIA BARTUSZOVÁ: PROVISIONAL FORMS**
Edited by Marta Dziewańska
Museum of Modern Art in Warsaw, 2015
Working alone behind the Iron Curtain, Maria Bartuszová (1936–96) was one of a number of female artists who not only experimented formally and embarked intuitively on new themes, but who, because of a position at odds with mainstream modernist trends, remained in isolation or in a marginalized position. The book deftly reveals how Bartuszová experimented with materials, never hesitating to treat tradition, accepted norms, and trusted techniques as simply transitory and provisional.
ISBN 978-83-64177-26-2

No. 12 **POINTS OF CONVERGENCE: ALTERNATIVE VIEWS OF ON PERFORMANCE**
Edited by Marta Dziewańska
& André Lepecki
Museum of Modern Art in Warsaw, 2017
 Always happening in the here and now, and yet implicating past and future, performance is a practice open to the unknown, constantly questioning its own subjects, materials, and languages. *Points of Convergence: Alternative Views on Performance* explores these ideas, potentials, and capacities of performance, stimulating new discussion between theorists and practitioners on the genealogies of performance, on unexpected lines of influence, and on off-center historiographies.
ISBN 978-83-64177-38-5

No. 14 **THE OTHER TRANS-ATLANTIC: KINETIC AND OP ART IN EASTERN EUROPE AND LATIN AMERICA**
Edited by Marta Dziewańska, Dieter Roelstraete, Abigail Winograd
Museum of Modern Art in Warsaw, 2017
 The Other Trans-Atlantic is attuned to the brief but historically significant period between 1950 and 1970 when the trajectories of the Eastern European and Latin American art scenes converged in a shared enthusiasm for kinetic and Op art. As the established axis of Paris, London, and New York became increasingly dominated by a succession of ideological monocultures—such as the master concepts of gesture and expression, Pop, or minimalism—another web of ideas was being spun, linking Warsaw, Moscow, and Zagreb, with Buenos Aires, Caracas, and São Paulo. These artistic practices were dedicated to a different set of aesthetic concerns: philosophies of art and culture dominated by notions of progress and science, the machine and engineering, construction and perception.
ISBN 978-83-64177-42-2

BOOKS

No. 6 **LOVELY, HUMAN, TRUE, HEARTFELT: THE LETTERS OF
ÁLINA SZAPOCZNIKOW AND RYSZARD STANISŁAWSKI 1948–1971**
Edited by Agata Jakubowska & Katarzyna Szotkowska-Beylin
Translated by Jennifer Croft
Museum of Modern Art in Warsaw, 2012

The previously unpublished correspondence between Alina Szapocznikow and
Ryszard Stanisławski, a woman of increasing importance in twentieth-century art and a man
who was an eminent critic and museum director.

ISBN 978-83-933818-6-9

Object Lessons: Zofia Rydet's Sociological Record

The essays assembled in this book are a selective record of a research symposium curated by Krzysztof Pijarski titled "Between 'Old Objectivity' and 'Naive Conceptualism'" (January 8–9, 2016), held on the occasion of the exhibition, "Zofia Rydet: *Record, 1978–1990*" (September 25, 2015–January 1, 2016), curated by Sebastian Cichocki and Karol Hordziej. Both the exhibition and the symposium took place at the Museum of Modern Art in Warsaw. Maren Lübbke-Tidow's essay, "Concepts of Agency: Zofia Rydet from the Perspective of German Photographic Art of the 1970s," was commissioned especially for this publication.

Editor
Krzysztof Pijarski
Series Editors
Marta Dziewańska
Katarzyna Szotkowska-Beylin
Managing Editor
Meagan Down
Translations
Anda MacBride (Polish–English: 31–37; 49–67; 69–92; 327–366)
Marcin Łakomski (German–English: 179–213)
Design concept and layout
Ludovic Balland Typography Cabinet, Basel
Typesetting and lithography
Noviki Studio
Katarzyna Nestorowicz, Marcin Nowicki
Typefaces
Ludwig Pro
Printed by
CHROMAPRESS Sp. z o.o.
ul. Jutrzenki 82, 02-230 Warsaw
Cover photographs
Front cover: Zofia Rydet, *People in Interiors*, from the *Sociological Record*, Ostropa, Silesia, 1980, black-and-white negative, 24×35 mm, archive signature zr_04_072_35, © Zofia Rydet Foundation, 2017.

Back cover: Anna Beata Bohdziewicz, *Podhale region*, 1988, © Anna Beata Bohdziewicz.

Copyrights
The editor would like to thank the authors, artists, collecting agencies, and rights-holders for providing permission to reproduce select images in this book. With special thanks to the following for the provision of images without fee: Wilmar Koenig; Agnieszka Pajączkowska; Zdzisław Sieńkowiec; Wojciech Prażmowski; Ulrich Wüst; Archive of Quantitative Data, Institute of Philosophy and Sociology, Polish Academy of Science; Beaton Institute, Cape Breton University; the Foundation for Photography and Media Art, the Michael Schmidt Archive; Loock Galerie, Berlin; and The Walther Collection.

The Museum of Modern Art in Warsaw wishes to thank its partners on the four-year digitization and dissemination project "Zofia Rydet: *Sociological Record*" initiated by the Foundation for Visual Arts: the Zofia Rydet Foundation and the Museum in Gliwice. The results of this project are available online, at the dedicated homepage http://www.zofiarydet.com.

Publisher
Museum of Modern Art in Warsaw
Pańska 3
00–124 Warsaw
www.artmuseum.pl

ISBN: 978-83-64177-37-8

Distributed by
The University of Chicago Press
www.press.uchicago.edu

The Museum of Modern Art in Warsaw is funded by the Ministry of Culture and National Heritage:

The premises and selected projects are funded by the City of Warsaw:

Ministry of
Culture
and National
Heritage of
the Republic
of Poland.

Patron of the Museum and the collection:

Strategic Partner of the Museum:

Partner of the Museum:

Legal advisor:

The Zofia Rydet Foundation was established, in 2011, by Maria Sokół-Augustyńska and Zofia Augustyńska-Martyniak, who have ensured the preservation and accessibility of the artist's estate since her death, in 1997. The foundation is primarily engaged in inventorying and digitizing the archive of Zofia Rydet.

In the recent past, the foundation has organized and co-organized a range of exhibitions in Poland and abroad to showcase Zofia Rydet's work. In 2014, it launched *Something That Will Remain*, an ongoing community art project designed by Agnieszka Pajączkowska, and based around Zofia Rydet's working methods and photographs.

A large-scale project devoted to the *Sociological Record*, organized in 2012–16 together with the Foundation for Visual Arts, the Museum of Modern Art in Warsaw, and the Museum in Gliwice, spawned the www.zofiarydet.com website, the exhibition "Zofia Rydet: *Record*, 1978–1990" at the Museum of Modern Art in Warsaw, and the book *Zapis* (Muzeum w Gliwi-

cach, 2015), featuring photos and texts selected and written by Wojciech Nowicki, with graphic design by Witold Siemaszkiewicz.

In 2016, work began on inventorying, archiving, and scanning the *Documentation 1950–1978* collection. That period resulted in other series of Rydet's, such as *Little Man, Time of Passing*, and *The World of Feelings and Imagination*, including the so-called *Pre-Record* (i.e. photographs taken before *Sociological Record*), as well as thousands of previously unknown motifs illustrating the scope of her output.

All digitization work is undertaken in collaboration with the LabLab Foundation in Kraków.

Since 2016, the Foundation has also been cooperating with Raster Gallery in Warsaw.

The Foundation's activities are subsidized by the Ministry of Culture and National Heritage, the General Directorate of State Archives, the Marshal of Lesser Poland Voivodeship, and Rabka Town Council.